To my <u>Abba</u>,

I am proud
of you and your
achievement.

This is a day
to remember
forever!

with love,
James

CHAGALL

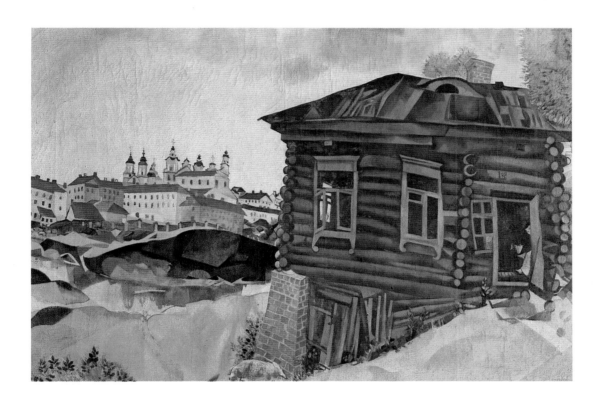

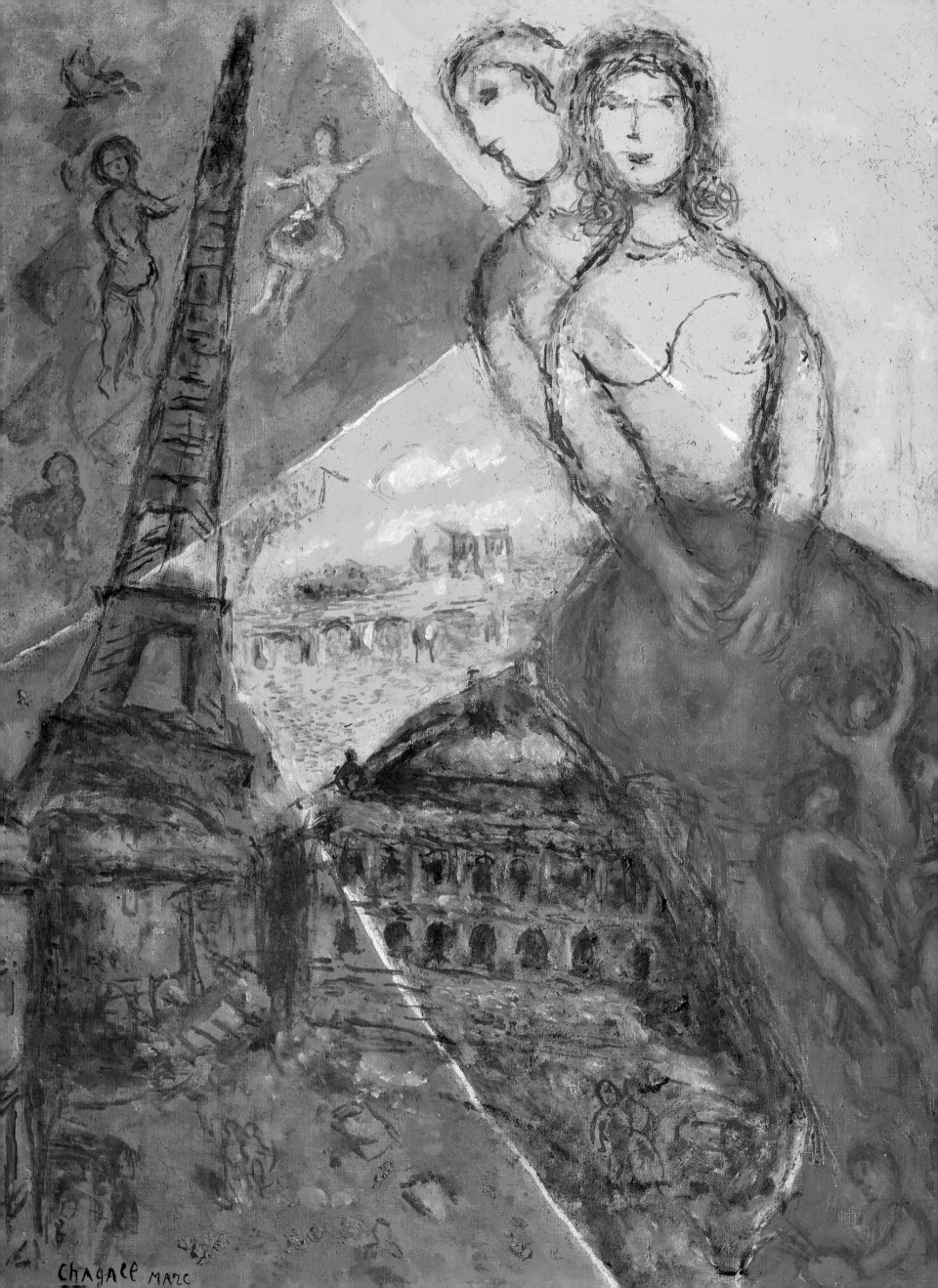

CHAGALL

SHEARER WEST

SMITHMARK

This edition published in 1994
by SMITHMARK Publishers Inc.,
16 East 32nd Street
New York, New York 10016

SMITHMARK books are available for bulk purchase for
sales promotion and premium use. For details write or
telephone the Manager of Special Sales, SMITHMARK
Publishers Inc., 16 East 32nd Street, New York, NY
10016, (212) 532-6600.

Produced by Brompton Books Corp.,
15 Sherwood Place
Greenwich, CT 06830

ISBN 0-8317-1349-6

Printed in China

10 9 8 7 6 5 4 3 2 1

Contents and List of Plates

Introduction

The prolific and idiosyncratic oeuvre of Marc Chagall extends over a period in which art underwent decisive and radical changes in conception and presentation. Throughout his career, which lasted nearly 80 years, Chagall both participated in and stood apart from the major art movements of his day. He persisted in a figurative, yet lyrical, approach to art which eschewed pure abstraction but reveled in the possibilities of color. His thematic repertoire was limited, relying heavily on imagery established in his native Russia, but Chagall used these simple, often childlike, recurrent themes as a means of tapping a spiritual reality underneath the mundane reality of everyday life. Chagall sustained his singleminded artistic vision through life-long contacts with persuasive and influential art movements: the Symbolist and Futurist tendencies in Russian art; the Cubism, Orphism, and Fauvism of pre-War Paris; the Constructivist and Suprematist rebellions of Vladimir Tatlin and Kasimir Malevich; and the Surrealist movement of the 1920s. Chagall's art remained a form of lyrical autobiography, evoking his Russian and Jewish heritage through a striking juxtaposition of bold color and naively presented imagery. At the time of his death in 1985, Chagall was one of the most respected of living artists, leaving behind him not only a staggering quantity of paintings, prints, and drawings, but also sculpture, ceramics, stained glass, mosaic, and tapestry.

Throughout his life, Chagall presented an imaginary world in which the laws of nature are subverted and mocked. Otherwise mundane figures and objects such as milkmaids, cows, onion-domes, and decrepit shacks, become in Chagall's hands elements of fantasy or fairy-tale. His special form of poetic painting had much to do with his heritage and upbringing. Chagall was born on 7 July 1887 in Peskovatik, a village on the outskirts of Vitebsk, but his family soon moved to Vitebsk, which was a large, prosperous industrial city. Vitebsk was among the regions segregated by the Pale of Settlement – an act which limited the areas in which Russian Jews were allowed to live and work. Of the more than 60,000 inhabitants of Vitebsk, half were Jews, many of whom were involved in some aspect of the city's trading concerns. However, the Jews in Vitebsk and in Russia at this time were not uniform in either their beliefs or their aspirations. Chagall grew up in an environment in which aspects of conservative Judaism were being challenged by progressives who desired more rights for Jewish citizens. Not only were Russian Jews herded into the Pale of Settlement, but their freedom to travel and attend university was also limited, and they were regularly exposed to pogroms which confirmed their subjugation. However, Chagall was not strongly influenced by the new Zionist and Socialist supporters, but rather by the older practices of Hasidism, an anti-rational movement which had been founded in the 18th century. The Hasidic credo 'serve God in joy' confirmed sadness as a sin, promoting instead an ecstatic approach to life. Hasidism saw perceived reality as a veil disguising a more essential reality, and storytelling was a prominent part of this practice. Fantasy was thus not felt to be self-indulgent, but enlightening, whereas intellect, rules, and dogmatism were considered false and constricting. Chagall himself said: 'Dogma means separation; and separation means conflict, struggle, hate, and war,' echoing the Hasidic suspicion of rationalism.

These influences came to bear on Chagall throughout his childhood, which was spent in modest surroundings with a family struggling to avoid poverty. Chagall's father worked as a herring packer, and his mother ran a small grocery to support their seven daughters and two sons. Chagall studied at the local *heder*, or religious school, but he later attended a Russian school, where he learned to speak Russian and, more importantly, he began to become interested in art. It is difficult to avoid attributing to Chagall the kind of mythological success story that is so characteristic of writing about artists, especially given the factors that were working against him. His Jewish background virtually disqualified him from considering art as a career: the Mosaic injuction 'Thou shalt not suffer unto thee any graven

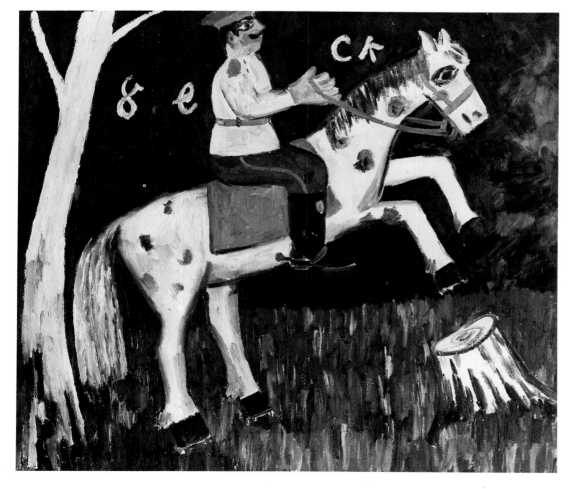

Left: *Soldier on a Horse*, c. 1911, by Mikhail Larianov, an artist of the Russian avant-garde.

was the center for both Symbolist and later Futurist art movements. From the 1890s the World of Art group had reacted against Russian provincialism by holding exhibitions of modern western art in St Petersburg. The World of Art advocated the doctrine of 'art for art's sake,' and through exhibitions and a periodical, they introduced the work of Symbolists and others such as Whistler, Burne-Jones, and Puvis de Chavannes, as well as the vibrant colorism of Post-Impressionists such as Cézanne, Van Gogh, and Gauguin. Russian art responded quickly to these new stimuli, and in Moscow the enlightened collector Sergei Shchukin was one of the first advocates of both Matisse and Picasso. In St Petersburg reaction came in the form of the Union of Youth movement, which preached progress, newness, and the abrogation of the old order. The Union of Youth was St Petersburg's answer to Italian Futurism, and it promoted similar enthusiasm for modern life. Paradoxically, just as modern Western art entered Russia through the activities of the World of Art and the Union of Youth, artists were returning to their Russian heritage for inspiration. This did not actually involve a rejection of Western modernism, but modernist tendencies such as Fauvism and Cubism were adapted to specifically Russian subject-matter. This new concern for things Russian was primarily advocated by Moscow artists such as Larianov and Goncharova, who self-consciously adopted forms and subjects derived from Russian icons and *lubki*, or simple folk

image' had dissuaded Jews from practicing art for hundreds of years. Image-making was a form of blasphemy, and was not justified in Jewish law. But Chagall, seemingly unaware of the implications of his activities, began copying pictures from magazines while he was still in school and managed to persuade his reluctant parents to allow him to progress to formal study. In 1907 he first studied with the most proficient of local portrait-artists, Jehuda Pen, whose old-fashioned methods of copying plaster casts proved too limiting for the headstrong and ambitious Chagall. Indeed Vitebsk was hardly a center of artistic activity at the time, whereas Moscow and St Petersburg were both flourishing with new artistic ideas. Feeling that it was impossible to progress without a proper training and environment, Chagall went to St Petersburg in the winter of 1907/8 and spent much of the next two years there.

In St Petersburg Chagall was exposed to a rich array of both old masters and new developments in art. The Hermitage displayed a vast spectrum of art history, and some early paintings by Chagall show evi-

dence of close study and emulation of 17th-century European art contained in the Hermitage. More importantly, St Petersburg

Below: Caricature of the Svanseva School exhibition, 1910. 1 and 5 are by Chagall.

Below left: *The Cardiff Team* by Robert Delaunay, 1912-13. Chagall shared with Delaunay an interest in the effects of color and in the use of modern Paris as a subject for painting.

prints. Although Chagall did not visit Moscow during this rich and exciting period, these experiments would have been conveyed to him both through art journals, such as the *Golden Fleece*, and through his teachers in St Petersburg. Chagall's art from the beginning seems to suggest this peculiarly Russian blend of the native, the ancient, and the archetypal, with the modern and the experimental.

Chagall's own study in St Petersburg was characterized by many setbacks and continual financial difficulty. He took and failed the exam to enter the St Petersburg School of Arts and Crafts, but he managed to gain admittance to the Free Academy, or the School of the Society for the Protection of the Arts. Here he was again exposed to the academic methods of his former teacher, Pen, and forced to copy antique casts and old-master paintings, as well as to draw from the life. He obviously felt constricted by this environment, and he left the school before the end of 1908. Over the next two years he studied under many different teachers in several private schools, but the most influential of these experiences was when he studied at the Svanseva School under Léon Bakst.

Bakst was one of the original members of the World of Art, who specialized in exotic and violently colored set and costume designs used for the productions of Diaghilev's Ballets Russes. Bakst was not especially impressed with Chagall at the time, nor did Chagall have much patience with Bakst, but through the Svanseva School, Chagall was exposed to enthusiasm for the

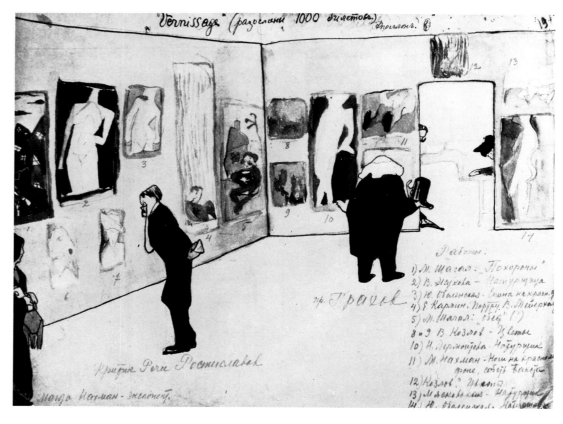

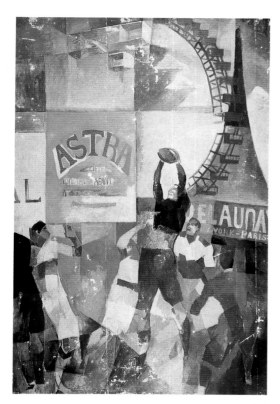

art of the Impressionists, Van Gogh, and Cézanne. Direct influence of Bakst can be seen much later in Chagall's career, when he too designed sets, costumes, and curtains for the theater from the 1940s onwards. In productions such as the *Firebird* and *Daphnis and Chloe*, the rich and unapologetic use of color and evocative, rather than literal, representations, recall Bakst's designs for the theater and ballet.

While Chagall was being both enlightened and frustrated by his new exposure to art in St Petersburg, he was also struggling to earn a living and forced to suffer from some of the more stringent discriminations against Jews. His presence in St Petersburg required permission and a passport, and he found himself having to acquire this permission by pretending to make deliveries for his father. He had to return regularly to Vitebsk when his passport ran out, and this tense situation was compounded by the difficulties he had supporting himself. He worked as a sign-painter, a photographic retoucher, and a domestic servant. This unsatisfactory state of affairs was improved somewhat by the intervention of two powerful and wealthy men who saw in Chagall a worthy artistic representative of the Jewish race. The first of these enlightened patrons was Baron David Guinsburg, a financier, who gave Chagall a small sum of money to help him fund his education. Both Guinsburg and Chagall's other patron, Maxim Vivaner, were connected with the committee pleading for Jewish rights to the Duma — the legislative

assembly formed by the Czar in 1905 as an appeasement to the rumbling revolutionary forces in the country. Thus Chagall's early supporters were connected directly or indirectly with the new stirrings of feeling and resentment among the Russian Jews, who wanted to improve their position through legislation. Vivaner was the first person to purchase paintings from Chagall, and he increased his support for the artist by providing him with the means to go to Paris in 1910.

Paris was the center of European artistic activity in the years immediately preceding World War I. Through experimentation and art exhibitions, new 'movements' were initiated each year, provoking first public outrage and eventually winning public approbation. The exhibition of colorful paintings by Matisse, Derain, and Vlaminck at the Salon d'Automne in 1905 gained these artists the nickname 'Fauves' or 'wild beasts.' By 1910 Picasso's experiments influenced by African and Iberian art, combined with Braque's attempts to rethink the formalism of Cézanne, resulted in Cubism. Futurism was introduced by Marinetti's Manifesto, which was published in *Le Figaro* in 1909, and Robert Delaunay's Orphism combined elements of both Cubism and Futurism in a new manipulation of color, space, and subject-matter based on modern Parisian life. The time was exciting, argumentative, and sometimes hysterical; artists banded together and then separated to follow individual paths; art exhibitions became

arenas for novelty, inspiring both disgust and enthusiasm from among the public and critics. Chagall entered Paris during this fruitful time and was touched by many of the new experiments, without being overwhelmed by them.

When Chagall arrived in Paris, he was still rather ingenuous and inexperienced, but his retainer from Vivaner of 125 francs per month was a princely sum compared to the meager resources of many artists already there. He settled first at 18 Impasse du Maine, where he shared a room with a relative of a Russian acquaintance. Although he could not speak French, and he had little sense of what he could learn, Chagall set out to gain as much as he could from the varied artistic offerings of Paris. Initially he followed the pattern he had set in St Petersburg, by studying both old and modern painting, and by half-hearted attendance at various private art schools. His knowledge and awareness of art was reinforced by many visits to the Louvre, where he saw and admired the paintings of Delacroix, Courbet, Rembrandt, and Chardin. Contemporary art could be seen in various dealers' galleries such as those of Durand-Ruel and Bernheim, and Chagall also took advantage of the controversial annual exhibitions at the Salon des Indépendents and the Salon d'Automne. He was present at the Salon des Indépendents exhibition of 1911, which, for the first time, accepted the validity of Cubism by showing Cubist paintings together as a group. Chagall also studied spasmodically at various private schools such as *La Grande Chaumière* and *La Palette*, where the Cubist painters Le Fauconnier and Jean Metzinger taught.

Many of the movements and artists that he encountered in Paris had a profound effect on the formal qualities of Chagall's art. In works such as *Half-Past Three (The Poet)* (page 51) he began to fragment space and superimpose planes in patterns unrelated to the actual subject-matter. Chagall's use of color became much bolder, following not only Fauvist painting but also the experiments with simultaneous contrasts of colors carried out by his friend Delaunay. But Chagall's use of these formal experiments rarely went beyond the superficial. From the beginning, he rejected the tenets of Cubism, just as he had rejected Talmudic rationalism in his native Russia. Cubism was an art based on the geometric deconstruction and reconstruction of real objects. To the Cubists, objects were not meant to have significance beyond their physical properties. Chagall,

on the other hand, was a self-professed fantasist, and such a literal use of reality bored and offended him. He felt that Cubism, like Impressionism, was too shackled to optical reality – the reality that we perceive through the senses and translate through the intellect. He appreciated the beauty inherent in Cubist geometric form, but did not accept the strictures of that geometry. In a later interview, Chagall clarified his reaction to Cubism, paraphrasing a remark made by Maurice Denis in the 1890s: 'For me a picture is a surface covered with representations of things (objects, animals, human forms) in a certain order in which logic and illustration have no importance.' Instead, Chagall sought to achieve a 'psychic realism' based not on the seen world but on the world of the spirit and of the soul.

These ideas were consolidated after Chagall moved to the artists' studio, La Ruche, in the winter of 1911-12. La Ruche, or the 'Beehive,' had been bought by the sculptor Alfred Boucher in 1902 in order to provide a commune for poor artists. By 1911 this round building was filled to the brim with Polish and Russian refugee

artists. Located in the Vaurigard section of Paris, La Ruche was similar to the artistic colony on Montmartre where Picasso and others worked in the 'Bateau Lavoir.' At La Ruche an equally thriving community included poets and artists. During Chagall's time in La Ruche, Laurens, Soutine, Archipenko, Lipchitz, and Metzinger all lived there, and the poets André Salmon and

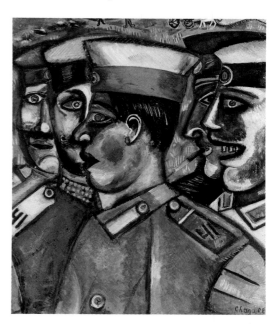

Below: *Carcass of Beef* by Chaim Soutine, c. 1925. Soutine was a fellow Russian Jew who, like Chagall, was part of the so-called School of Paris in the 1920s.

Below right: Blaise Cendrars admired Chagall's work and wrote evocative poems dedicated to him.

Above right: Photograph of an artist's studio in La Ruche, Paris, 1906. Chagall had a studio here from c. 1911 until 1914 when he returned to Russia via Berlin. The small, narrow rooms were not always conducive to this purpose, but Chagall was fortunate enough to have a studio at the top of the building where there was more natural light.

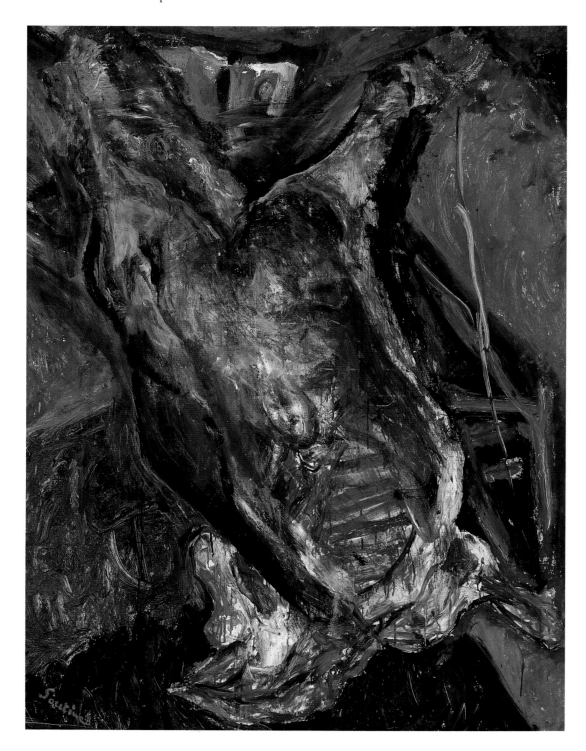

approach to painting has much in it that is poetic. The Surrealist leader André Breton summed up the effect of Chagall's work in 1945 when he spoke of the artist's Paris paintings as representing the 'triumphal appearance of the metaphor in modern painting.' Chagall did not use symbolism in a blunt and straightforward way; instead he evoked an alternative reality in his paintings that makes any literal interpretation of them unenlightening and reductive. The poetic analogy is the most useful one when trying to understand works such as *The Soldier Drinks* (page 42) or *Homage to Apollinaire* (page 44), and this unusual metaphorical approach to art inspired both Cendrars and Apollinaire to dedicate poems to Chagall.

The Paris poets also helped Chagall break into the competitive art world there. Cendrars introduced Chagall to the art dealer Malpel, who gave the artist 250 francs per month in return for paintings. Cendrars may also have assisted Chagall in his efforts to have his art exhibited in Paris, and in 1912 he showed paintings in both the Salon des Indépendents and the Salon d'Automne. Through André Salmon, Chagall met Apollinaire, the poet and art critic who had already championed the Cubists and given the Orphists their name. Apollinaire's influence was significant, and he praised Chagall's paintings for their 'supernatural' qualities. Through Apollinaire, Chagall was introduced to Herwarth Walden, who was in charge of a progres-

Blaise Cendrars provided Chagall with a new kind of inspiration. The artists in this colony were dubbed the 'School of Paris,' although there was little that bound their art under this common appellation except their shared enthusiasm for new possibilities of color and form.

Chagall's intimate friendships with the poets at La Ruche, and his continued resistance to purely abstract art, led many critics in pre-War Paris to refer to his art as 'literary.' In the critical milieu of the time, this word was hardly flattering. Painters were more and more asserting the separation of art from literature: art was not meant to tell a story or provide a subject or symbol for the audience to interpret; it was a thing in itself, a display of colors and

forms, a reinterpretation or recreation of the visual world. Chagall too rebelled against the definition of his painting as literary, and he persisted in rejecting this label throughout his life. He later said: 'If one speaks of literature in art, he does not understand either painting or literature.' Chagall did not intend for his subject-matter to be interpreted as a series of symbols with specific meanings. He claimed to be both a formalist and a representational artist, taking the 'matter' of the perceived world and transforming it through color and line into something new and different that he himself had created. However, even sensitive writers about Chagall have found it difficult to avoid making analogies between his art and literature, as his

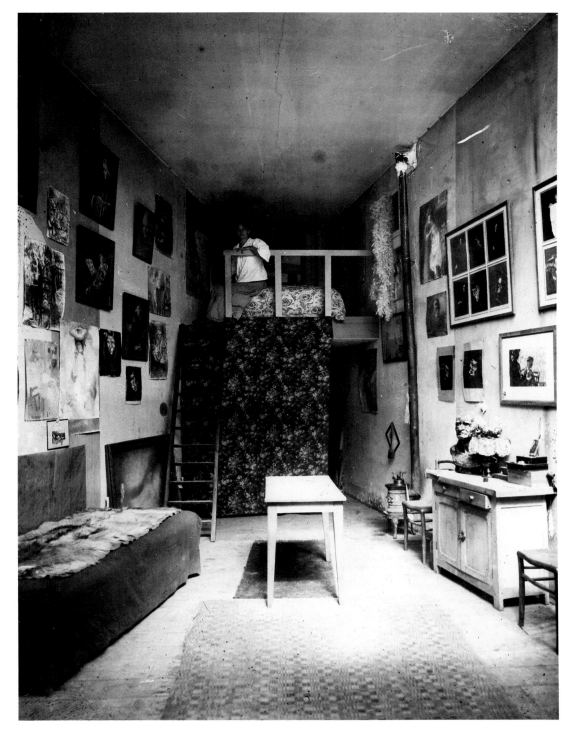

Below left: Guillaume Apollinaire, 1917. Apollinaire recognized Chagall's unusual talent and dubbed his painting 'surnaturel'.

Below: Herwarth Walden by Oskar Kokoschka. Walden, exhibited Chagall's work in Berlin.

His artistic reputation also increased in his native land through exhibitions, patronage, and a spate of writing about his art. Chagall's work appeared at many major exhibitions both in Moscow and Petrograd (as St Petersburg was known before it became Leningrad) during this time, and in 1919 the First State Exhibition of Revolutionary Art held in the Winter Palace contained two rooms devoted to paintings by him. Such a preponderance of his paintings in a major state exhibition indicated the reputation he had achieved in his own country. In addition to these successes, art collectors began to take an active interest in his painting, and in 1918 the first monograph of Chagall's life and work was published. As he had in Paris, Chagall continued to befriend poets, and he exchanged ideas with Mayakovsky, Pasternak, Essenin, and other radical new writers responding to the stimulating cultural scene in pre- and post-Revolutionary Russia.

Chagall's training had always been rather haphazard, but it was brought to an abrupt halt during these years when the demands of family, society, and political unrest directed his attentions elsewhere. The shock of returning to a provincial Russian city after having relished the cultural excitement of Paris was made especially difficult by his lack of materials and preliminary studies. Chagall's response to this problem was to make use of what was at hand. His paintings of 1914-17 are often produced on cardboard, tablecloth, or whatever flat surface was available. They

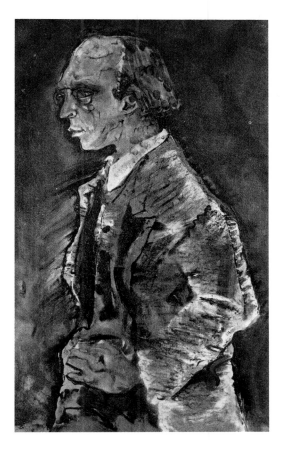

sive gallery and periodical in Berlin, *Der Sturm*. Walden encouraged Chagall to send three works to the first German Herbstsalon in 1913, and Chagall was persuaded to have his first solo exhibition in the same gallery from June 1914. In Germany Chagall met with significant success, and his art inspired the flourishing Expressionist movement there. Chagall's visits to Germany to view his exhibitions brought him closer to Vitebsk, and the magnetic pull of his homeland, as well as the fiancée he had left behind, resulted in a trip to Vitebsk in 1914. Unfortunately the outbreak of World War I extended his visit to eight years, and he was forced to leave behind numerous paintings and sketches, abd a growing European reputation.

The time he spent in Russia between 1914 and 1922 was a fruitful yet frustrating period for Chagall both personally and professionally. He married his financée, Bella Rosenfeld, in 1915, and this was the beginning of what would be a passionate and inspirational union for both of them.

Below: Cover of *Der Sturm*, 1912. This was the periodical edited by Herwarth Walden that stimulated interest in Expressionism in Germany before World War I.

Below right: Photograph of a demonstration in one of the streets of Petrograd on the first anniversary of the victory of the Red Army, 1918. For the anniversary, streets all over Russia were decorated by artists. As Commissar of Art, Chagall supervised this activity in Vitebsk.

Below: Photograph of Boris Pasternak. While undertaking compulsory military service in St Petersburg, Chagall met the novelist and poet Pasternak shortly before the Russian Revolution.

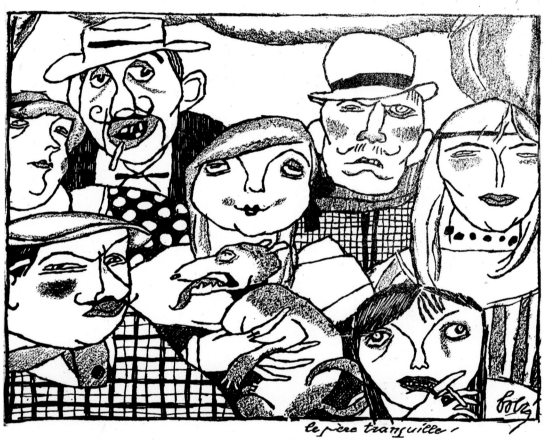

Hanns Bolz: Le père tranquille / Zeichnung.

At first the Russian Revolution seemed a coup for both Jews and avant-garde artists. After the Bolshevik victory in October 1917, segregation and discrimination against Jews were relaxed, and art was harnessed by the Bolshevik government as a powerful force for the improvement of modern industrial society. The Revolution was the trigger for the various avant-garde movements that had been fermenting in Russia for some time: a new society required a new art, and artists saw the opportunity to forge a positive new link between culture and the State. The two major trends in post-Revolutionary art were fostered before the Revolution at a Moscow exhibition of 1915: 0.10, or The Last Futu-

represent views of Vitebsk (*The Blue House*, page 90), members of his family (*David in Profile*, page 73), local soldiers and other unexceptional scenes of daily life, evincing a literalness that led Chagall to refer to them as 'documents.' Only rare vestiges of Cubism, Fauvism, and Orphism remain in these works, which show Chagall exploring the resonance of his homeland as if trying to rediscover what he had left behind when he went to Paris. After his marriage to Bella, Chagall went to work in an office in Petrograd, and he was eventually sucked into the vibrant circle of the avant-garde, whose ideas about the symbiotic relationship between art and society found their strongest expression after the Revolution.

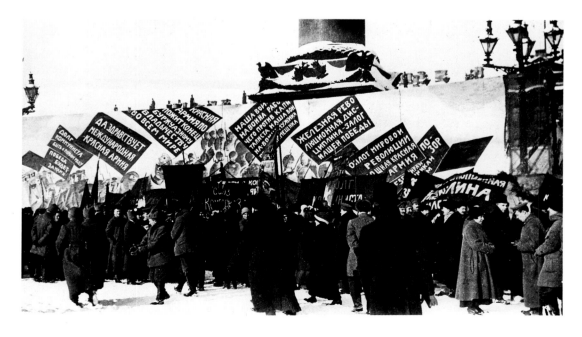

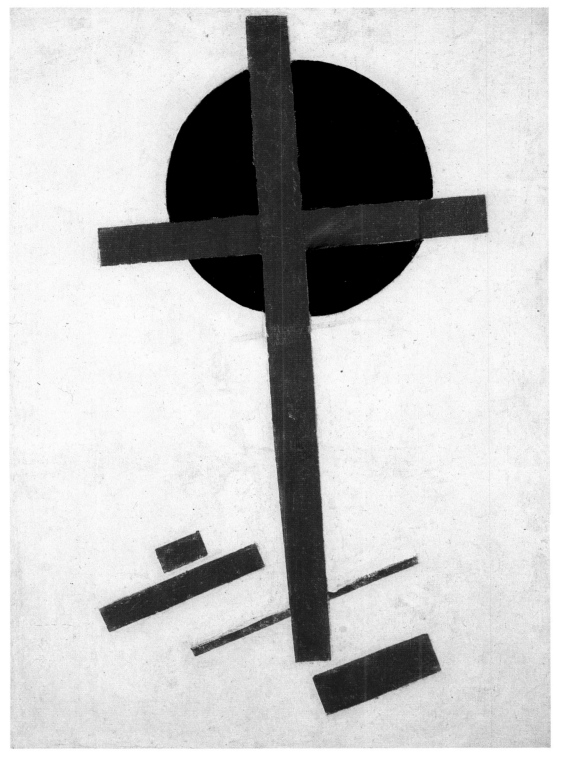

rist Exhibition. Here Kasimir Malevich first showed his Suprematist canvases, paintings consisting of little more than colored rectangles but meant to evoke the universal spirit of mankind through an avoidance of materialistic, or realistic, values. At the same exhibition Vladimir Tatlin showed three-dimensional 'reliefs' made of basic materials such as wood, glass, and wire, forming the basis of the later Constructivist movement, which advocated a truth to materials and a use of art for the betterment of society. In contrast to these two important movements, Chagall's art had a realistic basis. Unlike Malevich's abstract paintings, Chagall's figures and animals were still recognizable objects; as opposed to Tatlin's insistence on modernity, Chagall's work was suffused with a gentle archaism. Nevertheless Chagall was not neglected or scorned by the new government. At a meeting in Petrograd, Chagall's name was proposed for Director of Fine Arts in the new Ministry of Culture, a position complemented by Mayakovsky as Minister of Poetry, and Meyerhold as Minister of Theater. Chagall, however, refused the position and returned to Vitebsk. Although he turned his back on involvement with the new government, he was persuaded by Anatoly Lunacharsky, the Minister of Culture, to take on the position of Commissar for Fine Arts in Vitebsk, which involved setting up art schools, museums, lectures, and exhibitions. Chagall held the post from September 1918 until May 1920. During this period he painted little, but concentrated his energies on turning Vitebsk into an important artistic center.

In gathering teachers for his new art school, Chagall showed an open mind and a receptivity to recent trends in art, including those that were alien to his own practice. He invited Ivan Puni and El Lissitzky to teach there, and at Puni's recommendation, Malevich was also asked to join the staff. The last appointment proved to be a mistake, for Malevich's advocacy of abstract Suprematism had a tinge of fanaticism to it. Malevich had the certainty of the converted, and his charismatic persuasiveness drew Puni and Chagall's former supporter Lissitzky into his camp. Chagall's village scenes and flying lovers were perceived as hopelessly realistic and thus bourgeois. Despite the support of a more open-minded Lunacharsky, the Suprematist faction dominated, and eventually took over, the Vitebsk art school, which left Chagall somewhat isolated artistically.

While Chagall was Commissar in Vitebsk, he took many trips to Moscow to visit Lunacharsky and discuss the future of art in the region. When conflict with Malevich led to the collapse of his school, and famine and poverty arising from civil war made Vitebsk no longer a desirable place to live, Chagall, Bella, and their daughter, Ida, moved to Moscow to seek a living. There Chagall had the opportunity to expand his artistic repertoire by designing sets for the theater. The theater had also become a target for avant-garde ideas and practices. The insistence on realism that characterized Stanislavsky's acting technique contrasted with Meyerhold's conception of the theater as a work of art. To Meyerhold, the idea of a theatrical performance as a 'slice of life' was anathema: theater was to be fantastic and stylized in set, costume, and performance. Meyerhold's ideas were not generally accepted, and Chagall himself had previously designed sets and costumes which had been rejected simply because they did not adhere to this concept of the theater as a mirror of reality. Further opposition came

Below: Lithograph by El Lissitsky, c. 1920. El Lissitsky originally admired Chagall, but when he came to teach at Chagall's Vitebsk school, he advocated the new Suprematist style instead. This caused great tension in the school between those who followed Chagall's ideas and those who found the more progressive theories of Lissitsky attractive.

Below right: Photograph of Chagall in 1920.

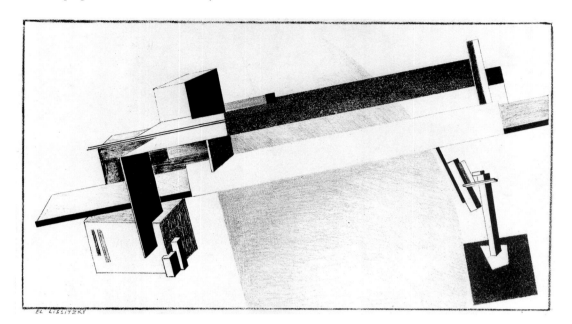

fact and fantasy in a rush of clipped but elegant verbosity. Writers on Chagall have been influenced and even prejudiced by this conception of himself. Often effusive art-historical description of Chagall's paintings is due in no small part to his own poetic self-examination.

The autobiography must have been therapeutically cathartic at a particularly difficult time in Chagall's career. He had been defeated both by the radicalism of the avant-garde and the conservatism of Socialist Realism. At the first opportunity he obtained an exit visa for himself and his family, and although the visit abroad should have been temporary, Chagall never returned to live in the Soviet Union. His decision to leave was sparked off by a

from Alexander Granovsky, Director of the Jewish Kamerny Theater in Moscow, who commissioned a series of murals and set designs from Chagall, but was rather uneasy about their liberation from the confines of life-like representationalism. Works of this period such as *Composition with Goat* (page 89) come surprisingly close to the Constructivist and Suprematist aesthetics that he had previously rejected. Chagall's designs for the Jewish Theater earned him no money in the impoverished and strife-ridden environment of post-Revolutionary Moscow, but his experiments with theatrical design were to bear fruit later in his career when directors and audiences were no longer so hostile to such an approach.

While Chagall was working in Moscow, his financial situation became desperate, and the exhilarating climate for avant-garde artists was dampened by Lenin's hostility to abstract art. Lenin's pamphlet *Left-Wing Communism: An Infantile Disorder* of 1920 dealt the first death blow to avant-garde enthusiasm. Abstract art was seen as childish and even subversive, whereas bland Socialist Realism, glorifying the state and its leaders, became the national art and eventually the only acceptable style. Although still representational, Chagall's art was alien to this dogged and unimaginative approach, and his fortunes reached their lowest ebb in 1921 when he was forced to take a job as a teacher in a colony for homeless children. During this sad and deflating period, Chagall began to write the story of his life. This autobiography, *My Life*, although not published until ten years later, expressed Chagall's experiences in France and Russia through an odd, ecstatic prose-poetry that romanticized even mundane events and blended

letter from a friend in Germany, who reported that many had feared Chagall's death, but that his fame had spread during and after the War. The letter declared that Chagall's pictures had 'created Expressionism' in Germany and that they were commanding high prices throughout Europe. Such bait could not fail to be attractive to an artist living in impoverished conditions and teaching underprivileged children in an environment that promised to become stifling, rather than stimulating, to artistic individualism. Chagall later claimed that he left Russia not for political but for artistic reasons, and certainly his paintings continued to be dominated by echoes of his homeland until the end of his life.

When Chagall arrived in Berlin in 1922 he was disappointed to learn that 40 oil paintings and 160 gouaches that he had been forced to leave behind when he returned to Russia had all been sold. Walden, the director of the Sturm gallery, assured Chagall that they had assumed him dead, but reimbursement of the artist in the inflated economic circumstances of post-War Germany was pointless. A barrel-full of devalued Reichsmarks would hardly have compensated Chagall for the loss of some of the best work he had ever produced. Through a lawsuit, Chagall recovered some of his works, but further disappointments came to him in Paris when he returned to the city in September 1923. He hastened to his old haunt, La Ruche, foolishly expecting that the paintings he had left behind would still be there. Those that were left had been used to paper walls and plug up drafty holes in windows; many others had been authenticated by a well-

meaning Cendrars and sold for large sums to eager collectors. Chagall never forgave Cendrars for what he saw as treachery. Partly in response to this major loss of early work, Chagall began at this time a frantic attempt to recreate these lost works by painting copies based on photographs and sketches. This persistant effort to recapture what was lost stayed with him for a good deal of his life, and one wonders how much his recurrent imagery can be attributed to his desire to rediscover the vitality of paintings that he would never see again.

The more positive side of Chagall's return to Berlin and Paris was an expansion of his technical repertoire. The art dealer Paul Cassirer introduced Chagall to a printmaker, Hermann Struck, who taught him techniques of drypoint, etching, and wood cut. Over the next ten years, Chagall produced some of the best works of his career, exploiting the new techniques greedily and successfully. His first project was a proposed publication of his autobiography, *My Life*, which Cassirer hoped to produce with 20 etchings and drypoints by Chagall. However, the quirky prose style of the text proved difficult to translate, and the prints appeared in a portfolio without text in 1922. The illustrations of scenes around Chagall's modest birthplace provided a primitive simplicity that was well in keeping with previous German prints by the artists of Die Brücke, although Chagall's often humorous and fey interpretations of his history contrasted with the Expressionists' manipulation of stark contrast and rough outline.

Chagall's graphic ability was offered its biggest challenge after he returned to Paris

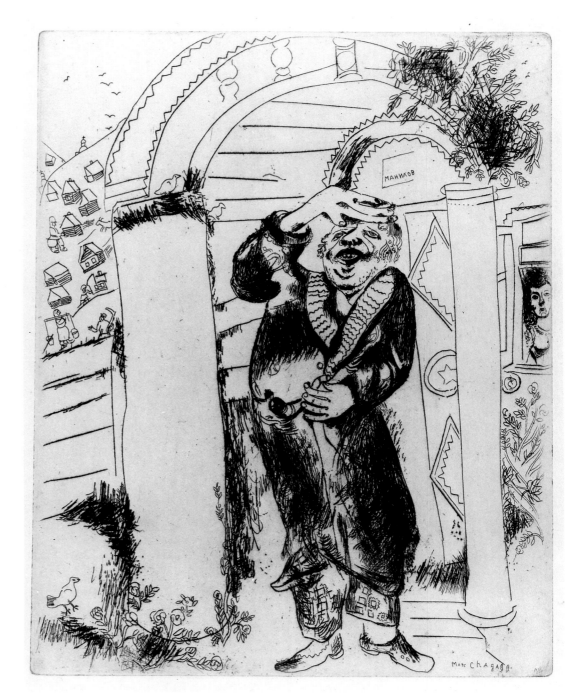

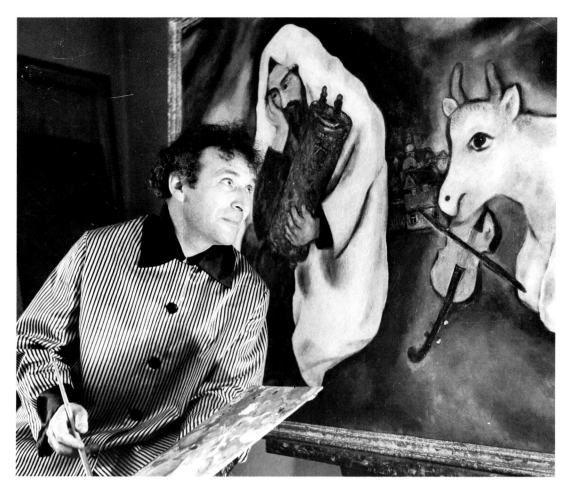

expression and in the process reviving a type of subject-matter that, with the advent of modern art, had become relegated to Christmas cards and calendars. But at this time in his life, his trip had the more specific purpose of inspiration for his Bible illustrations. Throughout the 1920s Vollard provided Chagall with a livelihood, but none of the works which he commissioned from Chagall actually appeared at this time. It was not until after Vollard's death in 1939, and indeed until after World War II, that *Dead Souls*, the *Fables*, and the Bible were published.

Chagall's graphic work shows a concentration, freedom, and humor that is somewhat belied by his painting of these years before World War II. Still lifes such as *Lovers with Flowers* (page 106) were inspired by the bright flowers seen in the South of France, and circus imagery based

and settled in a studio on the Avenue d'Orléans in 1923. Here he was hired by the art dealer Ambrose Vollard to produce etchings for Gogol's *Dead Souls*, La Fontaine's *Fables*, and the Bible. *Dead Souls* was a quintessentially Russian novel, laced with Gogol's penetrating humor and set in a country village not unlike the ones evoked in some of Chagall's paintings. His etchings for the publication are stark, but show his new enthusiasm for the power of line. By contrast, the *Fables* reveal Chagall's discovery of the painterly possibilities of etching. Chagall originally painted 100 gouaches for the series, and the etchings based on the gouaches show a transfer of qualities from one medium to another. Vollard was criticized for choosing Chagall, a foreign artist, to illustrate a work considered a classic of French literature, but Vollard defended his choice by pointing out that the *Fables* were Eastern in origin. What better artist to design the illustrations, Vollard argued, than an Eastern one? Vollard was pleased with Chagall's work, but his eccentricity led him to hold on to the designs rather than releasing them in a publication. Nevertheless, he commissioned Chagall to produce the largest set of illustrations yet: 105 etchings for the Bible.

This project marked the beginning of what would become a major obsession in Chagall's life and art. In order to prepare the original gouaches for the Bible, Chagall traveled to Palestine in 1931, where he was touched by the sight of the Jewish homeland. From this time onwards, he often returned to religious and Biblical themes in his art, searching for a means of universal

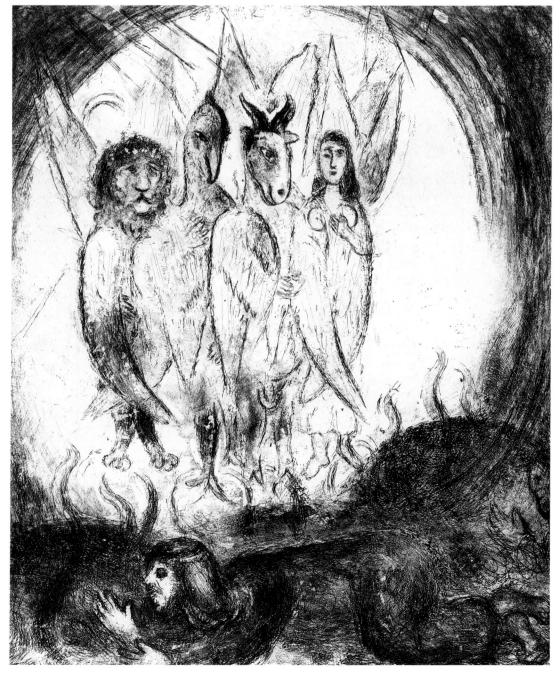

on trips to the Cirque d'Hiver with Vollard begin to emerge at this time in works such as *The Acrobat* (page 112). These paintings tend to be delicate in color and conception, more often sentimental than penetrating, and pretty rather than powerful. Although the earlier sharpness of his work had somewhat retreated, Chagall's already strong European reputation was consolidated at this time. His first retrospective exhibition was held in Paris in 1924, followed by others in New York, Basel, and elsewhere. Monographs of his life and work were published almost yearly from 1922, and a wider circle of patrons confirmed his success. Chagall capitalized on his greater financial and artistic freedom by traveling extensively in France and Europe, expanding his artistic knowledge through a study of old masters. In Holland he saw the work of Rembrandt, in Spain El Greco and Velázquez impressed him, and in Italy he was able to study the dramatic color of Titian and Tintoretto. A trip to Poland in 1935 proved less than satisfying, as Chagall experienced an unwelcome reminder of the continuing discrimination against Jews in parts of Europe. His visit to Poland was grimly indicative of the present and forthcoming tensions in Europe. Throughout this time, Chagall continued to follow his own course. Having resisted the lure of Fauvism, Cubism, Constructivism, and Suprematism, he now refused to join the Surrealist movement, established in Paris in 1924. Although the Surrealist artists shared Chagall's fascination with unusual juxtapositions and dream-like subjects, Chagall objected to their emphasis on automatism. The Surrealists at first advocated a form of automatic painting as a means of releasing subconscious forces: Chagall, however, believed that his imagery was much more self-conscious.

Chagall obtained French citizenship in 1937, and he moved with his family to Gordes in Provence in 1939. Europe was then undergoing the first stirrings of what would become World War II, but Chagall was for a time content with his painting and his new life in France. Even after the Vichy government began discriminating against the Jews in 1941, Chagall only reluctantly admitted that his presence in France was rather precarious. Only after arrest and other humiliations and warnings, did Chagall accept an invitation to go to the United States offered by the Emergency Rescue Committee. His trip was financed by the Museum of Modern Art in New York, which also extended invitations to other artists whose life and work were

threatened by the war. This time Chagall arranged in advance for some of his paintings to be stored and guarded, and he had other works forwarded to him once he arrived in New York. On 23 June 1941, the day Chagall's ship landed in New York, Germany invaded Russia – an event that Chagall saw as cataclysmic and symbolic of his own displacement.

Although the prospect of being exiled in New York filled Chagall with apprehension and depression, he again found himself plunged in the midst of an exciting and vital artistic environment. The war brought a number of the older avant-garde artists to America. During Chagall's stay in New York, Max Ernst, Amadée Ozenfant, André Masson, Piet Mondrian, and Fernand Léger all visited the city. This influx of new artists fueled the interchange of ideas in New York, as the city replaced Paris as the nucleus of the avant-garde. Two major European artistic influences dominated the New York art world at this

time, and attracted a rush of American imitators. Abstraction was made attractive to New York artists by the work of Mondrian, who responded immediately to the tall buildings and the mechanized life around him. More significantly, Surrealist artists such as Ernst and Masson brought over a new approach to representing the subject that was eagerly adapted by the younger generation of American painters. But Europeans in New York did not find the culture wholly congenial to their habits and attitudes, and some artists attempted without success to replicate the café society of Paris. Chagall could certainly not avoid other European exiles in New York, but he did not seek out their company. Instead, he continued to pursue friendships with literary men and women, many of whom were Jewish. His friendships with Jacques and Raîssa Maritain and Claire and Ivan Goll developed alongside his reunion with acquaintances from Russia, such as the actor Michoels, who

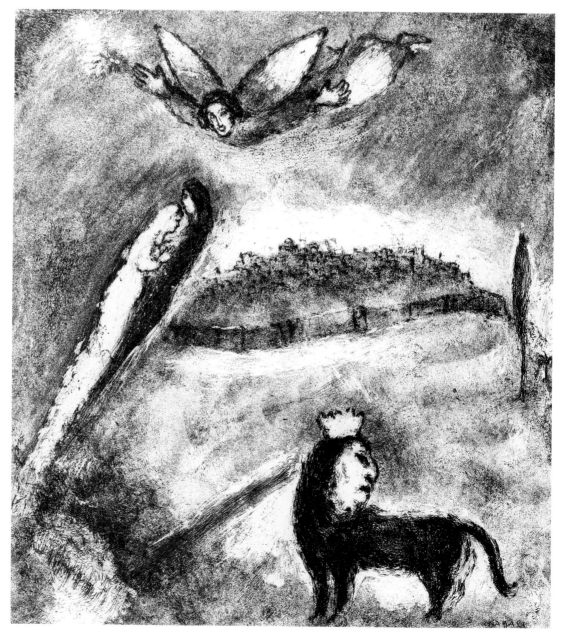

Left: Photograph of Chagall painting a portrait of his wife Bella, 1936. The picture on the easel is *Bella in Green*, one of many portraits of his wife.

Below: Drawing of André Breton by Max Ernst, 1923. Although Breton praised his work, Chagall avoided direct involvement with Surrealism.

came to New York with a Soviet delegation while Chagall was there. The War brought out in Chagall a desire to reinforce his links both with his native Russia and with his Judaism. Although he had not been a practicing Jew for many years, Chagall was shocked by the atrocities of the Holocaust, and in the crowded and often anonymous New York society, he found the means to close ranks with an intimate circle of Jewish friends.

Chagall continued to forge professional links with other avant-garde artists. His New York dealer, Pierre Matisse, was soon busy capitilizing on the fame of the exiled artists by holding various exhibitions in his gallery. In 1942 he put together a show called 'Artists in Exile,' which included Chagall's Vitebsk fantasies among Léger's tubular bicyclists and Mondrian's hygienic horizontal and vertical lines. Pierre Matisse proved to be an important contact for Chagall, as he gave the artist a monthly retainer in exchange for paintings, and organized several shows of Chagall's work between 1942 and 1948.

Chagall's steady production of pictures was halted by the death of his wife in 1944. Her tragic death of an untreated virus overwhelmed Chagall and left him unable to work for several months. From the time of their marriage, Chagall and Bella had been virtually inseparable, and even as late as the year of her death, Bella was writing a book called *Burning Lights* which recaptures their early romance in Vitebsk. She

wrote the book in Yiddish, and Chagall translated it into French after her death. The ecstatic, almost mystical, significance she places on their youthful passion dramatizes the feeling they continued to have for each other. When Chagall did begin to paint again, works such as *The Soul of the City* (page 137) were subdued or even gray in their coloring, filled with thinly-disguised images of Bella in the role of bride or lover. Although it would be false to read such paintings as a sort of therapy for Chagall, in them we see his continued use of painting as a means of conveying personal, spiritual biography.

While in America, Chagall was given the chance to undertake two exciting new challenges. The first of these was a commission to design the sets and costumes for the New York Ballet Theater's production of Léonide Massine's *Aleko* in 1942. For this production, Chagall had his first chance in over twenty years to experiment with theatrical design, but his early work for the Moscow State Kamerny Theater was modest compared to the monumentality of this production. Here was an opportunity to realize his art on a grand scale, and Chagall took full advantage of the chance to display his art in such a way. His work for the theater gave him a taste for the large-scale and grandiose which was to blossom in later years. *Aleko* also took him to Mexico, where the production first premiered, and here he had another re-awakening, as bright color returned to his

work. The brilliant sun of Mexico was not unlike that of the south of France, and his paintings slowly crept out of their gray lethargy. Chagall also extended his coloristic interests further by accepting a commission from Kurt Wolff in 1946 to provide twenty colored lithographs for a limited edition of the *Arabian Nights*. Although Chagall had worked extensively with etching and drypoint in the 1920s, he had only rarely attempted lithography. His approach to the medium was very much that of a painter: he used the lithographic crayon to draw directly on to a piece of paper, and the design was then transferred to the lithographic stone which was used to print the lithograph itself. This transfer process allowed Chagall to be as self-indulgent as he liked with his color and design, and the resulting volumes show a new boldness of execution and confidence in the use of color.

The interest of these and other new possibilities perhaps kept Chagall in America longer than he originally intended. In 1946 he visited Paris to attend the opening of a retrospective of his work held in the Museum of Modern Art. In letters from Paris he expressed scorn mingled with envy for the success of Picasso and Matisse, who were the most talked-about artists of the day. But he also responded positively to his return to France by producing a series of gouache and pastel sketches of Paris. The lure of the country proved more than he could resist, and Chagall admitted: 'My art needed Paris – like a tree needs water.' He returned to France in 1947, staying first in Orgeval, then moving to the South of France. He settled finally in Vence in 1949, and although he moved house several times, he remained in the south of France

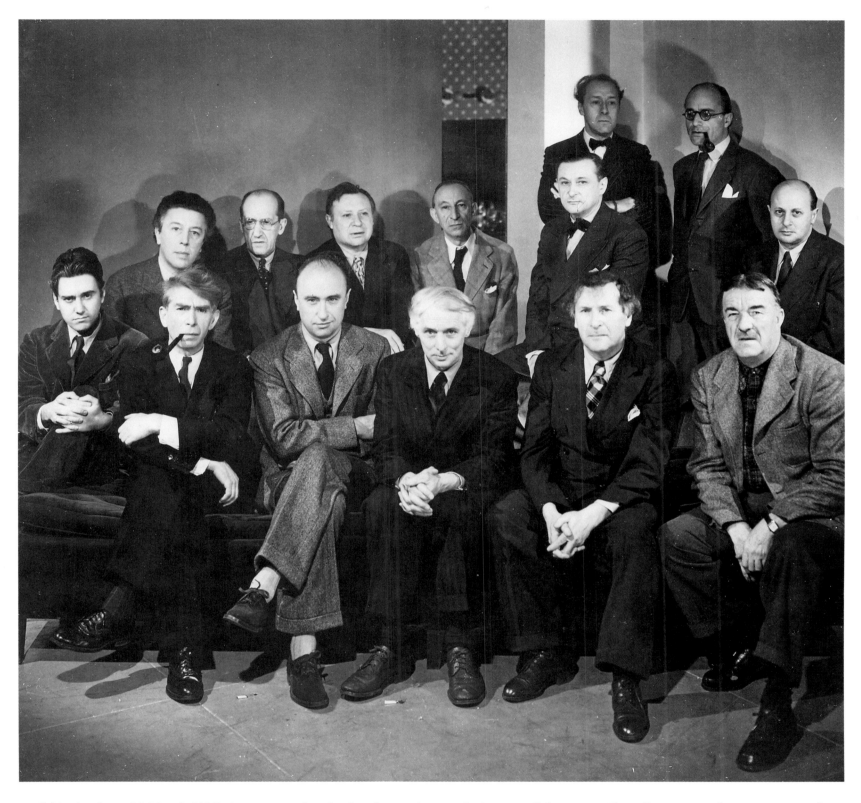

until his death on 28 March 1985. A more settled existence was followed shortly by a second marriage in 1952 to Valentina (Vava) Brodsky, another Russian Jewish exile who first acted as Chagall's secretary. Like Bella, Vava assumed the role of manager of Chagall's artistic affairs, and he relied on her shrewdness to cope with his increasingly complex finances, and to shape his public persona.

The Côte d'Azur during the 1950s has been referred to as the 'new Montparnasse' because it was frequented by so many artists. Picasso and Matisse had both settled there, and the bright sunlight was inspirational to artists exploring possibilities of color. But unlike the artists' colonies in Paris during the early part of the 20th century, the south of France was the province of artists who were already well established with international reputations. Their concerns were with major retrospective exhibitions, wealthy patrons, and challenging new commissions, rather than with bare subsistence and artistic discovery. Picasso and Matisse produced some of their most interesting work while living in the south of France, and Chagall too consolidated his earlier efforts and expanded his technical potential.

Chagall continued to paint, produce lithographs, and create theater designs for the rest of his life. His paintings retained much of his earlier imagery, but several changes of both form and content can be detected in his later work. Paris began to play a much more prominent role, to an extent replacing Vitebsk as the location of his nostalgia and sentiment. In the 1950s he painted a series of metaphoric visions of Paris, and from that point onward, the Eiffel Tower, the Place de la Concorde, the Opéra, and various other Paris landmarks creep into his thematic repertoire. The most significant change in his post-War

painting was his use of color. Always a skilled colorist, Chagall became bolder and even at times reckless in his use of color after the War. His paintings were more often saturated with a dominant shade of strident green or sumptuous purple, and the prevailing tone dictates the mood of the whole work. In some respects, his use of color in these paintings recalls lithography, which was another post-War passion. Chagall's lithographic series *Le Cirque* was published in 1952 by Efstratios Eleftheriades, better known as Tériade – an enterprising Greek who was also responsible for the publication of Matisse's *Jazz*. Tériade's other significant contribution to Chagall's post-War career was his purchase of the plates that Chagall had produced for *Dead Souls*, La Fontaine's *Fables*, and the Bible, all of which were finally published in the 1940s and 1950s. Chagall also began to explore other possibilities of two-dimensional design through poster art, and he was responsible for many of the posters that accompanied exhibitions of his work.

A continual restlessness and desire for new challenges led Chagall into more theatrical projects. In 1952 he was commissioned to design the sets and costumes for a production of Ravel's *Daphnis and Chloe* at the Paris Opéra. He had earlier traveled to Greece to seek inspiration for a series of lithographs on the *Daphnis and Chloe* theme, and Greece also became the background for these brilliantly colored curtains which expressed the tone of Ravel's music. An even more ambitious undertaking was the commission for designs to accompany the production of Mozart's *Magic Flute* at the New York Metropolitan Opera in 1967. Chagall had deep affection for the music of Mozart and felt that the *Magic*

Flute was his greatest opera. But here Chagall somewhat overreached himself: there were a number of technical hitches and many designs had to be redone at the last minute. Chagall was criticized by those who felt that his unapologetic and even garish colorism was overwhelming and distracting, rather than complementary to the production.

However, despite setbacks such as these, Chagall spent the last 30 years of his life seeking and accepting commissions for large-scale works. He became eager for new modes of expressing himself and new technical challenges. Painting began to take second place to ceramics, sculpture,

stained glass, mosaics, and tapestries. His familiar imagery repeated itself in different media and on an increasingly larger scale. His first tentative experiments in new media came in 1951 in Vence. There he became friendly with a local potter who taught him how to produce ceramics. At first Chagall only painted designs on works which had already been cast, but he soon found this activity limiting. He received further instruction from Ramié at the Madoura pottery works in Vallauris, where Picasso was already working. There Chagall began to participate in the whole process of creation, and his unusual, sometimes awkward, ceramic designs are surprisingly faithful to his established style. Sculpture also attracted Chagall in Vence, and he collaborated with a local marble cutter to produce bas-reliefs and stele which also sported his characteristic imagery.

This graduation to three dimensions was symptomatic of Chagall's restlessness. Now that he was settled and his fame was assured, he saw the potential for expanding his knowledge and experience. With this restlessness came a desire for monumentality and permanence – a sense that his works were not just portable easel paintings but objects with a more significant setting and purpose. For this reason, Chagall welcomed the commission in 1957 to produce work for the new church of Notre Dame on the Plateau d'Assy in

Savoy. The enlightened Father Couturier also hired Bonnard, Braque, Matisse, Léger, and Rouault to decorate the church, hoping for a revival of religious painting through outstanding contributions from contemporary artists. Chagall presented a ceramic mural for the main wall of the baptistry and made some sculptures for the church. Most significantly, he produced his first stained-glass window design for the church, the start of what would be one of his most important contributions to 20th-century art.

Stained glass proved to be the perfect medium for Chagall's personal use of color and subject-matter. A visit to Chartres in 1952 had convinced him of the power of windows which rely on their own beauty as well as the contributing factor of light. Chagall declared that windows signified 'the transparent division between my heart and the world's heart.' In 1959 the French bureau of historic monuments commissioned Chagall to begin a major program of stained-glass windows for the Cathedral at Metz, and for this, he began a beneficial collaboration with Charles Marq of Reims. Chagall and Marq worked together on many windows in France and elsewhere over the next few years, including a stunning series for the Hadassah medical center in Jerusalem (pages 148-159).

Stained-glass windows allowed Chagall to express himself on a large scale and for a significant purpose, and other monumen-

tal works of his later years further demonstrate this new scale of subject and status of location. In 1964 Chagall was commissioned by the French Minister of Culture, André Malraux, to decorate the ceiling of the Paris Opera House (pages 164-167). Chagall's ceiling contrasts pointedly and even arrogantly with the setting, and assumes a position of major importance in the interior of one of Paris's prominent landmarks. The following year Chagall received an even more prestigious commission from the Israeli government. For the

Knesset, or parliament, he designed a large tapestry in the form of a triptych representing the Prophesy of Isaiah, Exodus, and the Entry into Jerusalem. The tapestry was woven at Gobelins and now holds a prominent place in this major legislative center. Important commissions also came from the United Nations to design a *Peace* window (page 161), and from the Faculty of Law at the University of Nice for a mosaic representing Odysseus, Mediterranean symbol of wisdom. Chagall's monumental work began appearing as representative of peace, harmony, wisdom, and hope in major centers throughout the world.

The culmination of Chagall's monumental activity was a building devoted entirely to his work – the Museum of the Biblical Message in Nice. Opened as a National Museum on 7 July 1973, the Biblical Message contains examples of Chagall's works in many media, all of which concentrate on conveying the message of the Old Testament. Chagall's interest in the Bible had been initially inspired by his visit to Palestine and his work for Vollard in the 1930s, and Bible imagery re-emerged in his art during World War II. From the 1950s Chagall's development of Biblical themes became much more single-minded and self-conscious. His contribution to the decoration of the church at the Plateau d'Assy must have inspired him with the idea of a single edifice housing a variety of art. But the art was not to have merely a decorative function; it was to be imbued with universal significance. The Museum sits in the district of Cimiez, on a hill overlooking Nice. The building itself is modern and lit by both natural and artificial light. Chagall

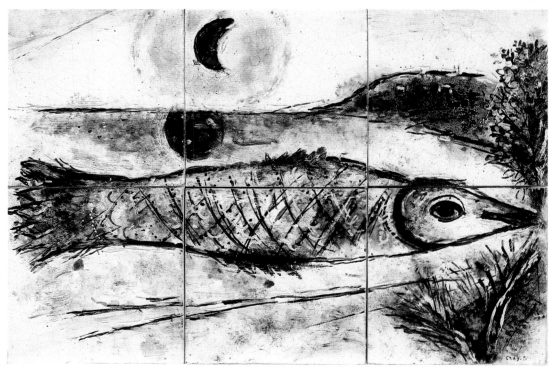

Below: *The Lovers,* color lithograph by Chagall from the *Circus* series, 1967. Lithography was another technique that Chagall developed and perfected after the War. Here the technique is employed for a theme that had recurred in Chagall's work from the 1920s. Much of his later painting also uses the circus theme.

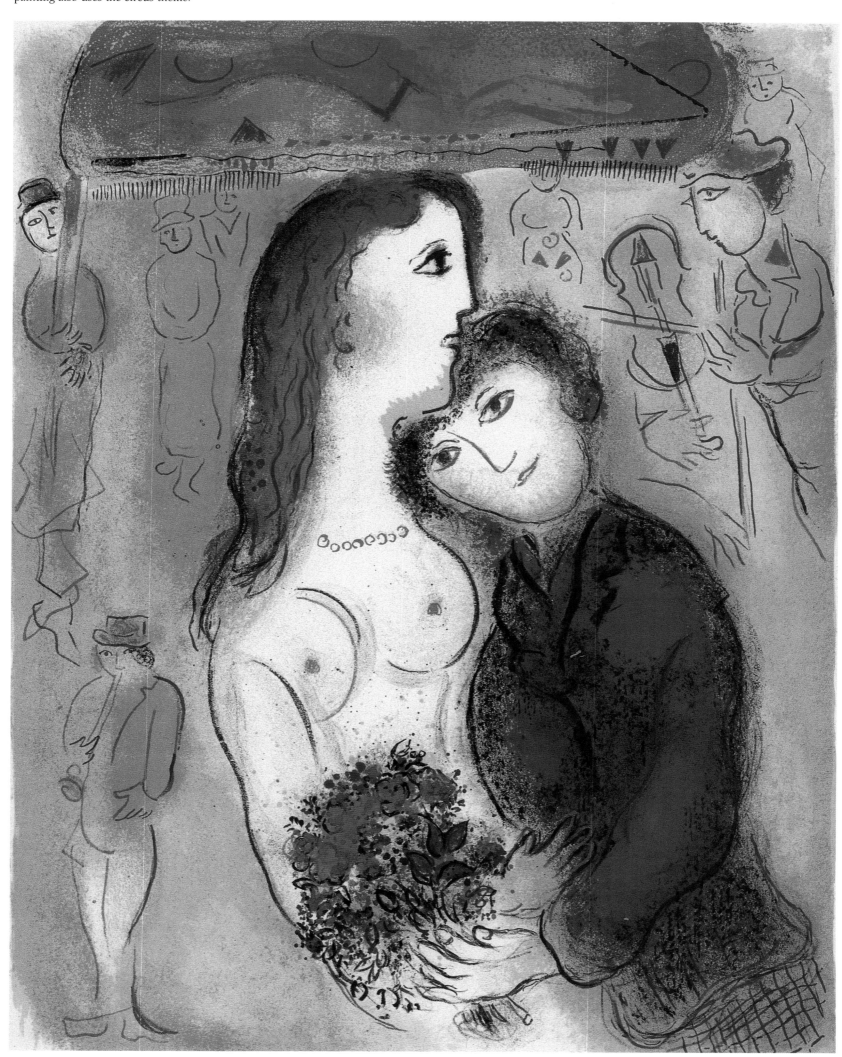

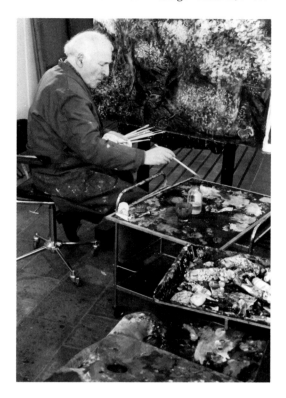

rather than limited to Jews or Christians. Such expansive assurances do not completely dissolve a problem that had dogged Chagall for much of his life and intensified in later years when his international reputation attracted a host of criticism as well as praise: the question of whether or not Chagall can be perceived to be a specifically Jewish artist, and how one should interpret his religious subject-matter, much of which is contained within Christian churches or has a predominantly Christian theme. From the beginning of his career, enthusiastic Jews, eager for an artistic representative of their race, embraced Chagall as a figurehead. In Russia before the Revolution, the Jewish engineer Kagan-Chabchay bought several of Chagall's works, intending them for a museum of Jewish art which unfortunately never materialized. Chagall was exposed to artists working in Paris in the 1920s who

sought to reinforce, rather than conceal, their Jewish heritage. In 1931 when discrimination against Jews in Europe was becoming a matter of deep concern, René Schwob wrote a book called *Chagall and the Jewish Soul* in which he interprets Chagall's art as an allegory of the Jewish race. However, Chagall's relationship with Judaism was paradoxical: although not a practicing Jew, Chagall made several trips to the Holy Land which he claimed to be moving and inspirational. He contributed drawings and poems to Yiddish periodicals in Israel, and most importantly, his work is filled with imagery of torahs, menorahs, phylacteries, and other symbols of Jewish worship. But Chagall eschewed the role of 'Jewish artist' and at times appeared deeply embarrassed by it. In a penetrating interview published in 1984, André Verdet questioned Chagall thoroughly about his Jewish heritage and his religious subject-

wanted the stark stone exterior to have the stately nobility of the walls of Jerusalem, and the play of light within the building contributes an effect of solemnity mingled with joy. From the 12 large Biblical canvases in the main hall, the visitor enters an adjacent room which contains 5 scenes from the Song of Songs. The most secular and worldly book of the Bible, the Song of Songs epitomized for Chagall a mingling of earthly and spiritual love. The theme of love was one which had appeared in his art continuously from the time of his first marriage onwards, but here love is glorified through its religious associations. The Museum also contains etchings, lithographs, mosaics, tapestries, sculptures, and stained glass – declaring Chagall's versatility and variety. A concert and lecture hall further expand the possibilities of the building, although temporary exhibitions are limited to works by artists who are dead and who painted works of a spiritual nature. The exclusion of the work of other living artists from the walls of the Biblical Message further isolates the building as a shrine to Chagall's achievements, but the professed function of the museum was somewhat different.

The first curator of the Biblical Message, Pierre Provoyeur, insisted that the museum was not meant to be a promoter of religious propaganda, and this defensive justification has been repeated by other apologists for Chagall. Chagall himself claimed that the paintings in the Biblical Message were to have meaning for all mankind: the museum was devotional but nondenominational, universal in its appeal,

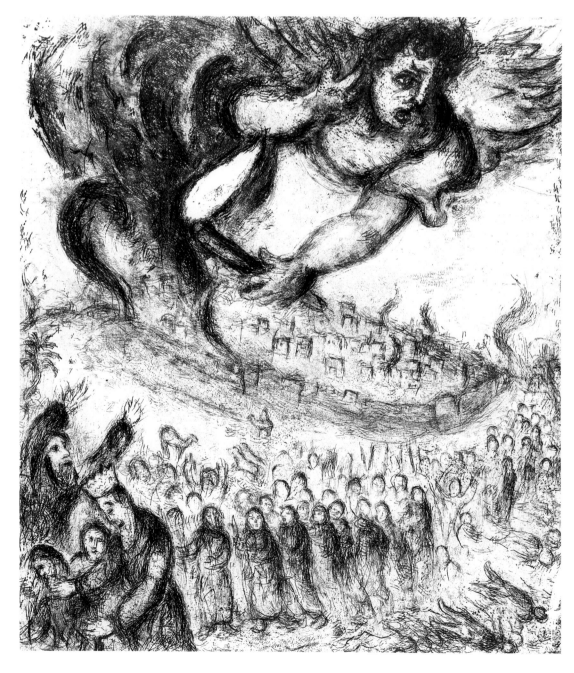

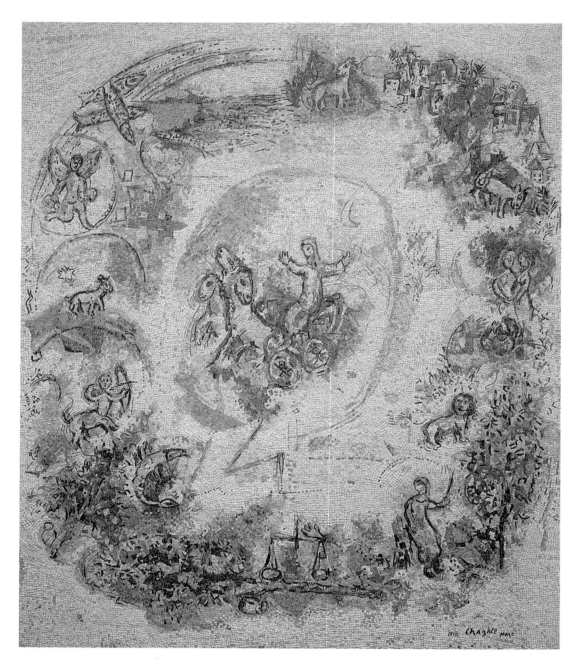

matter, but his eloquent and detailed questions were met by evasion or deflection. Chagall was a Jew and he was an artist, but he did not want to be pigeonholed as a Jewish artist. Unfortunately, his artistic neutrality roused a great deal of criticism from other Jews for both his art and his personal activity.

From an early period many Jews found Chagall's high profile as a figurative artist offensive. Not only did he produce figurative work, but he also increasingly specialized in Biblical subjects which were open to a Christian interpretation. Aside from his windows for the Hadassah Hospital (in which the human figure was forbidden) and his Knesset tapestry, all of Chagall's commissions for religious art were produced for specifically Christian settings. Chagall himself claimed that this was part of his campaign for universal brotherhood. On the Baptistry in the Church at Plateau d'Assy, he inscribed the words 'in the name of freedom of all religions,' beginning his quest for what he felt to be the true purpose of art – the promotion and depiction of love. Religious symbolism was thus felt to be an especially potent and resonant force in his attempt to reach a wide audience. However, there were a number of problems with both his specific choice of subjects and the way in which the subjects were used. One of the most powerful recurring images in his work is the Crucified Christ. He had first

used this figure in a painting of 1912, but he cast a number of ambiguities into the representation to muddle its meaning.

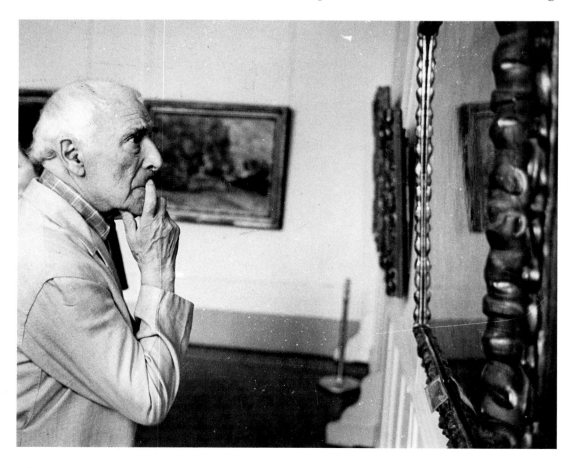

However, the Crucified Christ emerged unambiguously in his work of the 1940s, in which the figure was associated with the persecution and suffering of the Jews. In these works Christ was perceived as an example of the torments of all Jews. Although the potency of such imagery cannot be denied, critics of Chagall found cause for alarm at his appropriation of a symbol filled with Christian connotations. Even Chagall's Old Testament subject-matter, technically within the Jewish canon, did not escape censure. Critics claimed that when Chagall placed Old Testament scenes in a Christian setting, they took on the characteristics of prefiguration. For example, in a painting of *Abraham Preparing to Sacrifice his Son* (page 119), Chagall includes a Crucified Christ, and this juxtaposition suggests the Christian belief that the sacrifice of Abraham prefigured God's sacrifice of Christ on the cross. However well-meaning Chagall's desire for universality of religion, the work he produced for a Christian setting was interpreted wildly and variously by interested parties. A typical example was a book published in 1984 by a German priest called Klaus Meyer. This little monograph, *Beauty is Your Love*, offers a gentle sermon

on the theme of the paintings from the Song of Songs in the Biblical Message. That Father Meyer could use Chagall's paintings for his own purposes exemplifies how the artist's open-handed attitude to religion could be appropriated and even misinterpreted.

Chagall's persistence in producing Biblical subjects, particularly toward the end of his life, can be seen as a self-conscious attempt to create an art that had significance and purpose. His international reputation was established, he had explored the possibilities of technique open to him, but he obviously felt that a monument was needed – something which would set him apart from other artists of his generation who had achieved a similar status. Certainly Chagall can be credited with giving Biblical subject-matter a place in modern art. His two great rivals, Picasso and Matisse, did not promote such subject-matter to the same degree. But Chagall, conversely, remained true to his fairly limited range of subject and style throughout his life. His experiments with color, medium, and scale became so many variations on the same theme. The problem of a modern artist achieving international success in his own lifetime is one which impinges upon his artistic production. Picasso could thrive on fame, Matisse could be indifferent to it, but Chagall may have found success a burden and a hindrance to his artistic freedom. Art dealers adopted him and capitalized on his fame, driving up the prices for his paintings and inadvertently pressurizing Chagall to continue along safe and well-trodden paths. It is significant that at the age of 34, when still living in Russia, Chagall began to write his autobiography. Already he was aware that he was an artist of some stature. But the view of himself that he perpetuated in his poetic *My Life* to an extent guided the pens of many subsequent writers who attempted, often in vain, to penetrate the meaning of Chagall's work. Monographs or exhibition catalogues proliferated; poems eulogized his work; psychoanalytic and Jungian interpretations abounded. In 1979 the author Sidney Alexander uncovered a hitherto unknown aspect of Chagall's private life, alleging a problematic seven-year affair with Virginia Haggard after Bella's death. Such facts seriously undermined the image of himself that Chagall had constructed, and most art historians – including Chagall's former son-in-law Franz Meyer – have preferred to ignore this less savory aspect of his otherwise romantic life.

Chagall was not oblivious to the observations made about his art, nor could he avoid being influenced by them. From the 1950s he began talking more about his painting, using terms such as 'chemistry' to characterize the effect of his use of color. By adopting terminology to describe his art and insisting upon its universality, Chagall was struggling to give the admiring world a legacy that consisted not just of paintings themselves, but of paintings that had lasting significance. In many ways, he seems to have been overcome by his efforts: few could deny the power of his stained glass, but much of his later painting is mawkish or garish rather than convincing and decisive. His constant reliving of his Vitebsk childhood no longer had the vitality that it

had possessed in his earlier works. Intentionally or not, Chagall was painting for an already established market, and he continued to foster a myth about himself that he had invented in his autobiography. In the 1980s Boris Aronson, who had written a monograph on Chagall in 1922, dismissively summed up Chagall's development: 'He is a little man who made it big and can't take it.' The criticism leveled against Chagall and the sometimes distasteful 'revelations' about aspects of his private life which appeared in the 1980s have not spoiled his reputation or lessened the value of his work. He was an unusual and gifted artist who carried his childlike vision through a life that lasted for nearly 100 years.

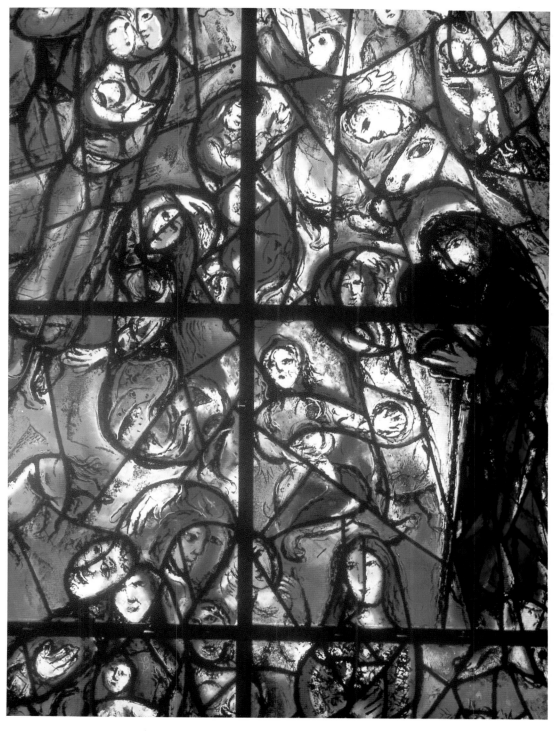

Self-Portrait with Brushes, 1909
Oil on canvas
22½×18⅞ inches (57×48 cm)
Kunstsammlung Nordrhein-Westfalen,
Düsseldorf

Chagall painted several self-portraits between 1907 and 1915. They show him beginning to develop a sense of self-examination that was based partly on truth and partly on delusion. The idea of himself that Chagall projects in this work has been variously interpreted. Certainly the image is confident and self-possessed. He holds the paint-brushes, the tools of his trade, proudly before him, and he stares boldly out of the canvas. The portrait was painted on one of his many visits home to Vitebsk, and it suggests a feeling of superiority or at best, accomplishment, that was reinforced by his contact with this somewhat provincial and unenlightened city. The work could also be seen as a symptom of Chagall's youthful narcissism. He was certainly attractive and sought-after, and he later admitted to using a touch of make-up to highlight his doe-like features. But other evidence suggests that this confident

façade may have been spurious. Chagall was at the time struggling to earn a living and continue his studies in St Petersburg, suffering humiliations and abject circumstances. In order to keep himself alive, he accepted any occupation, including that of a footman. The confidence of his self-portrait belies the humbleness of his actual position, and it seems more likely that Chagall was here being deliberately theatrical, presenting himself in a guise, rather than reflecting his actual state of mind. This self-consciousness is confirmed when the work is compared to portraits by Italian Mannerists and 17th-century Dutch artists that Chagall would have seen in the Hermitage.

The work bears affinities with artists such as Rembrandt, whose self-portraits were both a means of self-examination and a method of exploring the varied possibilities of his art.

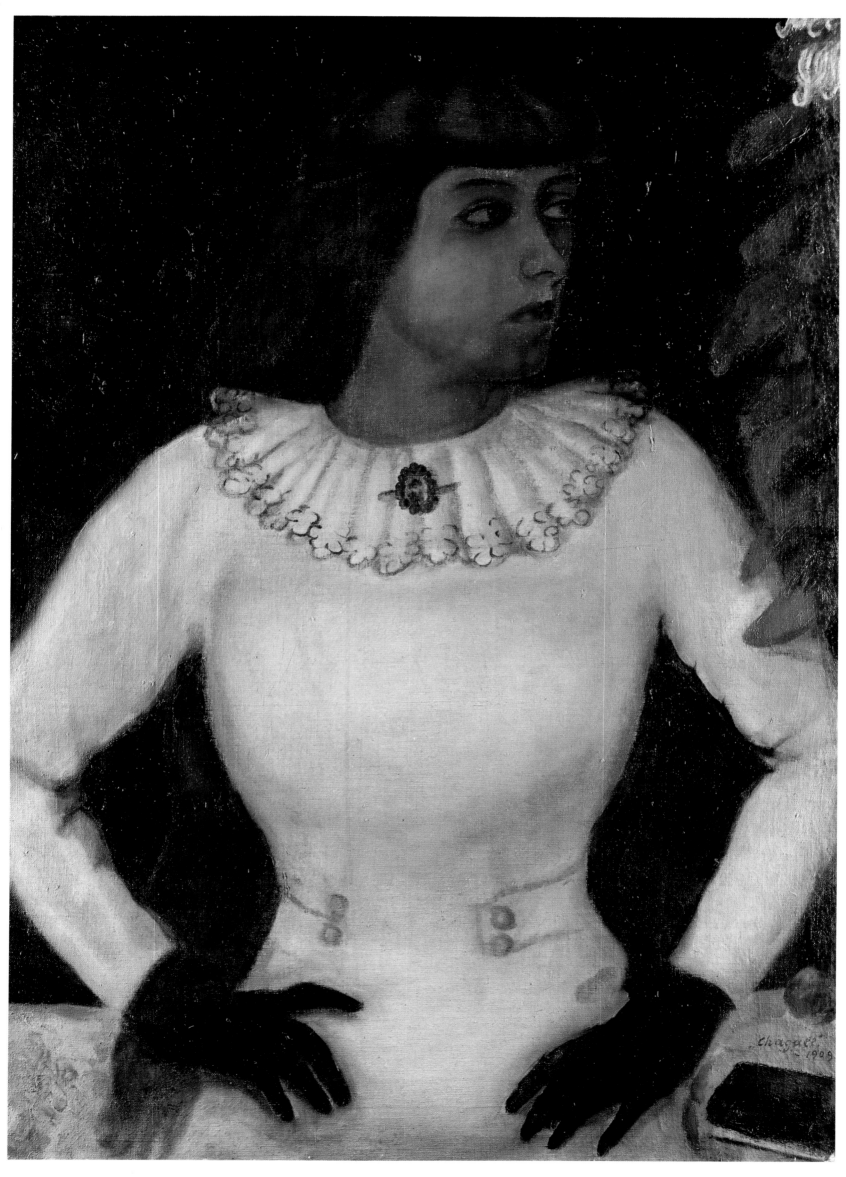

28

My Fiancée in Black Gloves, 1909
Oil on canvas
35⅝×25⅛ inches (88×64 cm)
Öffentliche Kunstsammlung Basel,
Kunstmuseum, Basel

Chagall's confident self-portrait is complemented by this vision of his fiancée, Bella Rosenfeld, whose arrogant and slightly scornful pose suggests a woman in full control of her situation. Ironically, Chagall was first introduced to Bella by his lover Thea Brachman, and he abandoned his romance with Thea on the strength of this first meeting. Like Thea, Bella was a progressive, liberal-minded young person, but her background contrasted strikingly with Chagall's. Bella was from a wealthy Vitebsk family, and her father owned three jewelry shops in the city; Chagall's family was poor, though not impoverished. Bella had been educated in the best school in Vitebsk; Chagall had attended the local *heder.* Bella had studied acting with Stanislavsky in Moscow; Chagall had been rejected from the School of Arts and Crafts in St Petersburg before gaining grudging admittance to the Svanseva School. However, despite large differences in their

background, education, and attainments, the union between Bella and Chagall proved lasting and fruitful. It is difficult to resist the cliché of 'love at first sight,' but this interpretation was suggested by both Chagall in *My Life* and Bella in her autobiography, *Burning Lights,* completed the year before her death in 1944. Chagall painted this work the summer after he first met her, and the painting seems to indicate his admiration for her determined personality. There are also vestiges of her class and position: the black gloves which she wears not only form a striking contrast to her pale dress but they add a touch of casual elegance to her attire. This portrait of Bella is the first of many images of her that Chagall introduced into his paintings, but later depictions were rarely so straightforward. As Chagall's personal iconography developed, he began to use Bella's visage symbolically: she came to represent the female principle, the bride or the lover.

The Holy Family, 1910

Oil on canvas
29⅞×24⅕ inches (76×63 cm)
Kunsthaus, Zürich

This work represents one of Chagall's earliest explorations of religious imagery, and the result is a complex blend of both Orthodox Jewish and Christian elements. After Chagall painted an unusual and symbolic picture *Dead Man* in 1908, his training confined him largely to portraits and still lifes, but in works such as this he began to show a desire to return to scenes of daily life, rendered symbolic through his manipulation of motifs. This painting relates directly to an earlier work, *The Family* or *Maternity* (1909) which shows a less ambiguous family group listening to a lesson being read. In *The Holy Family*, the simple family group becomes a collection of oddities whose scale is totally distorted. On the knee of the giant central figure sits a diminutive bearded child, while a woman reads from a book, and another figure prepares to slaughter a pig. The title and format of this work may have been inspired by Russian icons which Chagall saw on his visits to the Alexander III Museum of Russian Art in St Petersburg. Chagall was impressed by the formal simplicity and emotional sincerity of these very Russian objects. However, in his *Holy Family* this Christian context is subverted through the inclusion of several visual puns which are specifically related to Jewish parables. The bearded child could represent the Jewish saying 'every Jewish child is born old,' and the potential Christian symbolism in the work is deflated or diverted. Here the child does not sit on the Virgin's knee, but on the knee of a man, and the lamb symbolic of John the Baptist is transformed into an unkosher pig.

The Hasidism which dominated Chagall's Jewish background stressed the wisdom of the Cabala, or the mystic interpretation of the Bible. Nothing on earth was felt to be fixed and immutable, and story-telling was a crucial aspect of belief. *The Holy Family* shows Chagall's pictorial response to the humor, narrative, and mysticism of his Hasidic heritage.

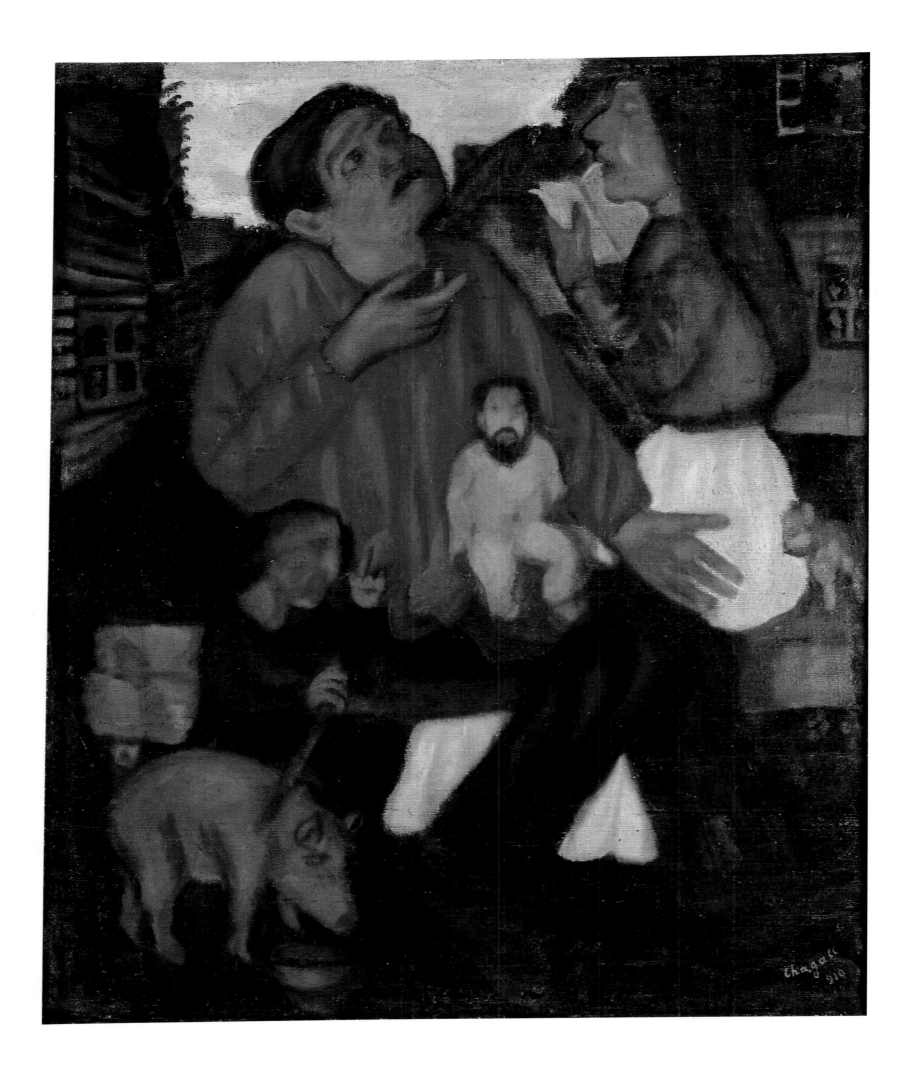

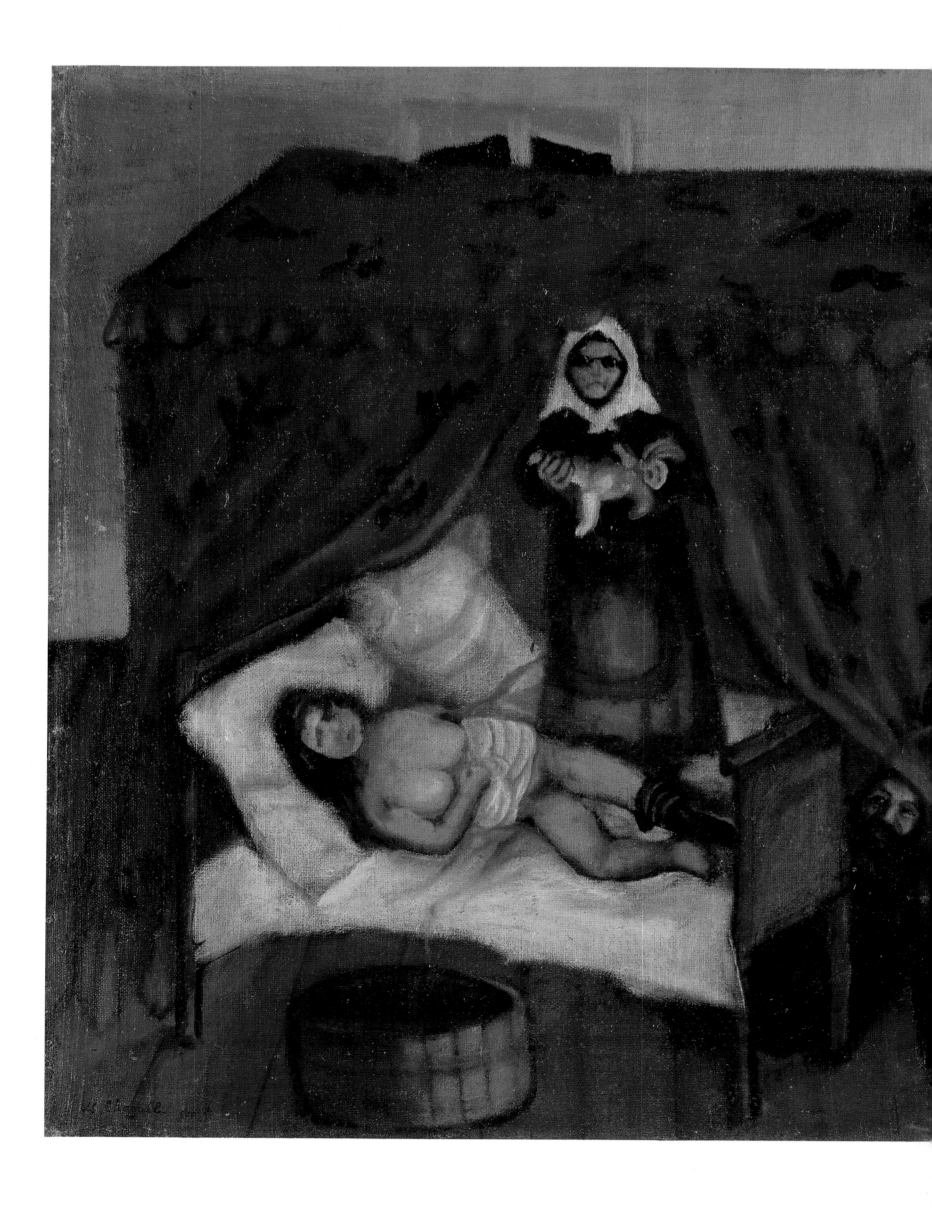

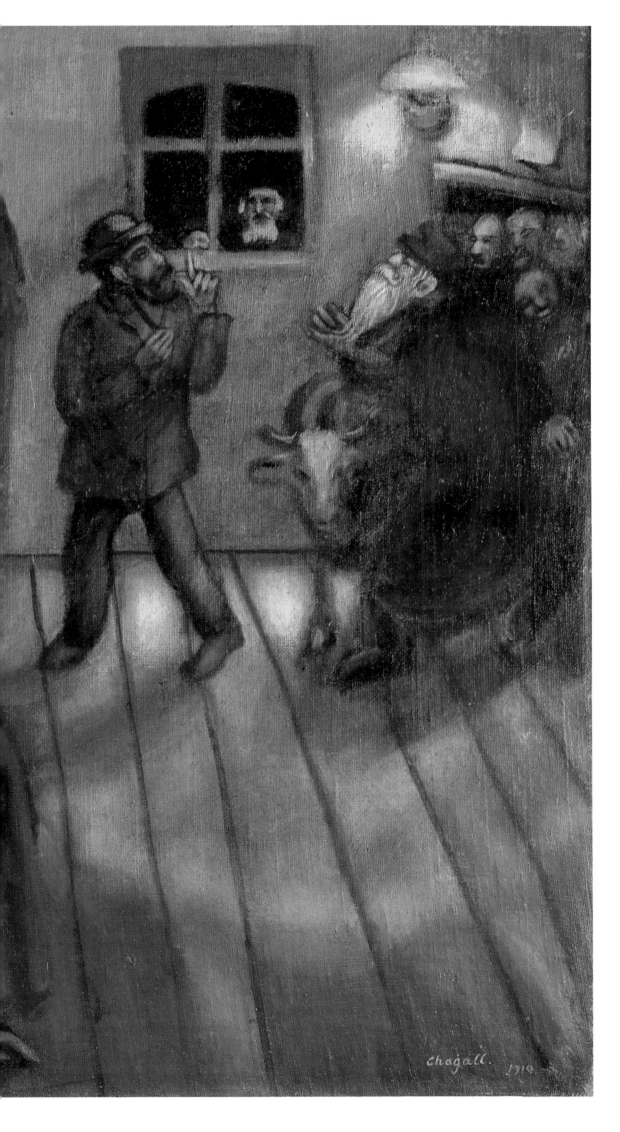

Birth, 1910

Oil on canvas
25⅝×35 inches (65×89 cm)
Kunsthaus, Zürich

Like Chagall's *The Holy Family* (page 31), *Birth* shows that he was beginning to use his artistic training to explore more complex ideas. This is one of several works he produced in St Petersburg which attempt to imbue the events of everyday life with a resonance that transcends the simple fact of the event itself. Chagall's conflation of a rather mundane narrative theme with a heavy symbolic aura was related directly to the work of Symbolist writers he met in St Petersburg. One such Symbolist, Viacheslav Ivanov, inhabited rooms in the same building as the Svanseva school studio, and the pictorial Symbolism of the Blue Rose group was also well known in St Petersburg. Russian literary Symbolism is best exemplified by Andrei Bely's novel *Petersburg* (1916), in which tediously accurate descriptions of city landmarks are suddenly disrupted by misplaced information or inaccuracies. The very use of a realistic technique made such inaccuracies disturbing and effective. Chagall employed such a method in his art of this period. *Birth* shows an everyday event, and the characters in it are recognizable human figures. But Chagall has overlaid this slice of life with some apparent oddities. The painting is divided into two sections. On the left side, the mother bleeds into a bucket as the midwife stands rather precariously on the bed to show the bloody newborn child. A humorous touch is introduced in the figure of the father, who hides underneath the bed, and represents male alienation from the female realm of childbirth. On the right side of the painting, other figures crowd the door of the house and peer in through the window. The separation of events is emphasized by a dual color scheme: the red of the mother's blood bathes the left side of the painting, whereas a more earthly yellow encompasses the intruders from the outside world.

Portrait of the Artist's Sister
(Aniuta), 1910

Oil on canvas
36¼×27⅝ inches (92.1×70.2 cm)
Collection, Solomon R Guggenheim
Museum, New York

While Chagall was beginning to experiment with new uses of subject-matter, he continued to paint portraits. He found this practice a necessity on his many visits to Vitebsk, which he was forced to make because of limitations on his passport. Away from the flourishing art world of St Petersburg, Chagall concentrated on a less experimental kind of picture, and he produced several portraits of his family. Chagall was the eldest child in a family of nine children, so he had no shortage of subject-matter. A portrait of his sister *Mania* (1909) shows Chagall exploiting his new formal concerns, and various changes

that his art was undergoing at the time can be traced in his portraits of his family. This portrait represents his sister Aniuta when she was 20 years old, and her stout healthiness and rather joking half-smile are well characterized by Chagall. The painting also reveals some other qualities common to Chagall's art at the time: the use of black outlines and the large expanses of color. The patterned sofa on which Aniuta sits recalls a device used by Matisse, whose work was gaining attention in Russia through the patronage of Moscow art collectors, Sergei Shchukin, who commissioned the famous *Dance*, and Ivan Morosov.

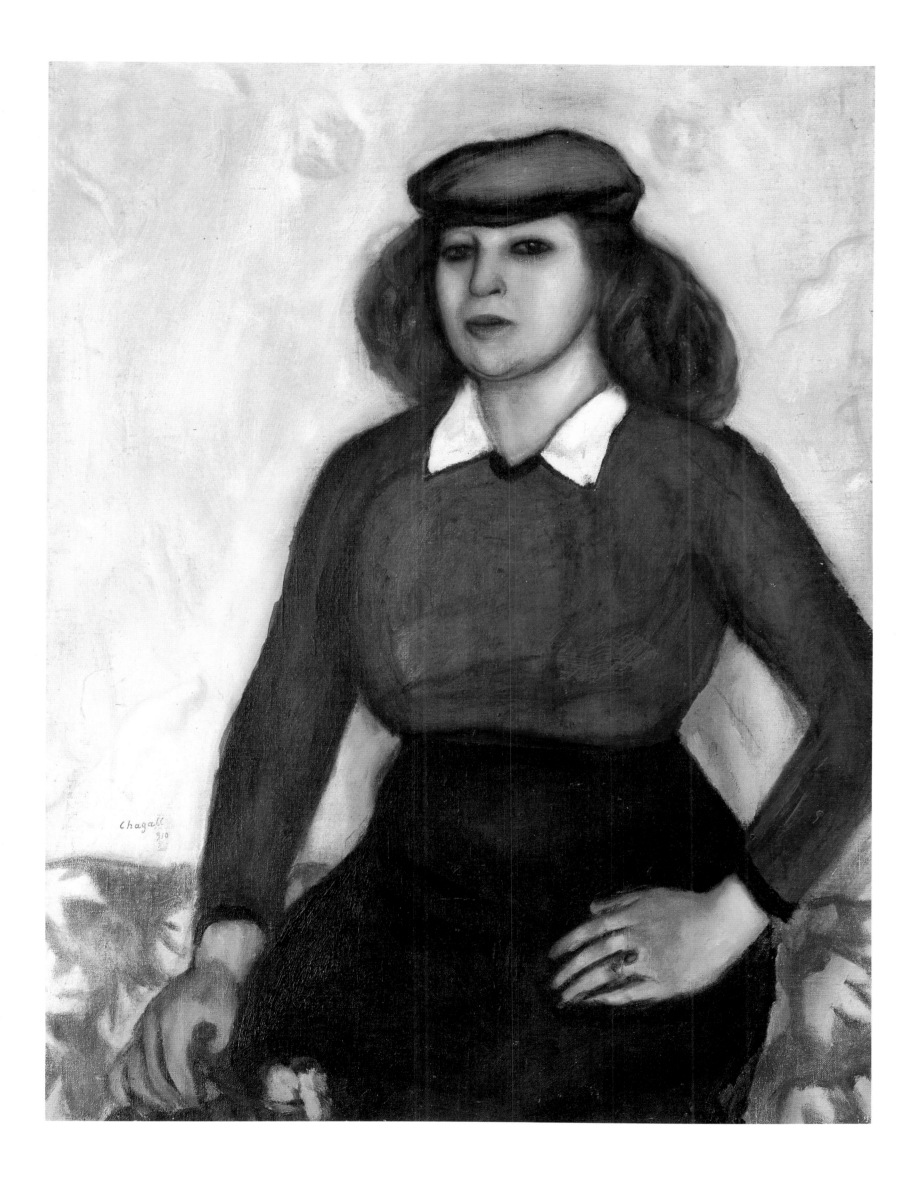

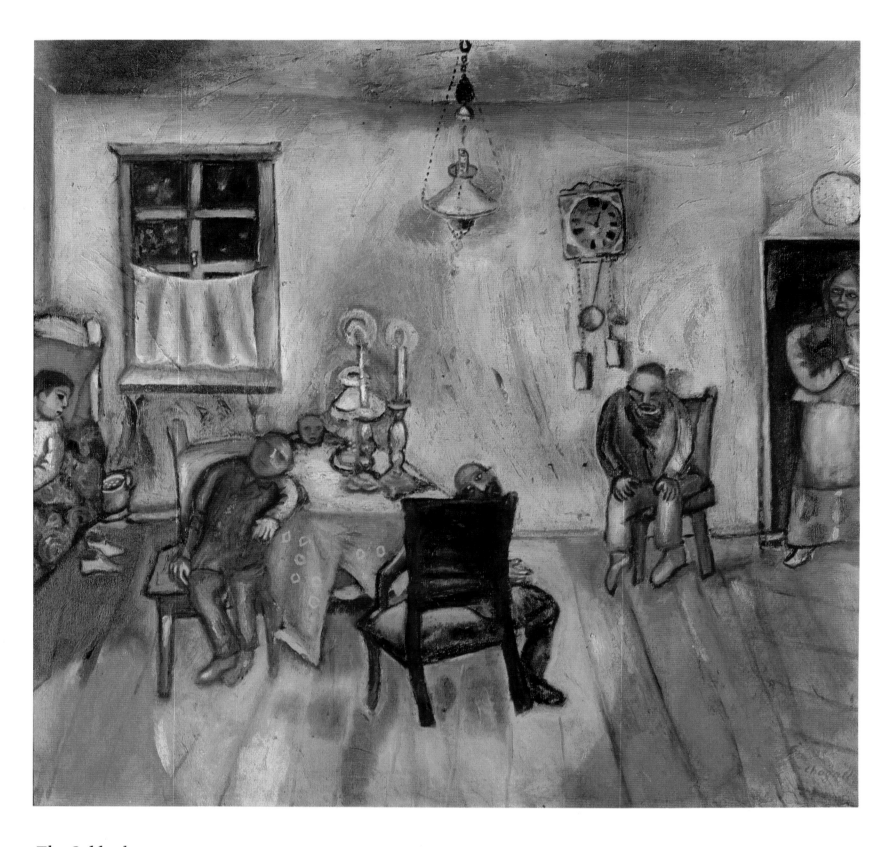

The Sabbath, 1910

Oil on canvas
35⅝×37⅓ inches (90.5×94.5 cm)
Wallraf-Richartz Museum, Cologne

This work was one of the first pictures Chagall painted after he arrived in Paris in 1910, and it shows him absorbing new influences while clinging to more familiar themes. Chagall felt compelled to go to Paris to improve his knowledge of contemporary art, but even before he reached the city he began to feel homesick for Vitebsk. Upon his arrival in Paris, he immediately began planning ways to get away, until his unhappiness was relieved by his first encounter with art in the Louvre. He also visited dealers' galleries and familiarized himself with artists who were becoming increasingly popular. Van

Gogh was one such artist, and Chagall's *Sabbath* recalls some of Van Gogh's expressive interiors. Chagall had been aware of Van Gogh's art before he came to Paris: the *Night Café* had been shown at the Moscow Golden Fleece exhibition of 1908, and Chagall would have known the work through reproductions. But the full power of Van Gogh's use of color did not come to him until he saw a larger proportion of that artist's work in Paris. The *Sabbath* echoes Van Gogh's juxtaposition of an interior distorted by irrational perspective, and fondness for heavily applied hot colors such as yellow. The effect is one of oppression, and here Chagall seems to have realized his early desire to paint an intangible feeling rather than merely a physical fact. Although Chagall has borrowed some ideas from Van Gogh, he uses these

adaptations in a characteristically Russian Jewish setting. Chagall described his strong childhood memories of the Sabbath during which his father would chew reluctantly on his roast while the children observed him greedily. The painting suggests a rather tired and strained family gathering, but the unusual colours and awkward depiction of space raise it beyond a simple document. The *Sabbath* reveals Chagall's unwillingness to abandon Vitebsk, even after he became absorbed by the new artistic excitements of Paris.

Dedicated to My Fiancée, 1911

Oil on canvas
83⅞×52⅛ inches (213×132.5 cm)
Kunstmuseum, Bern

This unusual and vibrant painting was one of the first works exhibited by Chagall in Paris, and it created a small scandal. Chagall wheeled the painting to the Salon des Indépendents in a handcart and hung it at the exhibition, only to be told that it was offensive and must be taken down. The 'pornographic' nature of this seemingly innocuous painting is hard to discern. Chagall referred to it as *The Ass and the Woman*, and it focuses on the two figures of a man with a bull's head leaning on his arm, and a woman who throws her legs around his shoulders and spits into his mouth. The authorities saw the woman's pose as suggestive, the spitting as ejaculatory, and the lamp in the lower foreground as phallic. Chagall repainted the lamp and convinced the exhibition authorities to show the picture, but it continued to be seen as erotic. Apollinaire described the subject as 'a golden donkey smoking opium,' and Blaise Cendrars later retitled it *Dedicated to My Fiancée* – both images reinforcing the heady nature of the subject. Putting aside its controversial subject-matter, the work shows Chagall beginning to embrace new ideas he was encountering in Paris at the time. His use of color is free and undescriptive. Primary colors are used boldly, interspersed with frantic patches of orange and pink. The colorism reveals Chagall's interest in the work of the Fauves. In addition, the distortion of form and mask-like visages imply an attention to Picasso and Braque's Cubist paintings. The work in many ways represents a new departure, but lurking beneath this is a characteristic attempt to blend elements of reality, creating an illogicality that is symbolic and suggestive.

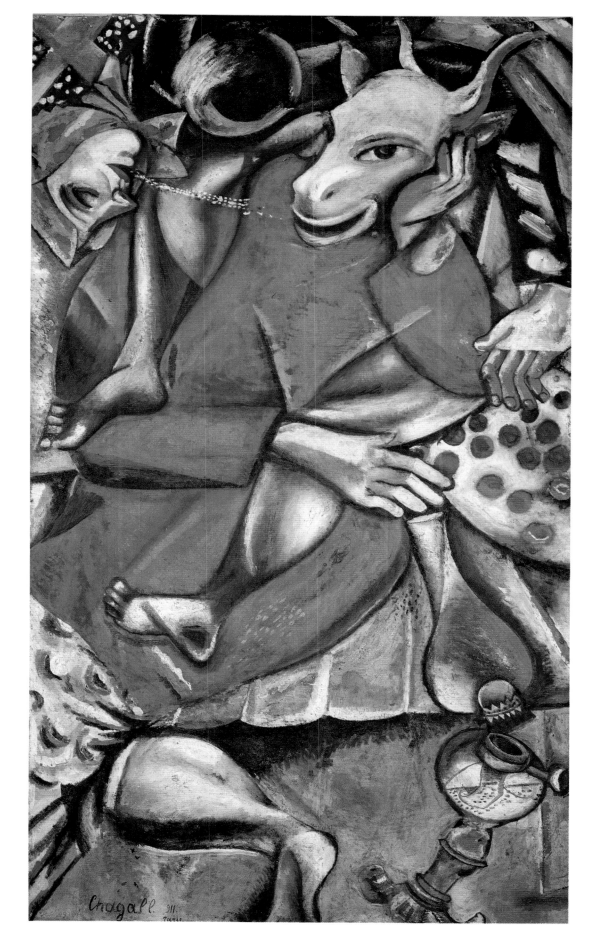

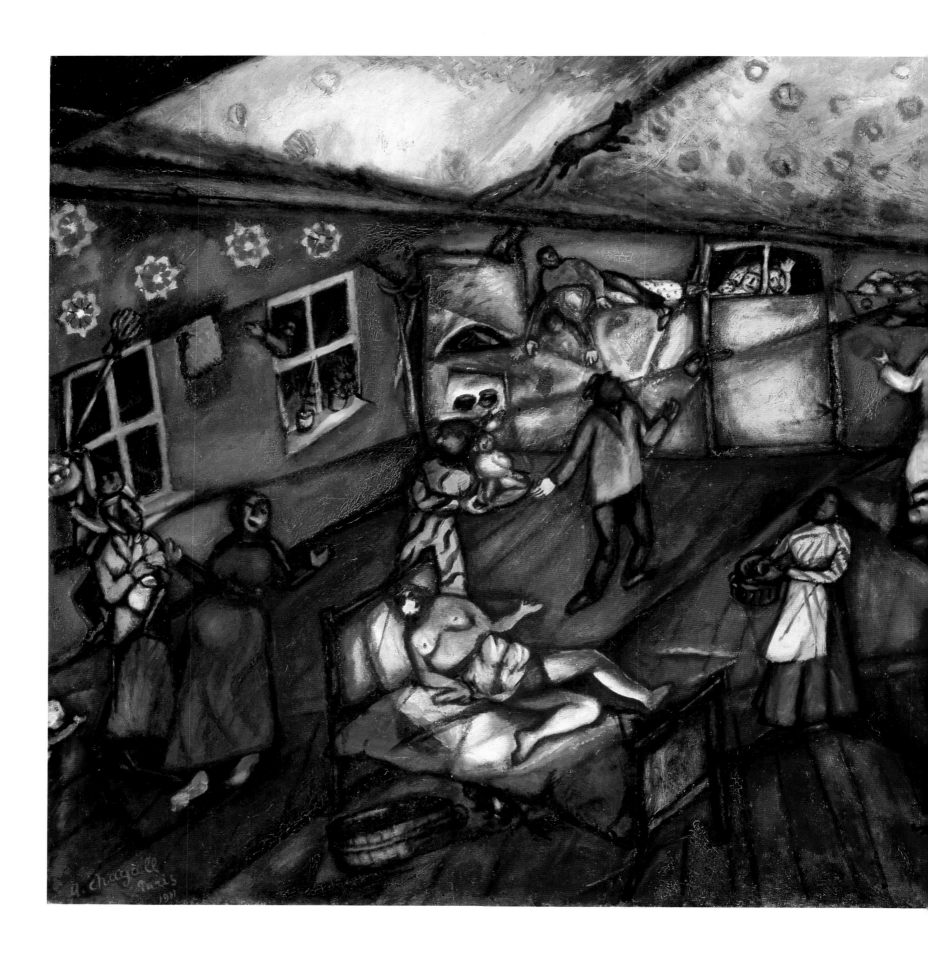

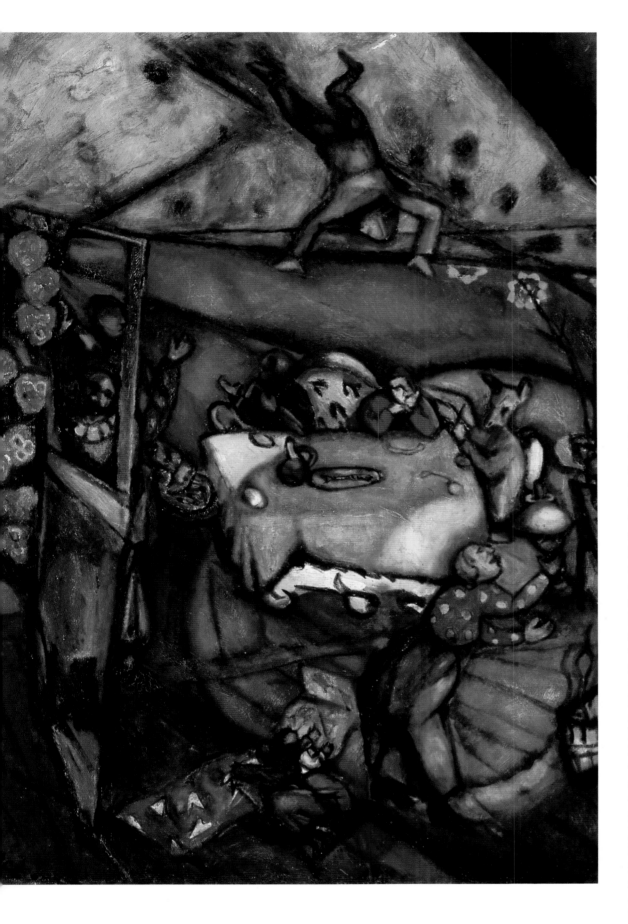

Birth, 1911

Oil on canvas
44¼×76¹⁄₁₀ inches (112.4×193.3 cm)
Art Institute of Chicago
Gift of Mr and Mrs Maurice E Culberg

Chagall's love for his homeland was not diminished by his sojourn in Paris, and at times his experimentation with new ideas seems to do little more than provide slight variations on his deeper obsessions. Chagall first painted the subject of birth while still in Russia (page 32), but his second version shows the theme enlarged in scale, more crowded with figures, and complicated by a new manipulation of color and space. The themes of birth and death permeate Chagall's autobiography. He allegorizes his own birth by speaking of a fire that broke out just at the moment he was born. Birth also provides a striking image later in the work when Chagall describes an episode in which he returned home, having nearly died in hospital, only to discover his mother flustered and dishevelled with a newborn baby in her arms. Birth was a social event as well, as prayers were to be said by the community to ward off evil or, as suggested by folklore, to prevent Adam's first wife, Lilith, from destroying the baby. This painting has all the folkloric qualities of Chagall's previous work, but it is fussier in composition. Many different events occur simultaneously, unified only by several bands of color which cut sharply across the picture plane. The bloody birth is separated spatially from the dining area, where a woman appears to mourn, although the reason for this reaction is somewhat obscure. Chagall has, quite literally, removed the ceiling and given us an aeriel view into this seeming madhouse. The use of disparate events within the same framework was a device employed in Russian icons, and Chagall may have been thinking of those he had seen in St Petersburg when he produced this work. But the large triangles of color which function independently from the narrative events are more directly related to the watered-down Cubism that appears in much of his painting at this time.

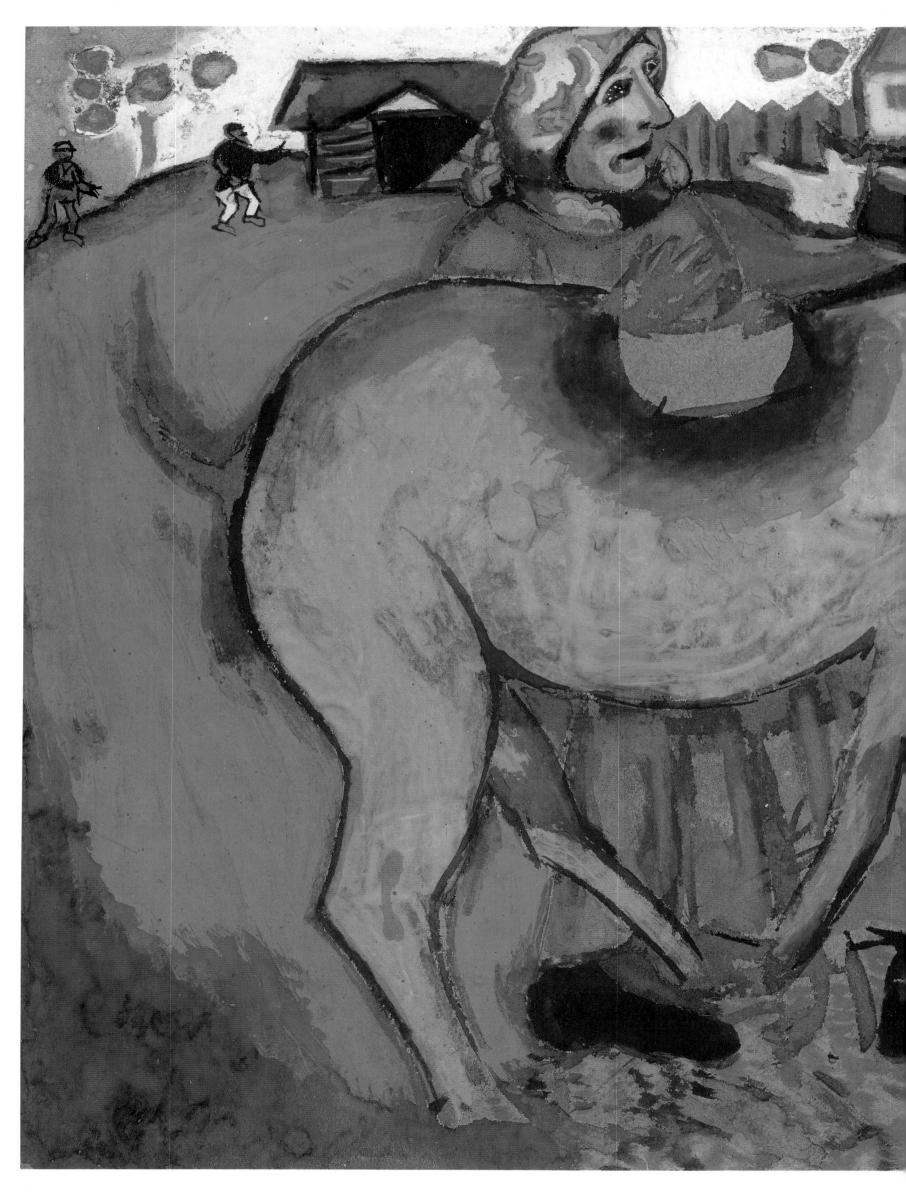

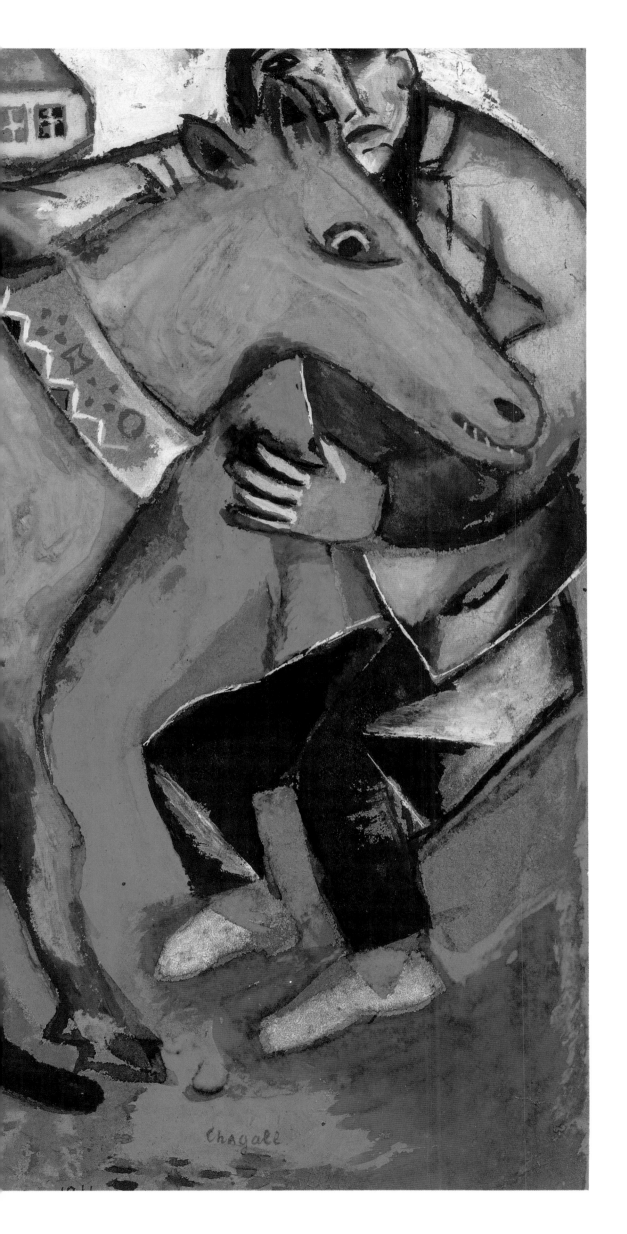

The Green Mare, 1911
Gouache on board
12¾×16¼ inches (32.4×41.3 cm)
Tate Gallery, London

The Soldier Drinks, 1911-12

Oil on canvas
43×37¼ inches (109.2×94.6 cm)
Collection, Solomon R Guggenheim
Museum, New York

Chagall's sense of humor is an aspect of his art which is too often ignored or dismissed, but *The Soldier Drinks* provides a prime example of this gentle comic element in his painting. Chagall later denied the commonly accepted interpretation of this painting as a representation of drunkenness, and certainly the samovar in front of the soldier implies that his drink is not alcoholic. But the strange miniature dancing couple in the foreground and the stray hat give the work a sense of the hallucinatory. The incongruity of these juxtapositions create humor, but they also arouse the observer's curiosity. Like many of his paintings of this period, Chagall's work has elements of realism, symbolism, Cubist formalism and Fauvist colorism. He did not entirely accept the formal canons of analytical Cubism, and he did not abandon the narrative subject-matter of his Russian paintings. However, these elements often blend together in a peculiar and unsettling way. As artists in Paris moved closer to pure abstraction, Chagall still painted figures that were recognizable. *The Soldier Drinks* also reminds us that Vitebsk was never very far from his mind. Soldiers played a prominent role in Chagall's early life, although he went to great pains to avoid compulsory military service. The samovar and the shack seen through the window also recall Chagall's Russian origins. But these simple images become transformed by being juxtaposed in an unusual way. Through this means Chagall did not actually use established symbolism, but he created his own personal symbolism that eludes any precise analysis.

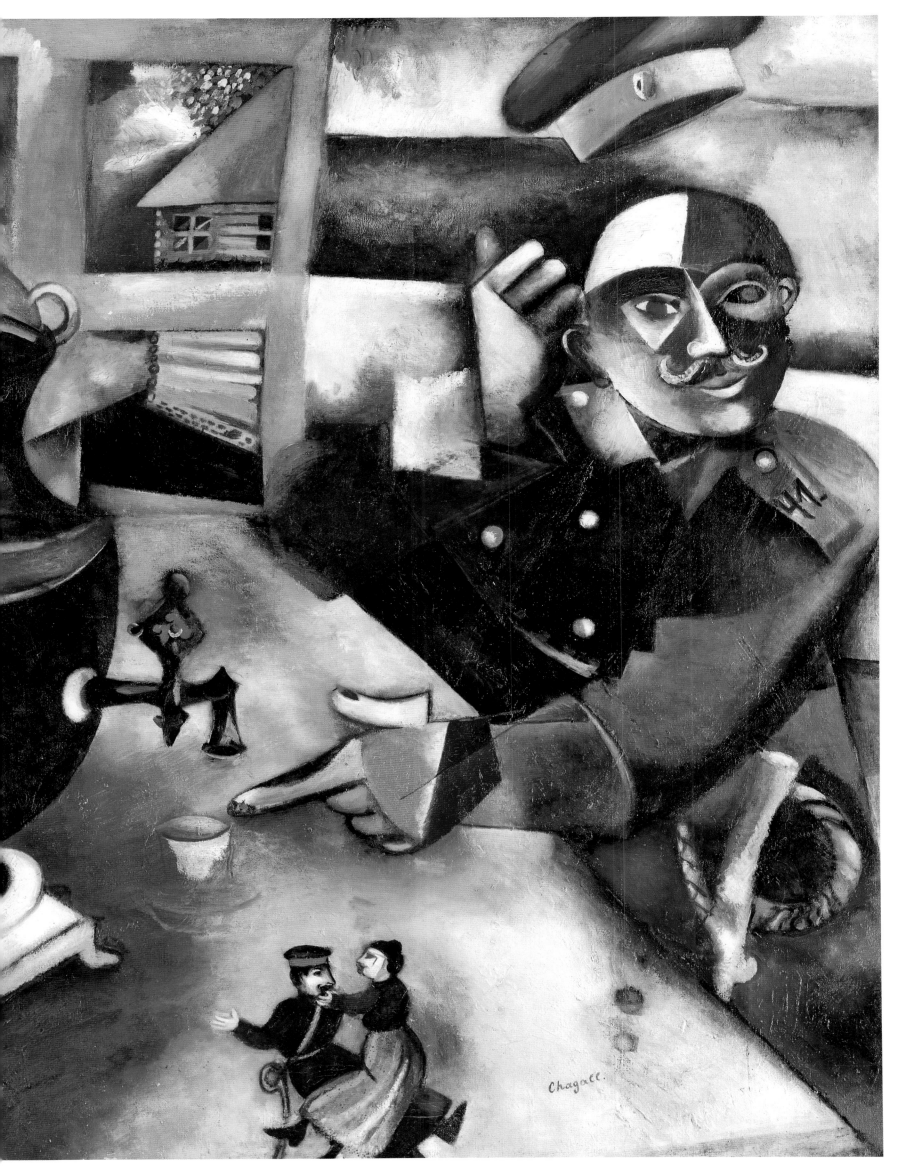

Homage to Apollinaire, 1911-12

Oil, gold and silver powder on canvas
78¾×75⅝ inches (200×189.5 cm)
Stedelijk van Abbemuseum, Eindhoven

The poet and critic Guillaume Apollinaire had a brief but significant impact on Chagall during his Paris years. Apollinaire had gained his reputation as an art critic through his enthusiastic, but sometimes misguided, advocacy of contemporary avant-garde art. His first visit to the studio of a poor and relatively unknown Chagall caused the artist great trepidation, but Apollinaire praised Chagall's works, referring to their effect as 'surnaturel.' The day after his visit to La Ruche, Apollinaire sent him a poem, *Rotsage*, which was later published in the catalogue to Chagall's exhibition at the Berlin gallery, *Der Sturm.* Chagall, in turn, dedicated this unusual painting to the poet, weaving together Apollinaire's admired Cubism and Orphism with a Cabalistic mysticism that was characteristic of Chagall's personal approach to art. In the lower left-hand corner of the painting, a pierced heart is surrounded by the names of four men: Apollinaire, Cendrars, Walden, and Canudo. Apollinaire and Cendrars had both encouraged Chagall's art, as had the poet Canudo, who was also a friend of the Futurist painter Marinetti. Herwarth Walden was the art dealer who gave Chagall his first one-man show in Berlin. These four names sit almost unnoticed at the bottom

of a colorful clock-like circle which recalls the series of color disks that Chagall's friend Delaunay was producing at the time. Indeed Delaunay's Orphism rejected pure Cubist geometry in favor of an emphasis on the effects of color and light, and Chagall was sympathetic to Delaunay's approach. However, Chagall's 'disk' still has a representational function, and in the middle of the clock-face, acting as the clock-hands, are the figures of Adam and Eve, growing hermaphroditically out of a single form. Early sketches for this painting show the subject of Adam and Eve in the Garden with the apple and snake of temptation, but in the final painting, only the clutched apple makes the allusion to the Garden of Eden apparent. Eve does not emerge from Adam's rib, but the two divide from a common body. Here Chagall endows the work with Cabalistic significance by suggesting the idea that the four elements had emerged from a single form. The four names Chagall includes in the painting refer cryptically to the four elements: the *aire* of Apollinaire; the *Wald* (German for wood/earth) of Walden; the *cendrers* (fire) of Cendrars and the *d'eau* (water) of Canudo. In Chagall's Hasidic, mystical perception, the goal of mankind was to reunite into a single form, and love was the means of this reunification. Chagall underlined the mystical significance of his painting by using gold and silver powder, alluding to the substances of alchemy.

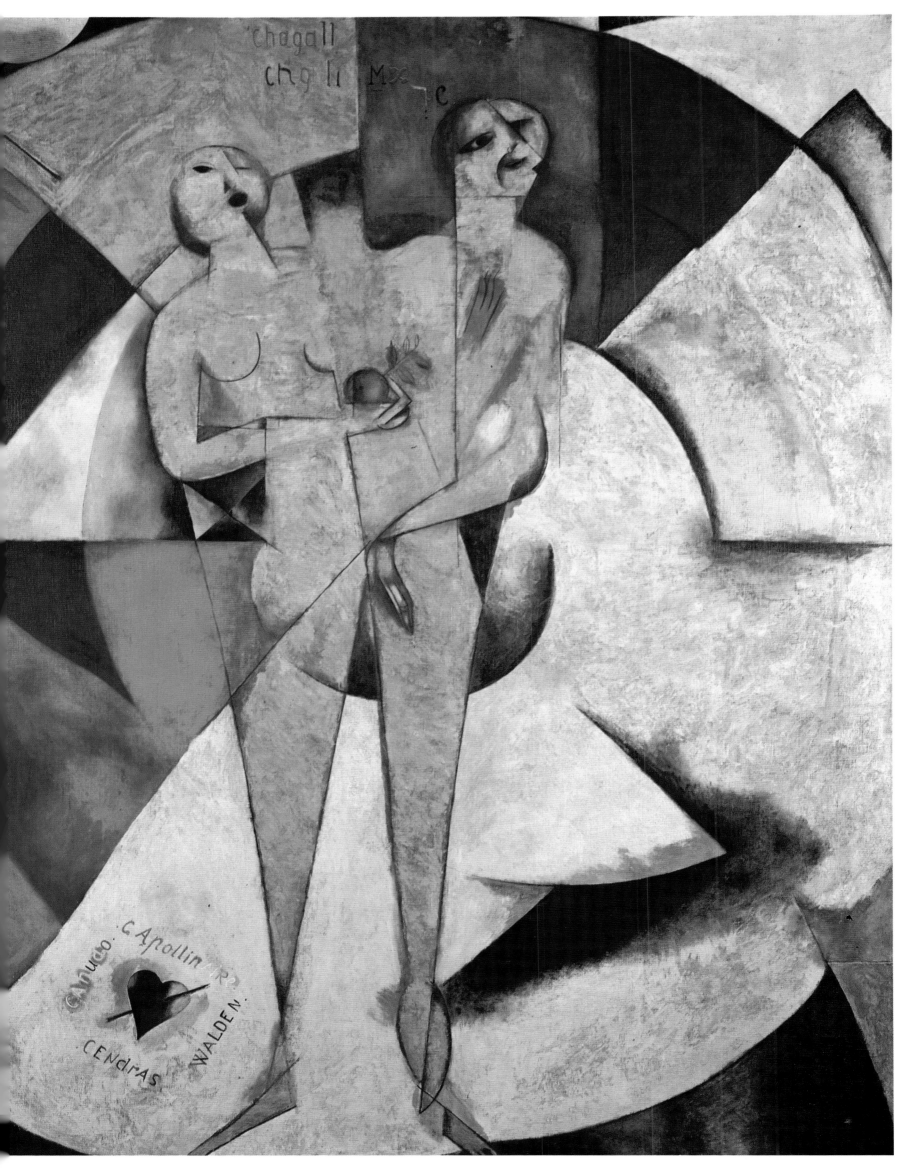

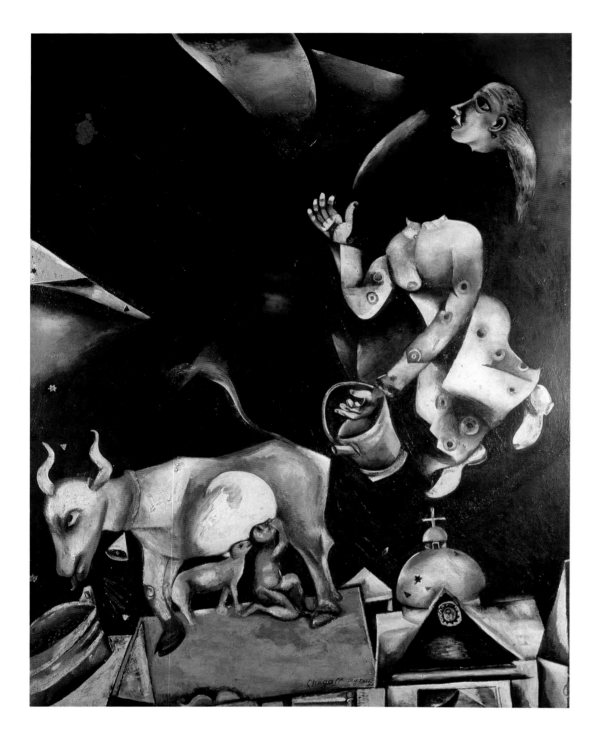

Right:
I and the Village, 1911-14
Oil on canvas
75½×59½ inches (191×150.5 cm)
Museum of Modern Art, New York
Mrs Simon Guggenheim Fund

Like *Homage to Apollinaire* (page 44), this painting suggests the contradictions and complexities of opposition and unity, but rather than representing male and female forces, *I and the Village* shows man confronting beast. Chagall has here expertly blended nostalgia for his homeland with his most blatant adoption of Cubism. The title, provided by Cendrars, also suggests extra layers of meaning inherent in the work. Chagall has represented the profile of himself on the right facing a rather unconvincing cow on the left. Within the cow's cheek is another cow being milked by a woman, and in the background, Chagall has shown Vitebsk populated by only two figures – one of whom carries a scythe and thus appears as an image of time or death turned literally upside-down. A closer study of the painting reveals both humor and ambiguity. The artist does not simply face the animal, but he offers him a nosegay. His gesture is a parody of courtship: the artist is striving for a unification of the bestial and rational, the spontaneous and the studied, man and beast. However, Chagall only suggests this significance, and any attempt to 'read' the symbols more thoroughly results only in frustration. By the time he left Paris in 1914, Chagall had already developed a form of personal symbolism which both demanded explanation and eluded it. Here he has created an atmosphere of nostalgia for Vitebsk, through a series of disconnected and puzzling images. The technique of *I and the Village* relates obviously to Cubism. The severe geometrical elements both define

To Russia, Asses, and Others,
1911-12
Oil on canvas
61⅜×48 inches (156×122 cm)
Musée National d'Art Moderne,
Centre Georges Pompidou, Paris

While in Paris, Chagall could not forget Russia, but his homeland emerges in his art in a new guise. In this painting, Vitebsk is seen through a Cubist vision. Against a night sky pierced with flashes of bright color, a headless milkmaid floats above the roofs of a Russian town. On one of these roofs, a red cow suckles a monkey and a lamb. An early study for the painting shows a more naturalistic landscape, including only the bizarre spectacle of a woman literally losing her head, but in the final painting the strange juxtaposition of subject-matter and setting creates a jarring and uneasy effect. Chagall here has learned some of the lessons of Cubism without adopting the Cubist vocabulary wholeheartedly. He maintains representational

forms, but he describes these forms through blocks of sharp, geometric color. Chagall's attitude to Cubism was ambivalent: although he adopted their use of fragmentation and surface effect, he also scorned their clinical approach to art. Chagall wrote vehemently of the Cubists in his autobiography: 'Let them choke themselves with their square pears on their triangular tables.' Nevertheless, like most artists in Paris, Chagall was not immune to the powerful influence of Picasso and Braque. The strange title of the work was one of several suggested by Cendrars, who was fond of attaching poetic significance to Chagall's paintings.

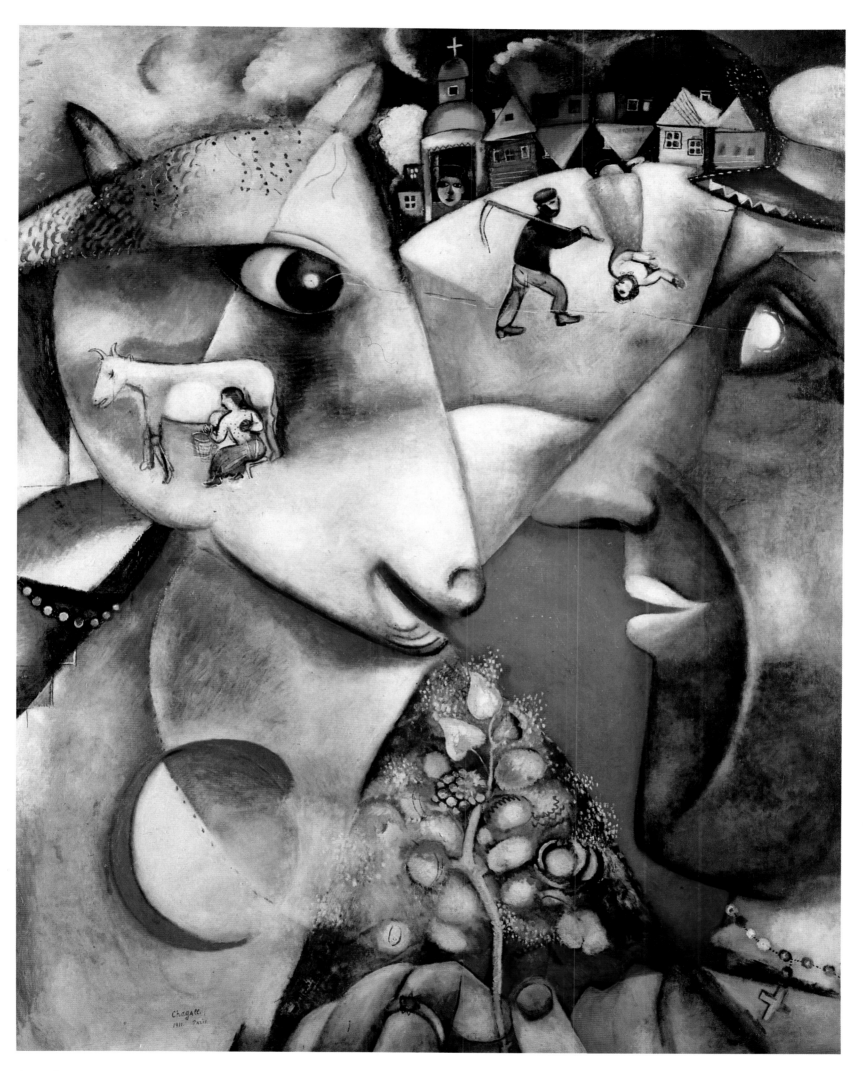

the subject-matter and have an independence from it. Chagall's unusually strict use of geometry in this work may be related to the work shown in the Section d'Or exhibition held at the Galerie La Boétie in 1912. Among those exhibiting were Chagall's friend Delaunay, and all the artists represented had sympathies with Cubism which led them to advocate the revival of the 'Golden Section' in painting. The Golden Section represented perfect proportion and had been in common use since the Renaissance, when it was considered to have mystical qualities. Although Chagall was rather scornful of the pragmatic side of Cubist geometry, he would have been sympathetic to a more mystical use of geometric form.

The Poet Mazin, 1911-12

Oil on canvas
28¾×21¼ inches (90×70cm)
Private Collection

While inhabiting a studio at La Ruche, Chagall lived a stereotypically bohemian existence. He starved and struggled for the sake of his art, and he habitually stayed up all night painting, adopting the strange practice of working in the nude. He was constantly involved in heated debates with artists and writers, and he was surrounded by the most innovative and eccentric men of the time. However, among his many acquaintances were poets and painters who never achieved the fame or success of which Chagall could later boast. Mazin was one such obscure poet. Like Chagall, he lived at La Ruche, but little is known about him. Chagall's friendships with poets throughout his life is well-known, and although he scorned the label of 'literary painter,' he obviously owed a great deal of inspiration to the ideas and writings of his poetic friends. Whereas Chagall never painted Cendrars and only sketched Apollinaire, he devoted one of his most unusual

works of this period to the little known Mazin. The painting differs from Chagall's other Paris works in several aspects. After Chagall returned to Russia in 1914, the portrait became an important part of his output, but while in Paris, he devoted very little attention to portraiture. The painting can also be distinguished from other works of this period by its formal concerns. It contains very little of the pseudo-Cubist experiments that permeated Chagall's Paris paintings. The cool, peaceful harmony of the tones give a sense of gentle intimacy that contrasts with the often wild fantasy of paintings like *Dedicated to My Fiancée* (page 87). The intimacy is reinforced by the actions of Mazin, who sits at a table with a book open in his lap, sipping from a cup. Chagall has obscured the features of Mazin's face by reddish brown shadows, which diverge from the more cheerful kaleidoscopic colors of the bottle beside him.

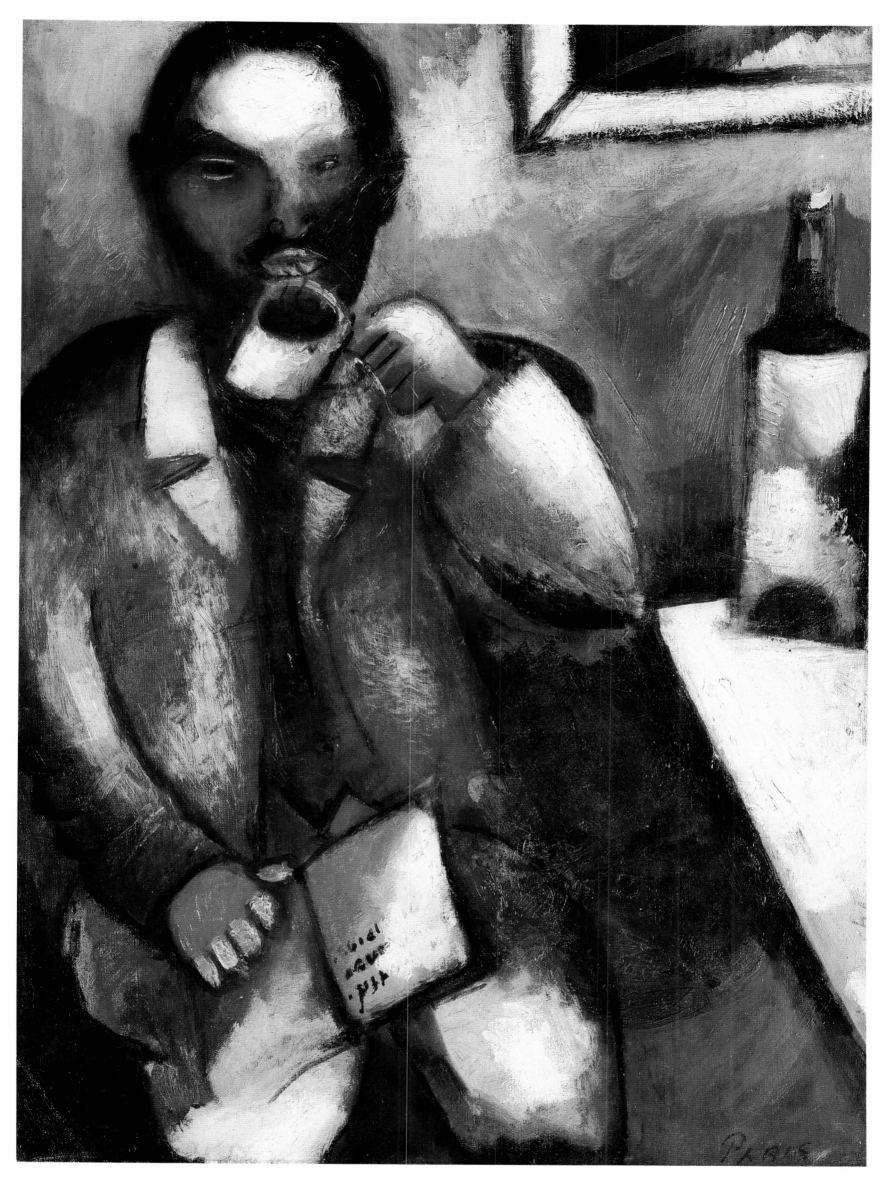

Half-Past Three (The Poet), 1911-12

Oil on canvas
77⅛×57 inches (196×144.8 cm)
Philadelphia Museum of Art
Louise and Walter Arensberg Collection

This painting shows Chagall plunging wholeheartedly into the new liberation of form and color that he experienced in Paris, but the work still contains vestiges of anecdote. Chagall did not name this painting himself, but accepted the title suggested by his friend, the poet Blaise Cendrars. The work itself is analogous to Cendrars' poetry, which pieces together images and fragments in order to suggest his subject, rather than describing it literally. Cendrars dedicated two poems to Chagall: a 'portrait' of the artist himself and a vision of his untidy studio in La Ruche. Perhaps in response to this, Chagall painted a poet, whose jumbled body and surroundings offer a humorous companion to Cendrars' fragmented poetry. The 'poet' is based on Chagall's earlier portrait of the poet Mazin (page 49), but he has manipulated the figure and dispensed with any semblance of realistic representation. The poet's body is compartmentalized into a series of decorative patches of blue-gray, and he sits at a table which consists of little more than a red rectangle. The detached head and floating bottle are

motifs that Chagall used in an earlier painting, The Drunkard (1911), but here they contribute to an overall effect of movement and energy. It has been suggested that this emphasis on movement is related to the painting of the Futurists, who attempted to convey the dynamism of modern life in their work. Chagall, however, uses movement as he uses Cubist geometry – to create a decorative effect which contributes to the impact of the composition. Chagall originally called this painting Rendezvous, and the cyrillic writing on the paper in the poet's hand could suggest the beginnings of a love letter. But Chagall happily adopted Cendrars' interpretation of the inspired poet achieving a burst of creative energy at half-past three in the morning. Chagall was always attracted to poets, and he began writing his own poems while in Russia, to the dismay of his patron Guinsberg, who could not see why a painter should want to write poetry. Guinsberg's dismissal did not quite quell Chagall's ambitions, and although he scorned the title 'literary painter,' he continued to write poetry all of his life.

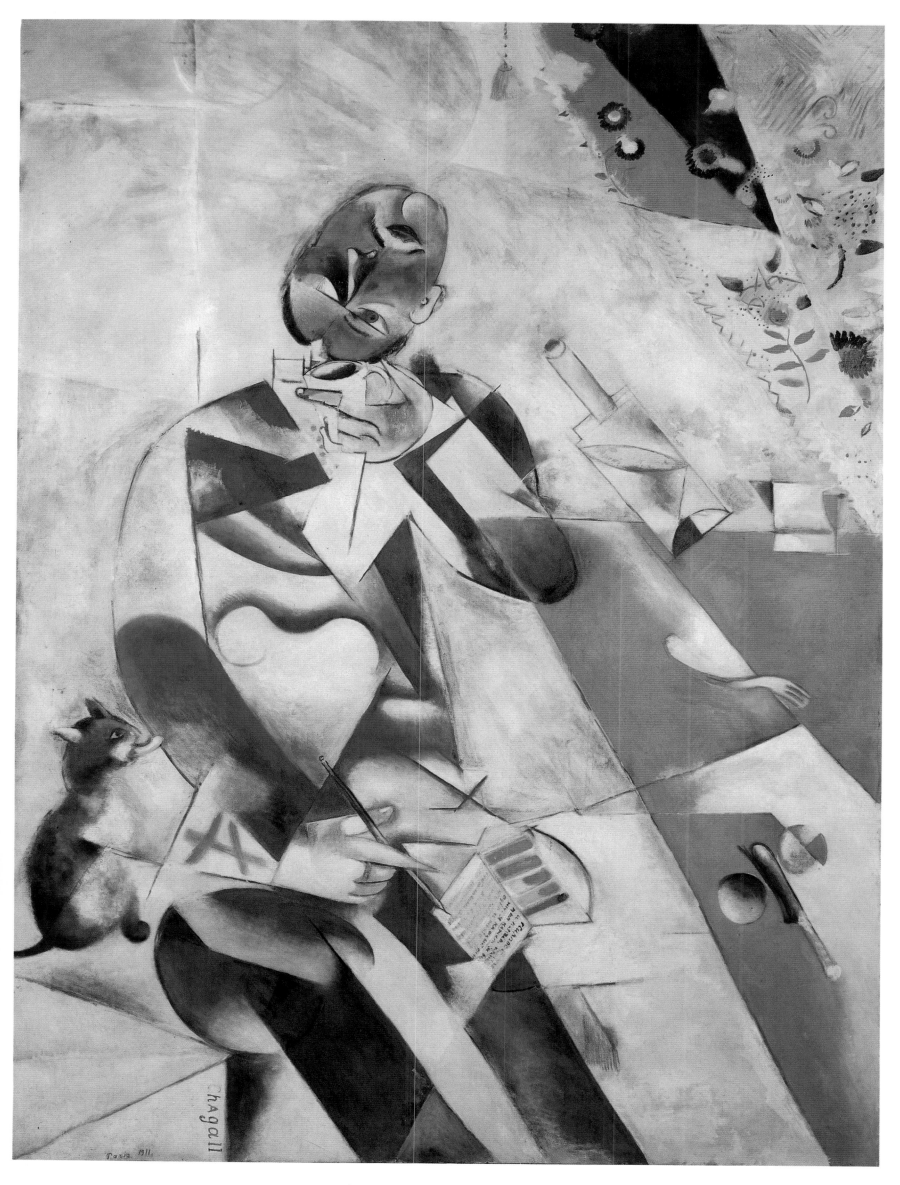

Temptation, 1912

Oil on canvas
63³⁄₁₆×44⁷⁄₈ inches (160.5×114 cm)
Saint Louis Art Museum, St Louis, Missouri

This painting was one of the earliest works Chagall exhibited in Paris, and its showing at the Salon des Indépendents in 1912 suggests that he hoped to be associated with artists in the Cubist circle. His sporadic training in private art schools in Paris put him in contact with Gleizes, Metzinger, La Fresnaye, Léger, and Lhôte, all of whom practiced some form of Cubism. The early period of Cubism has been known as 'analytical' because artists analysed the composition of real objects and reconstructed those objects on the basis of a number of different viewpoints. Artists working within the Cubist idiom accepted this re-interpretation of reality more or less literally: some artists adapted Cubist forms for what appeared to be purely decorative pur-

poses. In this work, Chagall shows that he had learned from artists such as Metzinger how to break down form and reconstruct it, although he abandons the Cubist technique in places, such as for the leaves of the tree. However, his use of bright green and yellow was in direct contradiction to the monochromatic paintings of Picasso and Braque, and Chagall could not resist adding a goat or two as a sort of signature. The appearance of this work with other brightly colored Cubist paintings at the Salon des Indépendents, inspired Apollinaire to classify these artists as 'Orphists' and to praise their 'more poetic vision of the universe and of life.' Apollinaire also identified the subject of this painting as *Adam and Eve*, despite the fact that it appeared in the exhibition as simply *Couple in an Arbor*. The subject of Adam and Eve also appeared in *Homage to Apollinaire* (page 44), although in that work the subject was used more allusively and symbolically.

Right:
Nude with Comb, c. 1911

Gouache on paper
13¹⁄₈×9¹⁄₈ inches (33.3×23.2 cm)
Private Collection

Drawing from the nude was traditionally part of the education of artists in Europe, but in the early years of the 20th century, the nude became a special focus for new formal experiments. Chagall's initial training in Pen's Vitebsk school had provided him with little opportunity to draw from the life, but life drawing was an important part of his study in St Petersburg. Chagall's earliest studies of the nude, such as the *Red Nude* (1908), show the impact of Cézanne's obsession with form and his detachment from the subject. Chagall outlined the figure in black and thus flattened the composition, emphasizing the formal structure of the model's standard academic pose. From Gauguin Chagall borrowed the idea of bathing the whole composition in a dominant color, asserting the properties of color and form, and relegating the importance of the actual subject. These qualities can also be seen in *Nude with Comb*, but here Chagall reveals that he has absorbed new artistic ideas that he encountered in Paris. This gouache is one of a series of studies executed in Paris between 1911 and 1914. Here the previous influence of Cézanne is superseded by a more apparent manipulation of Cubist formula. The parts of the body become almost geometric elements in themselves, and the face is reduced to a schematic, childish scrawl. Chagall's sketchbooks from this period reveal that he originally conceived of these nudes in a more straightforward way. He would first produce a simple drawing, and then he would create a second, more 'Cubist' rendering based on his first version. Elongation and distortion of the nude was particularly characteristic of Picasso's and Braque's paintings of 1907-09, as well as the Cubist sculpture of the Russian Alexander Archipenko, who was living in Paris during this period. However, Chagall did not persist with these paintings from the life, nor did they form a major part of his Paris work. Instead, they indicate the way his mind was working at the time, and the kinds of influences to which he was susceptible in Paris.

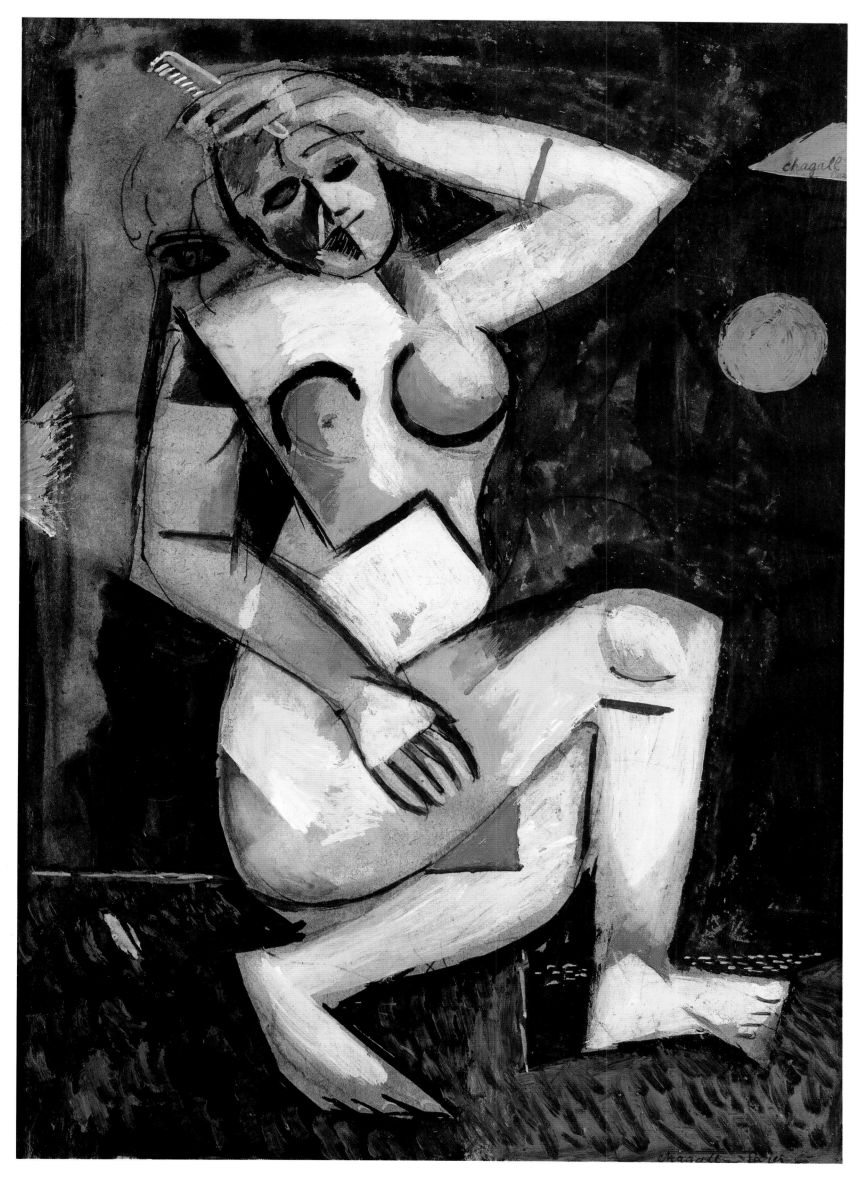

53

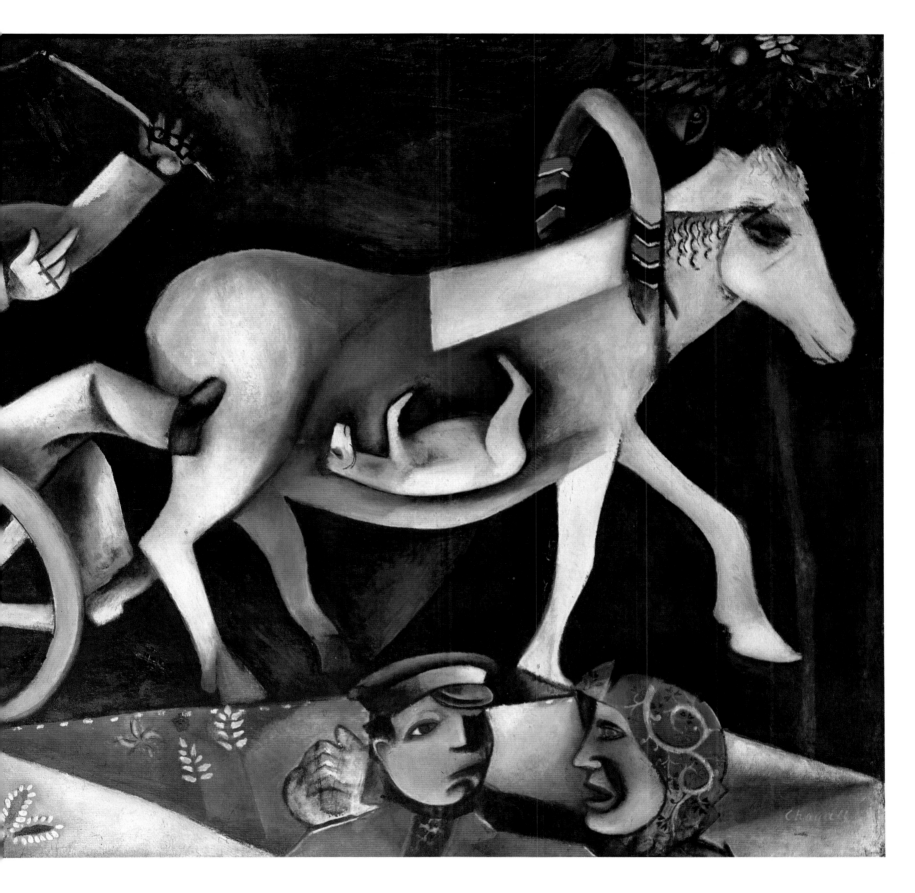

The Cattle Dealer, 1912

Oil on canvas
38×80 inches (97×200.5 cm)
Öffentliche Kunstsammlung Basel,
Kunstmuseum, Basel

In *My Life*, Chagall writes of going out into the country with his Uncle Neuch to get cattle, describing the scene that confronted him from the vantage point of his uncle's cart. This painting seems to recall this early experience. The horizontal composition is not characteristic of his work at this time, but it suits the subject-matter, adding to the frieze-like impression of a procession moving down a road. Chagall uses several now-familiar devices in his painting. The form is fragmented in a pastiche of Cubism, and colors are autonomous and bold. The subject-matter is both obvious and mysterious. The woman on the left who carries a cow around her shoulders could be either a peasant in the countryside or an allegory of the Good Shepherd. The horse which pulls the cart has a transparent stomach through which a colt is visible. Chagall here is playing with the paradox of visibility and invisibility: the unborn colt which is normally invisible to the eye is no less real than the horse that we can see. In Chagall's mind the world of appearances was not the only world, and he wished to visualize the world of the spirit. He shared this ambition with a number of artists at the time, including his fellow Russian Kandinsky, who hoped to tap mankind's universal spirit through color. But unlike Kandinsky's, Chagall's art was never completely subjective: he always retained some form of representation, and his striving for spirituality was thus at the mercy of recognizable images.

Chagall exhibited this painting at the Berlin gallery, *Der Sturm*, in 1914. On the eve of the outbreak of World War I, Chagall's one-man show in this gallery promised future success. He was especially admired by Expressionist artists who shared his ambition to depict sensations and emotions as well as physical objects.

55

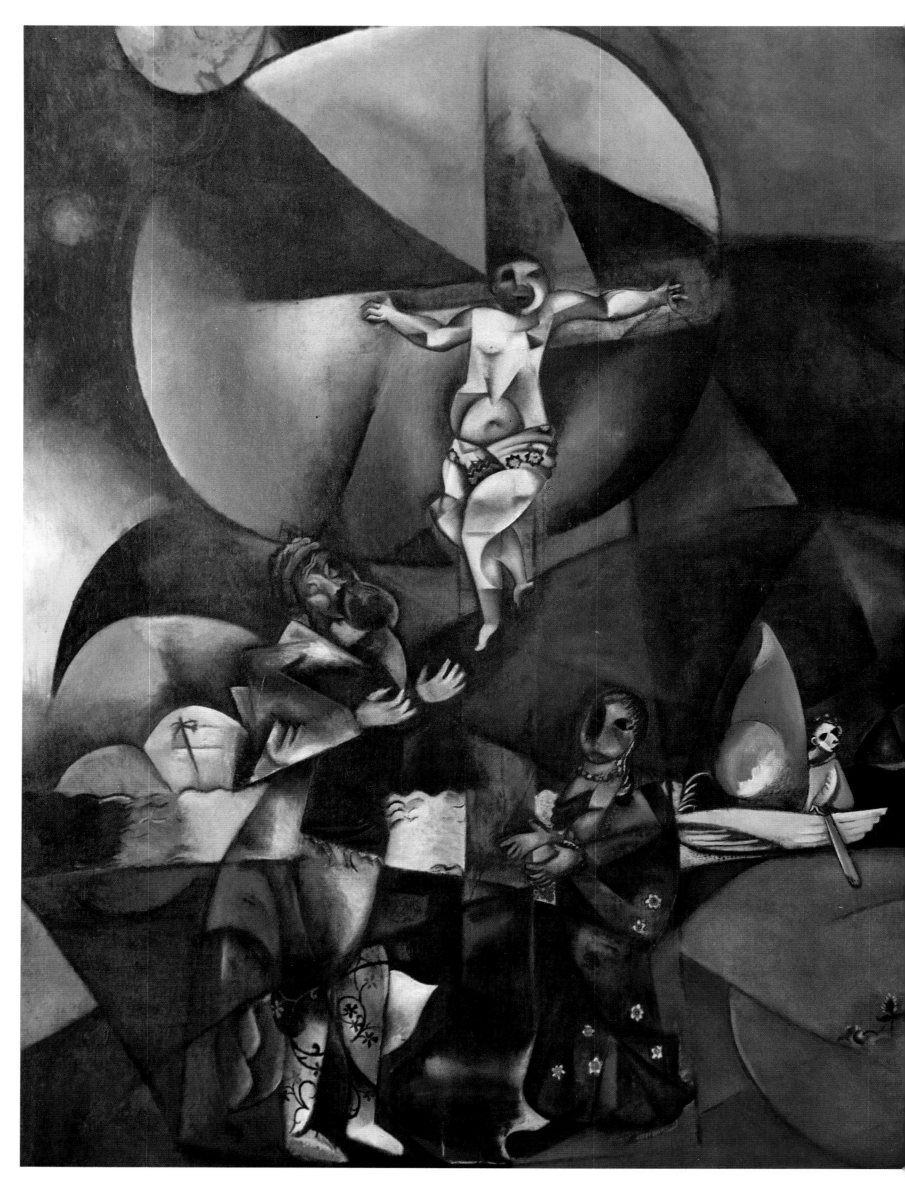

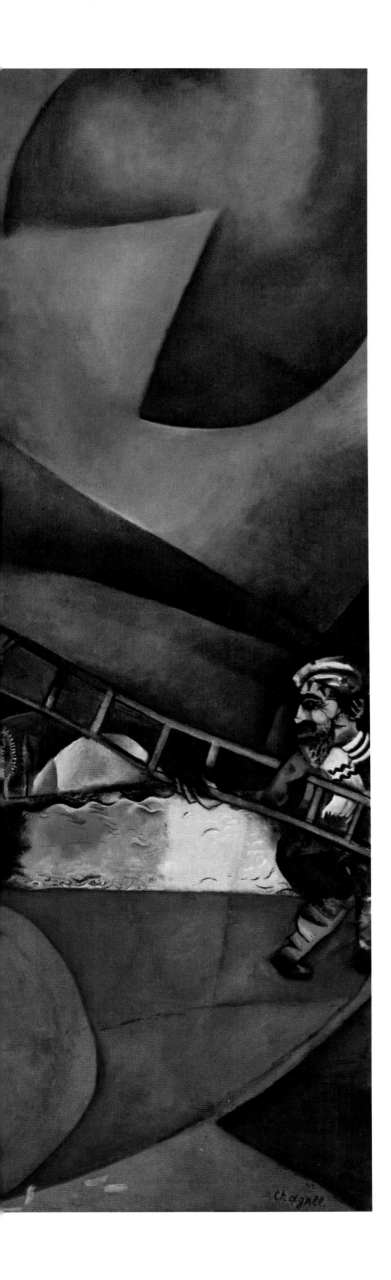

Calvary, 1912

Oil on canvas
68¾×75¾ inches (174.6×192.4 cm)
Collection, The Museum of Modern Art,
New York

This painting represents the first of Chagall's many attempts to delineate the Crucifixion of Christ, a subject that continually fascinated him and had various meanings for him throughout his life. While he was in Paris, Chagall did not yet perceive Christ as the universal symbol of Jewish suffering, but he used the image as a direct challenge to the Russian icons he had seen in St Petersburg. The painting is broken up into a series of narrative components, recalling the multi-narrative structure of many Russian icons. Individual figures also allude directly to icons, and the woman with the exposed breast below the cross refers to the Madonna in icons. In some ways the painting can be read as a straightforward representation of the Crucifixion: Christ is on the cross, Mary stands below it with Joseph of Arimathea, and the ladder glimpsed to the right was a symbol of Christ's torture that had a long tradition in Byzantine iconography. However, as in his earlier *The Holy Family* (page 31), Chagall has subverted the traditional meaning of these symbols. The figure of the crucified Christ appears as a baby wrapped in a loincloth that resembles a diaper. The image is not a strict rendering of a religious scene but an interpretation of it. In an interview in 1949 Chagall spoke of the meaning of this child Christ:

I wanted to show Christ as an innocent child. Nowadays, of course, I see it differently. When I painted this picture in Paris I was trying to free myself psychologically from the icon painter's outlook, as from Russian art altogether.

Chagall was working through the subject-matter and style of icon painting, in effect parodying it and transcending it. The painting was recognized as an important work at the time, and it was one of the first pictures he sold outside Russia. After its exhibition in the First German *Herbstsalon* of 1913, *Calvary* was bought by the collector Bernard Koehler.

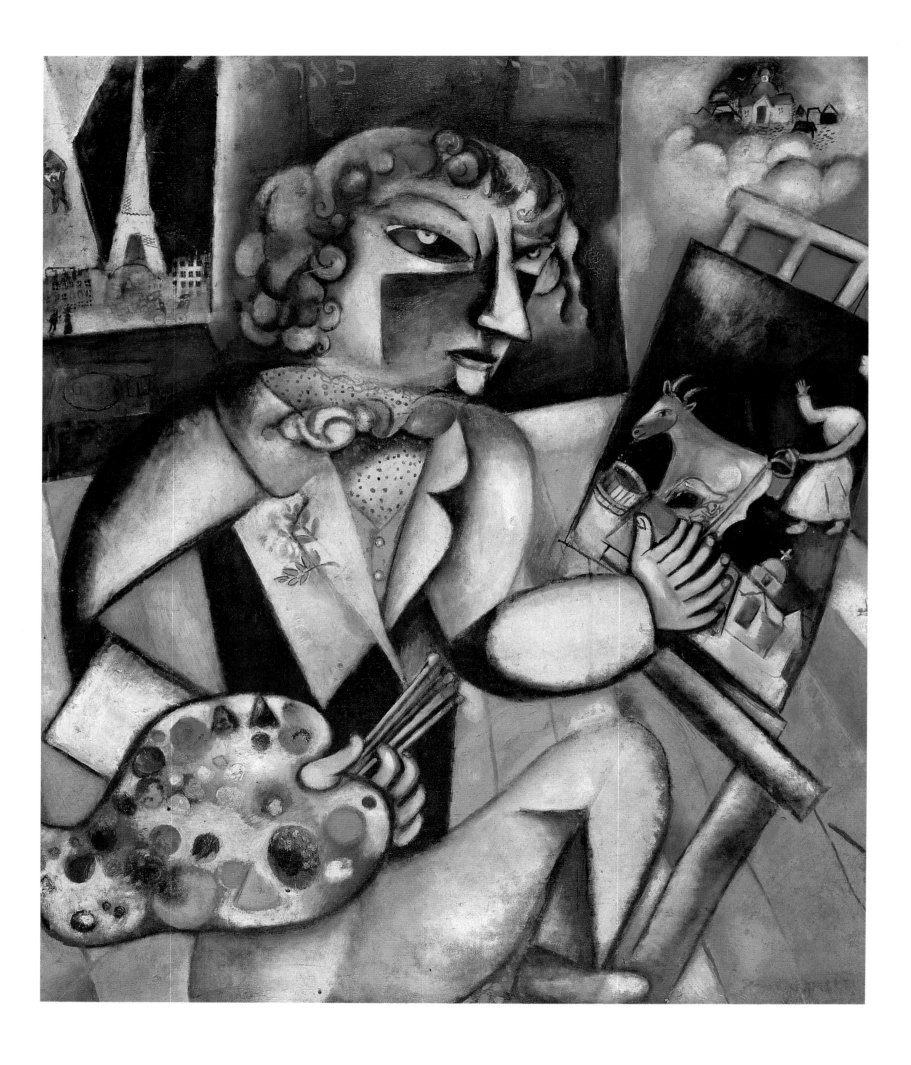

Self-portrait with Seven Fingers,
1912-13

Oil on canvas
50⅜×41⅜ inches (128×107 cm)
Stedelijk Museum, Amsterdam

This self-portrait, painted at La Ruche, best exemplifies Chagall's digestion of Cubist formulae. When compared to earlier self-portraits executed in Russia, the change in his style becomes apparent. Here Chagall shows himself as a dapper but stylized figure, his curly hair reduced to a few decisive dabs of color. The pseudo-Cubist technique which is applied to most of the composition is undermined by a realistically painted rose which he wears in his lapel. Such *trompe l'oeil* devices were also characteristic of the Cubists, but Chagall's use of it here seems intended as humor or parody. On the easel before him is his painting, *To Russia, Asses, and Others* (page 46), which he gestures toward with a seven-fingered left hand. When later asked why he painted himself with extra fingers, Chagall's reply was: 'Why seven fingers? To introduce an alternative construction, a fantastic element amidst realistic elements.' Chagall has combined the real with the fantastic to create a sense of psychic dissonance which both pulls the painting toward reality and lifts it beyond reality. The bare floorboards of his La Ruche studio are represented in believable, if imperfect, perspective, and through the window a schematic Eiffel Tower can be seen. In the upper right-hand corner of the picture, Chagall has introduced a vision of Vitebsk in a cloud which seemingly emerges through the wall. The conflicting allures of his provincial homeland and the European artistic capital are here represented, but Chagall turns his back on the view of Paris in order to paint a scene of Russia. Chagall has underlined this dichotomy through the Hebrew words written on the back wall, 'Proud Russia' and 'Paris.' Whether or not this painting can be read as an allegory of homesickness and nostalgia, Chagall here shows himself capable of painting a self-portrait which is at the same time representational and symbolic.

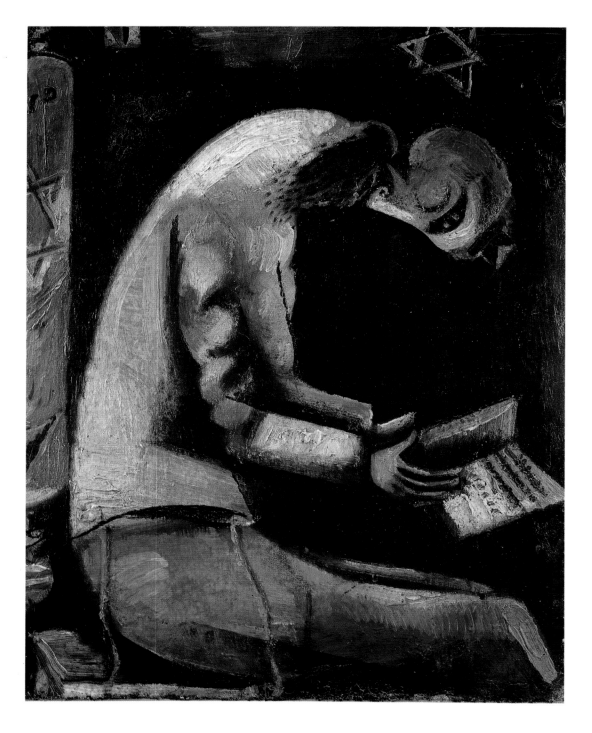

The Rabbi, 1912-13
Oil on canvas
15¾×12¼ inches (70×31 cm)
Israel Museum, Jerusalem

The Violinist, 1912
Oil on cloth
74×60⅝ inches (188×158 cm)
Stedelijk Museum, Amsterdam

This highly stylized representation of a praying Jew reveals Chagall's versatility toward the end of his Paris years. Despite strong Cubist influence in his work at this time, Chagall was not totally confined by the Cubist visual formula. In this work he does not employ Cubist geometric form, and more noticeably, he lays the paint on thickly unlike the Cubist's usual method of disguising their brushstrokes. The heavily impasted surface of this painting gives it an expressive quality, just as the striking posture of the praying form creates a pleasing visual effect. Chagall shows his Jew seated before a Torah scroll, with a Star of David floating like a halo above his head. Unlike the richly characterized depictions of Jews Chagall would later paint in Vitebsk, this Jew is faceless,

representative of all Jews rather than an individual. Works such as these show that Chagall was influenced by Expressionist tendencies in pre-War European art. He had already been exposed to the work of Van Gogh in Paris, but there he also came into contact with the more recent work of the German Expressionists, particularly that of Der Blaue Reiter. This group was a loose association of artists, including Kandinsky and Franz Marc, who believed that art should have a spiritual character. They were opposed to materialism and wanted to free art from the constraints of pure representationalism. Their idea of art was in many ways diametrically opposed to that of the Cubists, with their emphasis on a clinical reconstruction of real objects. Chagall's empathy with the ideas of the Expressionists is proven by the impact which he in turn had on their art after his work was exhibited in Berlin in 1913-14. A mutual desire to go beyond the material and the visual and achieve the spiritual and the internal, guided both Chagall and his German contemporaries.

Although the image of the fiddler on the roof has become a cliché, this odd conception had an important place in Chagall's art. From his very early painting Dead Man (1908), fiddlers appear frequently in Chagall's work, usually symbolizing ecstasy or inspiration and playing a prominent part at events such as weddings and funerals. As in much of Chagall's Paris work, this painting mingles the real with the symbolic. The snowy Vitebsk setting is a backdrop for the green-faced fiddler who is being admired by a three-headed man in the lower left corner. For Chagall the fiddler represented his Uncle Neuch who played the violin badly but enthusiastically. The fiddler also had a wider Russian significance, which Chagall would have known about through Russian language newspapers available in Paris. In 1905 at the time of an unsuccessful revolution in Russia, a Jewish fiddler called Edouard Sormus led workers through the streets in a demonstration of their rights. His association with a joyful and peaceful procession may have stimulated Chagall's imagination and reinforced his own image of the fiddler as a harbinger of the spiritual in man. Unlike other Vitebsk paintings of his Paris period, Chagall's Violinist does not adhere to a pseudo-Cubist compositional structure. Although color is used rather freely, it is not blocked off in geometric patterns. However, the painting does have an underlying geometric structure which was the result of the surface on which it was painted. During his lean years in Paris, Chagall relied on whatever materials were available in order to continue painting, and in this work he used a patterned tablecloth instead of a canvas. Rather than disguising this surface, he has retained elements of the pattern in his composition, and it emerges through the fiddler's clothes and over his right shoulder. Chagall has endowed the simple figure of the fiddler with the monumental power of an icon, but he softens the effect through touches of humor and nostalgia. The painting was exhibited at the Salon des Indépendents in 1912.

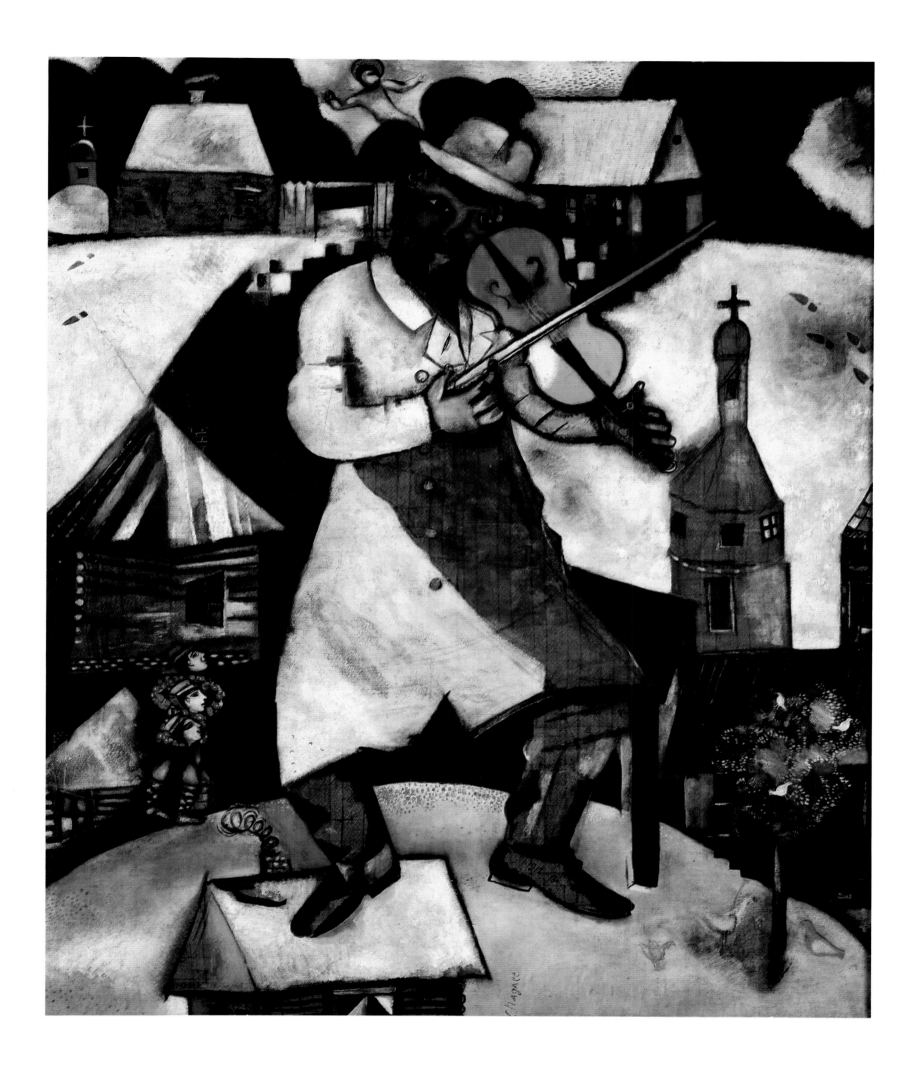

Paris Through the Window, 1913

Oi on canvas
53½ × 54¾ inches (135.9 × 141.6 cm)
Collection, Solomon R Guggenheim
Museum, New York

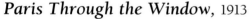

Chagall's feelings about Paris were ambivalent at first, and he continued to have a love-hate relationship with the city during his years there. However, by the time he wrote his autobiography in 1922, he had been won over by the beauty and excitement of his adopted city, declaring 'Paris, you are my second Vitebsk!' Paris had appeared as a tiny view through the window in his *Self-Portrait with Seven Fingers* (page 58), but here the city takes a more dominant role. The open window – a favorite device – frames the Eiffel Tower which stands pale and almost invisible amid the flashing colors which surround it. The city is further represented by its jumbled edifices and steam train, as well as by a man

and woman lying sideways and dressed for a stroll. The interior, by contrast, is inhabited by a cat, a bouquet of flowers, and a two-headed man who is torn between the distraction of the view and attention to the interior of the room. Chagall has used the colors of the spectrum freely, and they play about the composition, independent of the forms they describe. This use of color, combined with the image of Paris, may have been influenced by Robert Delaunay, one of the few artists in Paris Chagall unquestionably admired. Unlike the Futurists, who saw the city as an aggressive and powerful force, Delaunay admired the beauty and color of modern life. Delaunay painted a series of views of Paris in which the dynamism of city life is represented through contrasts of color – a technique that Apollinaire called 'Orphism.' In several of Delaunay's Paris scenes, the Eiffel Tower takes a prominent position, and works such as *The City of Paris* had been exhibited at the Salon des Indépendents, where Chagall would have seen it.

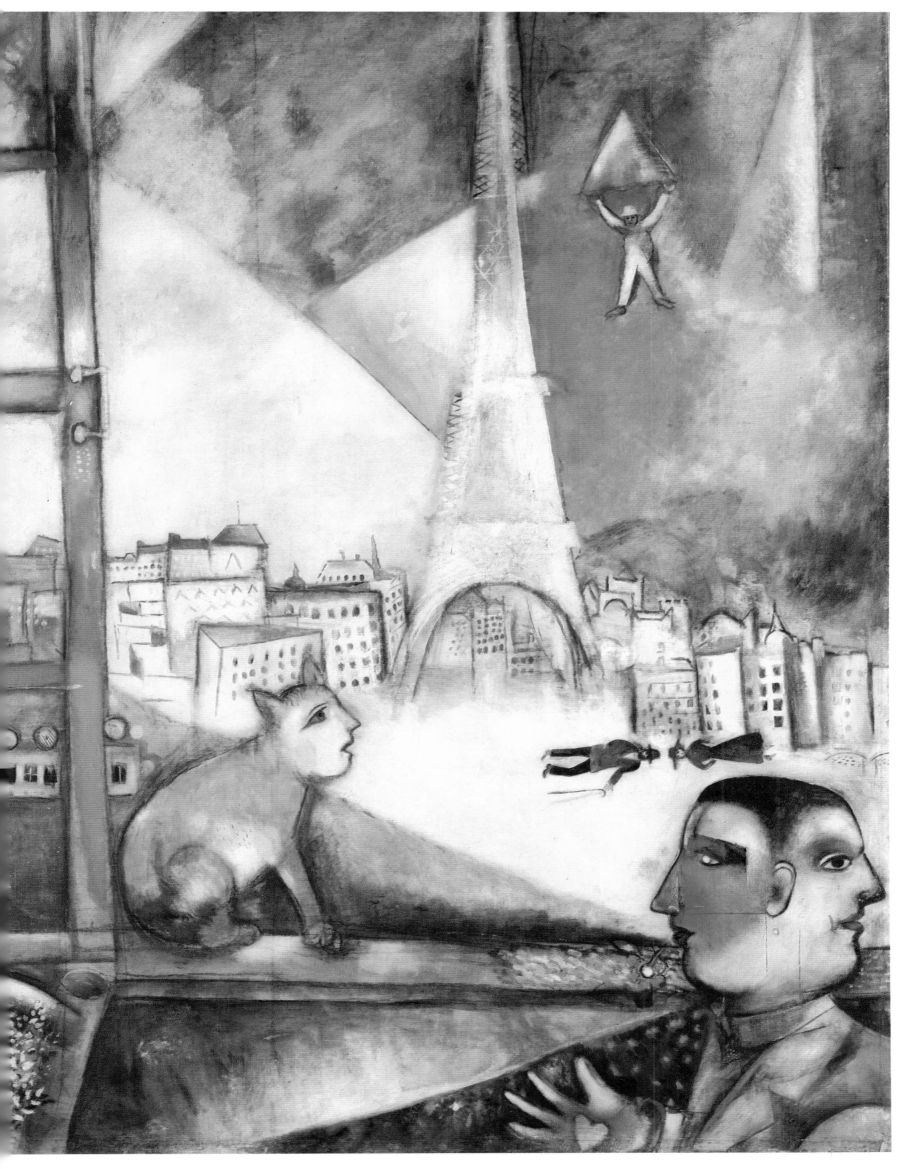

Pregnant Woman, 1913

Oil on canvas
76⅜×45⅞ inches (194×116.5 cm)
Stedelijk Museum, Amsterdam

As in his *The Violinist* (page 59), Chagall here creates an icon out of a simple image. The prototype of this painting can be found in Byzantine iconography. The 'Maria Blacherniotissa' of icon painting is a Virgin wearing a medallion of the child Christ on her breast. Chagall's *Pregnant Woman* does not wear a medallion, but carries a visible child in her oval-shaped womb. In his characteristic way, Chagall allows us to see the unborn, but fully developed, child, and the woman points to her womb to emphasize its importance. Despite its origin in icon painting, this painting does not represent the Madonna: she is rather a Russian peasant wearing a brightly patterned dress with her kerchief tied firmly under her chin. Chagall further subverts the Christian message of the Madonna image by including a male face sprouting out of the side of the woman's head. As in *Homage to Apollinaire* (page 44), the concept of a desired unity between man and woman is emphasized. The unity is achieved through the child which the woman carries. Here, however, the woman is the dominant force, as suggested by the crescent moon in the background, which Chagall often used as a female symbol. Chagall had used the symbol of a pregnant woman previously in a gouache of 1911/12 representing *Russia*. In this work Mother Russia is quite literally depicted as a pregnant woman carrying a visible baby.

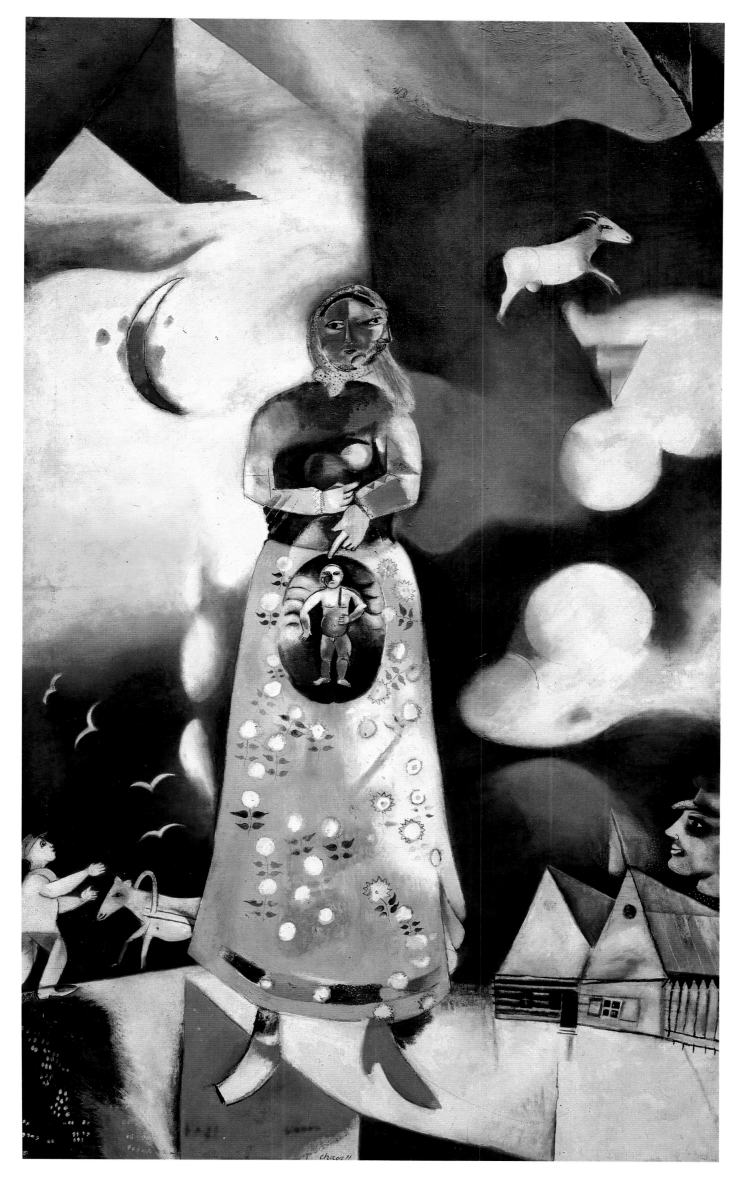

The Flying Carriage, 1913

Oil on canvas
41⅞×47½ inches (106.4×121.1 cm)
Collection, Solomon R. Guggenheim
Museum, New York

On the brink of World War I, Chagall painted a picture which could be described as apocalyptic. The theme of the end of the world emerged strongly in European art just before the war, and the conflagration suggested by *The Flying Carriage* may represent Chagall's contribution to this theme. But as usual, his work is ambiguous and laden with seemingly contradictory meanings. At first glance, the painting appears to be a scene of chaos and destruction. A formless sky is filled with burning flashes of red; a horse leaps into a void, pulling along a cart with its terrified driver; a woman in the background raises her hand above her head to ward off the heat or in fear or pain. Other elements of the painting contain the usual allusions to Chagall's Vitebsk childhood, and cast the subject in a more optimistic light. The shack which dominates the painting is identified by a sign-board *lav*, an abbreviation of *lavka* (shop). As Chagall's mother ran a small grocery shop to help support the family, this sign seems to refer to a memory from Chagall's childhood. In his autobiography, Chagall described several scenes of fire: he claimed that a fire broke out when he was born, and more significantly, he expressed the feeling of excitement that accompanied a fire in Vitebsk. Fire to him was not merely a destructive force, but also a thing of beauty representative of spiritual intensity. *The Flying Carriage* has also been called *The Burning House*, and Chagall later denied that the painting depicted fear. He insisted that the work evoked a sensation of ecstasy, and this reading can be reinforced by interpreting the man with the cart as symbolic of Elijah or Phaethon. Figures from the Bible and mythology respectively, both Elijah and Phaethon drove a chariot up toward the heavens. To Chagall this image of a chariot of the gods was symbolic of the human spirit.

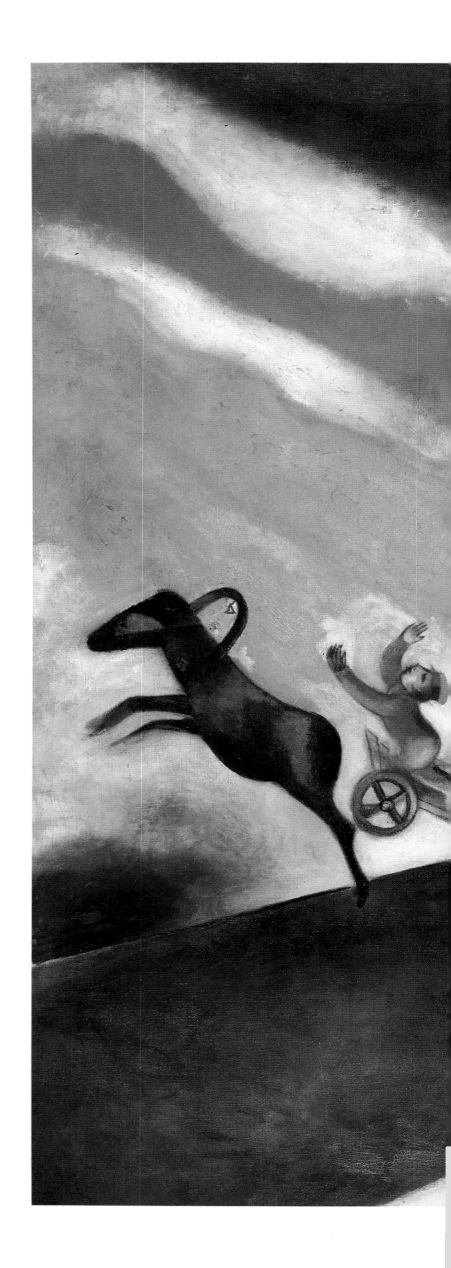

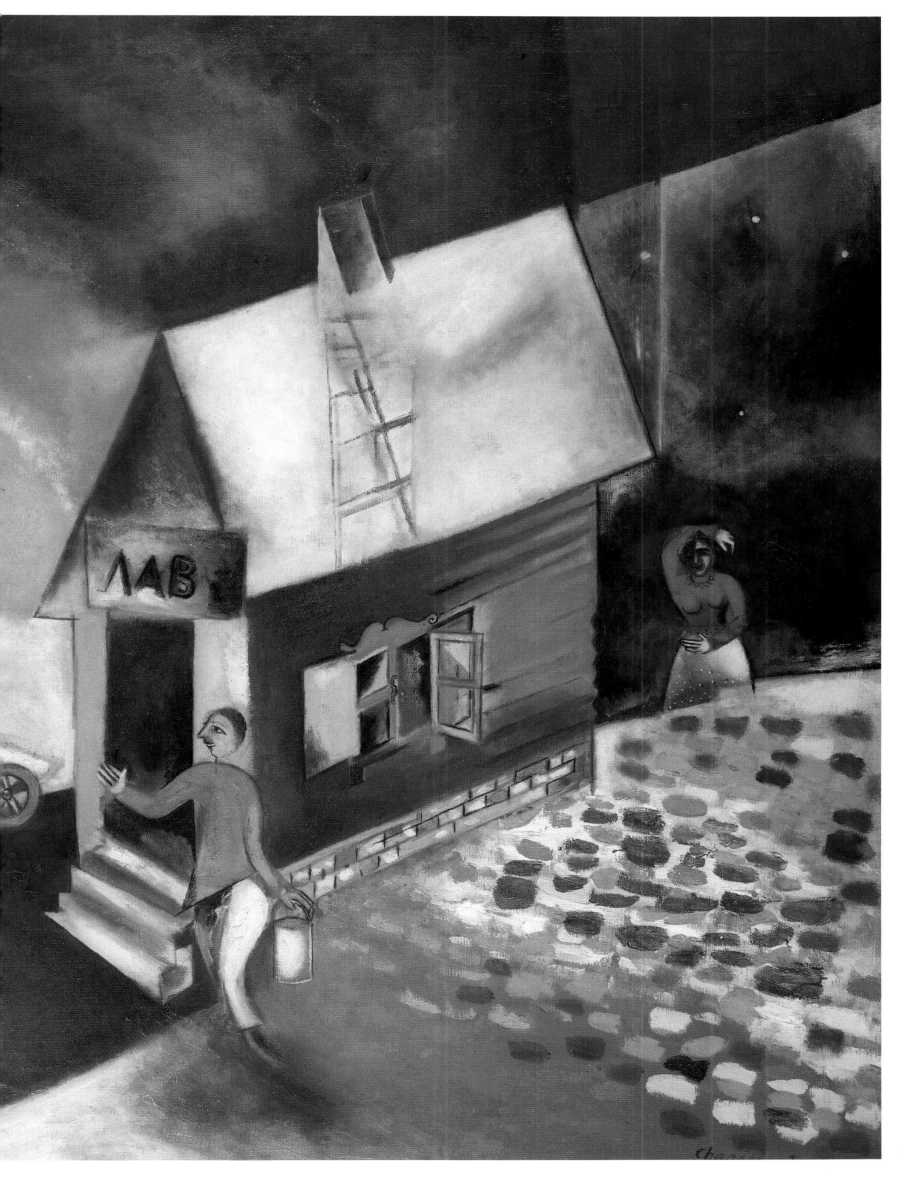

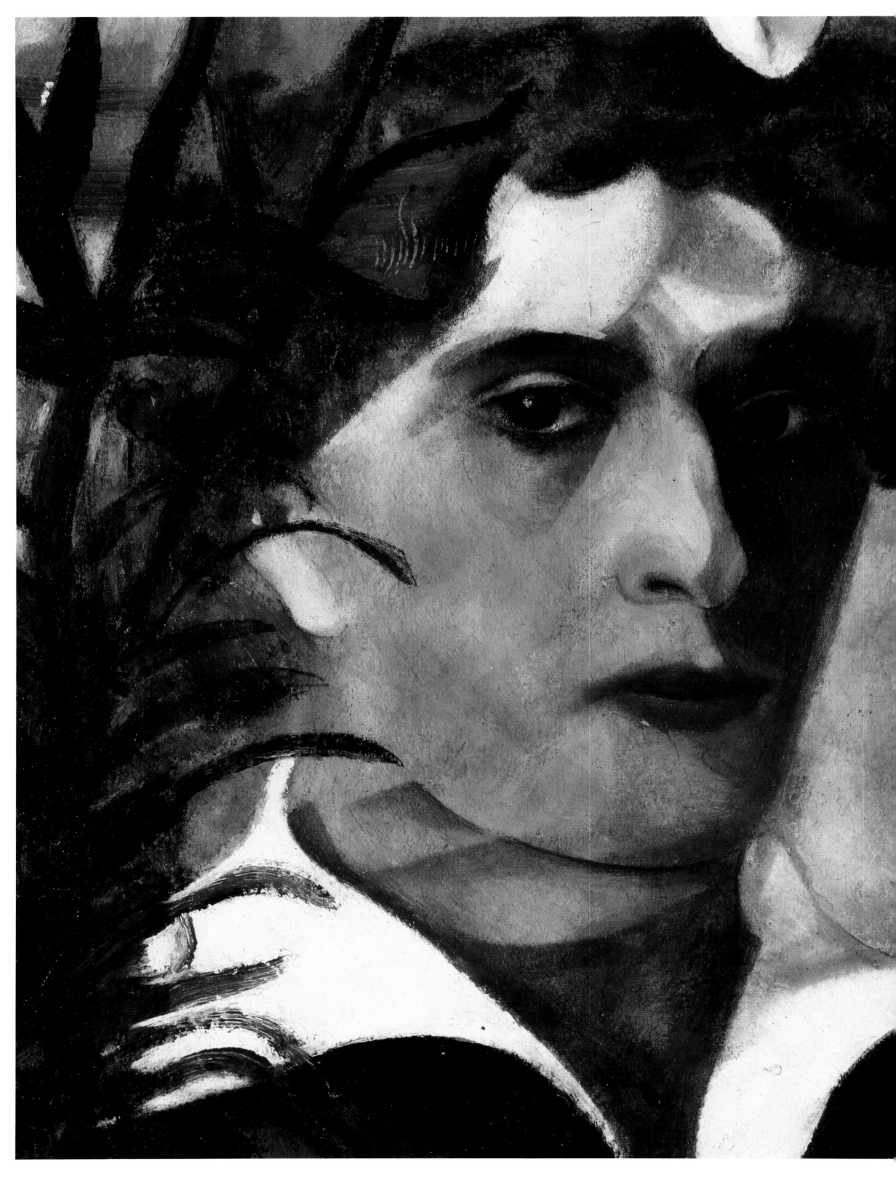

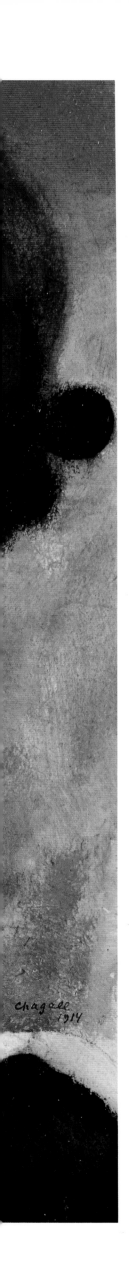

chagall
1914

Self-Portrait, 1914

Oil on paperboard
11¾×10½ inches (29.8×26.7 cm)
Philadelphia Museum of Art
Louis E Stern Collection

Chagall's years in Paris involved both struggle and success, uncertainty and growing confidence. In the wake of influence from Fauvism, Cubism, Expressionism, and Orphism, his art underwent a number of changes, but he managed to retain the integrity of his personal iconography throughout these years. However, the zenith of his early success did not occur in Paris but in Berlin, where he participated in two exhibitions at the Sturm gallery. To the first exhibition he sent only three paintings, but the second was devoted entirely to his art. While attending his one-man show in Berlin, Chagall's confidence must have been high. He was praised by artists, dealers, and collectors; he seemed sure of a success to rival that of the greatest avant-garde artists of the day. However, the proximity to Vitebsk was too much of a lure, and he returned there in 1914 for what he hoped would be a brief visit. His motives for returning home were more complicated than this suggests. He

had left behind his fiancée, Bella Rosenfeld, and the continued separation from her was proving to be a damaging strain on their relationship. In order to recover the threads, he made the visit home, but the start of World War I prolonged his stay to over seven years. Chagall must have known war was inevitable, but he did not consider the effect it could have on his own life. Having left all his paintings, gouaches, and drawings behind in Paris and Berlin, he had in effect cut the umbilical cord which tied him to his work. Detached from his own fruitful development, Chagall relied on the materials at hand to provide him with inspiration for his art. Not surprisingly, his art underwent a pronounced change in 1914. This self-portrait represents the first of a number of portraits that he was to paint while in Vitebsk. Compared to his earlier Vitebsk self-portraits, this work shows Chagall continuing to examine himself in light of artistic tradition. Just as he had previously painted himself in the manner of Rembrandt, so here his painting echoes the rather broody self-examination of Van Gogh, whose self-portraits Chagall would have seen in a Berlin retrospective exhibition held in Paul Cassirer's gallery in 1914.

Above Vitebsk, 1914

Oil on reinforced cardboard
28¾×36½ inches (73×92.5 cm)
Art Gallery of Ontario, Toronto

In *My Life* Chagall describes Vitebsk as 'a place apart; a town unlike any other, an unhappy town, a boring town.' His strong feelings for his home town did not leave him while he was in Paris, and they emerged with a new force when he returned there in 1914. Separated from the stimulus of a lively artistic environment, Chagall set about rediscovering Vitebsk through his art. The landscape of the town represented here was literally a view from the window of his lodgings in Vitebsk, dominated by the Ilytch church on the right. The silence and stillness of the empty town is reinforced by the snowy landscape, broken only by dark cart-tracks which cut across it. But the most puzzling object in the painting is the figure of a man floating above the town. Some critics have claimed that this figure represents the archetypal Wandering Jew, and he thus bears a relationship to Chagall himself, who had traveled away from his homeland only to return there. However, the floating Jew may have a deeper significance. The Biblical character Elijah was also a wanderer, who conveyed a prophesy of hope. Furthermore the Yiddish expression 'he walks over the city' signified a beggar who wanders from door to door. Chagall therefore may have intended this figure as a sort of visual pun, a practice that he had employed previously. The painting combines the elements of realistic landscape and supernatural figure in a new way. Although Chagall's Paris painting had contained qualities of both realism and illogicality, these elements were overlaid by a Cubist technique. Now in Russia, his technique has become smoother and less deliberately experimental.

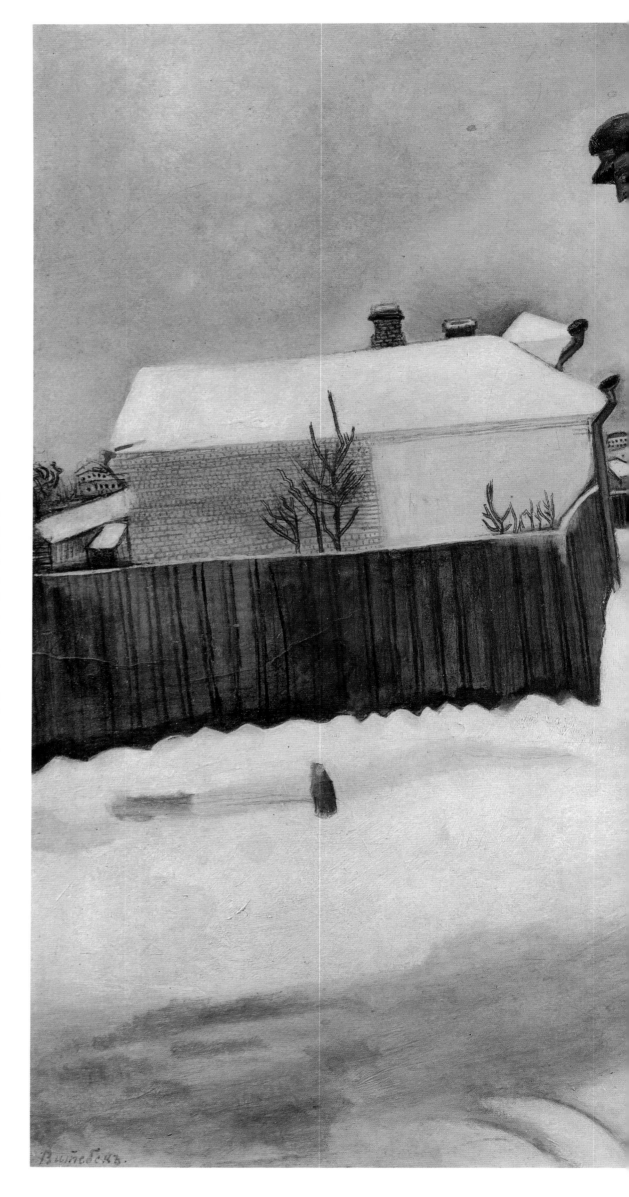

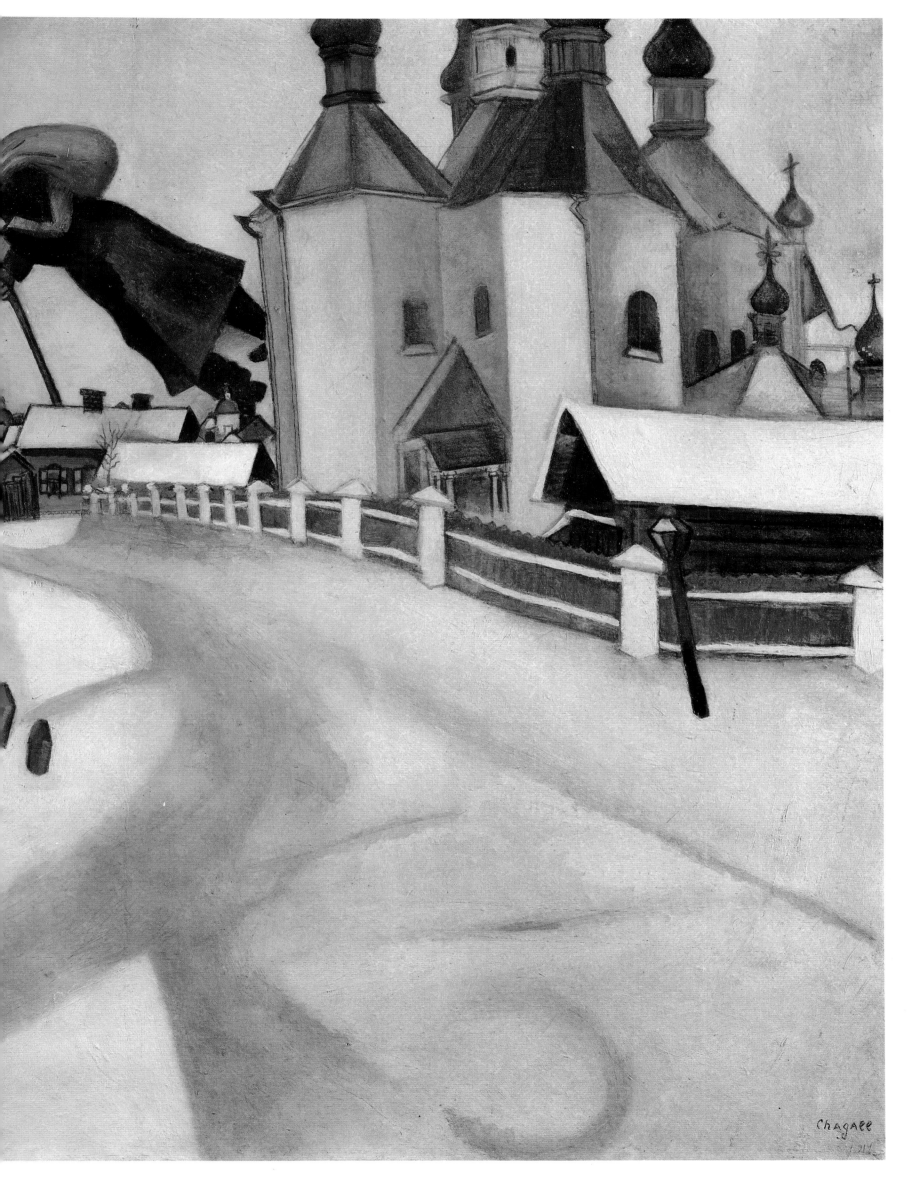

David in Profile, 1914

Oil on paper, fixed on board
19⅝×14¾ inches (50×37.5 cm)
Art Museum of the Ateneum, Helsinki

Chagall's relentless need to paint inspired a prolific series of studies showing people and places in Vitebsk. These works reveal a new sense of observational realism, and Chagall himself called them 'documents.' By documenting the scenes around him, he tried to capture the memories that had emerged as regular themes in his Paris paintings. While Europe was being convulsed by war, Chagall turned his vision inward toward his birthplace and immediate family. In order to avoid being drafted, Chagall took a job as a clerk in Vitebsk, and although he found this desk work tedious and soul-destroying, it did not entirely prevent him from pursuing his art. But Vitebsk was not an artistic center, and Chagall had to use whatever painting materials he could find. He painted many works on board or cardboard when canvas was not available, and these works often have a rough, uneven texture which gives them an additional bluntness. Among the documents of this period were many paintings of his family, including this one of his brother David. Although Chagall had seven sisters, David was his only brother, and he felt a deep affection for him. In *My Life* he wrote fondly of his brother, who died of tuberculosis at the age of 22 in a Crimean sanitorium. Using an unusual angle, Chagall shows David playing a mandolin. In the right background through a door can be seen a chair and table on a carpeted floor. Chagall has emphasized the colorful patterns of the tablecloth and carpet, and in doing so, he has flattened out the picture and given it a somewhat decorative quality. This method was one frequently employed by Matisse, whose work Chagall would have seen in Paris and read about in the Russian periodical *Apollon*.

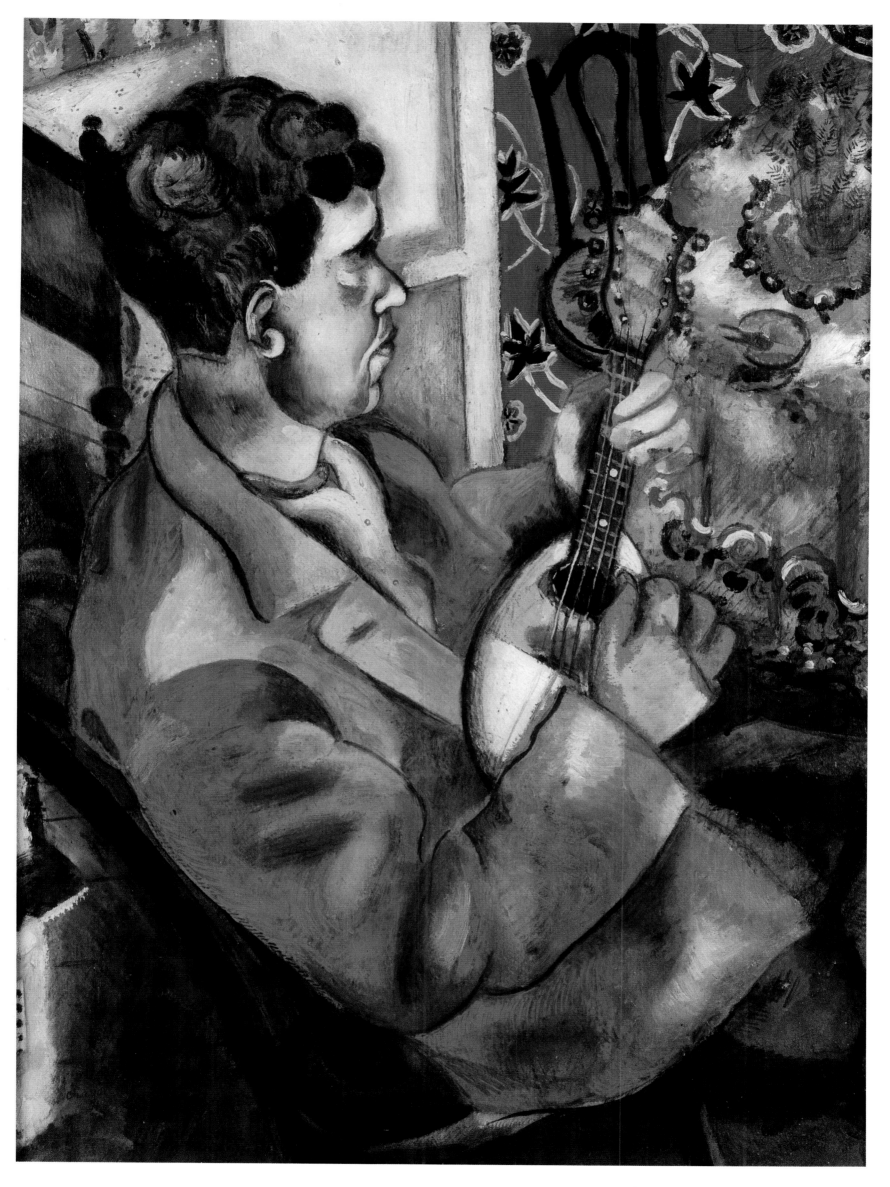

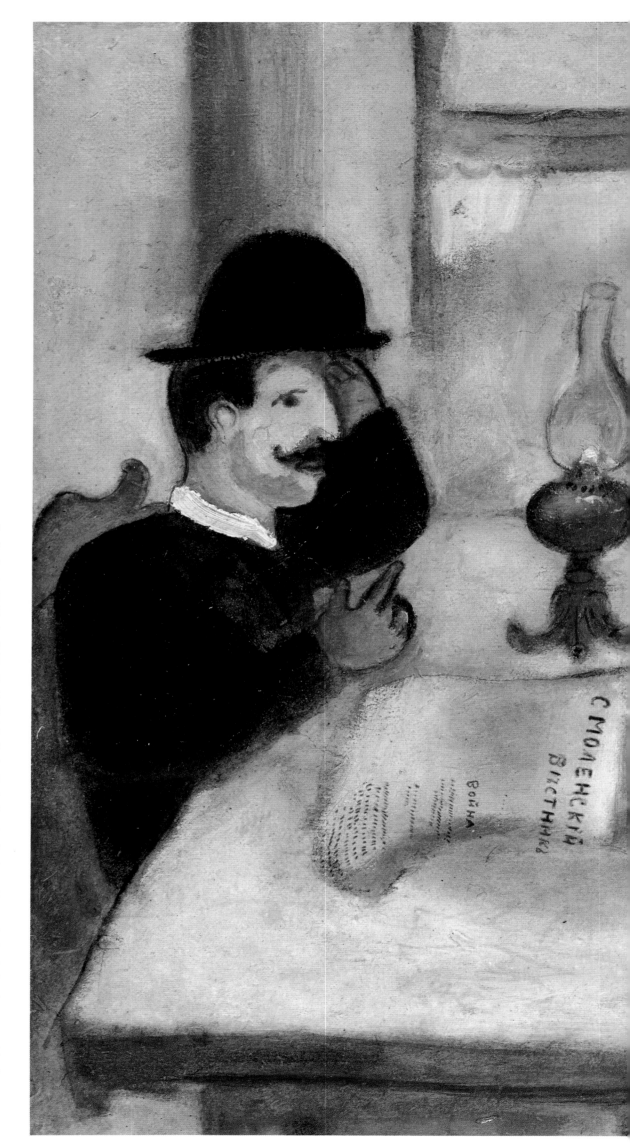

The Smolensk Newspaper, 1914

Oil on paper on canvas
15×19⅞ inches (38.1×50.5 cm)
Philadelphia Museum of Art
Louis E Stern Collection

This humorous painting epitomizes the more literal style Chagall adopted after he returned to Vitebsk. In a sparsely furnished room, two men sit in contemplation. A lamp and a newspaper separate them. On the newspaper, the word *voina* (war) suggests the object of their contemplation. The older man on the right is dressed in traditional Jewish attire and sports a full beard. The younger man, on the other hand, wears a smart modern suit and a bowler hat, and his moustache is curled in a fashionable manner. It would be wrong to see such a simple painting as an allegory, but there is nevertheless meaning in the work. The threats of war and revolution which hung over Russia inspired different reactions among her citizens. Much of the younger generation saw a chance to liberate itself from an oppressive Czarist regime and achieve a more enlightened and democratic government. Many young Jewish people were particularly enthusiastic about the possibility of change, and they had supported the abortive 1905 revolution in the hopes that it would bring them greater freedom and opportunity. Chagall himself expressed enthusiasm for the Revolution when it finally came in 1917, but he recognized the damaging effects of war in a series of paintings of injured soldiers that he produced in 1914-15. The conflict of domestic interests aroused by the threat of war is the sub-text of *The Smolensk Newspaper*, which shows that even the inhabitants of a quiet provincial town are not immune to the reverberations caused by wider political conflict.

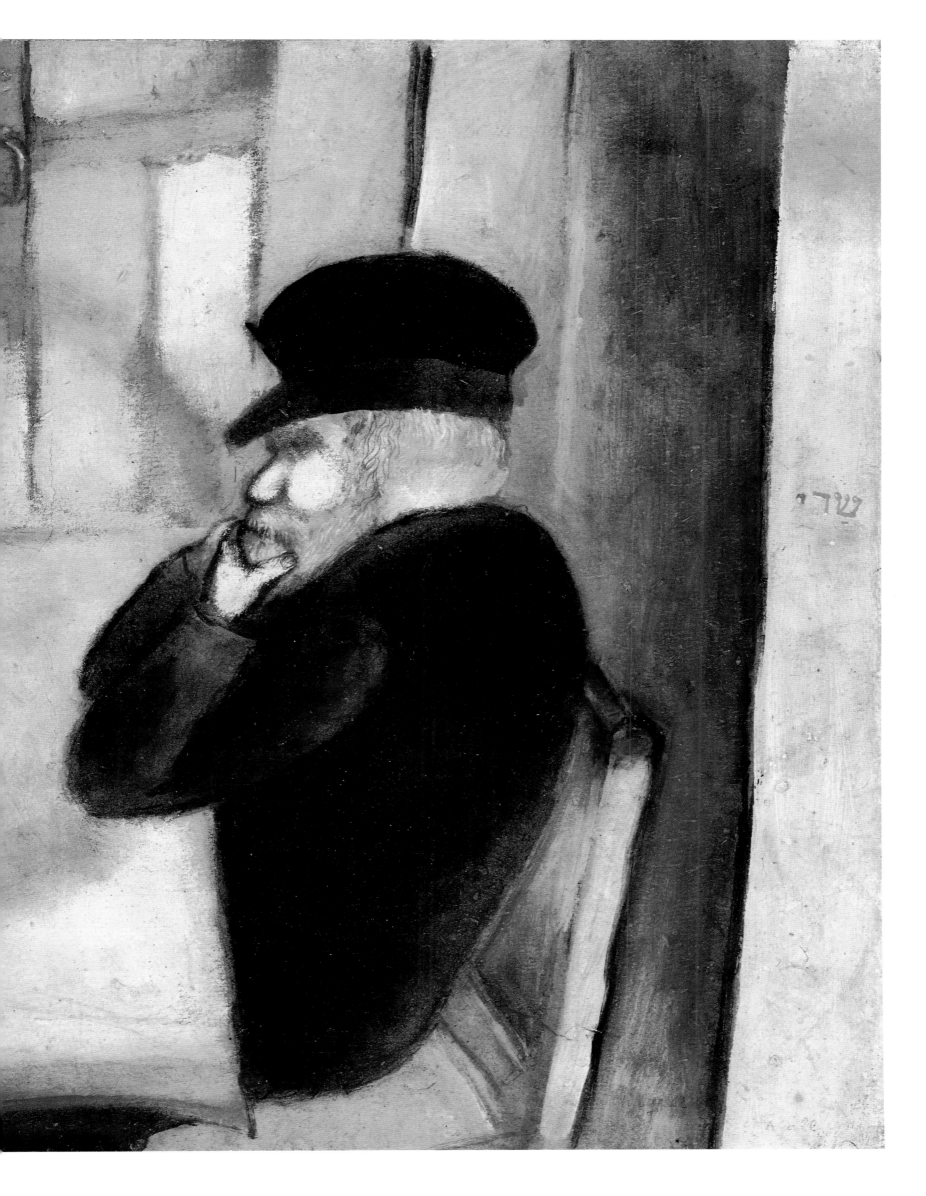

Feast Day, 1914

Oil on cardboard
39⅜×31⅞ inches (100×81 cm)
Kunstsammlung Nordrhein-Westfalen,
Düsseldorf

Chagall's documents of Vitebsk included a series of pictures representing old Jewish men sometimes placed in a religious context. This work is one of the more unusual of this series, as it contains the now-familiar juxtaposition of the ordinary and the bizarre. The feast day signified by the title is the Succouth or Feast of the Tabernacles. The characteristics of this feast day are derived from a passage in Leviticus: 'On the first day you shall take the fruit of citrus trees, palm fronds, and leafy branches, and willows from the riverside, and you shall rejoice before the Lord your God for seven days' (XXIII, 40). In Chagall's painting, his worshipper holds the lemon in his right hand and a palm frond in his left, thus signaling the nature of the festival. He approaches a set of steps leading to an edifice which could be a synagogue, and his state of worship is further reinforced by the prayer shawl which is draped around his shoulders. But the straightforward nature of the subject is counteracted by the presence of a diminuitive second figure standing on the worshipper's head. Even in the midst of his documentary period, Chagall could not resist humorous subversion of reality. The work itself is simple in composition and color, in contrast to his Paris paintings which were strident and flamboyant. Chagall's cooler tones and simpler composition may have been accidental: both canvas and pigments would have been difficult to obtain in Vitebsk in the uneasy political situation in Russia at the time. Limitations provided a different kind of challenge, and by simplifying his work, Chagall gave it a new power and monumentality. As Susan Compton has pointed out, the worshipping Jew in *Feast Day* is essentially a Jewish icon, paralleling images of Renaissance saints with their attributes.

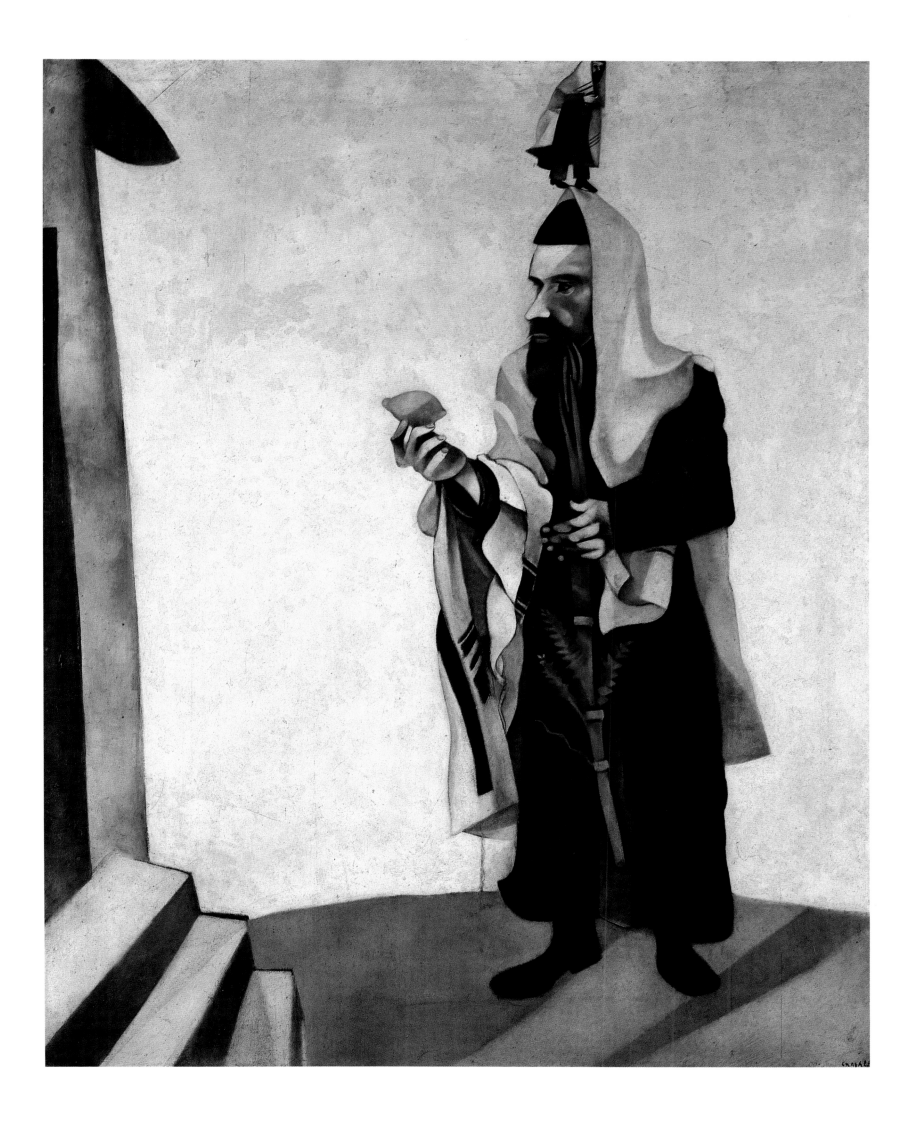

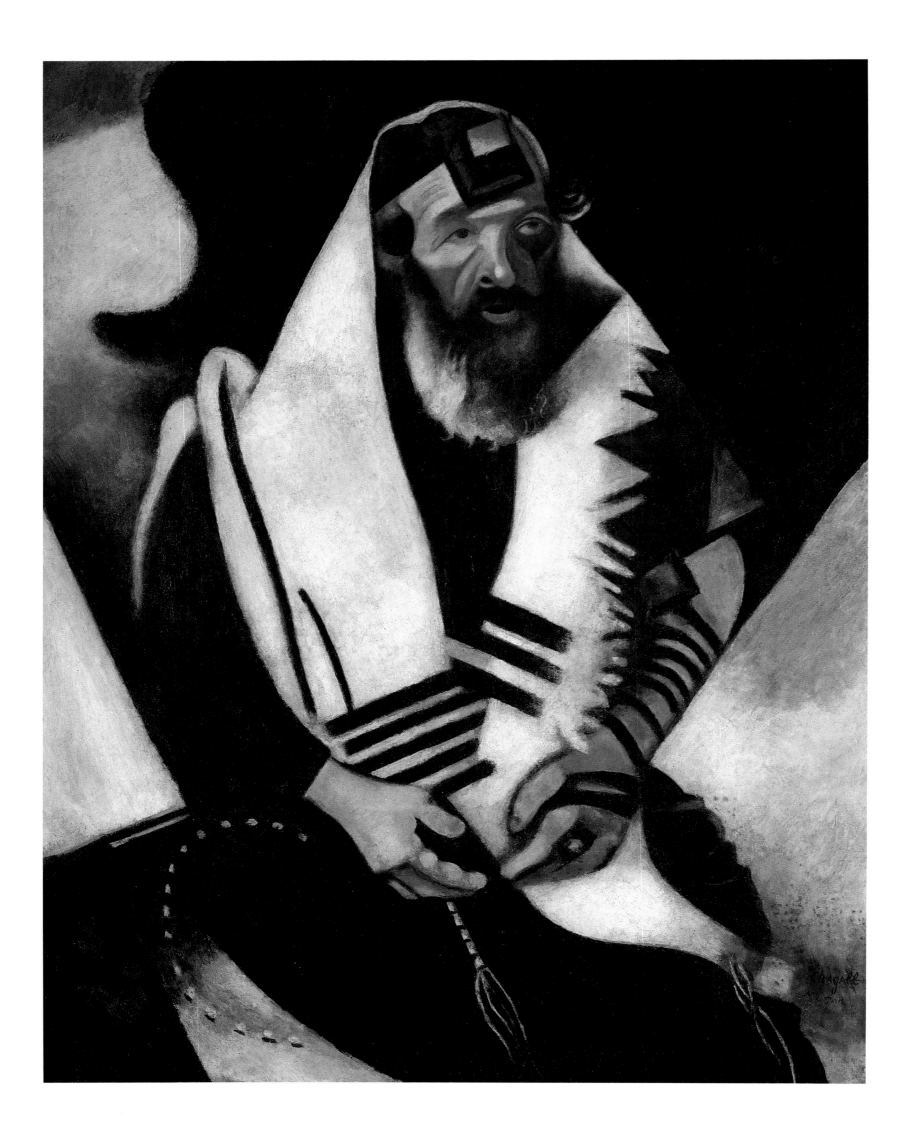

The Praying Jew (Rabbi of Vitebsk), 1914

Oil on canvas
41×33 inches (104×84 cm)
Museo d'Arte Moderna, Venice

Chagall's paintings of Jewish subjects after his return to Vitebsk suggest a new awareness of his own Jewish background. Single figure paintings of Jews during this period include *Jew in Bright Red* and *Jew in Green*; in both the subject-matter is less important than the play of color. In this painting the effect is somewhat different. He describes its genesis in *My Life*. A sulky, silent Jew carrying a sack was begging wordlessly from door to door in Vitebsk. Chagall spotted a potential subject in his weary, careworn face, so be brought the old man into his house, put a prayer shawl around his and painted him as he sat. The result was a work which has undeniable monumental power. Although Chagall himself described it as one of his documents, the writer Walter Erben sees a greater significance: 'Chagall's work proclaims the unbroken vigor of the Jewish spirit disclosed by the creative élan of genius.' In this interpretation, Chagall's work becomes a symbol of both the Wandering Jew and the sorrow of the Jewish people. The lonely image does indeed present a feeling of desolation, but it also has pictorial strength. The Jew wears a tallith or prayer shawl, and phylacteries on his arm and forehead. The strict black and white pattern created by these religious trappings give the painting an additional interest. It may have been the work that Chagall showed in the Moscow exhibition The Year 1915. The exhibited painting was called *Black and White*, the title suggesting that the work was seen for its abstract qualities rather than for its symbolic significance. Such a title has peculiar echoes of paintings by Whistler, who attributed similar titles, such as *Symphony in White*, to works which still had recognizable subjects. The title may also suggest that Chagall was more influenced than he liked to admit by the prevailing attitude toward abstraction in Russia. Although he never abandoned representationalism, Chagall was affected by the emphasis on non-objective art put forth by some of his Russian contemporaries such as Malevich.

The Birthday, 1915

Oil on canvas
31¾×39¼ inches (80.6×99.7 cm)
Collection, Museum of Modern Art,
New York

Chagall's relationship with his fiancée, Bella, intensified after his return to Vitebsk, and offered him a new inspiration. A series of paintings executed between 1915 and 1917 celebrate his love for, and eventual marriage to, Bella. This painting represents one of the earliest and most interesting variations on this autobiographical theme. The subject of this particular painting was later explained by Bella herself in her romanticized tale of her life with Chagall, *Burning Lights*. In ecstatic tones, Bella describes how she came carrying flowers to see Chagall, and hung up her colored shawls in his room. Before she could put the flowers away, Chagall demanded that she remain still while he painted her. While she fussed over the dying flowers, he began painting her picture in what could only be described as a frantic way: 'You fling yourself upon the canvas so that it quakes under your hand. You snatch the brushes and squeeze out the paint – red, blue, white, black.' At this point Bella's story sinks into fantasy as she described how Chagall grabbed her hand and both of them floated upwards toward the ceiling of the small room and then flew out the window. Chagall's frequent images of flying lovers becomes realized through Bella's narrative. Bella's evocation of the inspiration and joy of this meeting must be tempered by the existence of a pencil study for the painting, which suggests that Chagall thought out the composition very carefully. Indeed all such stories by Bella and Chagall himself must be read with the knowledge that they were writing retrospectively, and could thus construct their interpretations to suit themselves. Whether or not this painting offers a symbolic representation of a real event, there are real elements in it. Through the window is a glimpse of the Ilytch church which Chagall could see from his meager lodgings, and which had appeared earlier in *Above Vitebsk* (page 70). The colorful patterns of the shawls, tablecloth, and bedspread, as well as the spatial arrangement of the sidetable and chair, recall Chagall's knowledge of Matisse, as seen in other Vitebsk paintings, such as his portrait of his brother David (page 73).

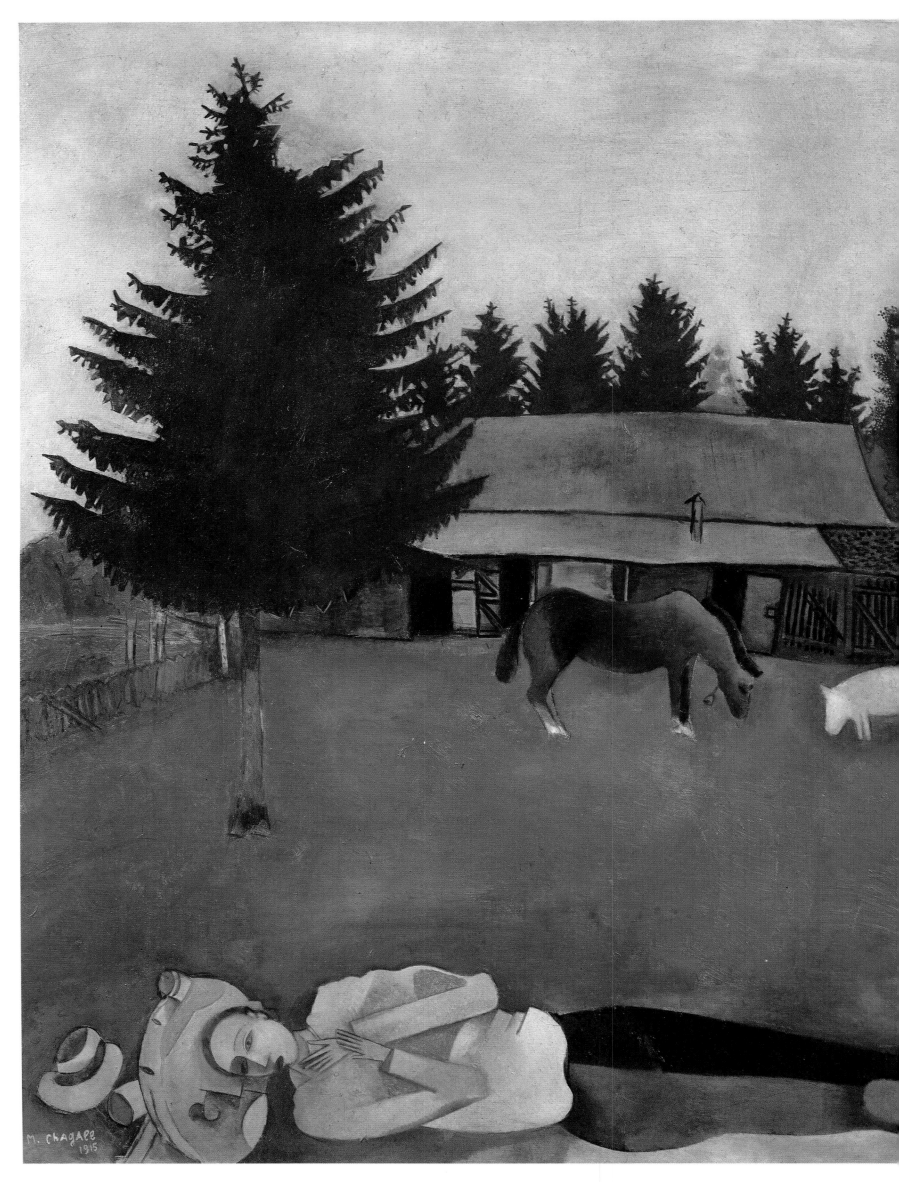

The Poet Reclining, 1915

Oil on millboard
30⅜×30½ inches (77×77.5 cm)
Tate Gallery, London

Despite the disapproval of Bella's parents, Chagall married her on 25 July 1915, and the two of them went on a honeymoon in Zaolcha, in the countryside near Vitebsk. They stayed there for three months, and if Chagall's description of the experience can be believed, it was a sort of romantic idyll for them. The sense of idyllic or pastoral harmony permeates *The Poet Reclining*, which was inspired by Emile Bernard's *Madeleine in the Forest of Love* (Musée d'Orsay, Paris; 1888). A resting figure, his jacket pillowing his head, lies on the ground of a field. Behind him a horse and pig graze in front of a simple shack. The sky has a muted pink richness and the forest crowding around the retreat is lush and green. A close scrutiny of the painting reveals that Chagall had envisaged a second figure lying on the ground next to the first. This possibly indicates that he originally intended the work as another celebration of his union with Bella. In any event, the painting glorifies the escapist fantasy that Chagall was living during his honeymoon. In *My Life* Chagall explains his agonizing realization that he could not stay forever in the quiet countryside, that he had to get back to the real world. This desperation was inflamed by the knowledge that he could no longer defer his obligation for military service. His initial decision was to return to Paris, but the war made that wish impossible. Unable to decide what to do, he consulted a rabbi, who agreed with whatever he said, but did not help him choose between staying in Vitebsk or leaving it. Chagall could no longer avoid military service, but to sidestep the more onerous military duties he was given a clerk's position in the War Economy Office in Petrograd by Bella's brother Jacov.

Purim, c. 1916-18

Oil on canvas
12¼×19⅞ inches (31.1×50.5 cm)
Philadelphia Museum of Art
Louis E Stern Collection

In many ways, Chagall's second stay in Petrograd (formerly St Petersburg) was even less satisfactory than the first. He had raised himself from an untutored youth to a professional artist, but now he was forced to work as a clerk, a job that he disliked and performed badly. However, Petrograd also provided new possibilities for him, and he was offered a commission to produce a series of murals for a Jewish secondary school. This appeared to be Chagall's first attempt to realize his ideas on a large scale and for a public purpose. Later in his life, monumental and public works were to dominate his production. But unfortunately these early murals were never executed, and all that remains of them are studies, of which this painting is one. 'Purim' refers to a Jewish festival that celebrates Esther's saving of the Hebrews from the cruelty of Haman. In Esther V, 9, Mordecai sends letters to all the Jews in the realm of Ahasuerus, telling them to celebrate on the 14th and 15th days of Adar (December). The celebration involved an exchange of gifts and provisions given to the poor. This became the basis of a Jewish festival in which food and sweets were exchanged. Chagall's painting is crudely executed and distinguished by a large wash of red which serves as a background to the two adults preparing to exchange their gifts. On the right, just discernible in the corner, a grim-faced stall-keeper overseas a child's choice of gift. In *Burning Lights*, Bella claimed that this figure was based on a real shopkeeper who did not allow the children to linger over their choice of sweets. Looming far behind these festivities are three poles with figures impaled upon them, possibly representing the executed sons of Haman. *Purim* was one of three intended murals: the other two were to represent the *Feast of the Tabernacles* and *A Visit to the Grandparents*. The Jewish and domestic nature of these three works would have been especially appropriate for the Synagogue school for which they were intended.

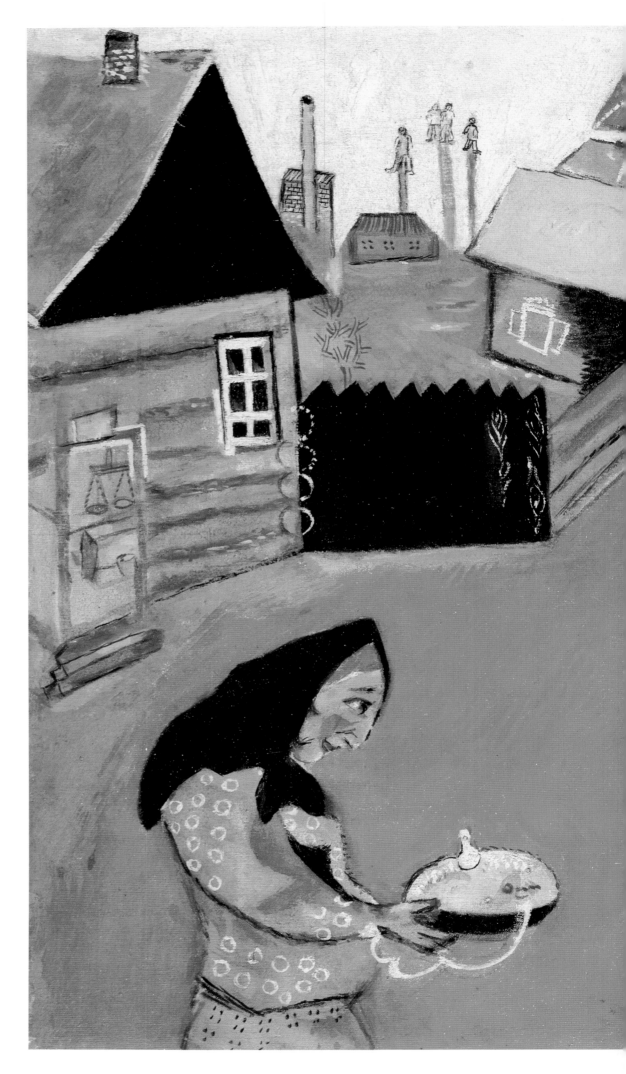

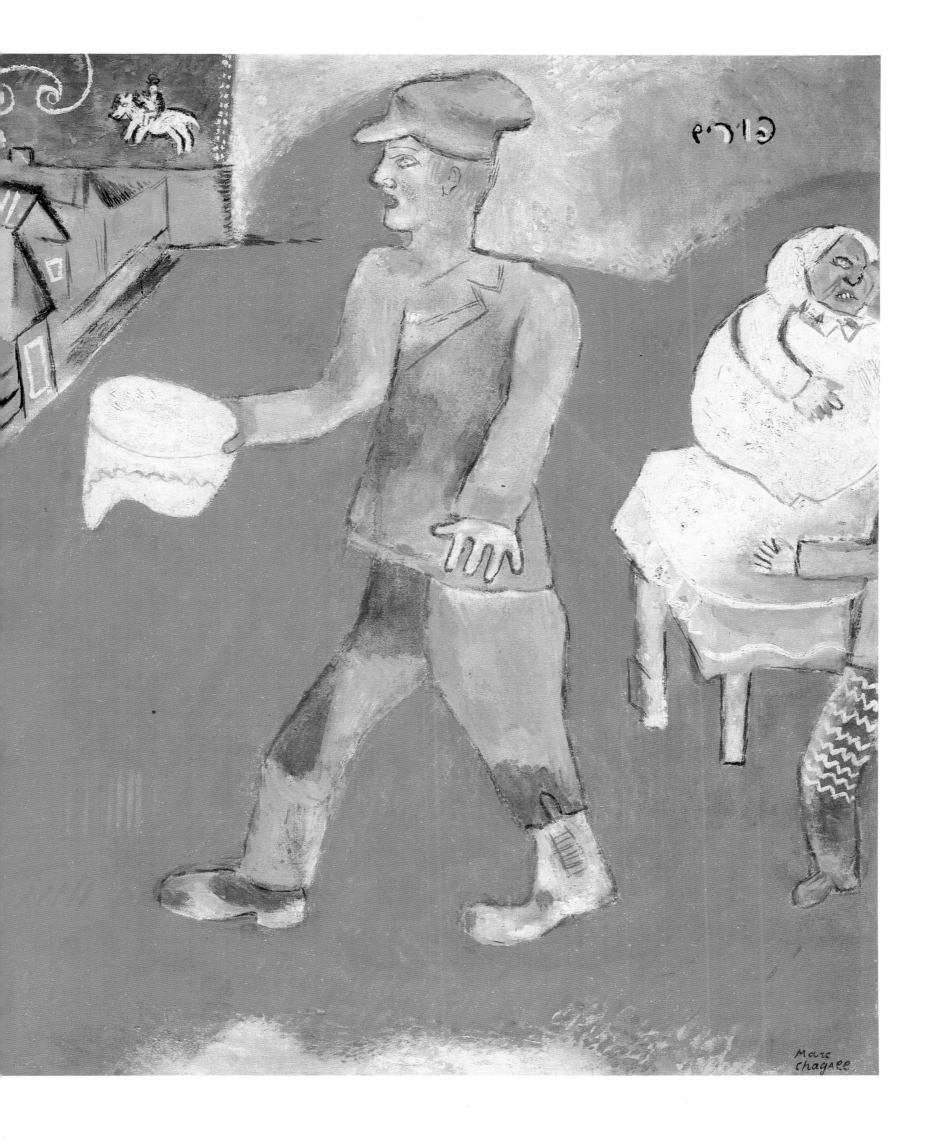

פורים

Marc
Chagall

85

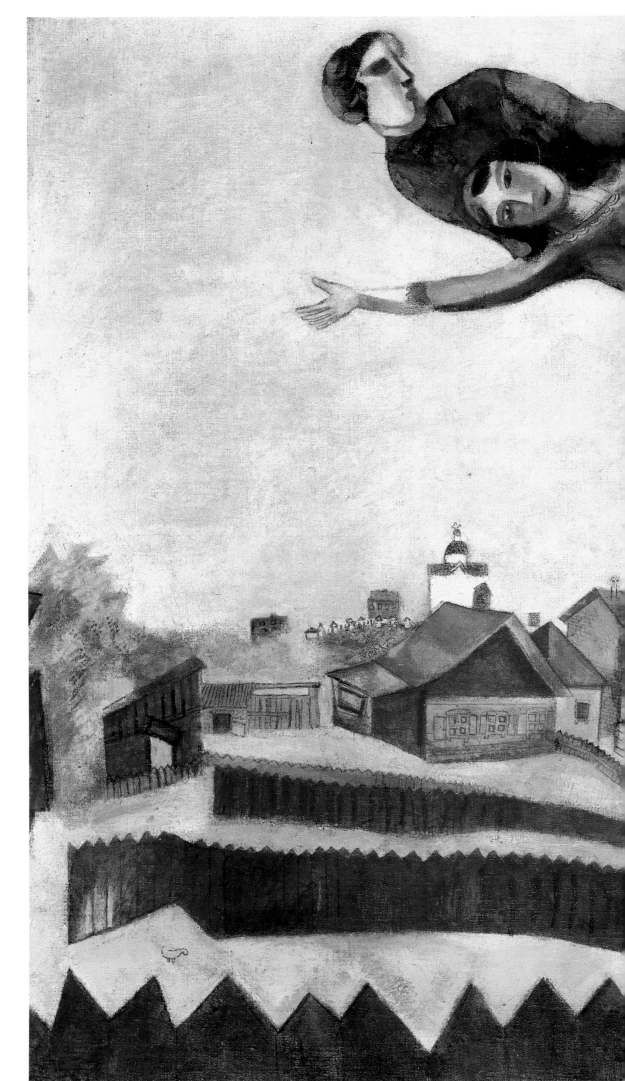

Lovers Above the Town, 1917

Oil on canvas
26½×35¾ inches (67.5×91 cm)
Galerie Beyeler, Basle

In the years before the Revolution, Chagall began to receive some recognition in Russia. At that time, the best way of being noticed by artists and collectors was to show work at one of the major exhibitions in Moscow. An invitation to send works to one of these exhibitions implied that an artist was well known, and Chagall received such invitations in the years 1915-17. He sent paintings to The Year 1915 exhibition, and the following year he exhibited 45 works at the Knave of Diamonds exhibition in Moscow. Although Chagall was recognized as an important contemporary artist, his idiosyncratic paintings did not adhere to any of the 'isms' of the avant-garde. Soon after Europe originated Fauvism and Cubism, Russian artists developed their own brands of these movements, and variations such as Cubo-Futurism, Rayonism, and Alogism were quickly snatched upon and then abandoned. The artistic environment was particularly rich in Moscow, but throughout the country, avant-gardism tended towards non-representationalism or non-objectivity. Chagall's work persistently retained its images, and autobiography and nostalgia continued to dominate the mood of his paintings. *Lovers Above the Town* is another work in his series showing himself with Bella. Here he revives the theme of flying as synonymous with ecstasy and joy. Below the loving couple, the quiet village of Vitebsk recalls Chagall's pastoral ideal, which he retained even while he was living in Petrograd.

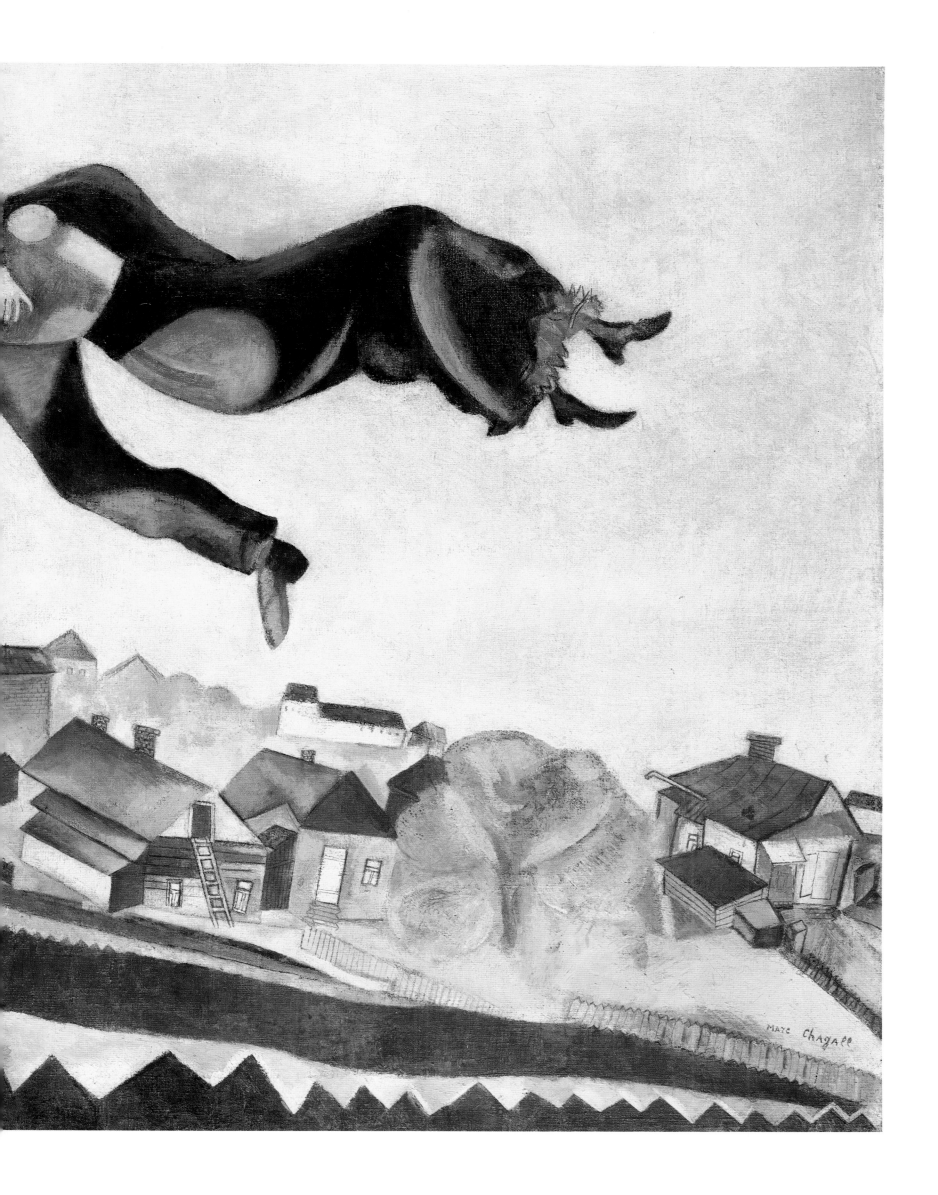

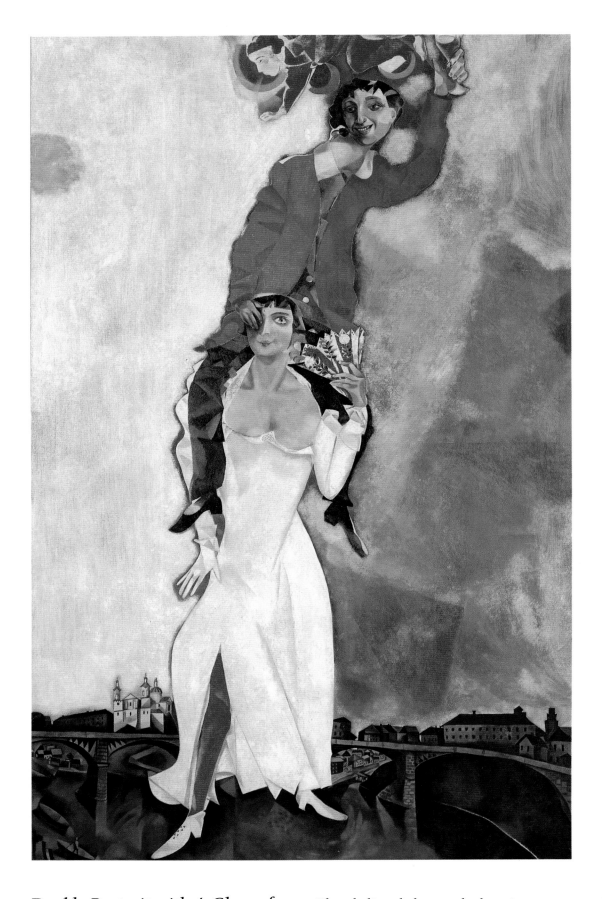

Double Portrait with A Glass of Wine, 1917

Oil on canvas
91¾×53½ inches
Musée National d'Art Moderne, Centre
Georges Pompidou, Paris

Avant-garde artists responded to the October Revolution of 1917 with wild enthusiasm. They had struggled previously to make a living from private patronage, and their experiments with non-objective art had done nothing to further their prospects. With the victory of the Bolsheviks, they saw an opportunity to bring about a closer alliance between art and the State.

They believed that art had an important function in a socialist society and felt that the State should encourage and promote this necessary part of life. One of the most immediate effects of the Revolution was a radical reorganization of government and its institutions as new ministries were formed. Chagall found his own name proposed for the Minister of Arts in Petrograd, but he did not accept the post, feeling that he had no place in such a public and politicized role. Instead he hastened back to Vitebsk with his family, where he painted works such as this one. Although Chagall's paintings are professedly autobiographical, it is impossible to see in this work any of the uncertainty or fear that he must have

been experiencing at the time. Instead it is a joyful, deliberately humorous vision of himself sitting on his wife's shoulders. The glass of wine he holds up in a toast echoes the lightheaded nature of the subject. The small figure flying across the top of the picture has been identified as an angel by some writers, but is more likely that it represents their daughter Ida. The image of a man with a glass of wine sitting on a woman's shoulders bears a startling resemblance to some 18th-century tavern signs and may derive from Chagall's earlier experience as a sign painter.

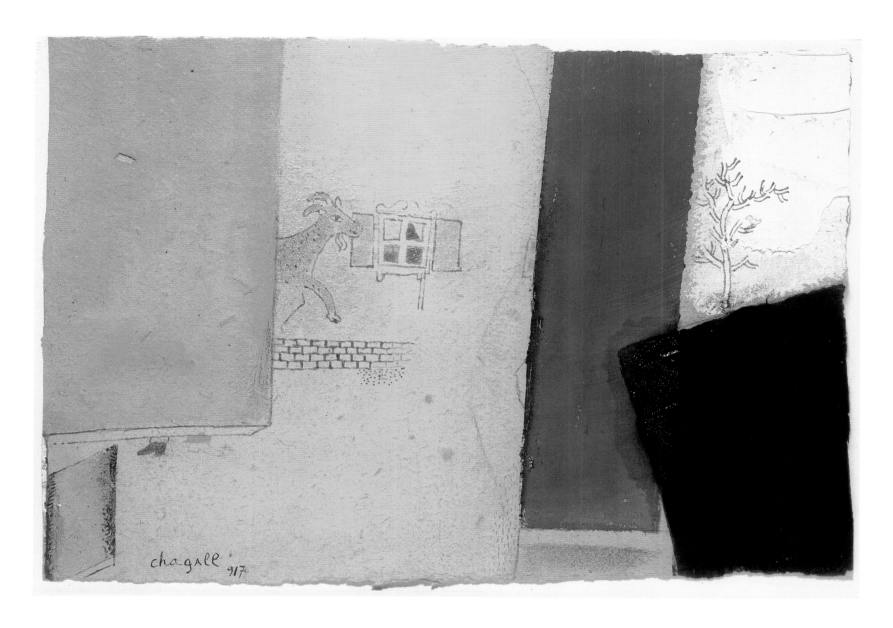

Composition with Goat, 1917

Oil on cardboard
6½×9½ inches (16.5×23.5 cm)
Private Collection

This unusual work is one of several small paintings that Chagall produced in 1917, and it shows him experimenting with a style that was somewhat alien to his own inclinations. The composition is a simple construction of overlapping colored rectangles, which may have been influenced by the art of Chagall's rival, Kasimir Malevich. Having sampled every contemporary style of art possible, Malevich finally invented one of his own in 1915. This new style, Suprematism, involved abandoning representation entirely in order to 'reach the summit of the true unmasked art and from this vantage point to view life through the prism of pure artistic feeling.' To achieve this goal, Malevich began a series of paintings of colored rectangles, circles, and triangles, including the infamous *White on White* (1918). Chagall's *Composition with Goat* alludes to and undermines Malevich's relentless geometric objectivity. For example, Chagall's work includes real objects such as a goat and a tree, whereas Malevich hoped to rid his paintings entirely of representation. By including representational elements within his appropriation of Malevich's style, Chagall may have been mocking the fashion for Suprematism. Chagall also overturns Suprematism here by devoting attention to the surface texture of the canvas – a practice avoided by Malevich in his struggle for 'pure painting.' *Composition with Goat* is especially pertinent when considered in relation to Chagall's later confrontations with Malevich. While he was Commissar of Arts in Vitebsk, Chagall hired Malevich as a teacher in his school. Although this was against his better judgement, he hoped to show himself an open-minded administrator, and he was strongly urged to bring Malevich to the school. The result was a division of loyalty among students: some remained faithful to Chagall; others were lured by Malevich's charismatic advocacy of Suprematism.

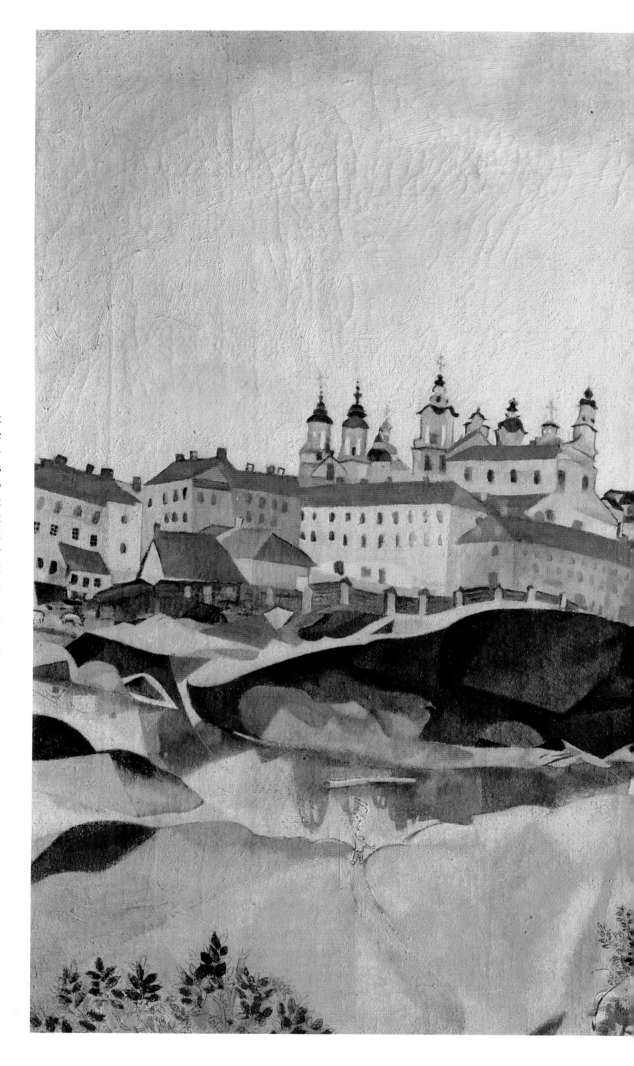

The Blue House, 1917

Oil on canvas
26⅛×38¼ inches (66×97 cm)
Musée des Beaux-Arts, Liège

This was one of a series of landscapes that Chagall painted on a visit to Vitebsk in the summer of 1917. As in the Vitebsk paintings of 1914-15, a sense of realism intrudes upon his usual fantasy world. Here are no flying lovers, headless men, or transparent wombs. The landscape is even somewhat conventional. This is the nature of Vitebsk as it appears in Chagall's work: the farther away he is from his home town, the more it takes on elements of a fairy-tale land; the nearer he is, the more realistic it becomes. Chagall has painted this view on the banks of the Dvina river, looking out towards a Baroque monastery in the distance. The blue house itself dominates the foreground of the picture. A carefully observed brick chimney and foundation serve as an interesting visual contrast to the more painterly representation of the house, the wooden beams of which create a geometric pattern. As a landscape, the work has force, and the virtual lack of living creatures, combined with the strange distortion of the house's perspective, give it an eerie quality. While Chagall was in Vitebsk, he renewed contact with Jehuda Pen, who had been his first art teacher in 1907. Although the youthful Chagall had been impatient and contemptuous of his teacher's persistent realism, he now seemed to welcome acquaintance with the artist. Pen and Chagall painted portraits of each other, and the older artist may have encouraged Chagall to try his hand at this more realistic style. Perhaps because of this renewed contact, Pen was particularly annoyed the following year when Chagall returned to Vitebsk as Commissar of Art. Chagall was responsible for creating a new art school in Vitebsk, and although he invited artists of very different orientations to teach at the school, he did not at first make use of Pen, as Pen's realism seems not to have fitted in with the Revolutionary progressivism that the art school was meant to represent.

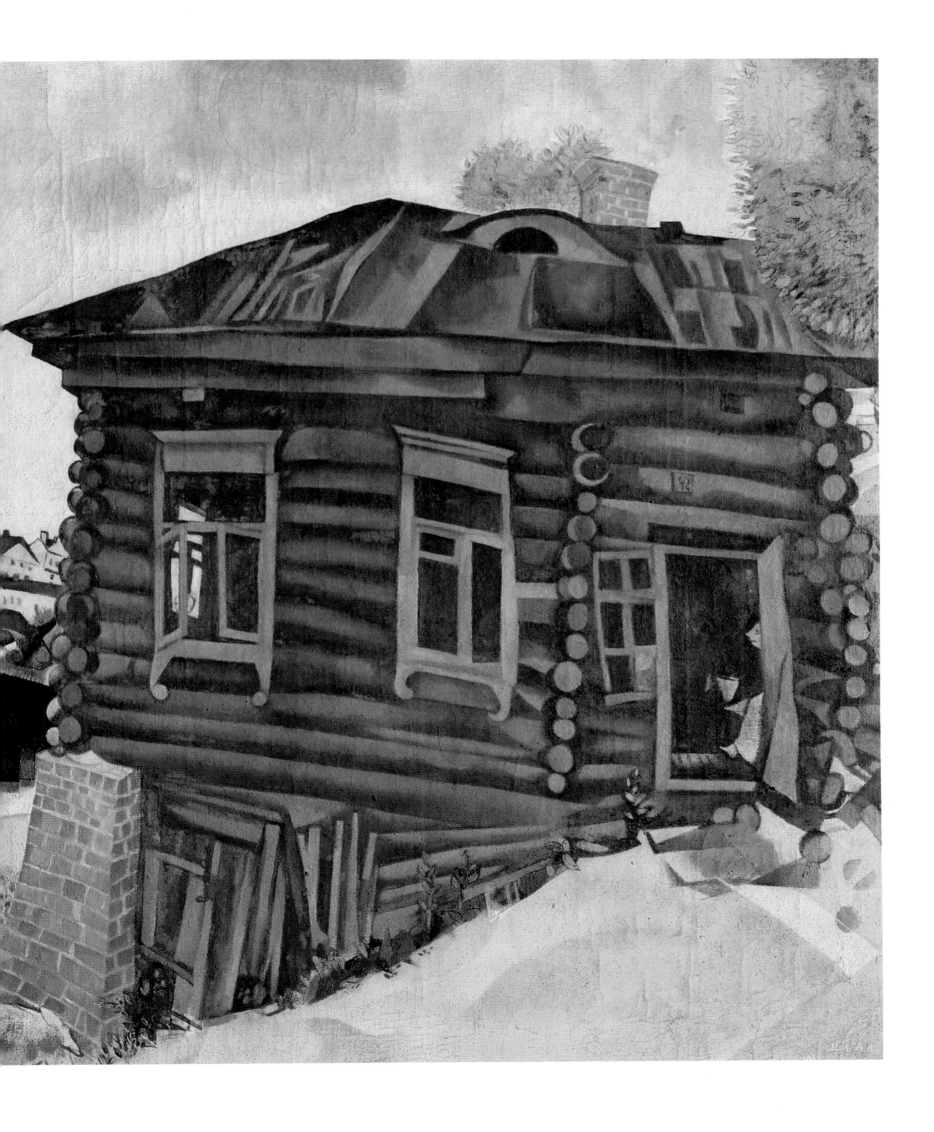

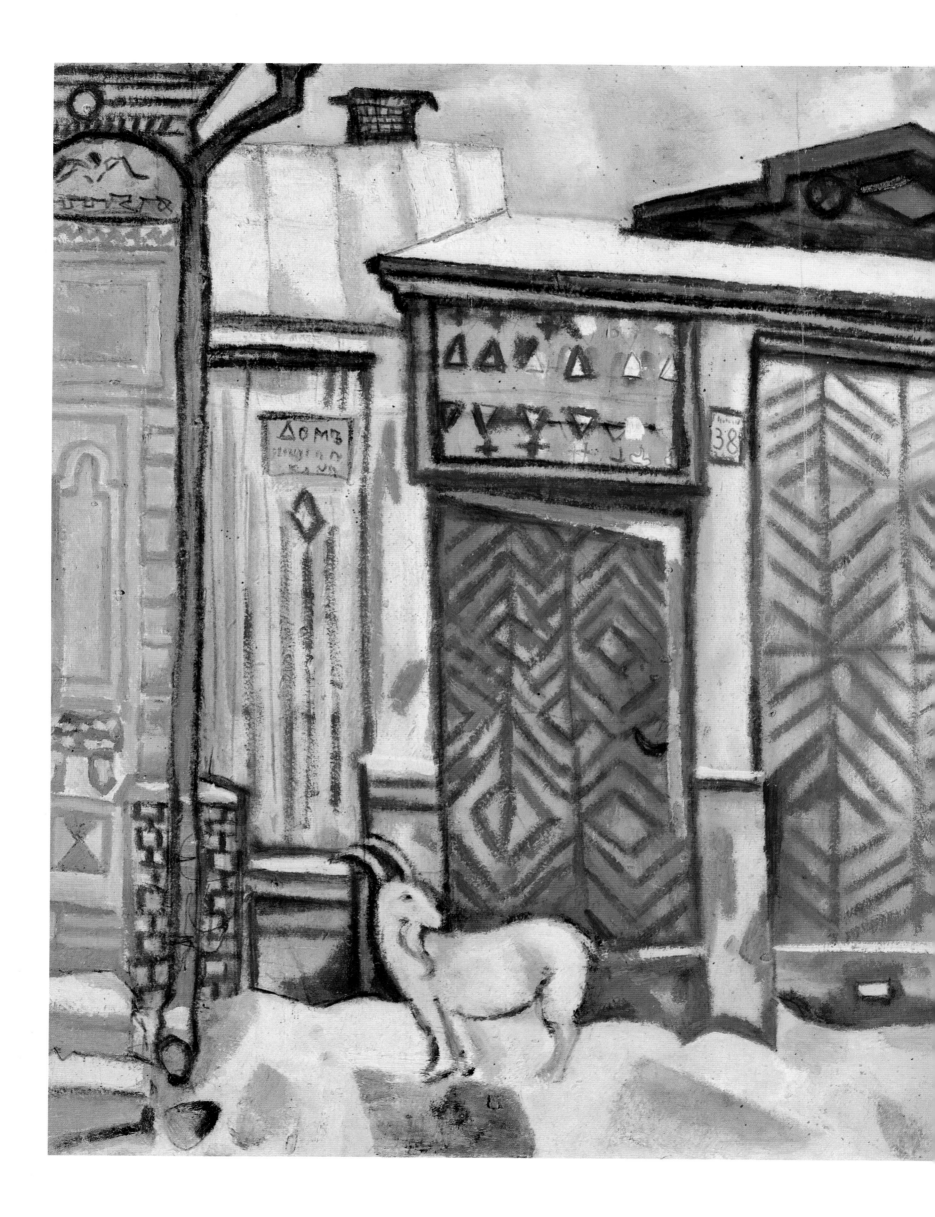

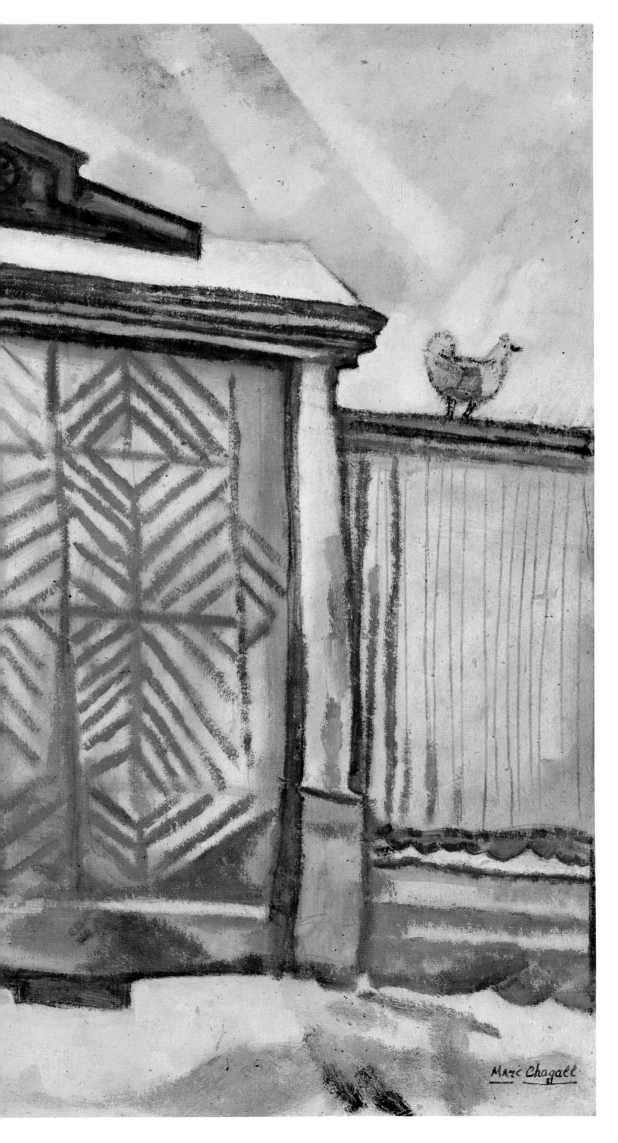

The Red Gateway, 1917

Oil on cardboard
19½×26 inches (49.5×66 cm)
Staatsgalerie, Stuttgart

Chagall's seemingly straightforward views of Vitebsk sometimes disguise a deeper meaning, and such is the case in *The Red Gateway*. The work appears to be another simple view of Vitebsk in the snow, overlaid with a dominant color, in this case red. But the work has further implications, as Susan Compton has pointed out. Over the open door of the gate are a series of signs which are most likely Cabalistic. These could be intended to ward off the Evil Eye, or to prevent evil from entering the house. The open gate thus invites in the good, but repels the evil. The figure of the goat may refer to the scapegoat mentioned in Leviticus XIV who carried the sins of the people into the wilderness on the Day of Atonement. Both the goat and the rooster were characters in a book of Jewish fairytales by Kletskin, which was published in 1917 with illustrations designed by Chagall. The particularly Jewish nature of the theme was characteristic of much of Chagall's Vitebsk work at the time. The symbol of the gate also reappeared in one of his most striking paintings, *Cemetery Gates*, also painted in that year. Written in Hebrew over the cemetery gate are significant words from Ezekiel:

Prophesy, therefore, and say unto them, these are the words of the Lord God: O my people, I will open your graves and bring you up from them, O my people. Then I will put my spirit into you and you shall live, and I will settle you on your own soil, and you shall know that I the Lord have spoken and will act.

The gate thus becomes the gateway between life and death, heaven and earth.

Homage to Gogol, 1919

Design for a theater curtain
Watercolor on paper
15½×19¾ inches (39.4×50.2 cm)
Collection, Museum of Modern Art,
New York

Chagall's connection with the theater began in Russia before the Revolution, and after an interruption of some 20 years, was re-established during World War II. The theater proved an especially appropriate place for Chagall to assert his enthusiastic fantasies, and this potential was recognized by directors and managers at the time. His first commission had been to produce a backdrop for a play performed in Petrograd before the Revolution. For this Chagall enlarged one of his paintings, *The Drunkard* (1911), which shows a man with his head flying off his shoulders. Chagall had a further opportunity to invent designs for the theater in 1919 when the Hermitage Studio Theater in Petrograd commissioned him to provide a series of scenes for Gogol's *The Cardplayers* and *The Wedding*. Although the scenes were never executed, this study shows the way Chagall hoped to bring some vitality and imagination onto the stage. The Hermitage Studio Theater was under the direction of Meyerhold, whose ideas that plays should be stylized and poetic were in contradiction to those of Stanislavsky, who advocated realism. The *Homage to Gogol* shows where Chagall's sympathies lay. The distorted, elongated figure balances a church with the bottom of his foot and holds a laurel wreath amidst the simple inscription 'To Gogol from . . . Chagall.' Chagall's fondness for the writing of Gogol would emerge again in the 1920s when he was commissioned by Ambrose Vollard to illustrate Gogol's novel *Dead Souls*.

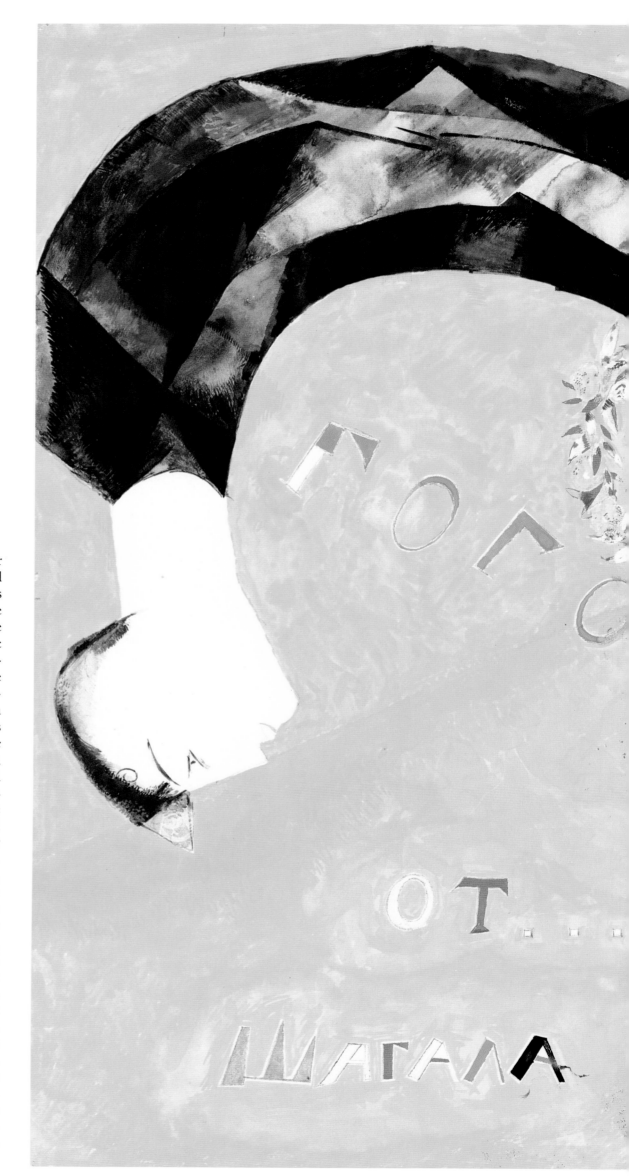

94

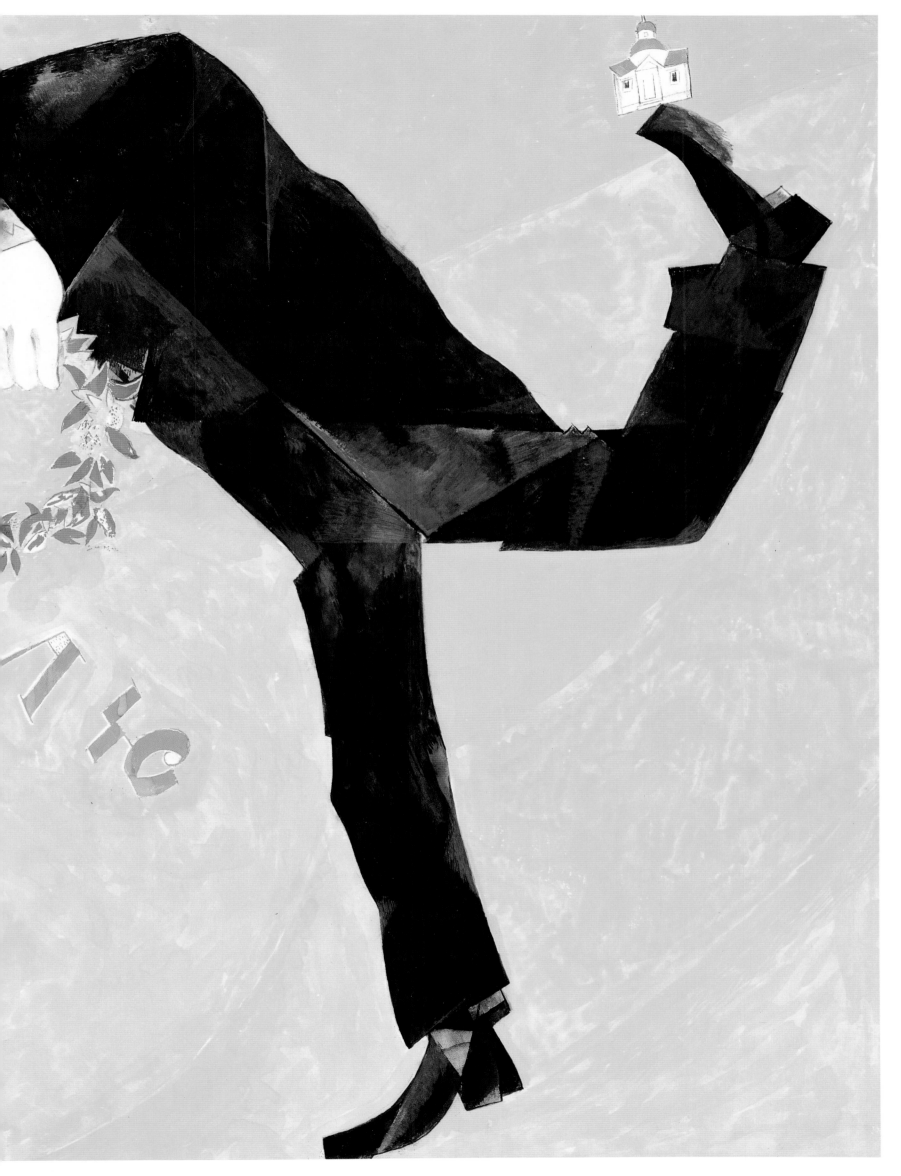

Cubist Landscape, 1918

Oil on canvas
39⅜×38¼ inches (100×59 cm)
Private Collection

This painting has been variously dated to 1918 and 1920, as it represents a unique example of Chagall wholeheartedly embracing a Cubist mode. While in Paris, Chagall had proven that he could borrow ideas from Cubist painters yet be coolly aloof from their more zealous extremism. In *Cubist Landscape* he has abandoned his personal iconography in favor of a work which approaches abstraction. However, the type of Cubism referred to in this painting is different from that which had influenced him in Paris. The early Analytical Cubism of Picasso and Braque involved breaking down objects into geometric components, and Chagall employed a decorative version of this Analytical Cubism in a number of his pre-War paintings. By contrast, here he shows some knowledge of a later type of Cubism, which was called Synthetic Cubism because objects were constructed from geometric forms rather than broken down into them. The Synthetic Cubism of Picasso and Braque was responsible for the earliest collages, in which real objects were pasted, rather than painted, onto the canvas. Once Synthetic Cubism was well-established, many artists produced collages as well as painting pictures which looked as if they could be collages. Chagall's *Cubist Landscape* is one such work. Contemporary Russian art provided a more immediate source for this use of Cubism, as Chagall's contemporaries Malevich and Tatlin were both influenced by the Synthetic Cubism of Picasso. For Tatlin, this proved an inspiration which led him to produce 'corner reliefs' – in effect, three-dimensional collages. Malevich adopted the look of Synthetic Cubism in his 'alogical' paintings, in which diverse and incongruous images were juxtaposed in a manner resembling collage. When assessing Chagall's development, such experiments as these must not be ignored. However scornful he seemed of contemporary art movements, his artistic curiosity was obviously aroused and exercised by them.

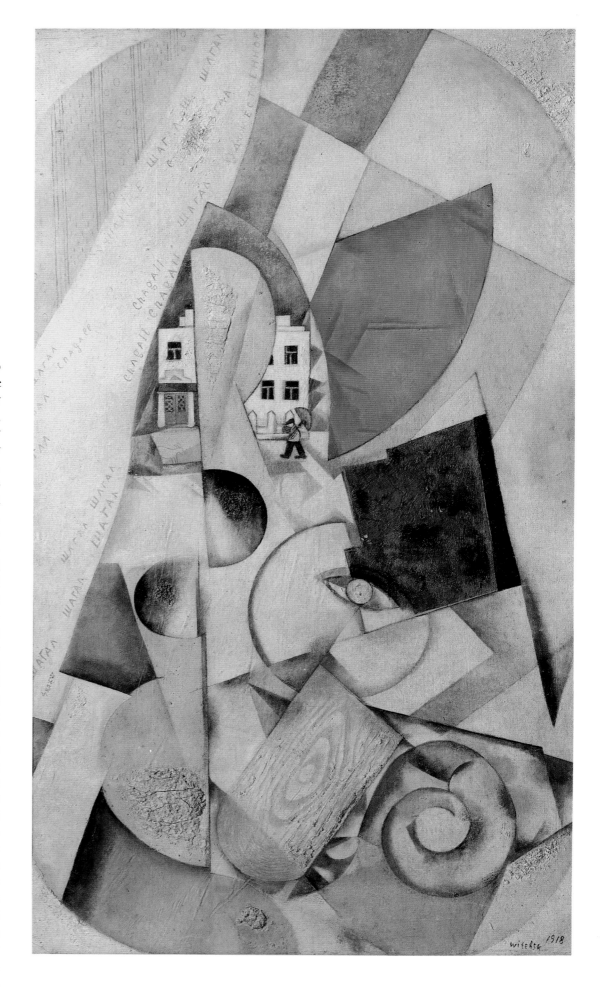

The Green Violinist, 1923-4

Oil on canvas
78×42¾ inches (198×108.6 cm)
Collection, Solomon R Guggenheim
Museum, New York

Chagall's last two years in Russia repre-
sented the lowest point in his life. The
genuine poverty which he and his family
experienced virtually called a halt to his
painting. The government grant provided
for artists was withdrawn from him, and
his work was out of favor both with pro-
gressive abstract artists and with the more
reactionary advocates of Socialist Realism.
In order to earn his living, in 1921 he
accepted the job as a teacher in a colony for
war orphans outside Moscow. These chil-
dren had experienced terrible suffering
and deprivation as the result of the war,
and Chagall felt a special tenderness
towards them. In *My Life* he said 'I loved
them. They drew pictures. They flung
themselves at paints like wild beasts at
meat.' It was during this period that
Chagall began writing *My Life*, which he
dated 'Moscow 1922.' The experience of
being rejected by his fellow-artists and by
the new regime in Russia finally moved
him to apply for a visa to return to Berlin.
He traveled to Berlin in 1922 and back to
Paris in 1923. As he went to Paris at the in-
vitation of Ambrose Vollard, Chagall's first
commissions were for etchings, an art he
had learned in Berlin. He did, however,
continue to paint, and *The Green Violinist*
is an example of his work at this time. The
composition is directly related to the figure
of Music in Chagall's decorations for the
Jewish State Kamerny theater in Moscow
(1919-20), and this repetition of a theme is
symptomatic of much of his painting
during the 1920s. As Chagall had returned
to both Berlin and Paris to find the paint-
ings he had left behind, sold, or lost, he felt
a strong need to recover these missing
works. By using photographs, he repainted
a number of his more famous pictures. The
same principle applied to work he had
been forced to leave behind in Russia, in-
cluding the subject-matter of his Jewish
Theater murals. While Chagall's graphic
illustration of the 1920s shows evidence of
new initiatives, his paintings were often
retrospective and reminiscent of previous
work.

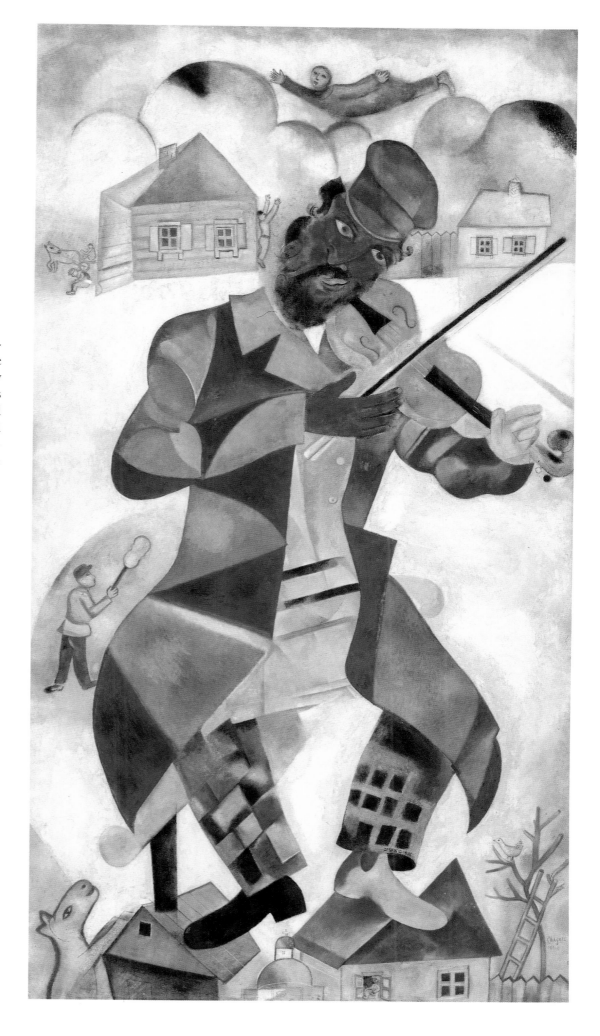

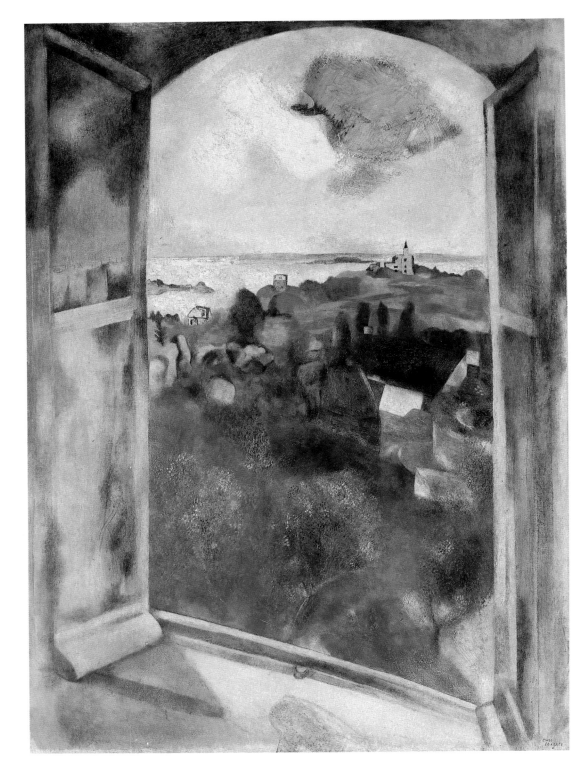

Window on the Ile de Bréhat,
1924

Oil on canvas
39½×28¹⁵⁄₁₆ inches (100.5×73.5 cm)
Kunsthaus, Zürich

When Chagall returned to Paris in September 1923 he settled eventually in a studio on the Avenue d'Orléans, where he remained until 1927. The dire circumstances he had experienced during his last year in Russia were replaced by a period of relative security. From Ambrose Vollard he obtained commissions to illustrate Gogol's *Dead Souls*, La Fontaine's *Fables*, and the Bible, which provided him with steady employment for a number of years. Chagall now had some artistic reputation, unlike during his previous stay in Paris. Although he had been scorned by the politicized artistic factions in Russia, his work was acknowledged in Europe as an important influence on Expressionism. Chagall was able to enjoy some leisure, and he and his family began to explore the French countryside. This painting is the result of one such trip. It was executed on the island of Bréhat, off the north coast of Brittany. In some ways, the work is reminiscent of the Vitebsk landscapes painted around 1917, as it is equally devoid of figures and provides a realistic view over the bay. The motif of looking through the window had also appeared in earlier works by Chagall, and had been used most imaginatively in *Paris Through the Window* (page 62). But *The Window on the Ile de Bréhat* suggests additional artistic influences, particularly that of Matisse and Derain. One of Matisse's first 'Fauvist' paintings, *Open Window at Collioure* (1905), employed a similar motif, and Derain's realistic landscapes of the 1920s perhaps offered Chagall further inspiration.

Ida at the Window, 1924

Oil on canvas
41⅜×29½ inches (105×75 cm)
Stedelijik Museum, Amsterdam

Like *Window on the Ile de Bréhat*, this work was painted while Chagall and his family were on holiday on the island of Bréhat, but here he has extended the composition to include the figure of his daughter Ida wearing a brightly striped green and white dress. Ida had been born in 1916, and Chagall admits in his autobiography that he wished she had been a boy and that he found the presence of a baby irritating and disruptive. Nevertheless, Ida became increasingly important to him as he grew older, and upon the death of his wife Bella in 1944, Ida took charge of his personal and financial affairs. The subject of *Ida at the Window* reveals Chagall's continued examination of himself and his private life through his art. The painting is domestic and peaceful, without any of the flashes of fantasy that characterized much of his previous work. Unlike his graphic work, Chagall's painting seems to have developed very little in the 1920s. His energies were devoted to Vollard's projects, and these provided him with a new kind of technical stimulation that appeared to sap his creativity in painting. Although he had made good use of Fauvism, Cubism, and Orphism in prewar Paris, and he had even experimented half-heartedly with the geometric abstraction of Malevich, Chagall rejected the Surrealist movement which was founded in Paris in 1922. In his Surrealist Manifesto, André Breton defined Surrealism as 'pure psychic automatism,' and it was just this definition of art that Chagall disliked. He did not believe, as the Surrealists did, that paintings could be created without conscious thought, nor that the main purpose of art was to unlock the subconscious. Ironically, Chagall's very combination of realism and fantasy was influential on Surrealist artists such as Max Ernst, who had seen Chagall's early work in Berlin. Much of Chagall's work does have a dream-like quality that the Surrealists found sympathetic to their own view of art. However, realist paintings such as *Ida at the Window* seem to underline Chagall's determination to follow his own path, regardless of contemporary tendencies in art. This determination became more pronounced as he grew older.

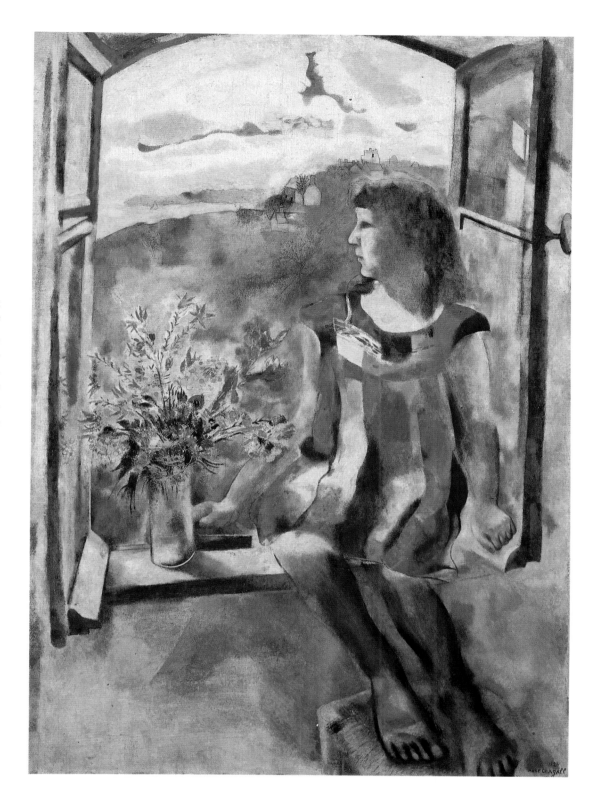

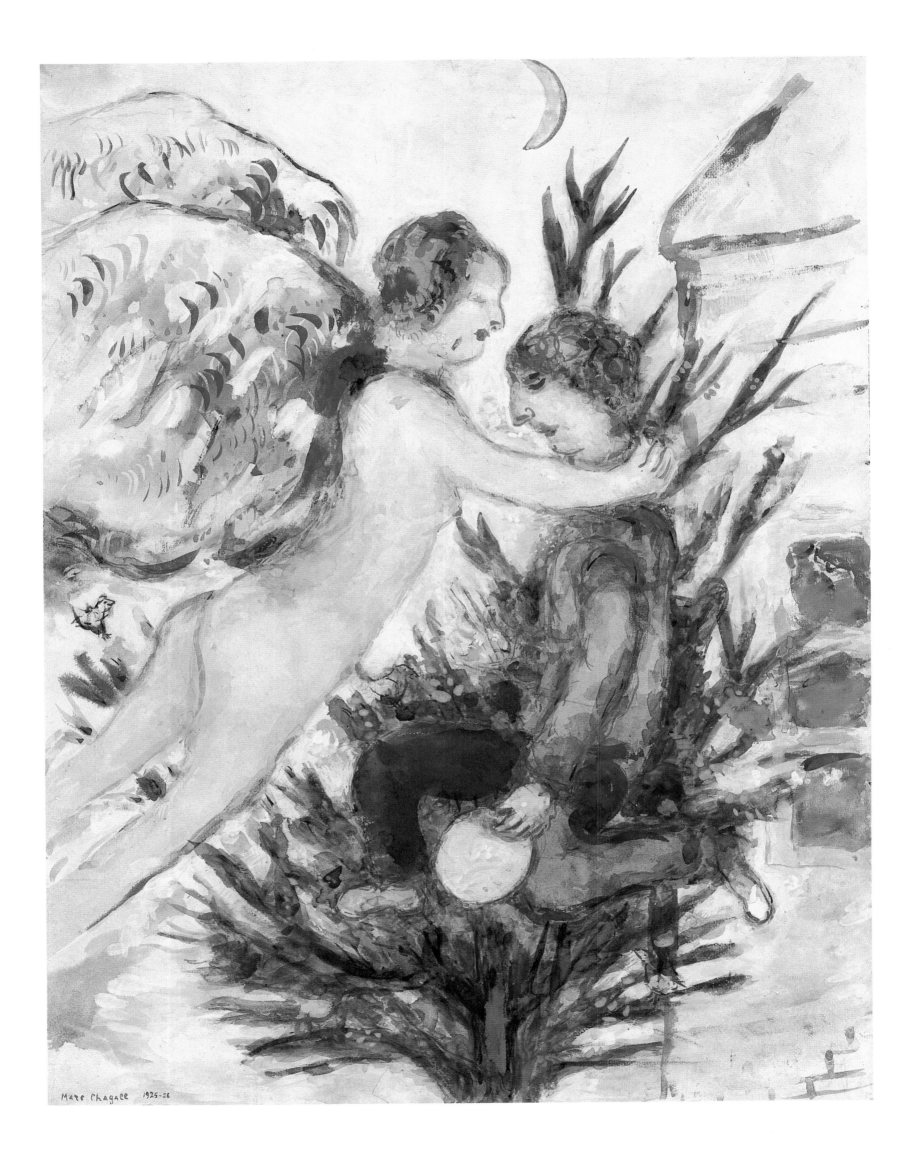

Marc Chagall 1925-26

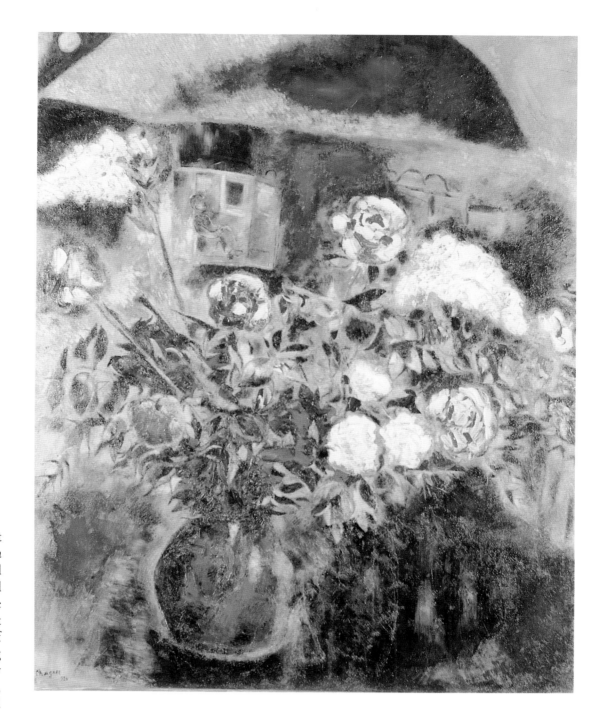

Left:
The Poet and his Muse, 1925-6
Oil on canvas
Private Collection

This is a variation on one of Chagall's most unusual paintings, *Muse, Apparition* (1917). In *Muse, Apparition*, Chagall used three principal colors – blue, white, and gray – to create an atmosphere of the supernatural. The composition is not Cubist, but equally Chagall's definition of form is not naturalistic. The painting almost has the feel of a drawing, with many elements, such as the apparition's wings, composed of simple outlines. Chagall painted this earlier work shortly after his return home to Vitebsk after declining an offer to be Minister of Fine Arts for the new Russian government. This time he did not look immediately to Vitebsk for subject matter, but called upon his experiences in St Petersburg. In *My Life* Chagall tells the mythical story of the genesis of his idea of painting an angelic insitation. He traces its inspiration back to the days before he had established himself as an artist. Chagall explains that as he had not yet acquired the patronage of Baron Guinsburg and Maxim Vivaner, he was totally impoverished and had to sleep wherever he could. He describes communal quarters where poor men such as himself shared beds in order to have a place to sleep. With no money and no way to practice his art, Chagall claims that he spent many hours in these quarters thinking and dozing. One of the dreams that plagued his peace concerned an angel who appeared through the ceiling of the garret room in a flash of light. In *The Poet and his Muse* Chagall has altered the emphasis of his dream slightly, giving the angel the character of a muse inspiring the creative artist.

Peonies and Lilacs, 1926
Oil on canvas
39⅜×31½ inches (100×80 cm)
Perls Galleries, New York

The type of landscape painting that Chagall had undertaken while in Vitebsk was abandoned in the early 1920s when he became absorbed in his work for Vollard. However, in 1926 Chagall spent long periods of time outside Paris, and he renewed his interest in painting from nature. He was particularly impressed by the southern coast of France, where the quality of the light made him look at the landscape in a new way. Chagall and his family stayed in a small fishing village on the southern coast, and took trips out each week.

Chagall was particularly impressed by the appearance of the Mediterranean and by the bouquets of flowers that Bella frequently carried home. In his art, this manifested itself in a series of flower paintings that signaled a new variation in his thematic repertoire. Flower paintings such as *Peonies and Lilacs* do not show the flowers in a landscape, but rather in an artificial arrangement. Chagall fills the canvas with flowers, and their domination creates a heady effect on the observer. After a spate of flower paintings in the late 1920s, Chagall used this motif less frequently, but nevertheless consistently, throughout the rest of his life. Flowers to him became a symbol of sensual love, and he often painted them in conjunction with lovers.

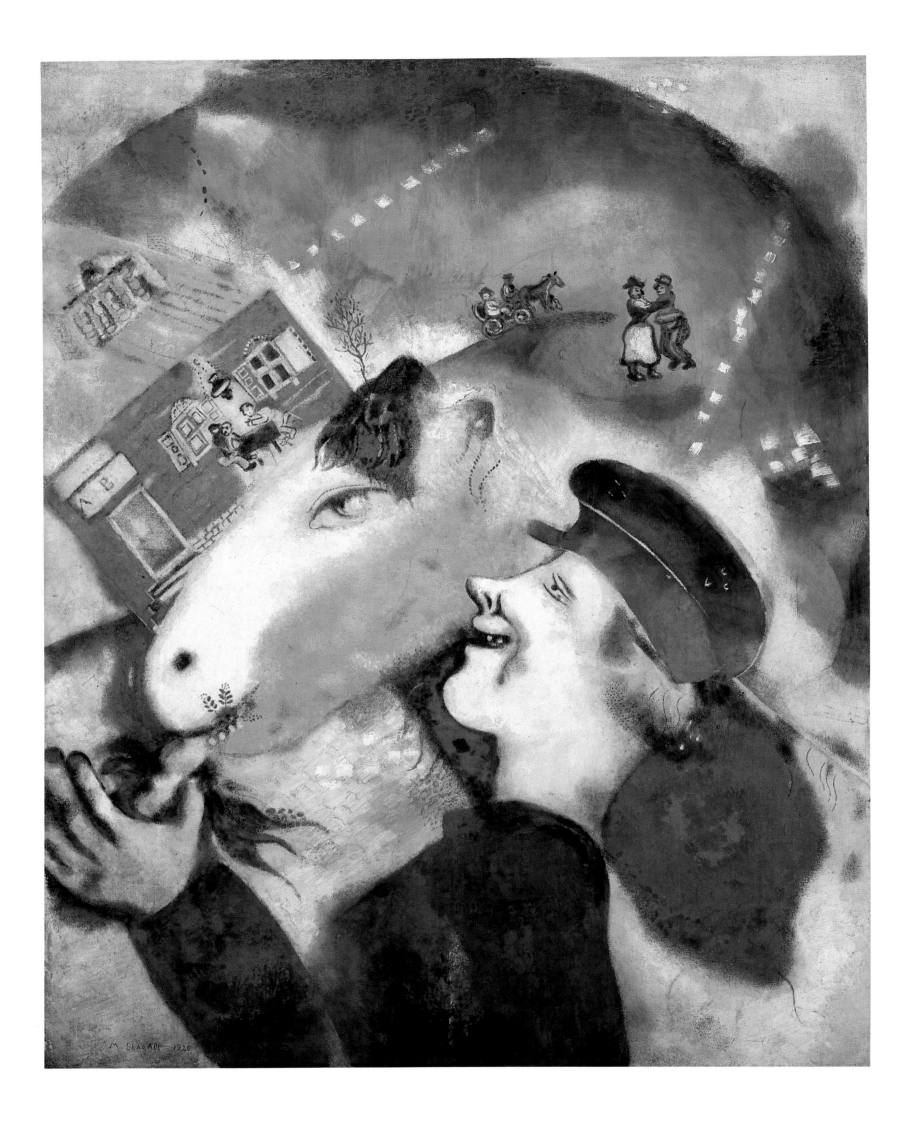

Peasant Life, 1925

Oil on canvas
39⅜×31½ inches (100×81 cm)
Albright-Knox Art Gallery, Buffalo,
New York,
Room of Contemporary Art Fund, 1941

Chagall's paintings of the 1920s often re-work old themes, and this example has been accepted as a revised version of *I and the Village* (page 47). The argument for this interpretation of the work rests largely on the fact that it represents a human and an animal figure acting in harmony, thus symbolizing the desired unity of man's bestial and intellectual natures. Certainly Chagall was still interested in his *I and the Village* theme, as he painted another version of the picture in 1922. But here he has altered both his approach and his style considerably. Now the man and beast do not face each other but stand side by side, and rather than proferring a nosegay, the man now feeds the donkey a carrot. Chagall has also divested the painting of any Cubist echoes; instead he uses the primary colors, red, blue, and yellow, and the secondary green in large, almost sloppy, washes. Chagall has also altered the location of the subject somewhat. The blue jacket which the peasant wears is not Russian attire, but rather the clothing of the French peasantry, whereas the man's cap and the cottage in the background are more obviously Russian elements. Paradoxically, the subject itself seems to relate more directly to the series of etchings that Chagall was producing for Ambrose Vollard to illustrate the Russian novelist Gogol's *Dead Souls*. These 107 etchings date from 1923-5, and they represent both significant and more picturesque scenes from the novel. *Dead Souls* tells the story of the wily Chichikov, who comes to a small Russian village hoping to take advantage of the villagers' naivety. Due to an obsolete Russian legal clause, peasant serfs who were calculated as part of a landowner's property as the result of a ten-yearly census, were still considered property within that ten-year period, even if they were dead. Chichikov 'buys up' these dead souls from local landowners who are eager to avoid paying taxes on them, making himself into a metaphorical man of property, without actually having the property to back up this claim. *Dead Souls* involves a series of humorous incidents in a tiny Russian village, and Chagall would have had the novel in his mind when he painted *Peasant Life*.

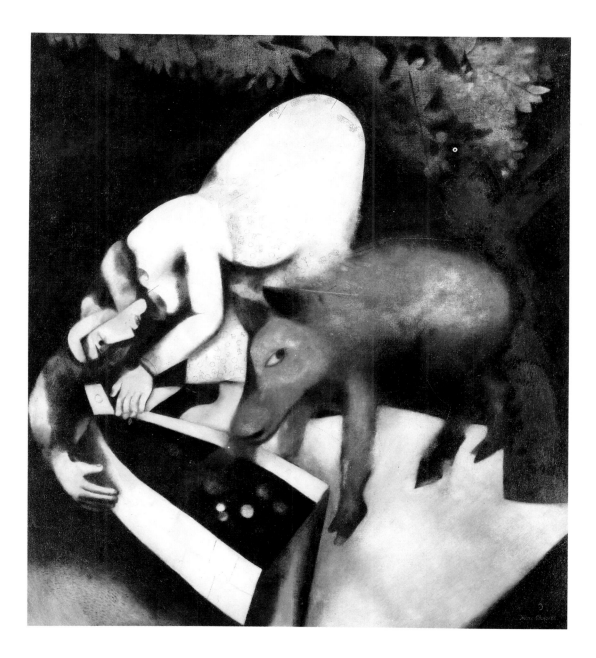

The Watering Trough, 1925

Oil on canvas
39¼×34¾ inches (99.5×88.5 cm)
Philadelphia Museum of Art
Louis E Stern Collection

This amusing and interesting painting shows that Chagall was still producing works indebted to his Russian heritage, but it also reveals new interests that he was developing in the 1920s. The subject has its origin in a gouache and a lithograph. The gouache, dated variously to 1912 and 1922, presents the same subject – a woman bending over a trough from which a sly pig is feeding – but shows a boldness of color that is tempered here by a softer tonality. The lithograph of *The Watering Trough* was published by Jeanne Bucher in 1925, and it represented one of Chagall's first efforts in the medium, which became a favorite graphic technique after World War II. Both the pastel color of the work and its subject-matter also reveal Chagall's current artistic interests. After his experiments with etching and lithograph, Chagall began to realize more subtle possibilities of tonality in painting. In many works of the 1920s his color is softened, and it bathes the paintings gently rather than invades them

harshly as in his earlier Paris works. The animal theme that he chose may relate to a commission to illustrate La Fontaine's *Fables* given to Chagall by Ambrose Vollard in 1925. Vollard was pleased with Chagall's imaginative etchings for *Dead Souls*, and considered him the ideal artist to illustrate one of the most popular children's books in France. The outcry that resulted from choosing a Russian artist to illustrate a book that had strong associations with France led Vollard to defend his choice:

Now if you ask me: 'Why Chagall?' my answer is 'Simply because his aesthetic seems to me in a certain sense akin to La Fontaine's, at once sound and delicate, realistic and fantastic.

Vollard also thought it was logical to choose Chagall, as the *Fables* themselves were originally of Eastern origin, and many were direct descendents of Aesop's *Fables*. Chagall's *The Watering Trough* is not an illustration of La Fontaine, but it does have the character of a fable and suggests a visual homily, without realizing one specifically.

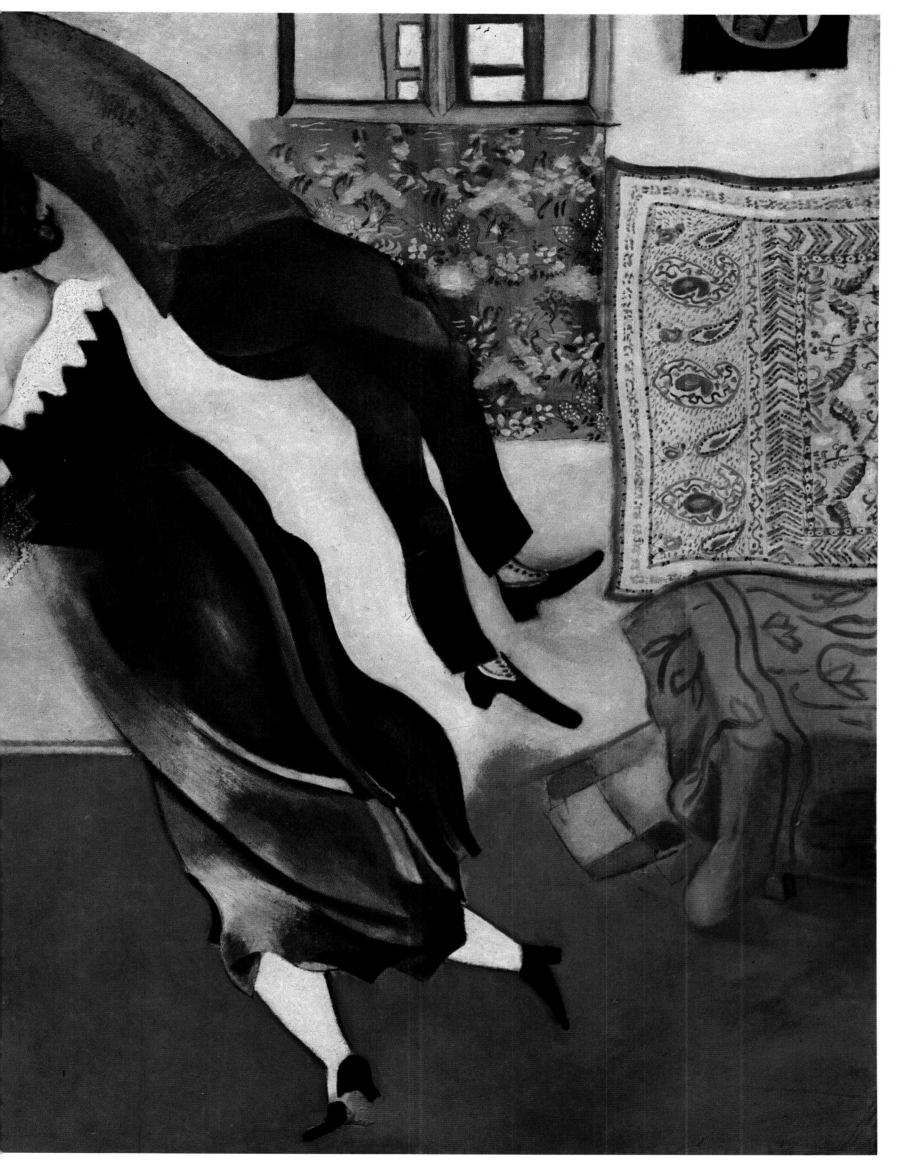

The Dream, 1927

Oil on canvas
31⅞×39⅜ inches (81×100 cm)
Musée d'Art Moderne de la Ville de Paris

The Dream was painted during the period that Chagall was undertaking the designs for illustrations to La Fontaine's *Fables*, and even more than *The Watering Trough* (page 103), which had an earlier origin, this work relates to a new attention to animal themes. As the *Fables* inevitably involved stories about animals, Chagall concentrated his attention on painting them, but here we see his tendency to conflate the characteristics of different animals into one form. The 'Chagallian animal' later became something of a cliché in writing about the artist, and the term carries the implication that the artist was unable or unwilling to distinguish one animal from another. The creature in *The Dream* resembles both a rabbit and a donkey, but in such a context, the presence of a pseudo-mythical beast is understandable. However, *The Dream* represents a very different kind of fantasy than those painted previously by Giorgio de Chirico and that would soon be painted by Surrealists such as René Magritte and Salvador Dali. Chagall is not unlocking the subconscious through a realistic or literal realization of bizarre images: his work is instead self-consciously 'painterly,' in that it draws attention to color and brushstrokes in a way that Magritte and Dali never did. But Chagall perhaps indicates his awareness of the Surrealist interest in Freud's ideas about dreams and sexual revelation. The woman is depicted in a supplicating and defenseless posture, submissive to the bestial aspects of her own nature. The work bears an extraordinary, if purely coincidental, resemblance to the theme of Henry Fuseli's 18th-century painting, *The Nightmare*, which similarly conflates dreams of animals with female torment and submission. It also recalls the mythical story of Europa abducted by the bull, which had been popular with artists for centuries. But Chagall's use of the theme cannot be said to be subtle, or Freudian in any but a superficial sense. Instead, the interest of the painting lies in a more imaginative handling of the canvas surface. Here Chagall juxtaposes different kinds of brushstrokes, including the gouache-like spread of blue in the background and the thick impasto of the woman's dress.

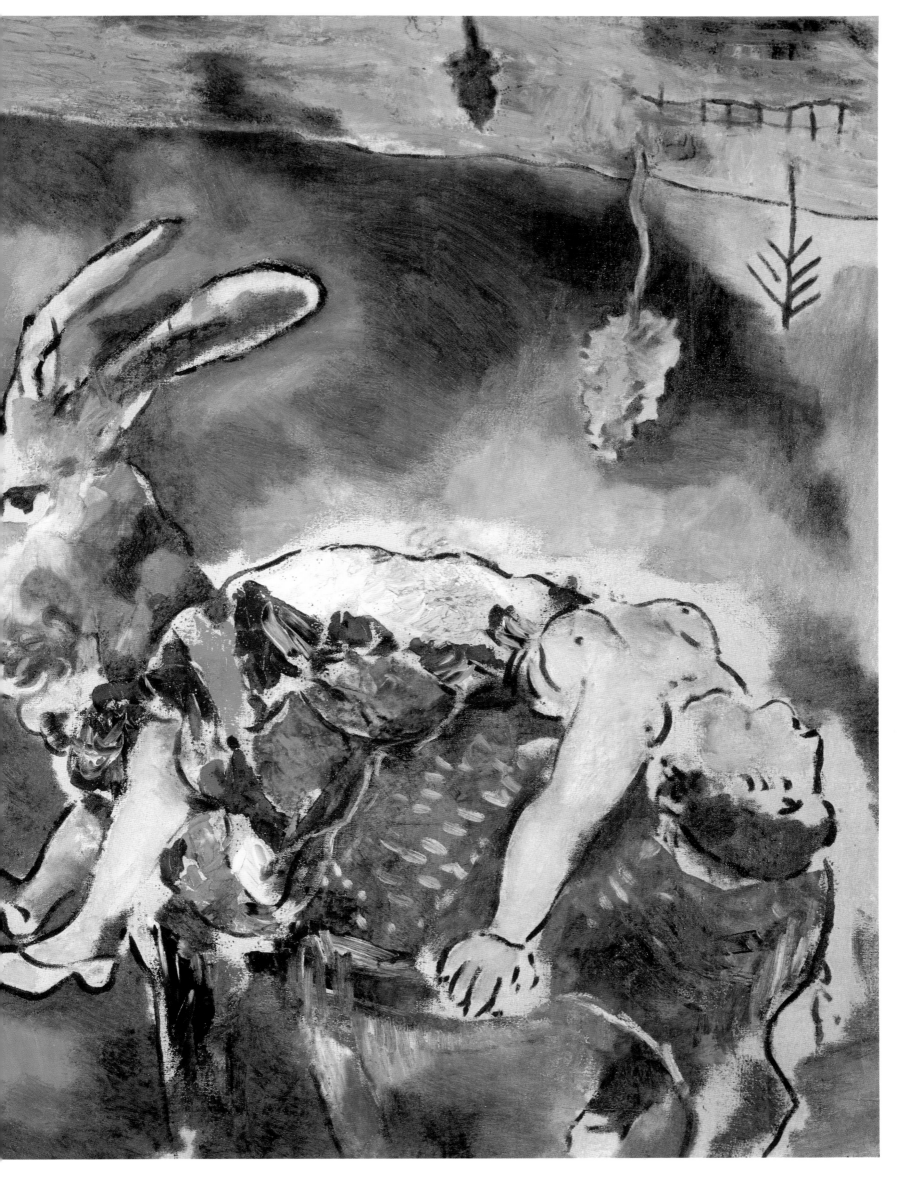

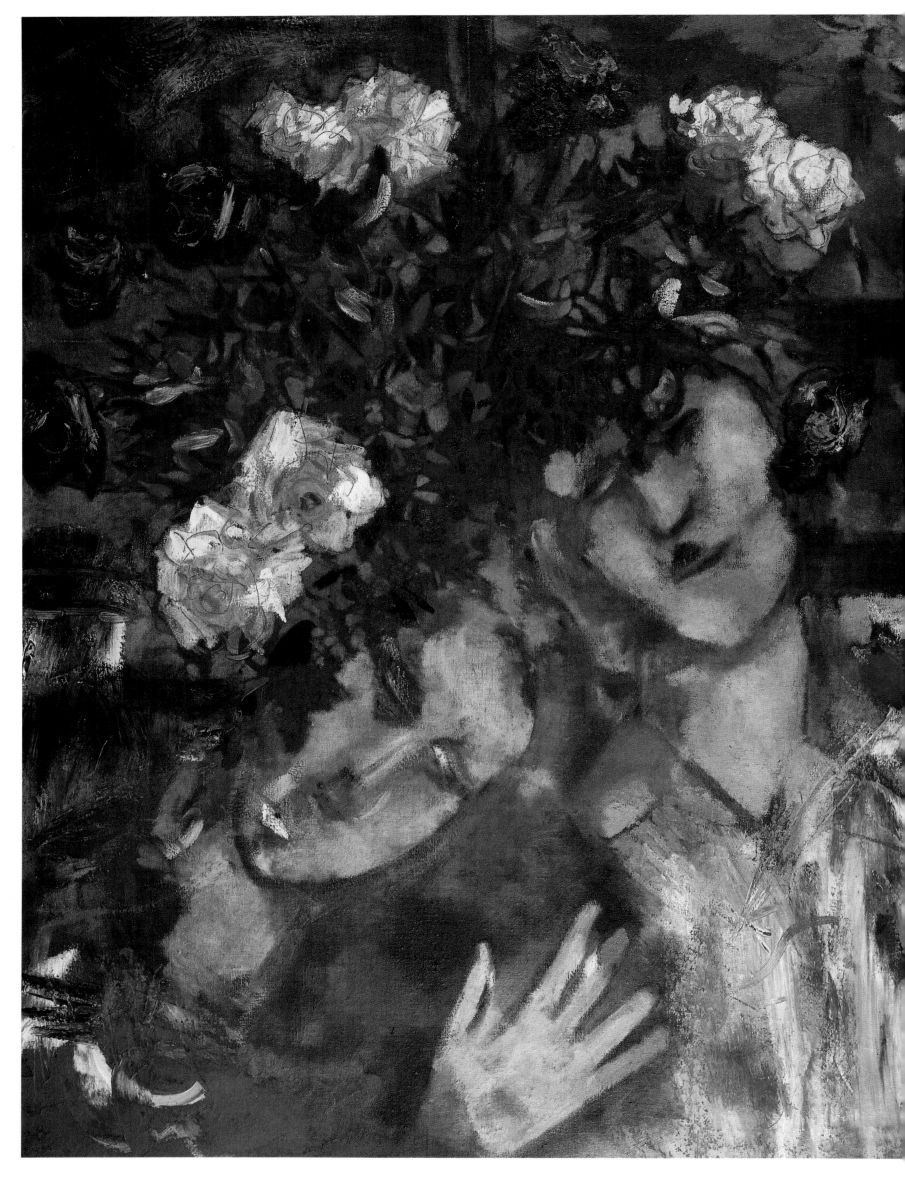

Lovers with Flowers, 1927

Oil on canvas
39⅜×35 inches (100×85 cm)
Israel Museum, Jerusalem
Gift of Baron Edmond de Rothschild

Later in his career Chagall spoke of the evocative qualities of flowers, suggesting that they can both reflect life and obscure it: 'Life and its events often have a tragic air like certain bouquets.' Chagall's paintings of flowers executed in the 1920s reveal his attempts to extract a mood from the still lifes particularly through the use of color. The surge of still-life pieces in the 1920s had some precedent in Chagall's previous work. Still lifes exist from as early as 1908, but these reflect the prevalent obsessions with the formal concerns of Cézanne and the Cubists. The tight structure and geometric composition of Chagall's early still lifes is loosened in the later works, which at their worst can be tame or insipid. *Lovers with Flowers* is an example of the combination of the new still-life composition with the old theme of lovers. The tender lovers lean gently against each other, their faces partly obscured by a burst of softly-colored flowers. This 'soft-focus' effect gives the painting its sense of mood, but it also serves somewhat to trivialize the subject. Chagall's treatment of still lifes does have some precedent in the late paintings of Monet, as well as those of Bonnard. A more interesting comparison between these works and paintings of the French Symbolist artist Odilon Redon shows some surprising similarities. Both Redon and Chagall were creating 'mood-pieces,' but the poignant and elusive nature of Redon's mythological or fantastic subject-matter contrasts strikingly with the whimsy of Chagall's sighing lovers.

Flowers and Fowl, 1929

Oil on canvas
39⅜×31⅞ inches (100×81 cm)
Göteborgs Konstmuseum, Göteborg

Another example of a still life from the 1920s, this painting includes an inexplicable dead chicken and the more familiar element of fantasy in the form of a flying horse. Chagall's interest in still lifes was aroused by a series of visits to the south of France. Chagall had the security and leisure to explore more of France after he settled there in 1923, and he took advantage of every opportunity to escape into the countryside and out of the busy bustle of Paris. His first visits to the country were with Sonia and Robert Delaunay, who invited him to travel with them to the Ile Adam on the River Oise in 1924. In 1926 he took a holiday at Mourillon near Toulon on the Mediterranean, and during that time he first saw Nice. The strong light and beauty of the Mediterranean coast impressed him immediately, and that, combined with the many bright flowers found in the south, inspired the series of flower paintings produced from 1926.

Although still lifes such as this look as if they have been painted quickly to catch the image in a moment, Chagall actually took quite a bit of time over each one. Their effect has been described as 'lyrical,' and they give the impression that they have been painted by someone drugged on the pleasant sunshine of the south. Chagall continued to paint flower pieces for a number of years, but gradually the flowers began to be relegated to the background of his compositions. However, one legacy from these flower paintings was the looseness of the handling and the softening of the colors. This sort of technique led many critics at the time and afterwards to classify his painting as 'effeminate.' Although he never denied the 'effeminacy' of his paintings, Chagall claimed that this softness was mingled with a strength, and that the combination provided a feeling of sadness or hope, mixed with despair. These elements created the mood of his flower pieces, gave them a resonance beyond their existence as reflections of observed reality, and gave them a status beyond the still-life genre.

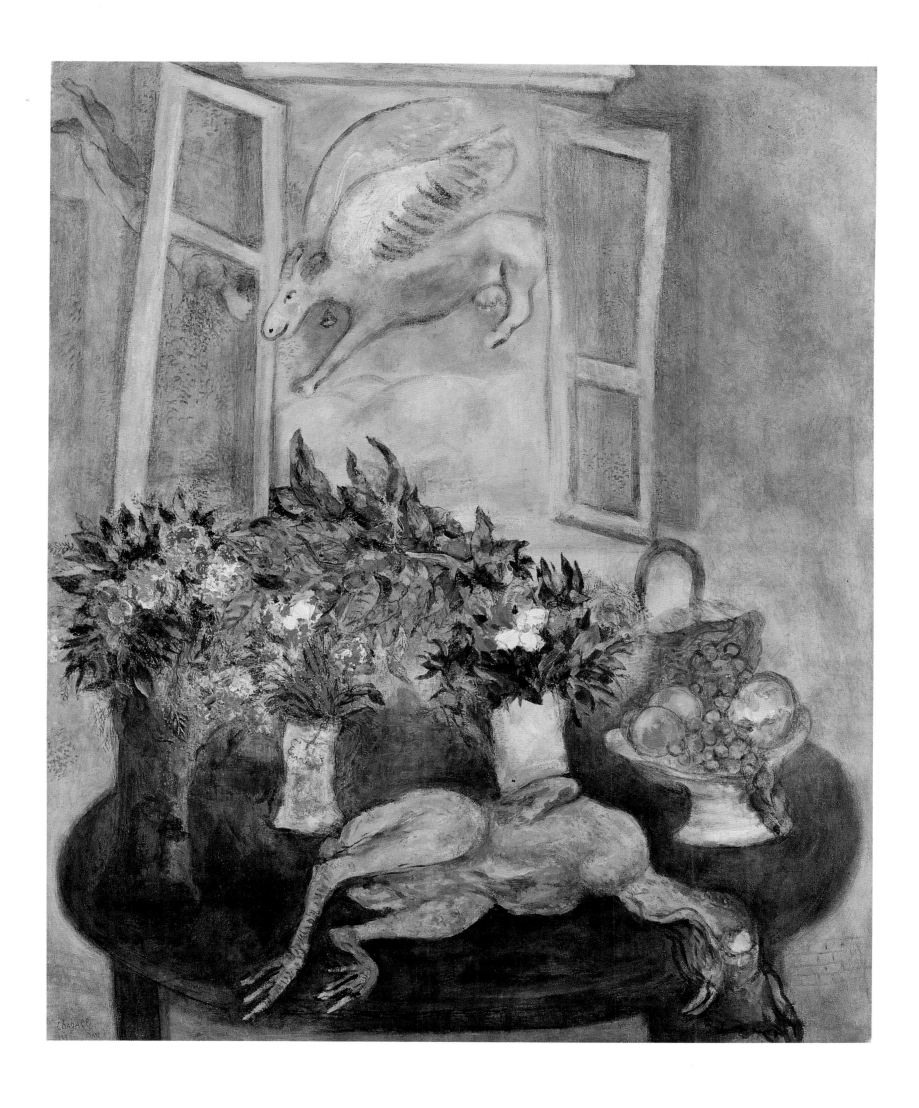

The Cock, 1929

Oil on canvas
31⅞×25⅝ inches (81×65 cm)
Thyssen-Bornemisza Collection, Lugano

The softer colors that Chagall adopted for his still lifes were more convincingly applied to animal subjects that had elements of fantasy or the supernatural. This representation of a woman riding a rooster bears some similarities to *The Dream* (page 104) of two years earlier, but the subject-matter is less overtly oneiric. The identification of the rider as a woman was made in 1948 by Chagall's friend, the writer Raîssa Maritain, who also characterized the figure as a Harlequin. The rooster thus provides a contrasting male symbol which unites with the female symbol. However, one should not read this painting as sexual in the Freudian sense of the term. Chagall's rejection of Surrealism was unequivocal, and he had no sympathy for Freud's explanations of human sexual behavior. Instead Chagall saw sexual union as a symbol of a deeper spiritual union, and the ethereal blue which bathes the painting underlines this spiritual theme. At the time Chagall painted *The Cock*, his reputation in France was at a peak. He was acknowledged by critics and the public as the leader of the so-called 'School of Paris,' and he was able to attain a standard of living that he had not known before. Security and comfort may have caused a certain slackness in his painting of this period, but the mood pieces of the 1920s also stimulated new interpretations of his art. The most notable of these new approaches to Chagall's painting was René Schwob's *Chagall and the Jewish Soul*, which described the mood of Chagall's works in terms of the aspirations and disappointments of the Jewish race. With success came re-examination. In an age in which artists wrote manifestos and critics provided complex and even pedantic explanations of their work, Chagall's peculiar combination of the real and the ideal, the mundane and the fantastic, was certain to inspire a variety of new evaluations.

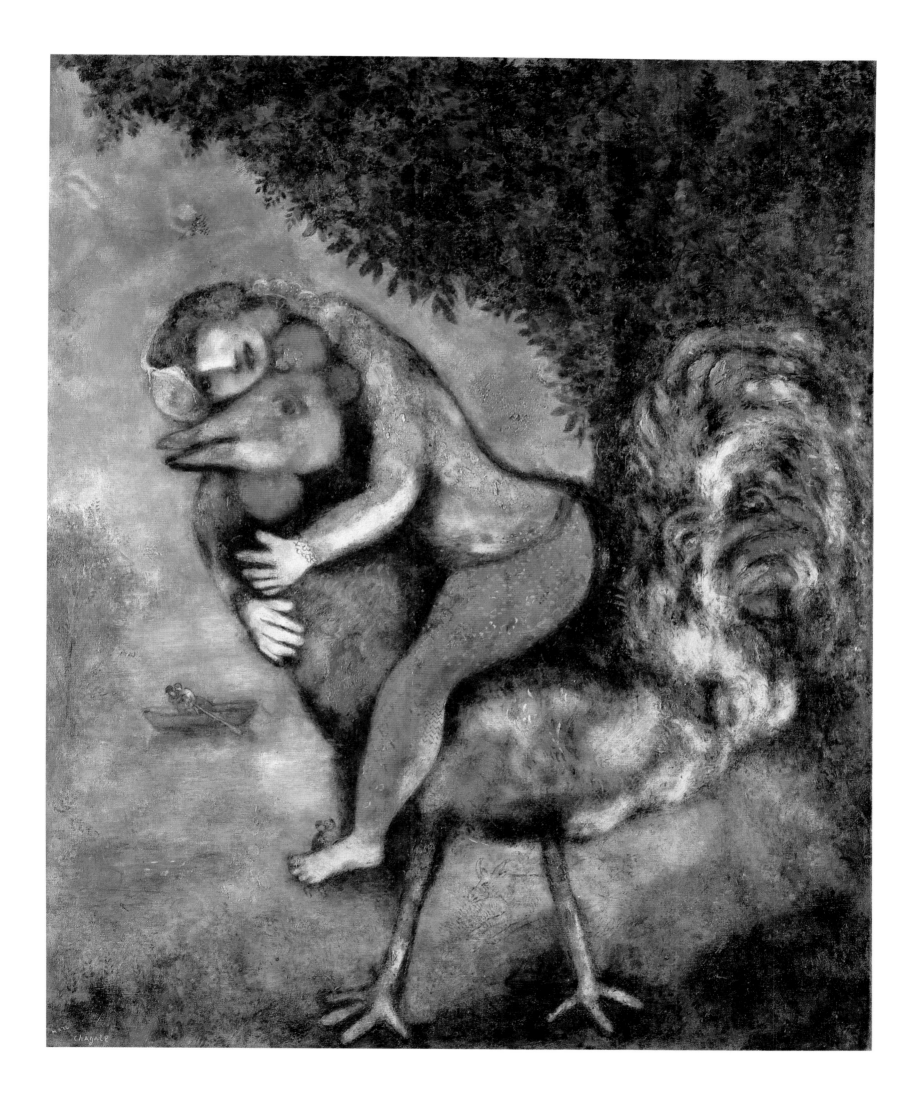

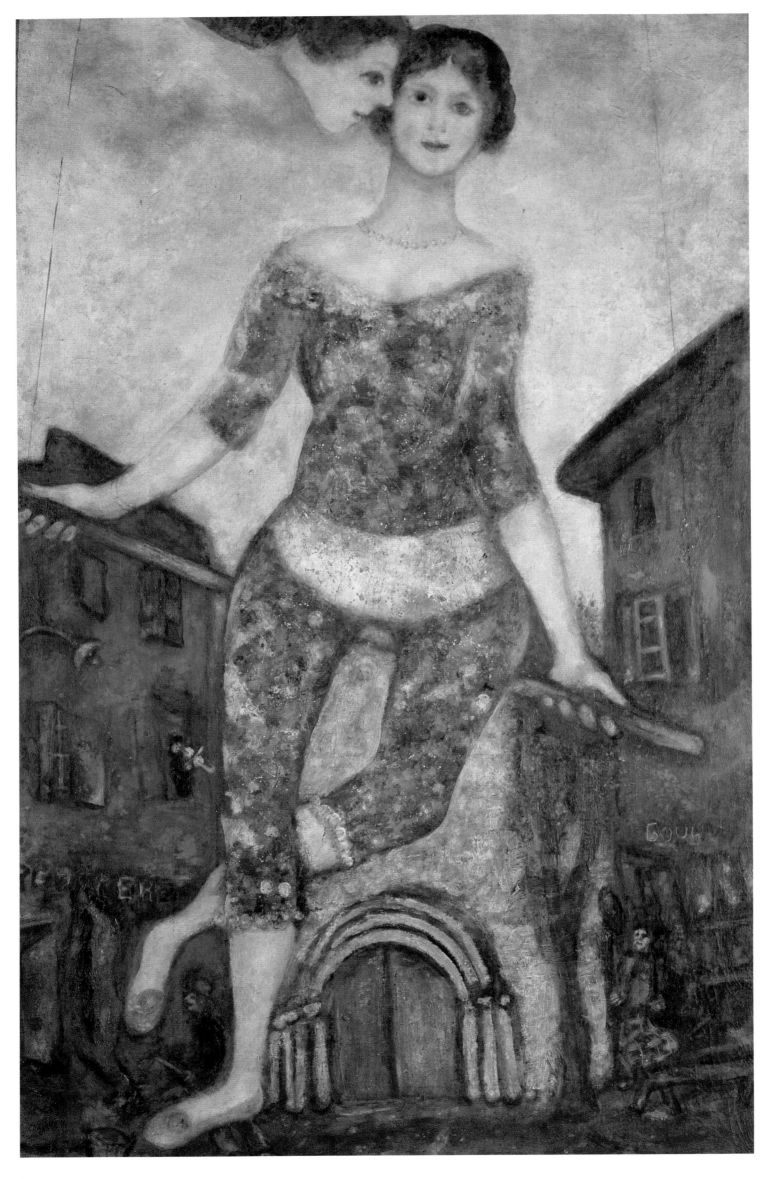

The Acrobat, 1930

Oil on canvas
25⅝×20½ inches (65×52 cm)
Musée National d'Art Moderne Centre
Georges Pompidoa, Paris

Chagall's relationship with Ambrose Vollard continued throughout the 1920s. After executing the etchings for Gogol's *Dead Souls* and La Fontaine's *Fables*, Vollard wanted to employ Chagall on another project. While Chagall was still producing the gouaches on which the *Fables* would be based, Vollard suggested the possibility that Chagall do a series of prints on circus themes. Vollard had a box at the Winter Circus, and he took Chagall there on a number of occasions to observe the performers. The 19 gouaches that Chagall produced at this time did not lead to an immediate publication, but they were published after the War, as were the rest of Vollard's projects. This painting is one example of the works inspired by Chagall's

visits to the circus, and from this point onward circus themes were to occur in his work. The stylized performances of the acrobats, and their seeming ability to transcend the limitations of gravity made them particularly appropriate subjects for Chagall. The fantasy of the circus, its simple appeal and naivety, were elements which had already characterized Chagall's painting. Previously, the circus had provided a theme for the Moscow Jewish Theater murals (1919-20), in which acrobatic motions were used as a metaphor for spiritual joy, and the stylization of such acrobatics as equivalent to the alternative reality provided by the theater itself. In *The Acrobat* the circus theme is simplified but equally metaphorical.

Time is a River without Banks,

1930-39

Oil on canvas
39⅜×32 inches (100×81.3 cm)
Collection, The Museum of Modern Art,
New York

The unusual title of this painting has echoes of the poetic titles given to Chagall's paintings by Blaise Cendrars before World War I. But here the title comes from a saying of Ovid which reflects upon the indefinable nature of time. Why Chagall chose such a recondite subject during this period is something of a mystery: the allegorical nature of the painting has little to do with his flower and circus mood-pieces of the 1920s and 1930s. Instead the imagery bears a striking relationship to that of the Surrealists, whose work he scorned. However, Chagall was not averse to experimenting, even in areas where he had serious doubts. He had been similarly dismissive of the Cubists in 1910-14, but this had not prevented him from trying out their geometric formulas in his own paintings. Chagall painted several versions of this subject, giving different names to each one, and a glance at one or other version shows how he was using visual language in a Surrealist manner. The painting *Winter*, also of this period, is dominated by a winged clock, the face of which substitutes for the face of a naked woman who is nestled inside the body of the clock. The use of a duality between clockface and human face, the presence of the naked woman and the juxtaposition of bizarre, unrelated images are all characteristic of the branch of Surrealism practiced by Max Ernst and René Magritte.

This type of Surrealism has been retrospectively called 'Magic Realism' to distinguish it from the earlier form of abstract Surrealism which involved the use of 'automatic' painting. In *Time is a River Without Banks*, Chagall has removed the woman from the clock to the riverbank, where she lies with her lover. Fish, wings, and clock loom above the river, and this odd juxtaposition of images also, surprisingly, relates to the 'alogical' paintings produced in Russia by Malevich before he became a Suprematist. It seems unlikely that Chagall would have been deliberately borrowing the ideas of his old colleague and enemy, but his vast store of visual experience often resulted in unexpected changes of emphasis.

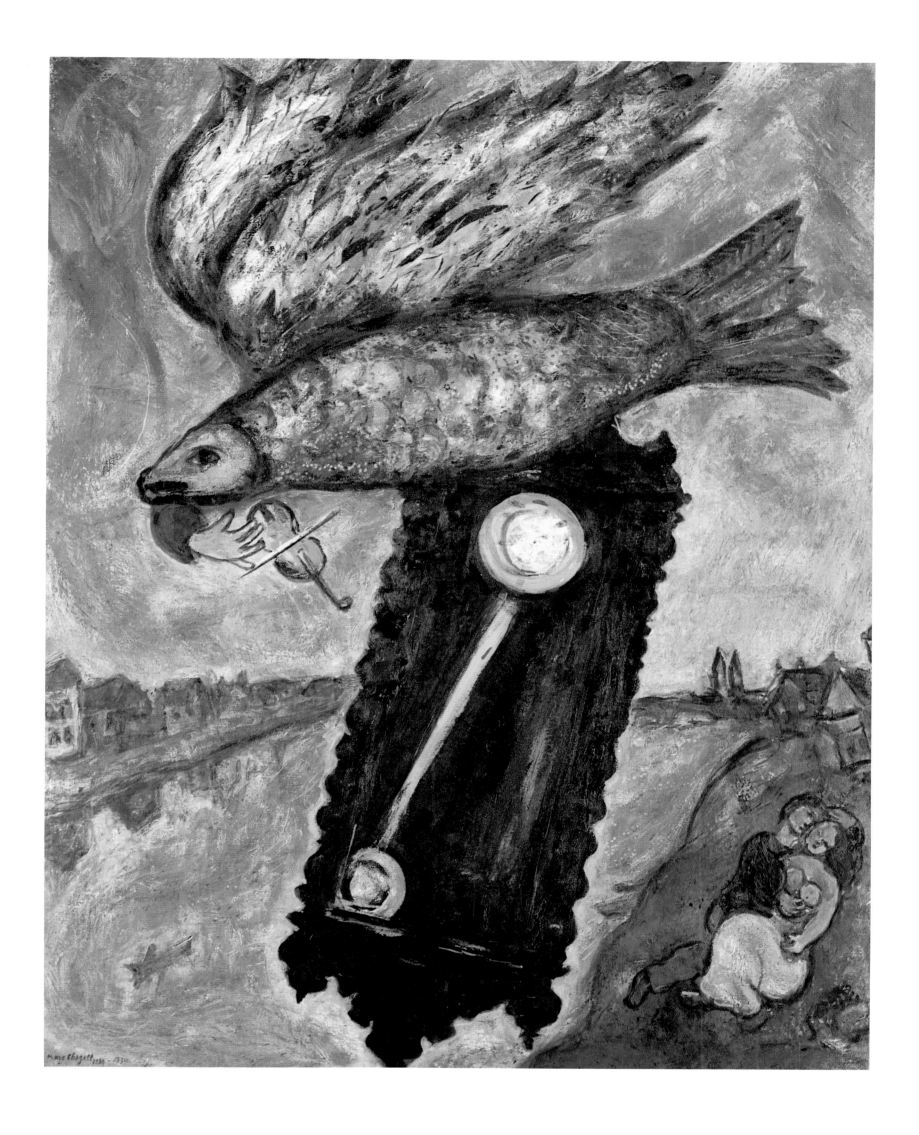

Circus Rider, 1931

Oil on canvas
39⅜×31⅞ inches (116×89 cm)
Stedelijk Museum, Amsterdam

In *Circus Rider* Chagall conflates a number of earlier themes together with his new interest in circus subject-matter. Focusing on the action of the horse and rider, Chagall also brings in a lover, and three violins – one under the horse's chin, one played by a fiddler in the lower right foreground, and another played by a man standing on what appears to be rather unstable scaffolding. Chagall's work for Vollard released his interest in circus themes, which he pursued beyond the specific commissions for Vollard's project. The *Circus Rider* is painted in the manner of Chagall's flower pieces, with the pale, soft colors challenged only by a bright red dash of fan in the rider's hand. The early 1930s were in many ways a period of consolida-

tion, rather than new experiment. Secure in his fame, Chagall during this time arranged for the publication of *My Life* in French. A previous attempt to publish the Russian text in German translation had failed due to the untranslateable nature of Chagall's pithy, poetic writing, and André Salmon was equally unsuccessful in his ambitious effort to translate the work into French. However, Bella Chagall, with Marc's assistance, did her own translation of the work, which proved more than adequate and resulted in the first publication of *My Life* in 1931. The publication of Chagall's autobiography was a gauge of his fame and of the acknowledgement his work had received from a wide range of critics and collectors.

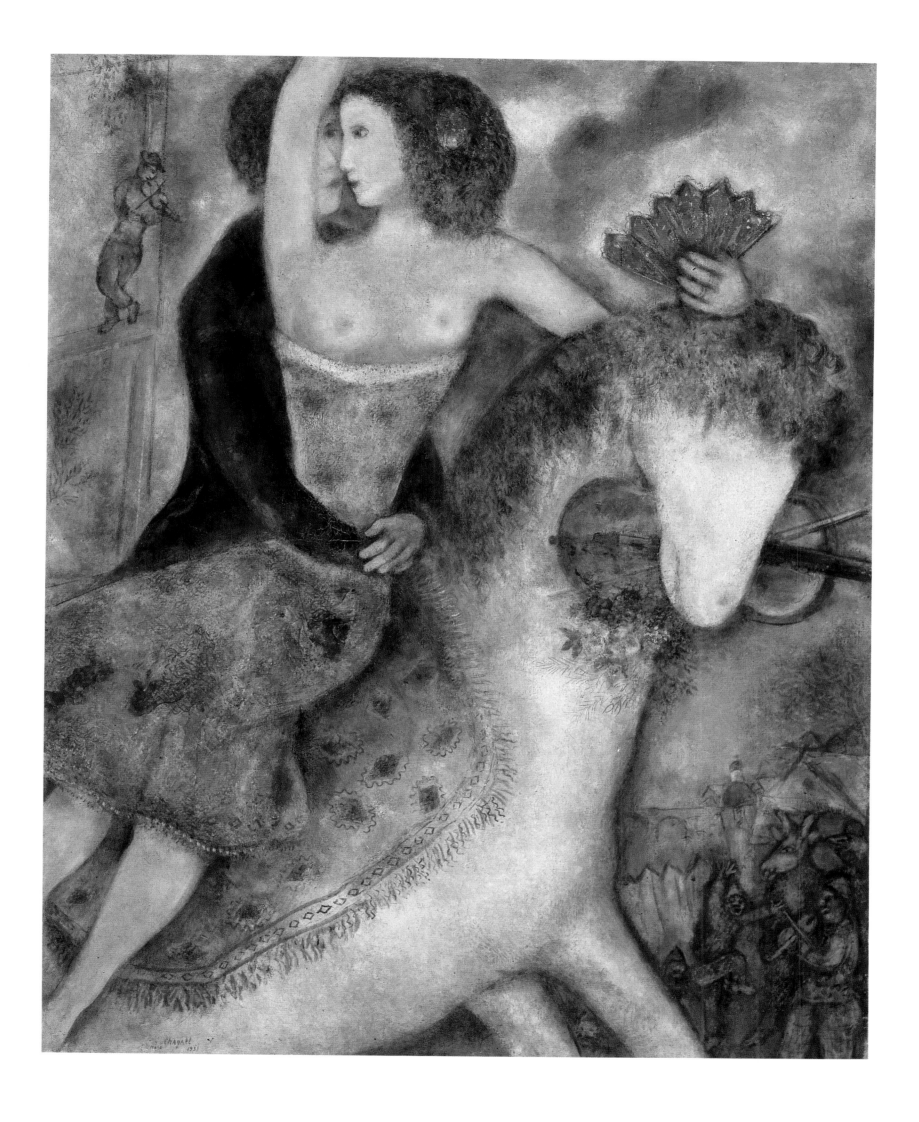

Abraham Preparing to Sacrifice his Son, 1931

Oil and gouache on paper
20⅛×20½ inches (66.5×52 cm)
Musée National Message Biblique,
Marc Chagall, Nice

After illustrating Gogol's *Dead Souls*, La Fontaine's *Fables*, and the Circus, Chagall embarked on his largest project yet for Vollard: a series of etchings to illustrate the Bible. The idea was first put forward in 1931, and was partly at Chagall's instigation. With the Bible etchings, Chagall began showing a new interest in religious subject-matter that would be with him for the rest of his life. Of all his contributions to 20th-century art, the revival of the Bible as a vital source of subject for the artist is perhaps Chagall's major legacy. This gouache is one of the 105 preparatory sketches for the Bible etchings, and it reveals the sensitivity and power that the simple images from the Old Testament contain. As soon as Vollard gave Chagall the Bible commission, the artist and his family prepared to go to Palestine, where Chagall hoped to find inspiration for the vast task ahead of him. There and upon his return, he produced gouache studies for the Bible scenes, and by 1934 he showed 40 etchings in a Paris exhibition. However, the project was a long and laborious one. Chagall painstakingly went over the etchings many times, producing as many as twelve different states of some prints. By the time World War II broke out he had completed 66 plates and had begun 39 more, but he was unable to complete the project until he returned to France in 1948. Through his concentration on Old Testament themes, Chagall hoped to give life to the ancestors of the Jewish race, and his depictions of the familiar Biblical characters both personalize and humanize them. Here Chagall's Hasidic background emerges again, for the Bible stories were to him not fantasies, but reflections of an alternative reality. The characters of the Bible were not fictions, but had a vital meaning and purpose in modern life. This gouache gives only a limited idea of the power of the final etched image, which led Jacques Maritain to write in 1936: 'he guides the etching needle independently of any method, following the example of the old masters.'

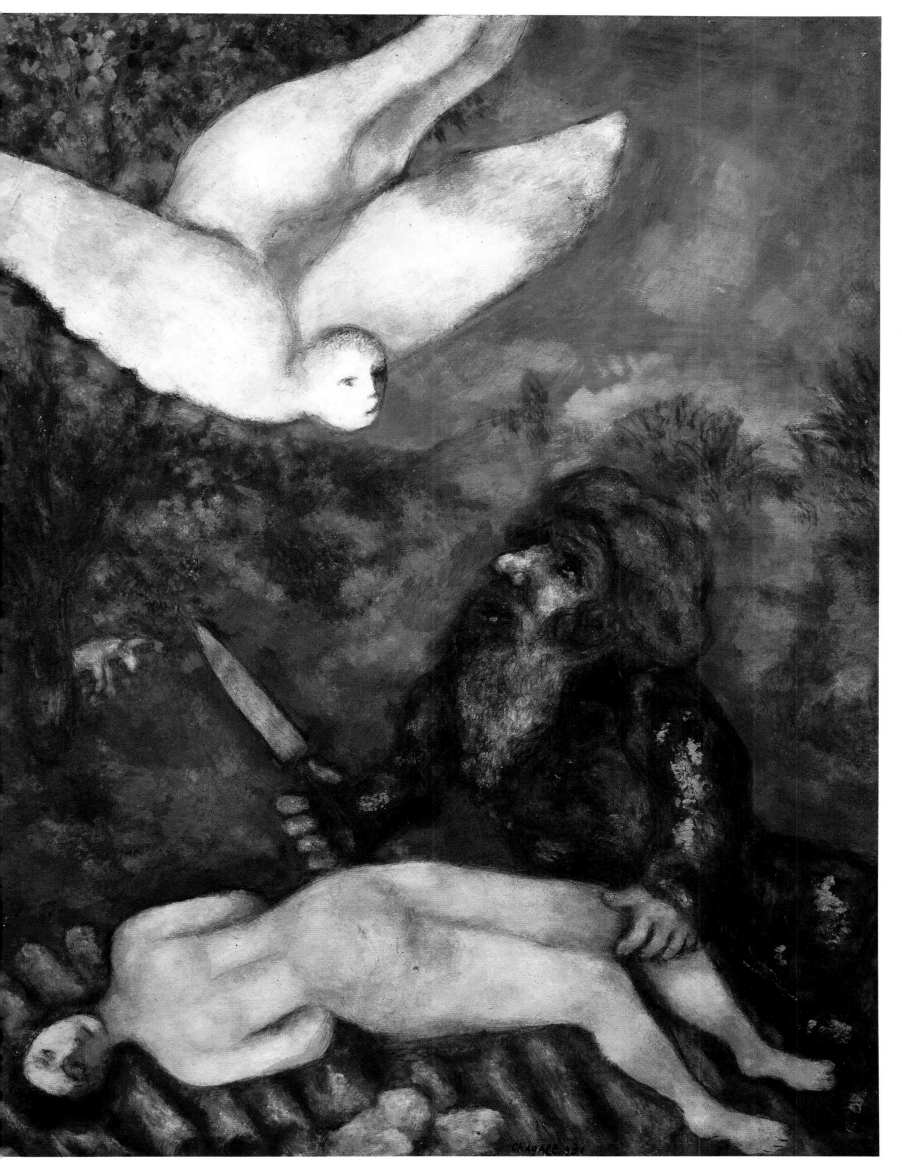

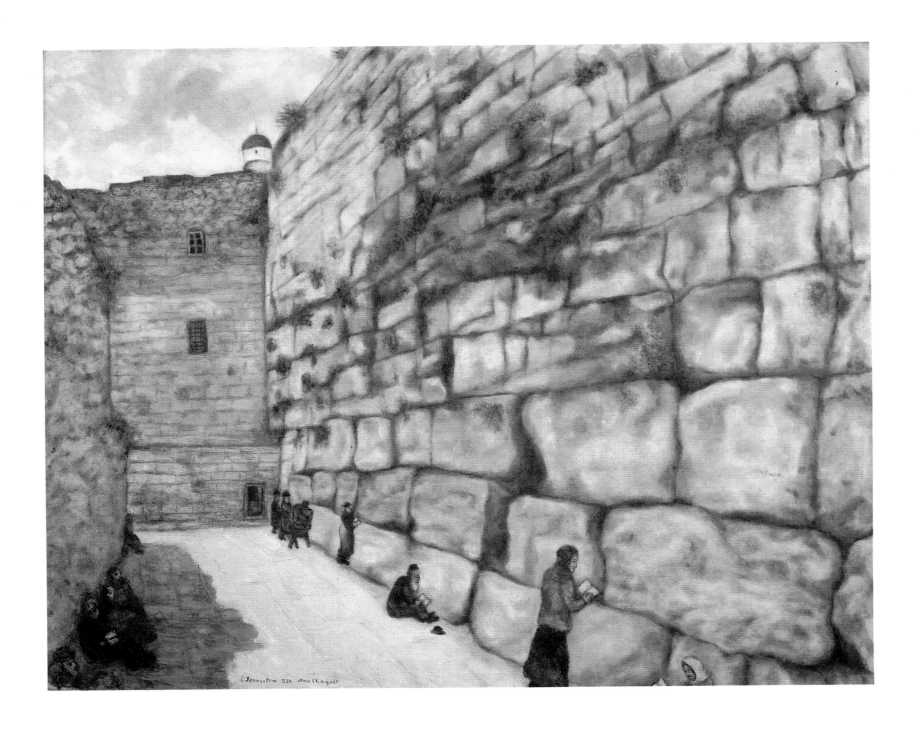

The Wailing Wall, 1932

Oil on canvas
28¾×36¼ inches (73×92 cm)
Tel-Aviv Museum, Israel
Gift of the artist, 1953

Chagall's visit to Palestine in 1931 was a revelation to him in many ways. He traveled through Alexandria and Cairo, saw the Pyramids, visited Beirut, Haifa, Tel-Aviv, and Jerusalem. There something of the documentary spirit of his Vitebsk paintings of 1914-17 returned. Now he was not so much rediscovering his own homeland as discovering for the first time the homeland of his people. The sketches and paintings remaining from this period show Chagall observing the interiors and exteriors of synagogues and, less characteristically, the rough rocky landscape. A photograph of the period shows him with easel and palette painting out-of-doors: such *plein-air* naturalism was not generally characteristic of his style. He was both moved and inspired by the Holy Land. This painting is an example of one of the documentary works from this period, and it shows a symbol rife with connotations for the Jewish people. The Wailing Wall is the legendary remains of the Temple of Solomon in Jerusalem, and Chagall depicts the stark and towering shrine as an object of

pilgrimage and prayer. The diminutive human beings praying at its base are dominated by the ancient symbol looming darkly above them. Chagall's trip to the Holy Land and his subsequent work on Vollard's Bible filled him with a desire to realize a religious spirit and subject-matter in his art. This goal led him to take a number of other trips over the next few years which were designed to enlighten him about great religious art of the past. In 1932 he visited Holland where he was particularly impressed by the paintings of Rembrandt. He had seen Rembrandt's work before, and *My Life* contains the ecstatic exclamation: 'I am sure Rembrandt loves me.' However, he now had the first opportunity to study a number of Rembrandt's works closely, and he was particularly impressed by the power of his religious imagery. In 1934 he went to Spain where he saw the very different religious paintings of El Greco, and in 1937 he visited Italy. He was determined to augment the wealth of past religious art with a new religious art, valid in the modern world.

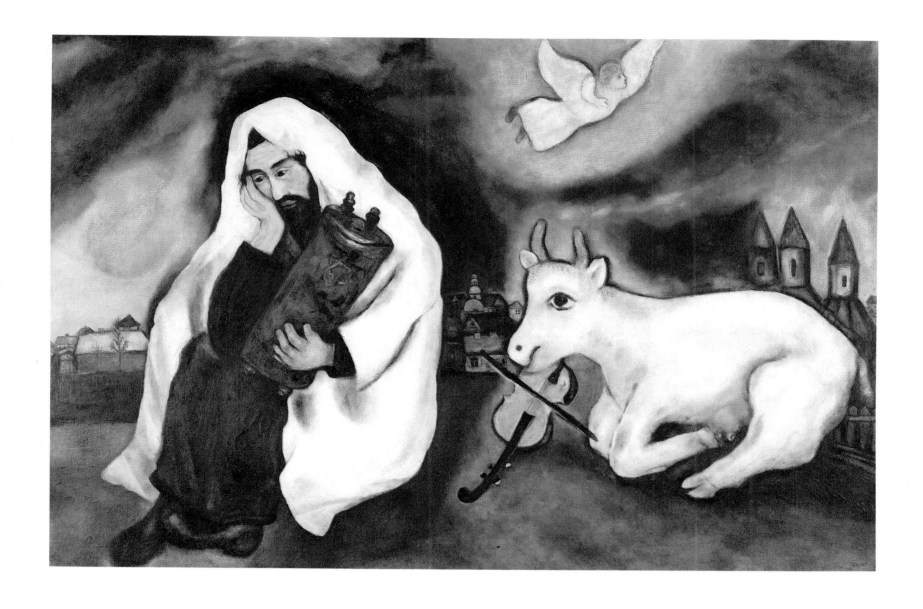

Solitude, 1933

Oil on canvas
40×66 inches (102×169 cm)
Tel-Aviv Museum, Israel
Gift of the artist

Chagall's new interest in religious subject-matter led to a rediscovery of themes that he had tackled in Vitebsk just before the Revolution, and this painting offers one striking example of how these old themes were transformed. *Solitude* shows a rabbi holding a Torah scroll and resting his head on his hand in what appears to be an attitude of resignation. Next to him is a white cow with a violin, above which floats a schematic angel. In the background the familiar outline of the Ilytch church identifies the setting as Vitebsk. In some ways, the painting bears a resemblance to earlier works such as *The Praying Jew*, (*Rabbi of Vitebsk*) (page 78) both in subject-matter and mood. But here Chagall has opened up the composition and allowed elements of symbolism and fantasy to intrude upon the

otherwise realistic representation. The work therefore takes on the trappings of an allegory: the rabbi represents the hope and despair of the Jewish people and the heifer perhaps signifies Israel. The simple composition contains an atmosphere of poignant hope, and it shows Chagall attempting to universalize his earlier, more realistic, Jewish subjects. Chagall here uses specifically Jewish subject-matter to create an allegorical statement equivalent to that of the Christian religious painting that he was studying in Europe at the time. Not only was Chagall responsible for reviving the Bible as an appropriate subject for a modern painter, but for the first time he created a vital Jewish pictoral idiom which can be distinguished in many ways from its Christian predecessors.

White Crucifixion, 1938

Oil on canvas
61×55 inches (155×139.5cm)
Art Institute of Chicago
Gift of Alfred S Alschuler

Chagall's experiments with religious themes began to take a new turn as World War II approached. He had been living a secure and happy life in France; he had confronted new challenges; and he was an acknowledged leader of the 'School of Paris.' His more complacent attitude toward both his art and his life was disrupted by a visit to Vilna in Poland in 1935. There he was reminded of what the persecution of the Jews actually entailed: he was shocked to see the ways in which Jews were herded into ghettos and treated as little more than animals. As his awareness of Jewish persecution grew, Chagall's paintings show an attempt to symbolize the trials of the Jewish people. White Crucifixion is his earliest and most successful effort. Chagall had long been fascinated by the figure of Christ, whom he saw as a symbol of human and divine love as well as Jewish suffering. Unlike his earlier painting Calvary (page 56), Chagall's depiction of Christ here is not ironic, although he does subvert the usual Christian imagery to create an allegory of Jewish oppression. Christ himself wears the tallith or prayer shawl in place of a loin cloth, and the candles of the menorah burn below him. In his halo is written INRI, which stands for 'Jesus the Nazarene, King of the Jews.' Around him are scenes of destruction and cataclysm. On the left a troop of soldiers storm over a hill, burning a small defenseless village; on the right both the Torah and the synagogue are in flames, while Jews hasten to save them. Originally Chagall's use of symbolism was even more explicit: the soldiers clambering over the hill wore swastikas on their armbands, and the old man in the lower left-hand corner of the painting carried a sign that said 'Ich bin Jude' (I am a Jew). The absence of these obvious symbols does not destroy the work's message, which is one of mingled anger and resignation.

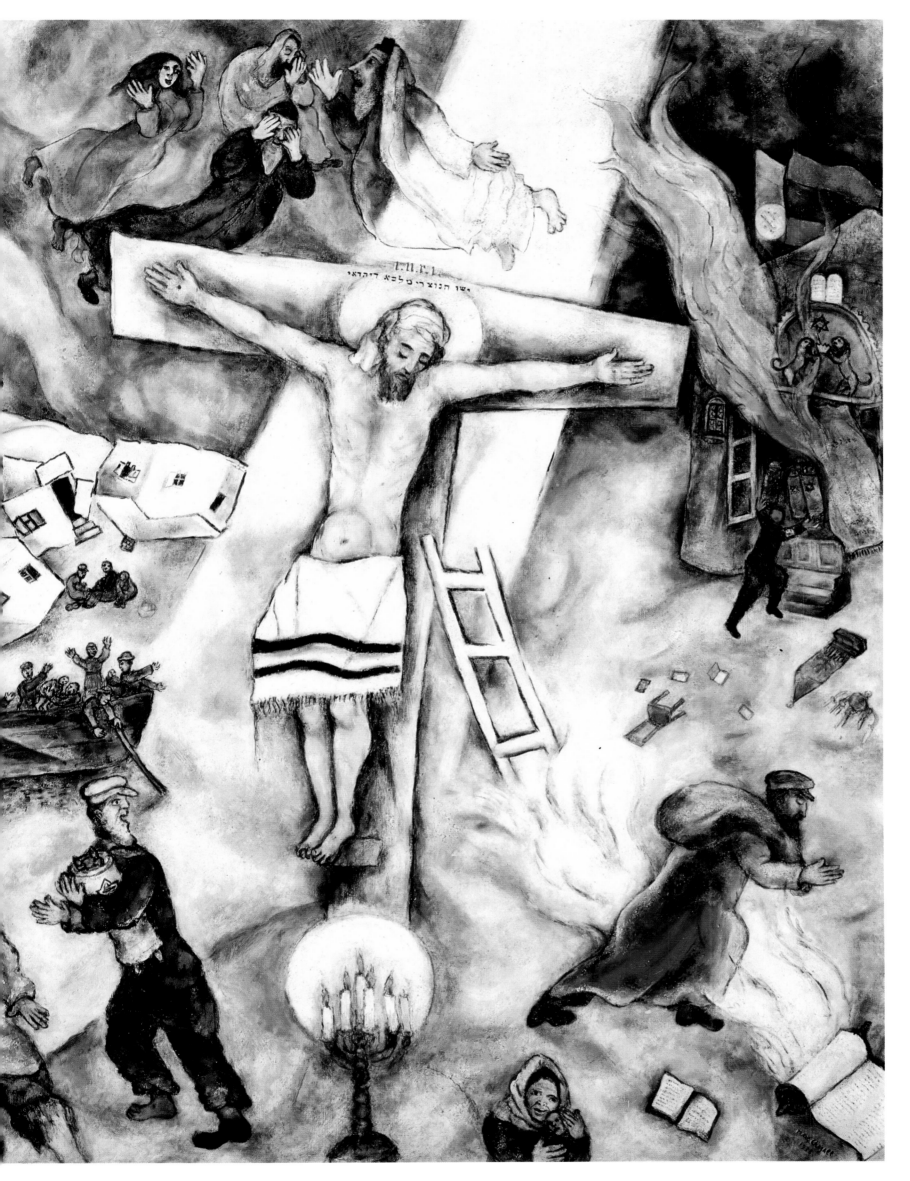

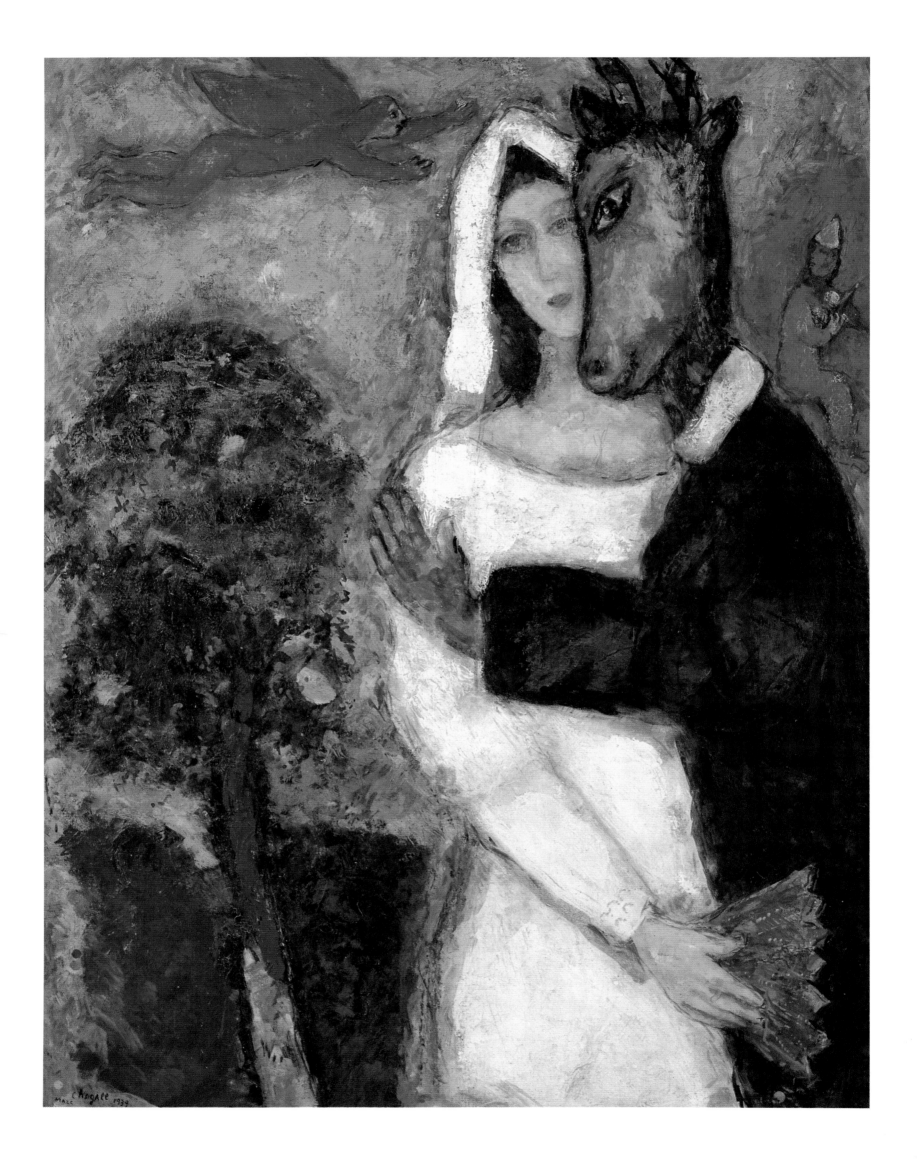

Midsummer Night's Dream, 1939

Oil on canvas
46⅛×34⅞ inches (117×89 cm)
Musée de Peinture et Sculpture,
Grenoble

As the tensions leading up to World War II began having an impact on the daily life of French citizens, Chagall and his family moved away from Paris. In the summer of 1939 they spent time in the Loire valley, and soon afterward, Chagall moved his studio out of Paris. At the advice of his friend André Lhôte, he settled in Gordes in Provence a year later. There he was able to purchase a large house with a spacious studio. Obviously Chagall felt that if he were away from the city, he would not be so affected by the troubles that were plaguing Europe. In retrospect, his attitude seems especially extraordinary given the growing anti-Semitism that intensified when the Germans occupied France. But Chagall hung on tenaciously to his security and continuity, not leaving France until it became impossible to stay there. While in the Loire valley in 1939 he painted this work which, rather unusually, illustrates a specific literary text. The title of the paint-ing suggests that it represents Titania and Bottom from Shakespeare's *Midsummer Night's Dream,* but other elements, such as the red angel and the green violinist, bear no direct relation to Shakespeare's play. Instead, Chagall seems to be replaying an old theme: the bestial nature of human beings and attempts to resolve the contra-diction between the bestial and the spiritual. Earlier works such as *The Dream* (page 104), *The Cock* (page 111), and *Circus Rider* (page 117) show a woman being transported by an animal. In all of these paintings, a sexual undertone prevails. The potential meaning of the *Midsummer Night's Dream* is enhanced by the fact that the woman is dressed as a bride – a motif that Chagall would repeat frequently over the next few years. The concept of the vir-gin bride gives the painting an added dimension, representing the essential spiritual nature of human sexual relation-ships.

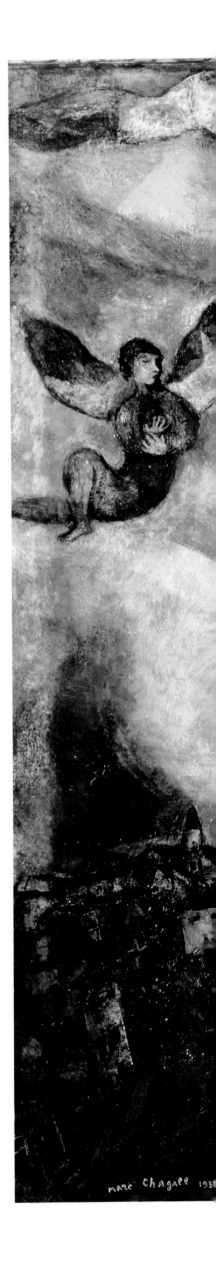

The Madonna of the Village,

1938-42

Oil on canvas
50½ × 38½ inches (102 × 98 cm)
Thyssen-Bornemisza Collection

The bride figure disguised as Titania in the *Midsummer Night's Dream* (page 124) emerges here in the character of the Madonna. Chagall's reinterpretation of the Christ theme here extends to another Christian emblem, but he uses the Madonna subject in a very particular way. The Madonna wears the costume of the bride, signifying for Chagall a symbol of the spiritual nature of sexual union between man and woman. The theme of unity through love had long been prevalent in Chagall's art, but during the 1940s the Madonna or bride image emerged in this context. Other aspects of the work relate more directly to earlier themes in his paintings: the Russian village, the glowing candle, the trumpeting angels, and the vio-lin-playing cow. This was one of many paintings that Chagall took with him when he went to America in 1941. He resisted this exile as long as he could, but it soon became impossible for him to do so. After moving to Gordes, he still contributed to exhibitions in Paris, despite the growing tensions in that city. Although Chagall hesitated about leaving Europe, a visit from the head of the American Emergency Rescue Committee convinced him of the danger of remaining. In April 1941, Chagall and his family packed up his paintings and moved to Marseilles, from which they went to Lisbon and then sailed to America. Chagall's trip to America was in response to an invitation from the Museum of Modern Art, who had also invited Matisse, Picasso, Rouault, Ernst, and others. Having learned from his earlier mistakes, he arranged for a larger number of his paintings to be transported to America as well, so he was able to continue with projects that he had begun in France. The *Madonna of the Village* is one such work.

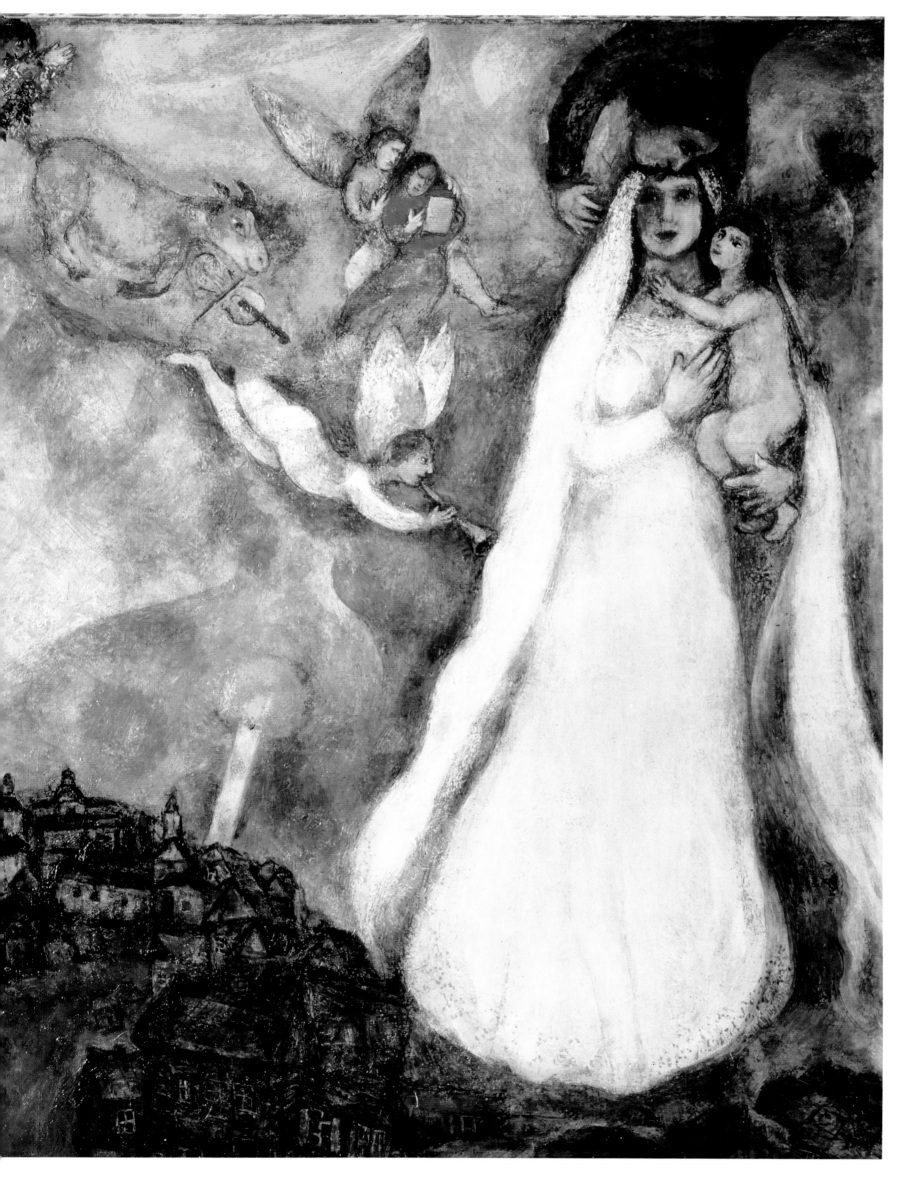

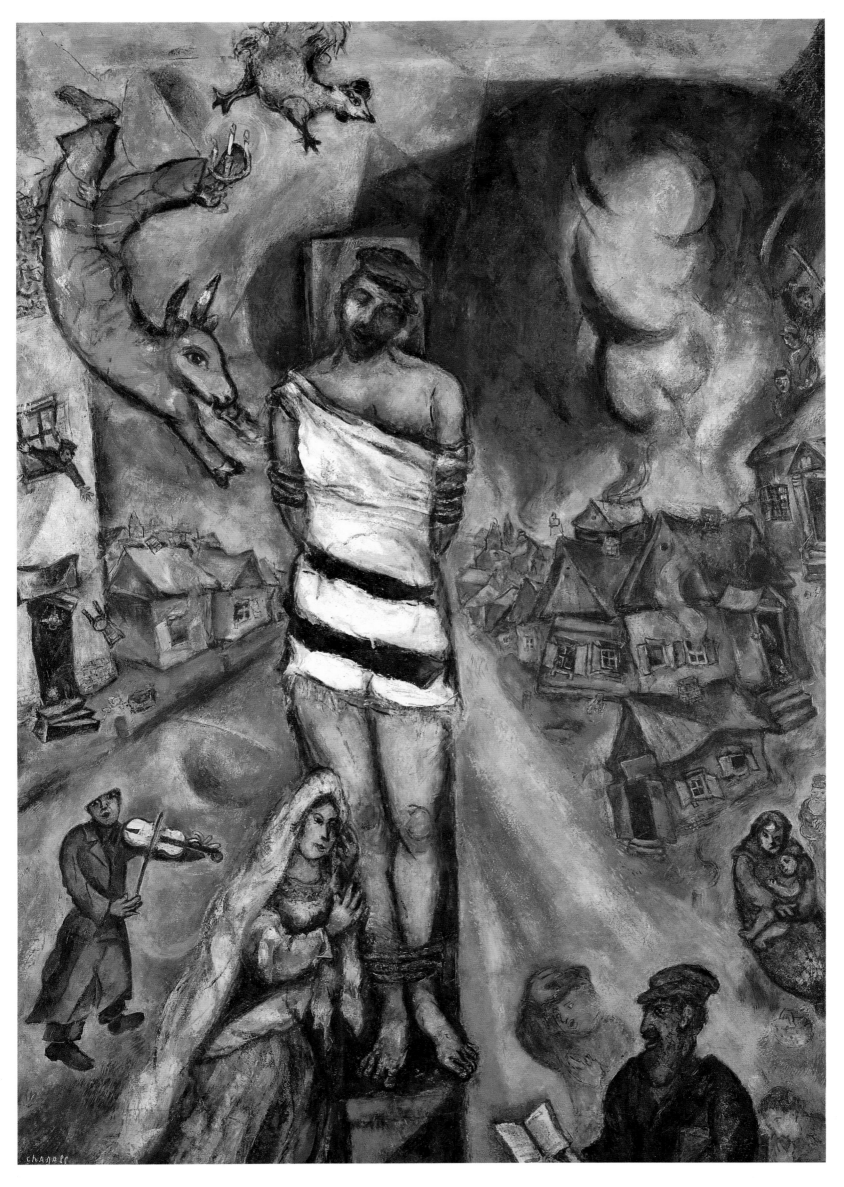

The Martyr, 1940
Oil on canvas
64¼×44⅞ inches (164.5×139.5cm)
Kunsthaus, Zürich
Donated by Electrowatt SA, Zürich

Crucifixion themes dominated Chagall's art during the early part of World War II, and this one shows a reworking of the *White Crucifixion* (page 122). However, this time Chagall focuses more generally on martyrdom, and a man tied to a post substitutes for the Crucified Christ. The composition is fussier and less convincing than that of his *White Crucifixion*, as Chagall could not resist cluttering the painting with his characteristic imagery. The burning village behind the martyr serves as a backdrop for a flying donkey and rooster, a wandering violinist, and Chagall's supernumerary Russian peasants. More significantly, the martyr himself wears a Russian peasant cap and is wrapped in a Jewish prayer shawl. The identification of this character as both Jewish and Russian relates to other crucifixion scenes of the period, in which Chagall substitutes his own figure for that of the crucified Christ. The figure at the base of the cross represents the now-common bride/madonna, but her weeping attitude also links her with Mary Magdalen. Chagall continued to produce crucifixion and martyrdom scenes after his arrival in New York, and although he intended them to be sympathetic to the Jewish cause, many Jews in New York found his use of Christian imagery distasteful.

A Fantasy of St Petersburg, 1942

Design for *Aleko*
Watercolor and gouache on paper
22×28 inches (55.9×71.1cm)
Collection, Museum of Modern Art,
New York

One of the great advantages of being in America was that it allowed Chagall to renew his contact with the theater. This opportunity came about when he was commissioned by fellow Russian Léonide Massine to design sets for the New York Ballet Theater's production of *Aleko*. The ballet *Aleko* was based on Pushkin's poem 'The Gypsies' with music by Tchaikovsky, so it was a thoroughly Russian production. The story involves a youth who seeks adventure by joining a band of gypsies. He falls in love with the daughter of the king of the gypsies, and when she betrays him, he kills both her and her lover. Chagall designed four scenes for the ballet, using color brilliantly and unapologetically. For the first time, he was able to create compositions on a massive scale, and many of his old themes return in this new context. The four scenes depict respectively: lovers flying through the air, a large bouquet of flowers, a brilliant yellow sun, and finally the flying horse represented here. None of the scenes related directly to the action of the ballet; they were instead poetic accompaniments, using a full range of color and subject-matter. Indeed, the overwhelming impact of the set designs inspired the critic of the *New York Times* to write: 'So exciting are they in their own right that more than once one wishes all those people would quit getting in front of them.' Although seemingly enthusiastic about Chagall's artistic ability, the critic's comment could also be read ironically. Chagall's desire to see his art in its full glory on a large scale was not necessarily conducive to a unified theatrical performance. He also designed the costumes, and was consulted on the lighting, props and even choreography, so the visual effect of *Aleko* was bound to be somewhat overpowering. Chagall traveled to Mexico to supervise the ballet's premiere in September 1942. A month later, it reopened in New York.

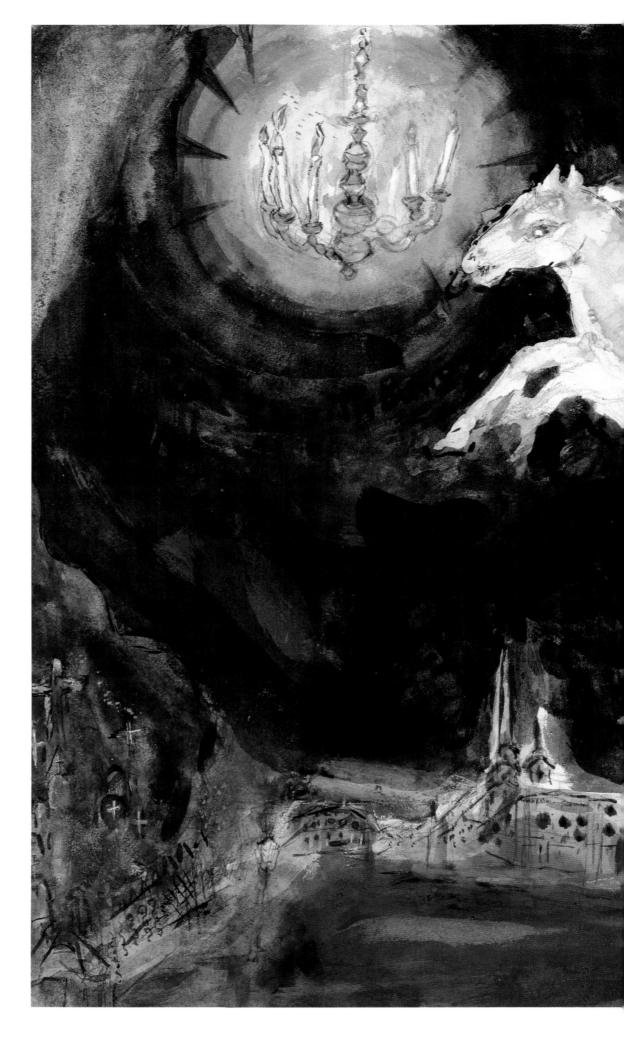

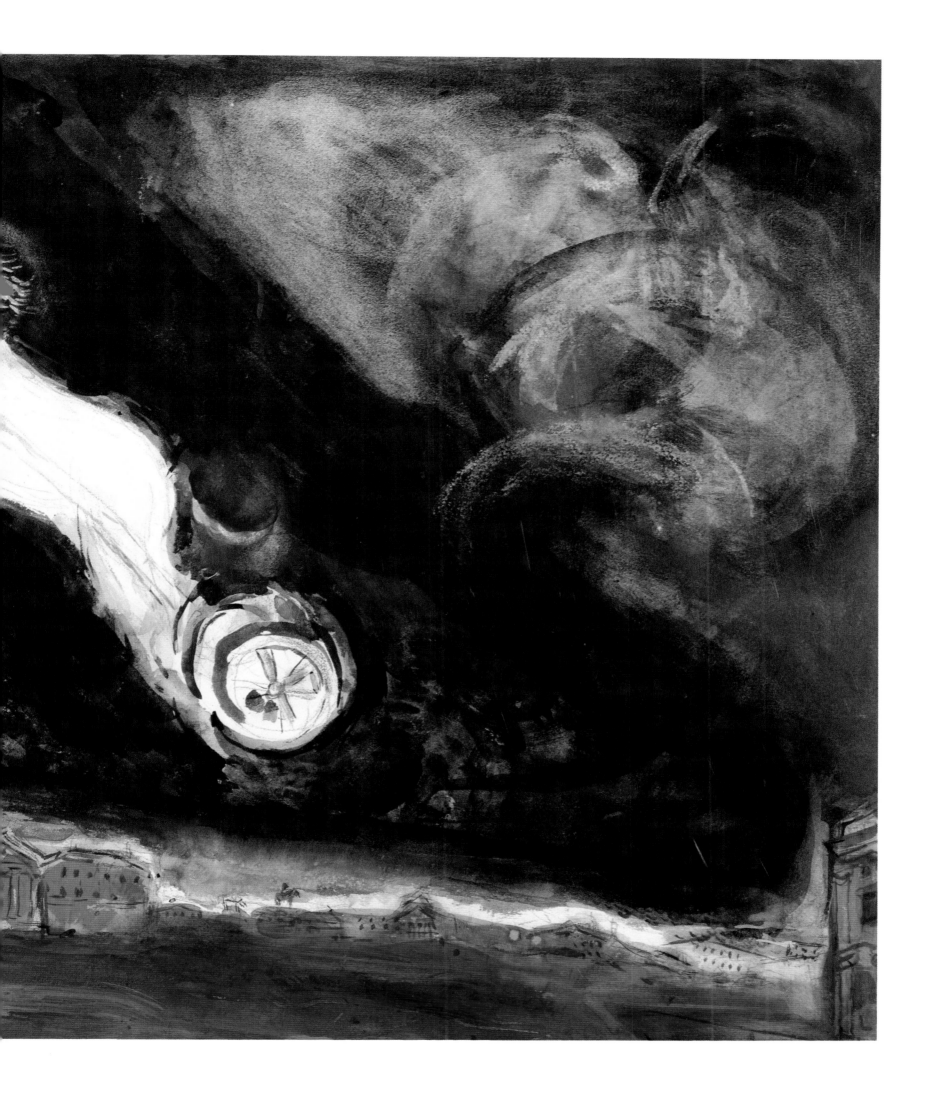

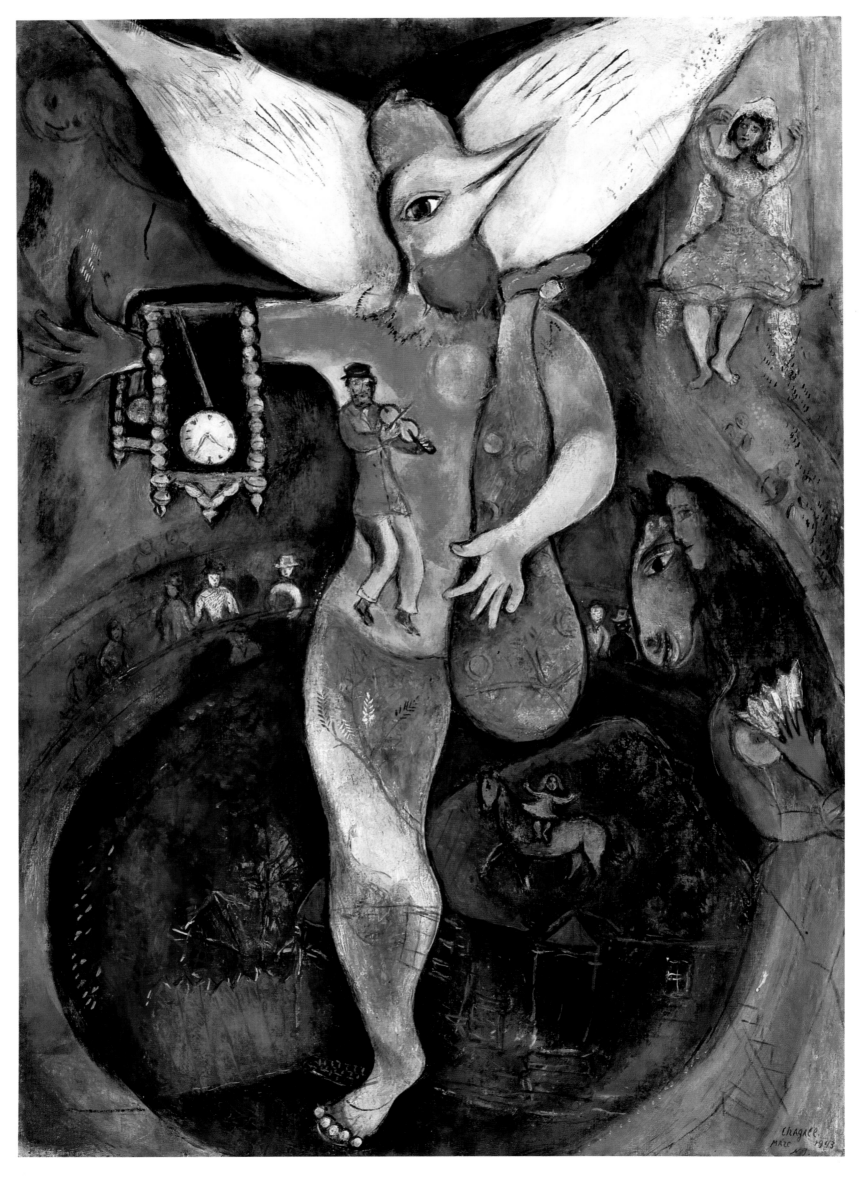

The Juggler, 1943

Oil on canvas
42⁹⁄₁₀×31 inches (109×79 cm)
Art Institute of Chicago

Chagall's trip to Mexico to supervise the production of *Aleko* renewed his interest in bright color. The penetrating sun of Mexico had a similar effect upon him as that of the South of France, and this painting was one of the results of his visit there. *The Juggler* combines a number of elements characteristic of previous paintings, and the overall symbolism contains echoes of the Cabalistic devices that he used in such early works as *Homage to Apollinaire* (page 44). In this painting, circus and animal imagery came together. Chagall has gone beyond the simple depiction of circus performers; his juggler is both an acrobat and a rooster standing in a ring which contains a Russian village. The circus ring thus becomes a symbol of the earth, over which the strange rooster-headed acrobat performs. Later in his life, Chagall described the effect circus imagery had on him:

I always considered clowns, acrobats, and actors to be like tragic humanity, who, for me, resemble characters in certain religious paintings.

Chagall's attribution of a religious poignancy to the circus is realized in this allegorical painting. Another theme which returns here is the idea of unity between man and woman. The male symbol, the rooster, provides the head for the body of a female acrobat: together these elements form an allegory of union similar to that represented by the two figures emerging from one body in the earlier *Homage to Apollinaire*. Another common Chagallian motif in this painting is the clock, which the rooster/acrobat wears over its arm as if it were a phylactery. The clock is used in an overtly symbolic, even Surrealist, way, as it was used previously in the strange allegory *Time is a River Without Banks* (page 115). However, Chagall's personal symbolism can never be interpreted too literally, nor does it ever relate entirely to the deliberately dream-like vistas of the Surrealists. *The Juggler* shows that he was still using a personal language in his art during his time in America, and that the thrust of his themes had altered slightly in form, but had not changed in substance.

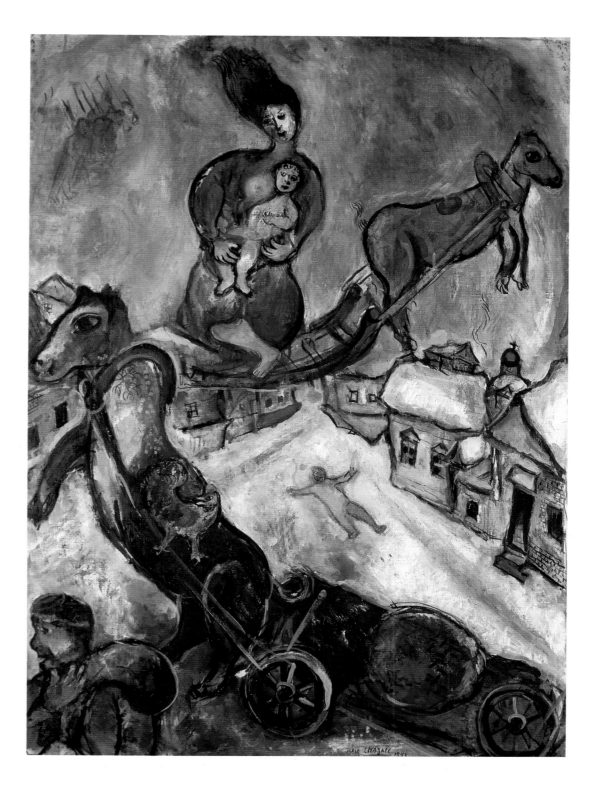

The War, 1943

Oil on canvas
41³⁄₈×29⁷⁄₈ inches
Musée National d'Art Moderne
Centre Georges Pompidou, Paris

Chagall made the most out of his time in America, but the events in Europe were never far from his mind. During the early 1940s he painted a number of works depicting burning villages, crucifixions, and war. Among these, this painting shows how he used his personal iconography to respond to the psychological, as well as physical, effects of war. In *The War* the familiar Madonna figure returns, hovering over a village suffering from the ill-effects of the cataclysm that has plagued it. The snowy landscape of the village was another element that Chagall used frequently at this time, for he equated the depressing bleakness of winter with the horrors of war. Lying in the street of this snow-filled village is a man with his arms splayed like the Crucified Christ. Allusions to the Crucifixion also occur in many works of the 1940s, including the strange *Flayed Ox* (1947), in which a dying animal takes the form of the Crucified Christ. Chagall's war paintings were obviously deeply felt, but the integration of his sometimes whimsical imagery into such serious subjects was not always appropriate. Apart from pain, exile, and disruption, war also brought Chagall unexpected surprises. In 1943 a cultural mission from the Soviet government brought Chagall's old friend Michoels to New York. Chagall enjoyed his reunion with Michoels, and he sent both a message and two paintings back to the Soviet Union with the actor. Such pleasant moments were infrequent, but welcome, during the years of World War II.

In the Night, 1943

Oil on canvas
18½ × 20⅝ inches (47 × 52.4 cm)
Philadelphia Museum of Art
Louis E Stern Collection

Chagall's success while he was in New York was aided by the dealer Pierre Matisse, who took advantage of the number of famous European artists in America during the War. Matisse arranged group and solo exhibitions of Chagall's work, and was in no small way responsible for spreading Chagall's fame in the United States. Chagall's own artistic aspirations at the time are rather more difficult to determine. He had renewed his contact with the theater and later, in 1947, he had the opportunity to produce a series of exquisite lithographs based on the stories of the *Arabian Nights*. He earned a living that was more than adequate, and was even able to take his family into the country during the summer, just as he had done in France. One could argue that the subject-matter of his paintings had become more serious and directly related to contemporary political events, although his wars and crucifixions do not break away completely from his characteristic imagery. But all of these circumstances do not mitigate the fact that Chagall was not advancing significantly as an artist. He was still reliving his Vitebsk childhood, still relying on an established personal iconography, still eagerly delivering the same ambiguous message about man's spiritual nature. *In the Night* is one such work from this period that reveals rather sadly that his repertoire of imagery was beginning to dry up. The familiar pair of lovers includes the now common image of the bride, standing in the equally recognizable Russian village under a lamp that could have been lifted out of one of Chagall's Russian interior scenes of around 1910. There is little doubt that the War had a damaging psychological impact on many artists, seriously affecting the progress of their work, but it is apparent that the kind of commercial success and international reputation that Chagall was beginning to realize were also endangering his artistic growth. *In the Night* is one of the many variations on old themes that Chagall was to continue to produce.

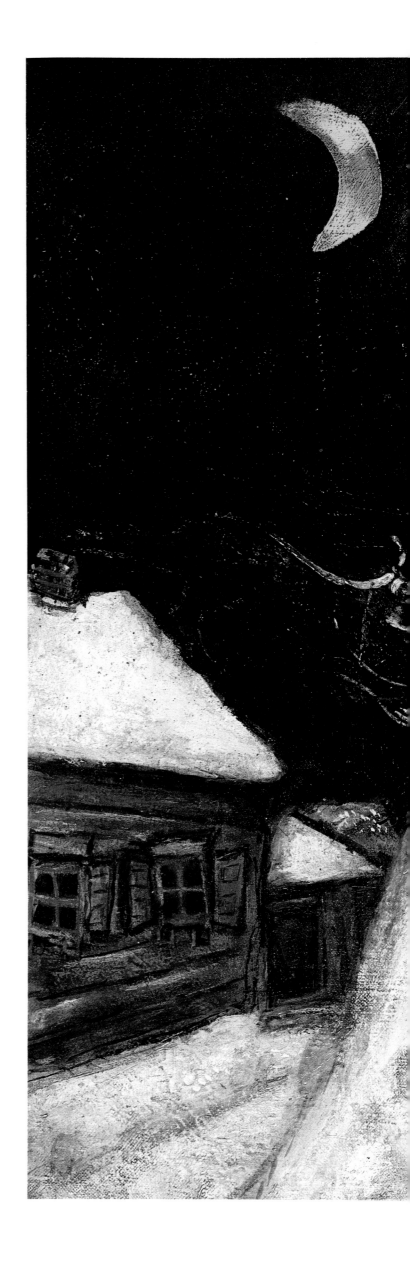

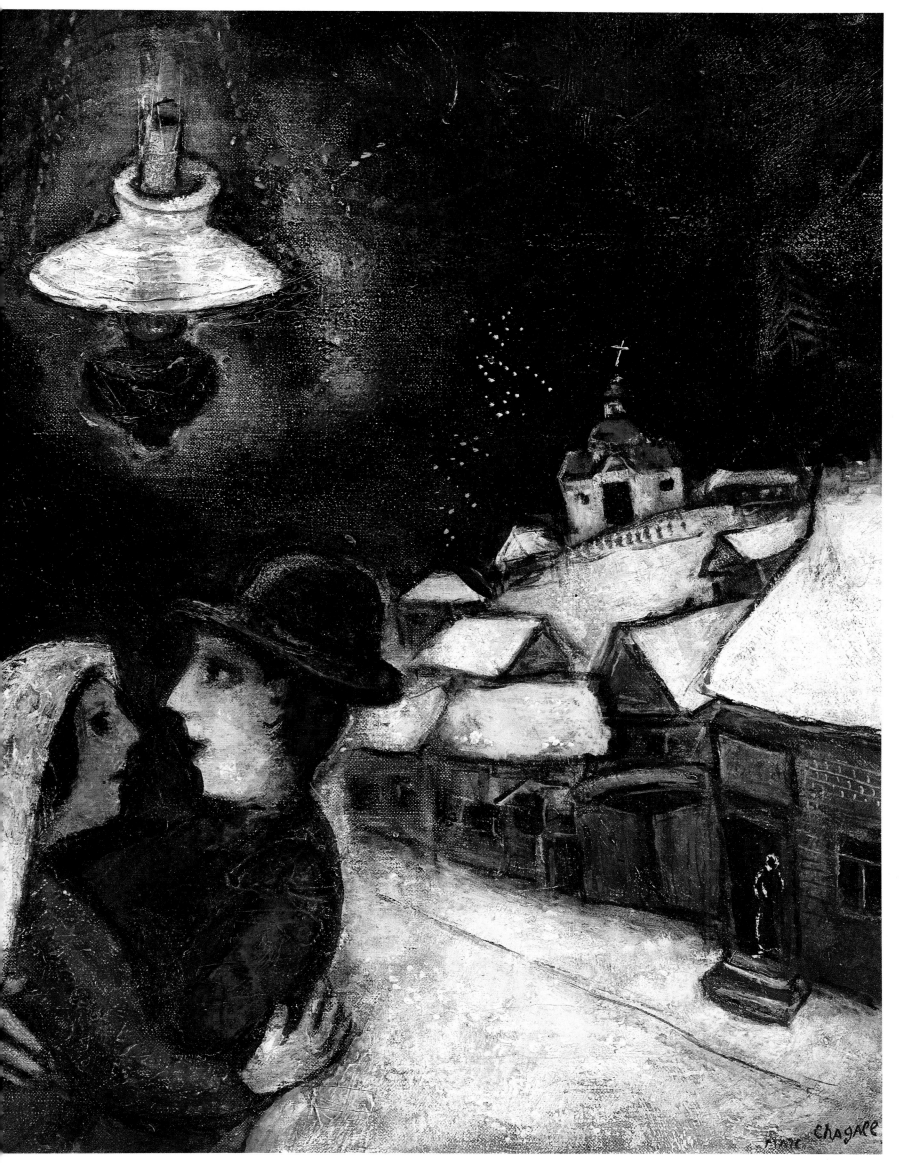

The Soul of the City, 1945

Oil on canvas
42⅛×32 inches (107×81.5 cm)
Musée National d'Art Moderne,
Centre Georges Pompidou, Paris

The gloomy color scheme of this painting reveals Chagall's mood at the time he painted it. On 2 September 1944, his wife Bella died of a virus while they were spending time on Cranberry Lake in New York. The death was particularly tragic, as Bella had only just heard of the liberation of France, and was looking forward to returning to Europe with her family as soon as possible. Equally tragic was the fact that the virus she contracted should not have been fatal, but a number of different anecdotes about the incident suggest that unfortunate circumstances led to the usual treatment not being received. In his state of grief, Chagall did not paint for several months. When he returned to the easel, it was with Bella foremost in his mind. *The Soul of the City* conveys both a tribute to Bella, and the more familiar theme of the sensual/spiritual dualism of man. Chagall himself in the role of the artist stands in the center of the painting. He has two heads,

one of which looks upwards toward a picture of the Crucifixion on an easel, and the other looks down to the white angel who swirls across the picture surface. Some writers have interpreted this indecision as indicative of conflict between the sensual and spiritual – the sensual in this case represented by the ghost of Bella. One may also see the image as indicative of Chagall's state of mind: his grief at the death of Bella was drawing him away from his art. But further imagery clouds both interpretations. A menorah can be glimpsed in the lower left-hand corner of the painting and in the upper left background is an altar which contains both a Torah scroll and the Tablets of the Law. Jewish symbolism thus coexists with Christian symbolism, and here we see perhaps the first glimpse of Chagall universalizing religious experience. It is not the Jewish or Christian which matter here, but the spiritual, in a general or ecumenical sense.

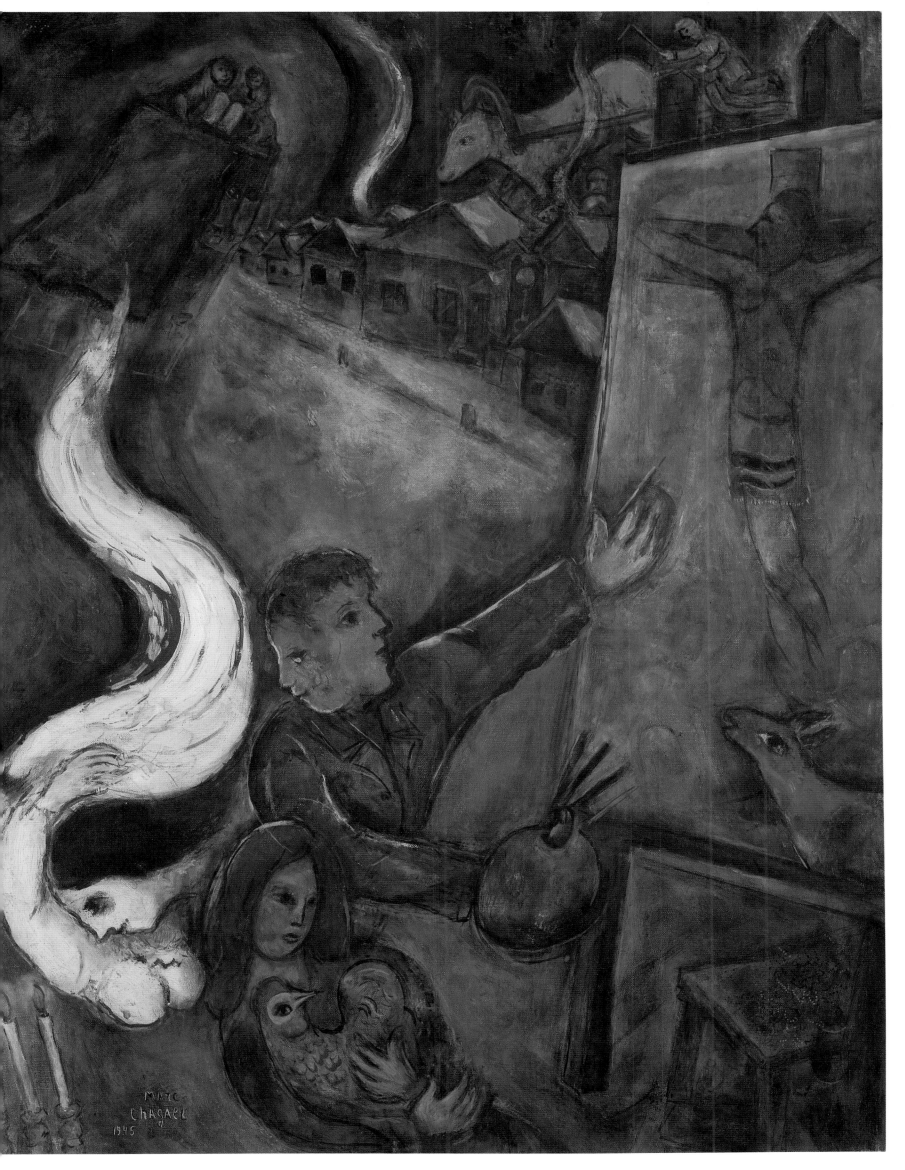

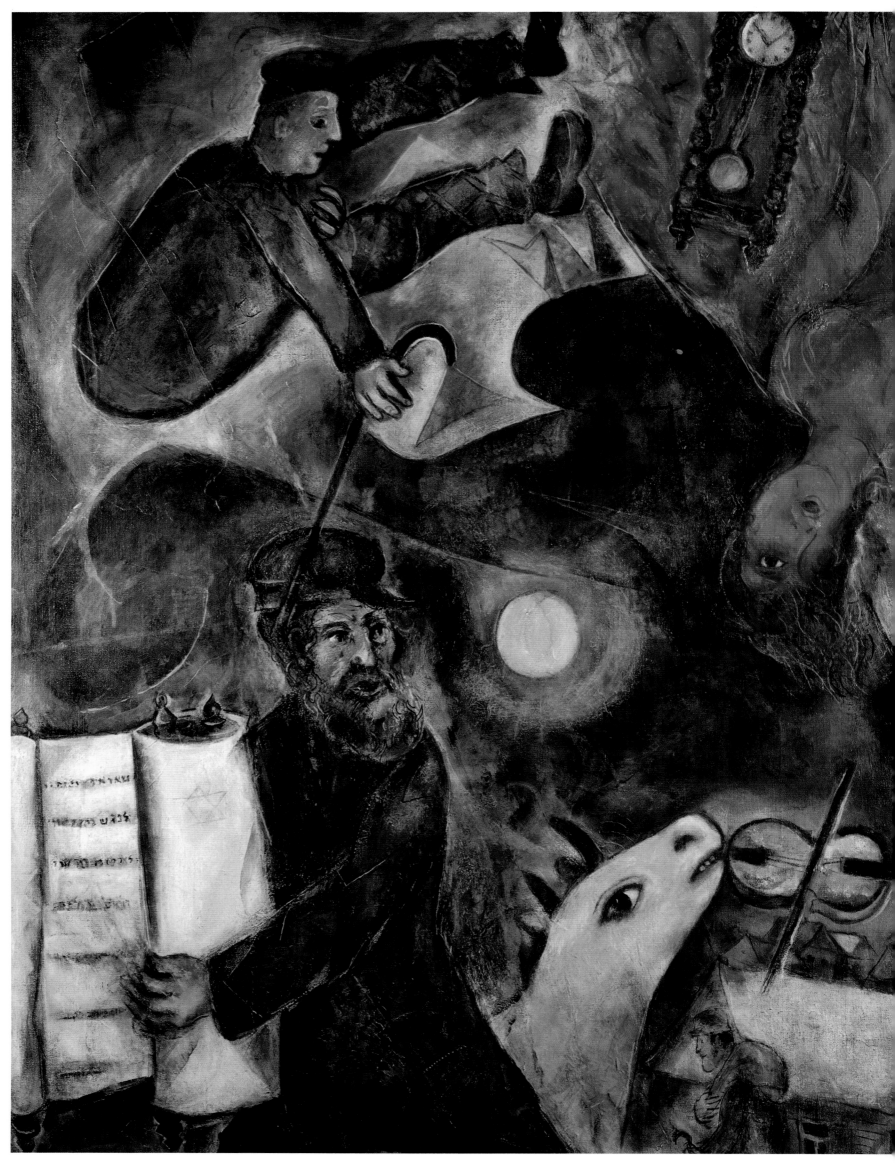

138

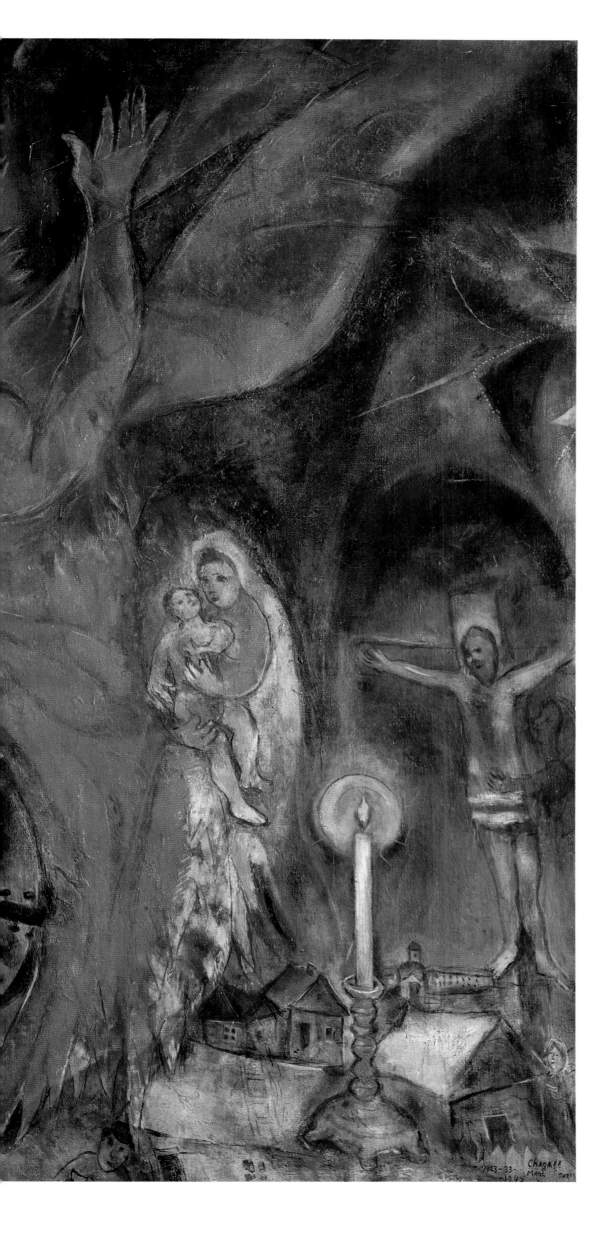

The Fall of the Angel, 1923-33-47

Oil on canvas
58¼×74⅜ inches (148×189 cm)
Kunstmuseum, Basel
Loan of Mrs Ida Chagall

Chagall signed this painting with the dates 1923, 1933, and 1947, signifying the three phases in which the work was produced. The cluttered composition brings together a mass of symbols from the decades in which he was working on the painting, and the meaning is formed by considering these symbols in relation to the world events which may have inspired them. The first version of the painting in 1923 contained only the Jew with the Torah, and the angel, who was not so much falling as soaring downward. In light of the anti-Jewish pogroms of 1933, Chagall reworked the canvas, and added a plunging man as well as an angel. At this time the Jew with the Torah took on a new significance, and could be equated with the Jews fleeing from the destruction of the synagogue in works such as the White Crucifixion (page 122). When Chagall came to America, he brought the painting with him and began working on it again in 1947. At this time he added the symbols of the Crucified Christ and the mother and child – both of which had dominated his war-time painting. In addition, the bright red color of the plunging angel bore a direct relationship to the color schemes he used in his set designs for the New York City Ballet's production of the Firebird, and symbols such as the clock had become established in his art. The apocalyptic nature of the imagery in this painting indicates that Chagall was again trying to use his personal iconography to create an allegory of his time. The art historian Werner Haftmann has compared this work to Picasso's Guernica (Museo del Prado, Madrid; 1937). As Guernica showed the horrors of the Spanish Civil War at the beginning of a period of international conflict, so Chagall's Fall of the Angel offers a post-mortem on its effects. Such a comparison makes a pleasing balance, but perhaps fails to acknowledge how much less communicative Chagall's imagery is than that of Picasso. Although Picasso too used a personal iconography in Guernica, the style in which the work was painted, and the obvious suffering that it depicted provide a more readable allegory of war than Chagall's candles, violin-playing donkeys, and falling angels.

Exodus, 1952-66

Oil on canvas
51⅙×63¾ inches (130×162 cm)
Private Collection

Chagall visited France twice between 1946 and 1948, and he finally settled there in August 1948. He first stayed in the village of Orgeval, near Saint-Germain-en-Laye, and he was near enough to Paris to renew old acquaintances. Later he revisited the south of France, and in 1949 he moved to Vence. Chagall spent a great deal of time during these years seeking to complete projects that he had begun before the War, specifically the publication of *Dead Souls*, La Fontaine's *Fables*, and the Bible. Although Vollard had supplied Chagall with these important commissions, he did not actually publish them, and after Vollard's death in 1939, the War prevented Chagall from concluding the projects with another publisher. But while visiting the south of France, Chagall met Tériade, and they began to make arrangements for the publication of the works. *Dead Souls* was finally published in 1948 with the *Fables* following in 1952. The Bible needed more work and therefore took longer, for Chagall spent a good part of the years 1952-6 working on these etchings. During this time, his interest in Biblical themes continued with a new intensity. *Exodus*, which was painted over a long period, is one example of how he began to use religious themes in what became a controversial way. The figure of Moses carrying the Tablets of the Law is barely visible in the lower right-hand corner amidst the crowd of Israelites who seem to be fleeing from a burning village. However, the figure of the Crucified Christ dominates the painting and casts an interesting potential interpretation over it. The conflation of Old and New Testament themes is a specifically Christian practice, and one wonders if Chagall was unwittingly furthering the cause of Christian iconography here. However, as Susan Compton has pointed out, the Russian/Jewish artist Anatokolsky, whose work Chagall would have known while in Russia, saw Christ and Moses as symbolic of the two aspects of humanity: Christ signified love and spirit, whereas Moses represented law and rules. Here the Hasidic glorification of the spiritual over the earthly can be seen through these familiar Biblical figures.

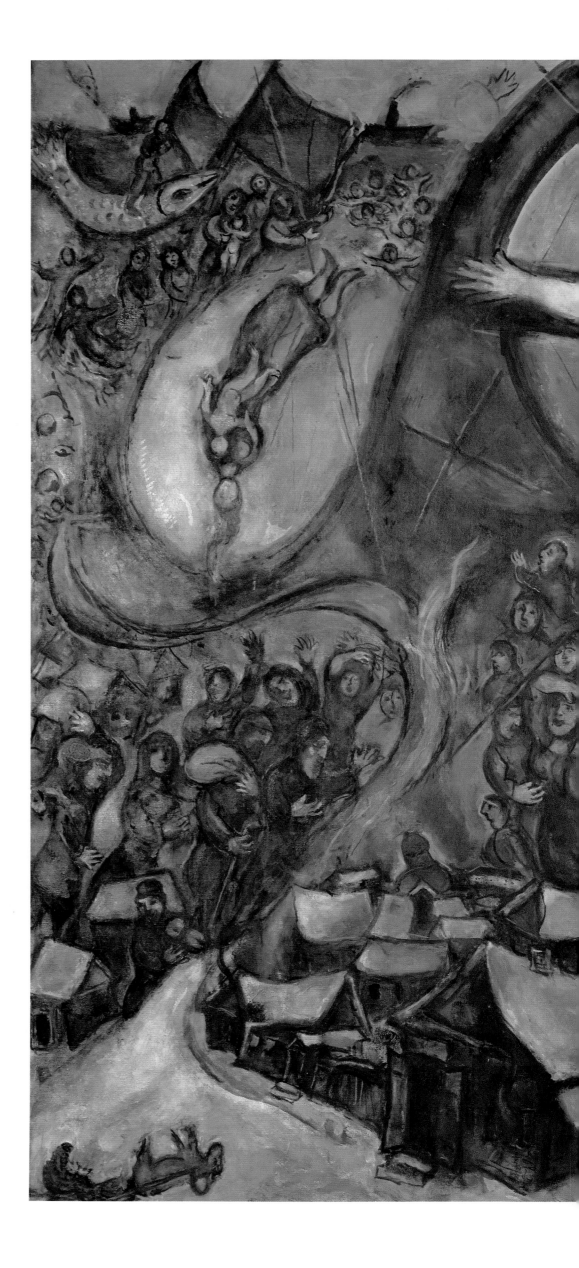

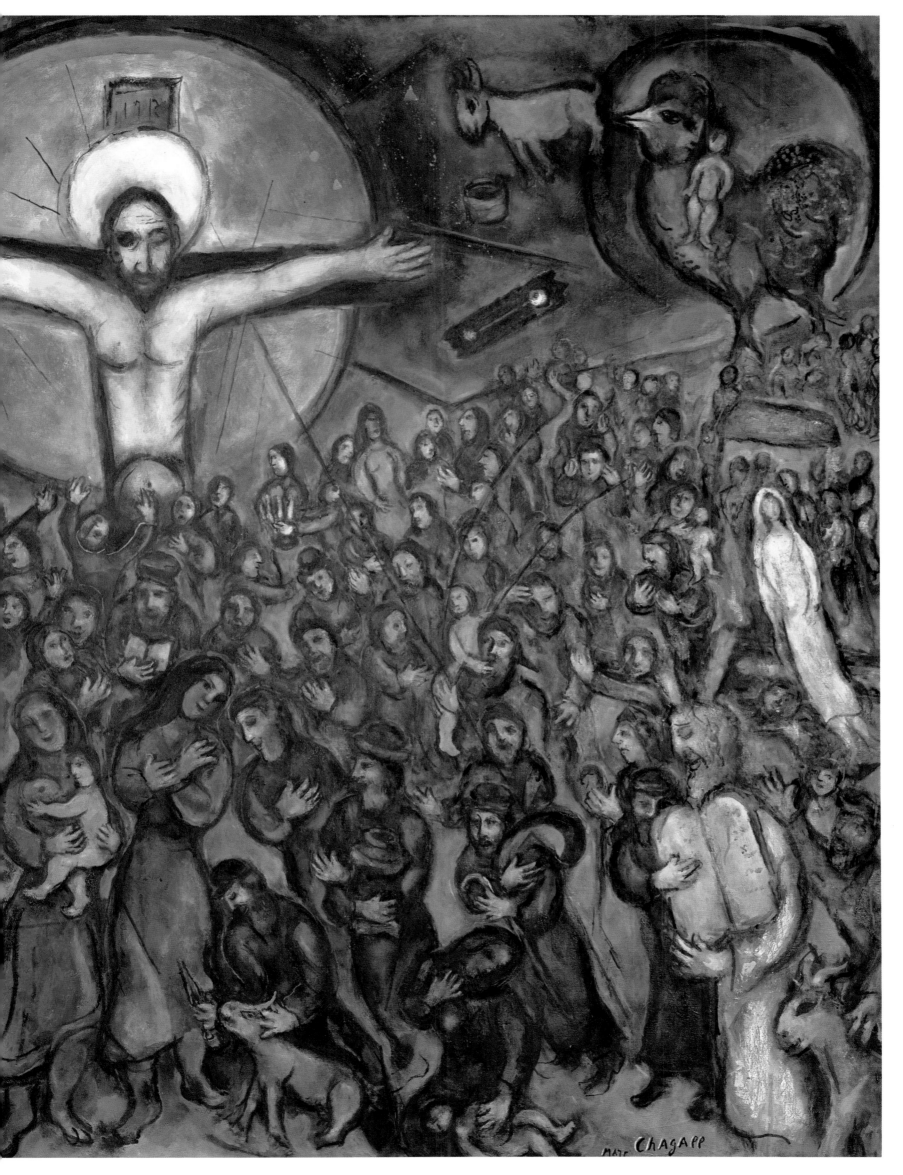

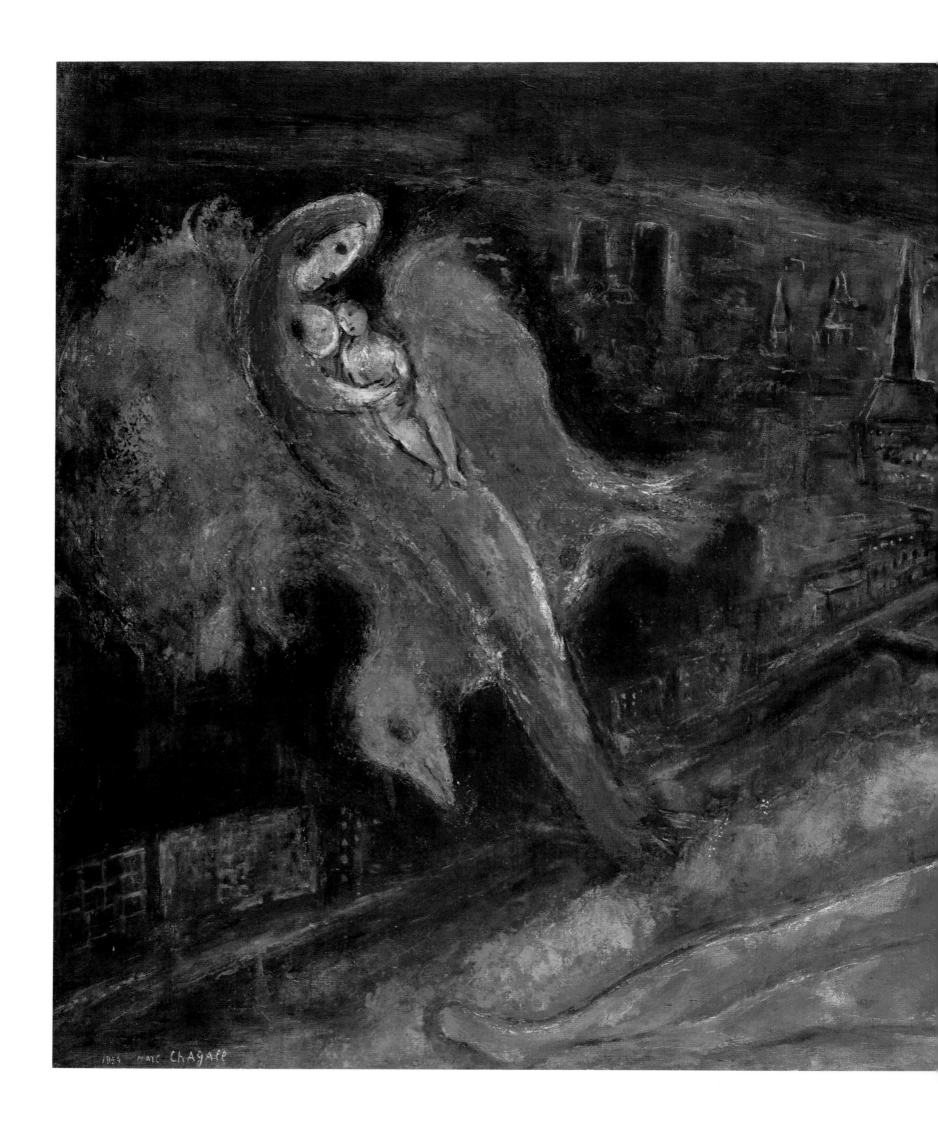

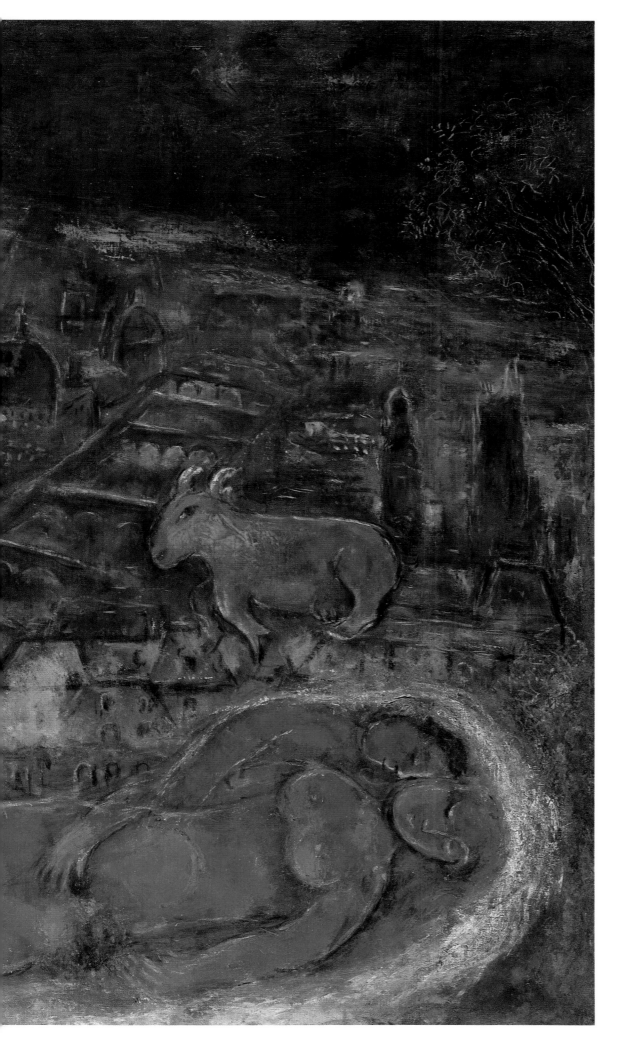

Bridges over the Seine, 1954

Oil on canvas
43⅞×64⅜ inches (111.5×163.5 cm)
Kunsthalle, Hamburg

During his visit to Paris in 1946, Chagall made a series of sketches of the city. As in his return to Vitebsk in 1914 and his first visit to Palestine in 1931, Chagall felt the need to capture on canvas a place that had a special meaning for him. He spoke and wrote about his return to Paris in terms that were both nostalgic and sentimental, and he obviously felt no enduring animosity toward the country whose political situation had been responsible for his exile. However, these sketches were not used until 1952, when Chagall, by then happily settled in Vence, decided to paint a series of large pictures representing various landmarks of Paris. In these works Paris both blends with Vitebsk and overwhelms it, as Chagall's allegiance to his Russian homeland becomes superseded by love for his chosen country. The Paris theme dominated his work during the 1950s. Not only did he produce 29 large paintings, but he also created two sets of lithographs. The first of these was designed for Tériade's periodical *Verve*, and the second was published in 1954 in another periodical *Derrière le Miroir*. The painting *Bridges Over the Seine* was inspired by one of the lithographs Chagall designed for *Verve*, which itself was based on a sketch of 1946. In this composition, the darkened aerial view of the Seine is partly obscured by three luminous figures: an angel/bird/ Madonna with child, a green Chagallian animal, and a pair of lovers.

Le Champ de Mars, 1954-6

Oil on canvas
59×41⅜ inches (149.5×105 cm)
Folkwang Museum, Essen

The city of Paris had appeared in earlier work by Chagall, most notably several pre-War paintings including *Paris Through the Window* (page 62). These works were influenced to some extent by the obsessions of Chagall's friend Delaunay, who was eager to depict Paris as the epitome of modernity and movement. In his later Paris scenes Chagall obliterates any sense of modernity, and in them he uses color not to define movement but to convey mood. In *Le Champ de Mars*, the familiar spire of the Eiffel Tower looms over a village resembling Vitebsk. The presence of the Sacré Coeur in the distance serves to reinforce, rather than deny, this sense of congruence between Paris and Russia, as the dome of the church has a distinctly Eastern feel. However, the most striking aspect of the painting, and of all the works in the Paris series, is the use of color. Although Chagall's subject-matter did not alter significantly in his later life, he became bolder and more experimental with color. Paintings became mood pieces, with one or two striking or overwhelming colors saturating the entire composition. Chagall's new approach to color was consolidated after a trip to Greece in 1952, where, again, the quality of the sun inspired some changes in his art. Chagall traveled to Greece with his second wife, Valentina (Vava) Brodsky, whom he married in 1952 after a relatively brief acquaintance. Vava became a new Muse to replace Bella, but more importantly, she took in hand his business affairs, leaving Chagall free to get on with his painting.

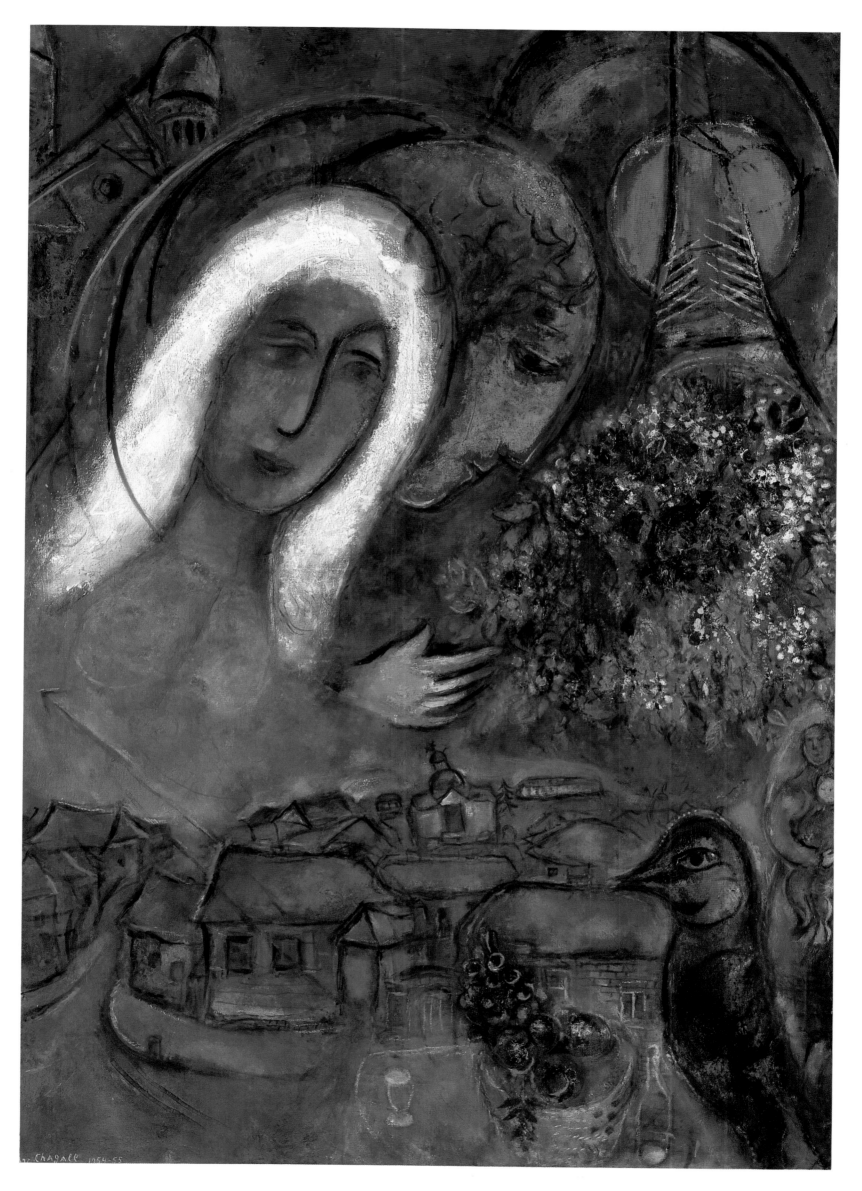

Abraham and the Three Angels,
1954-67

Oil on canvas
74¾×115 inches (190×292 cm)
Musée National Message Biblique,
Marc Chagall, Nice

The idea of painting a cycle of pictures had obsessed Chagall for a number of years, and the Paris series of the 1950s was one attempt to create such a cycle. But Chagall's work for Tériade on the completion of the Bible etchings gave him the idea of a more serious and important cycle of paintings: one which explored the main themes of the Old Testament. Chagall's desire to paint a series of Bible pictures was accompanied by the wish to place such works in an appropriate devotional setting. In this way, the paintings would not just be museum curiosities but objects for religious contemplation. His first chance to realize these ideas came when he was commissioned to contribute stained glass and mosaic to the baptistry of Notre Dame de Toute Grâce on the Plateau d'Assy. Pierre Bonnard had already produced work for this church, and its enlightened priest, Father Couturier, later commissioned work from Rouault, Matisse, Braque, and Léger. To Chagall, however, it was only a taste of what he wanted: although he was a contributor to the project, he did not instigate it or control it. He hoped to be able to mastermind such a religious project himself, and throughout the 1950s and 1960s, he painted works such as this one with the idea that one day they would all hang in the same place. *Abraham and the Three Angels* was painted over a 13-year period, but the composition was based originally on an etching he produced for Tériade's Bible. In this successful and striking painting, Chagall employs a form of spatial fragmentation that he had not used since before World War I. The painting is bathed in a blinding red color, cut across by the three angels who, despite their feathery wings, appear more human than divine. The figure of the aged Abraham adds an almost folk-tale element to the Biblical scene, and here Chagall best exemplifies the Hasidic belief that the characters of the Bible were still vital presences in modern life. Chagall's religious paintings of the 1950s and 1960s reveal his attempt to humanize the Jewish patriarchs in the Old Testament, and to suggest the magic of their experiences through strong, evocative color.

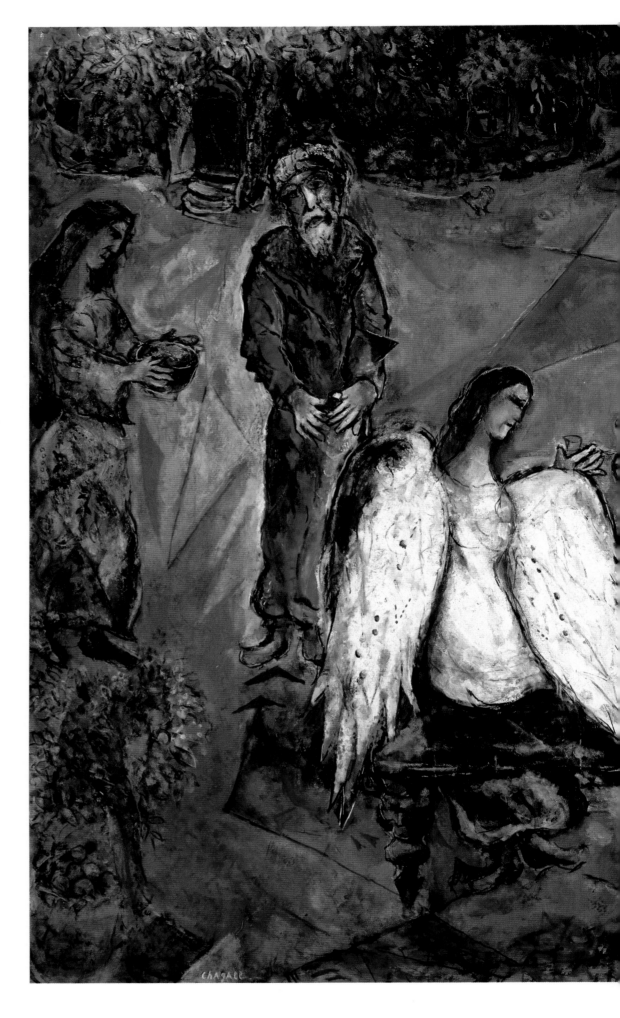

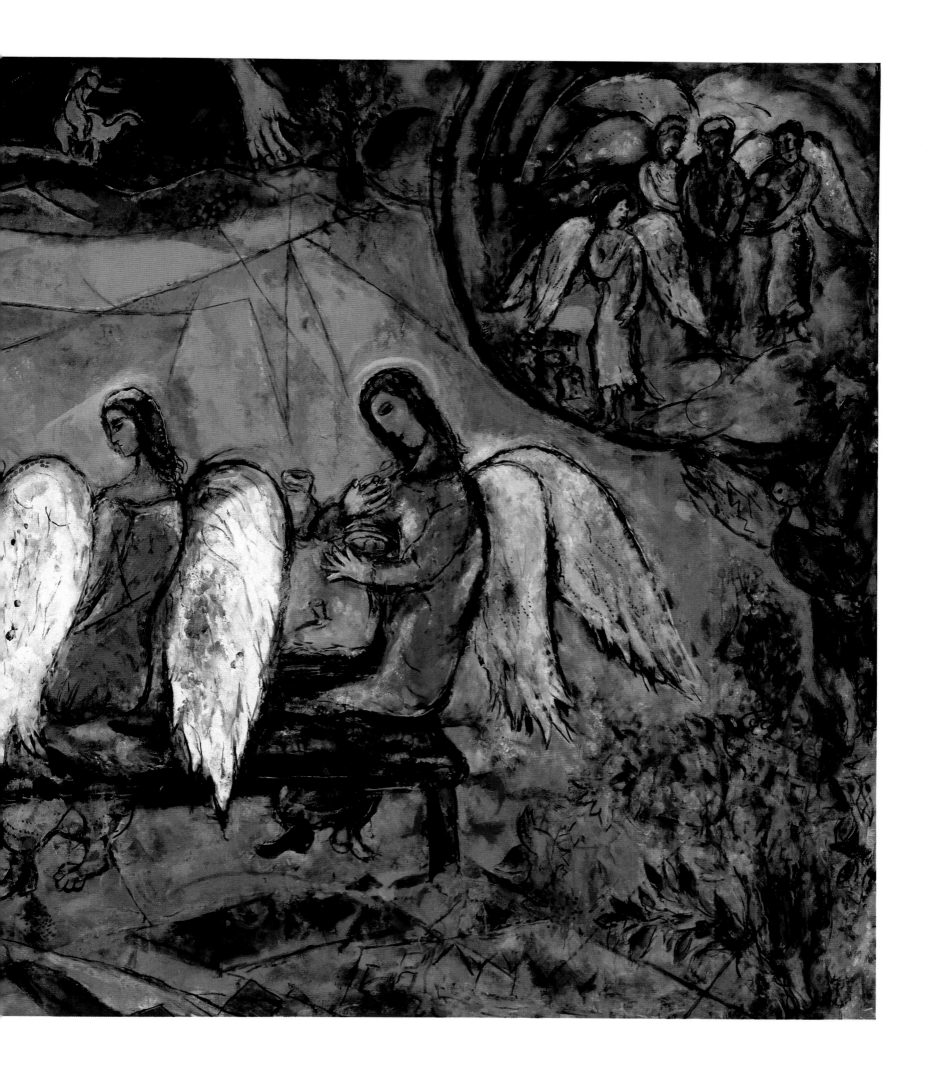

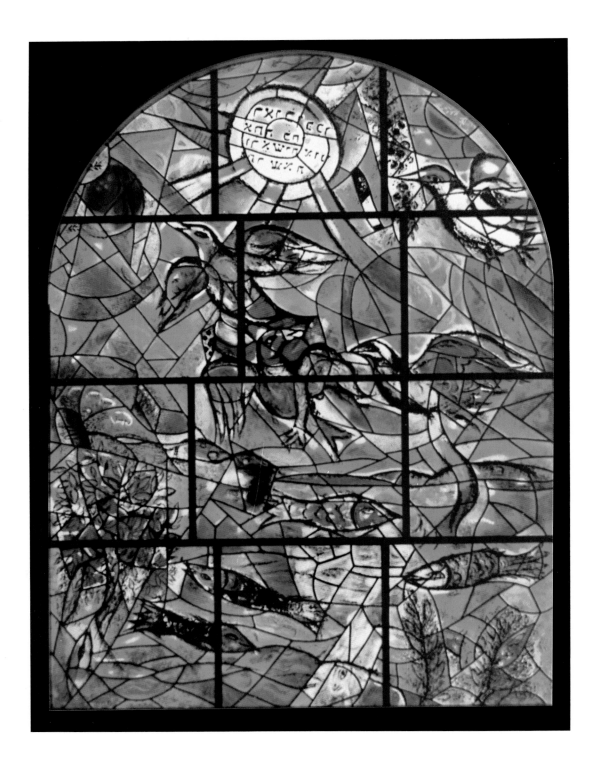

The Tribe of Reuben, 1960-61

Stained glass
133×93¾ inches (338×251 cm)
Synagogue the Hadassah University
Hospital, Jerusalem

One of Chagall's most important contributions to 20th-century art was his work in stained glass. This medium provided him with the best potential use of his striking color and allowed him to extend his Biblical themes in a more convincing and satisfying way. He accepted a number of stained-glass commissions from the 1950s onwards, and with the stained-glass specialist, Charles Marq of Reims, Chagall was able to develop his technical skills in this very difficult medium. His most successful series of windows was for the hospital synagogue at the Hebrew University Medical Center. The cycle consists of 12

large windows which signify the 12 tribes of Israel and carry an additional symbolic association with the signs of the zodiac. In Genesis, Jacob 'who is Israel' calls his 12 sons to him and blesses them, explaining their destinies, and in Deuteronomy, Moses again repeats the blessing to the descendants of Jacob's sons, the 12 tribes of Israel who are about to enter Canaan. The origin of the Jewish race is here symbolized, and the subject was thus particularly appropriate for its setting. Chagall was forbidden to depict the human form in the Hadassah windows, and had to rely on animals and other symbols to explain his message. Ironically, the success of the windows rests in part on this lack of distracting human form, for Chagall was able to concentrate on the colors, exploiting them to full symbolic and emotional advantage. For the color scheme of the windows, Chagall referred to a passage in Exodus, in

which Aaron's breastplate is described. The breastplate has four rows, each of which contains three different jewels which in themselves stand for the tribes of Israel. Chagall has grouped the windows in sets of three like the stones in Aaron's breastplate, and the colors of the windows relate to the colors of the breastplate jewels.

This is the first of the series of windows, representing the tribe of Reuben, the eldest son of Jacob and Leah. Jacob's blessing to Reuben was tinged with a reference to his son's seduction of Jacob's concubine Bilhah: 'Reuben, thou art my first born, my might, and the beginning of my strength, the excellency of dignity, and the excellency of power: unstable as water.' Chagall has taken this description as the basis for his first window, which is permeated by a watery blue and filled with sea creatures. In the lower right corner of the window is a

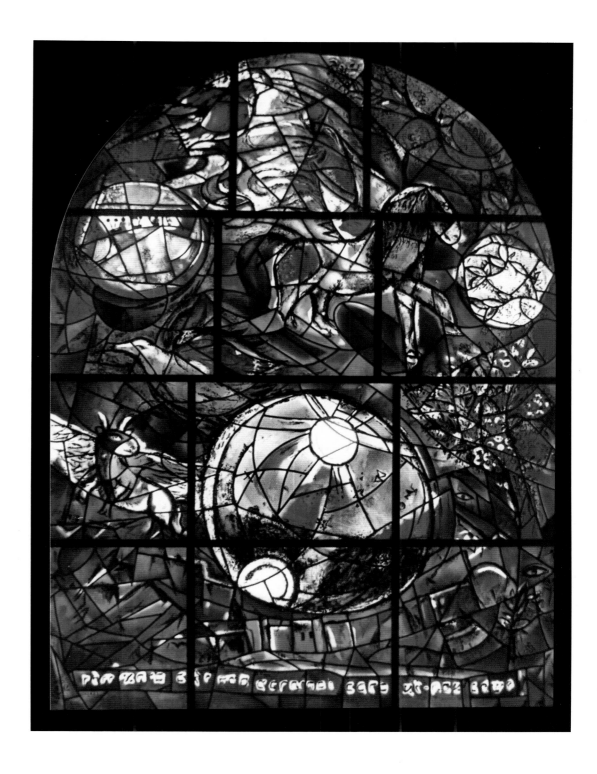

mandrake, which alludes to Reuben's helpfulness to his mother Leah, at a time when she was infertile. The mandrake was said to cure infertility, and Reuben brought one to Leah to help her bear another child. Chagall thus makes reference to both the generous and warm-blooded aspects of Reuben's character.

The Tribe of Simeon, 1960-61

Stained glass
133×98¾ inches (338×251 cm)
Synagogue of the Hadassah University Hospital, Jerusalem

From the watery blue of Reuben, the series of windows progresses to the deeper blue of Simeon. Like Reuben, Simeon and his brother Levi lost the full privilege of Jacob's blessing by committing sins. Just as Reuben had been guilty of lust, so Simeon and Levi were guilty of murderous vengefulness in response to the seduction of their sister Dinah. This act is alluded to in Jacob's words to Simeon and Levi, which takes the form of a curse, rather than a blessing: 'Simeon and Levi are brethren. Weapons of violence are their swords. Because in their fury they slew men, in their willfulness they hamstrung oxen.

Cursed be their fury because it is so violent.' As a result of their sins, these tribes were divided and scattered throughout Israel, and violence and division therefore dominate Chagall's Simeon window. On the lower part of the window is a sphere which represents the earth divided into portions of night and day. Above the earth are two other spheres, further symbolizing the divided nature of the tribes of Simeon and Levi. In the space between these 'planets' winged bulls and horses fly out from the center as if propelled by centrifugal force. The blue of this window is murkier and more somber than that of the Reuben window, signifying the greater seriousness of Simeon's crime.

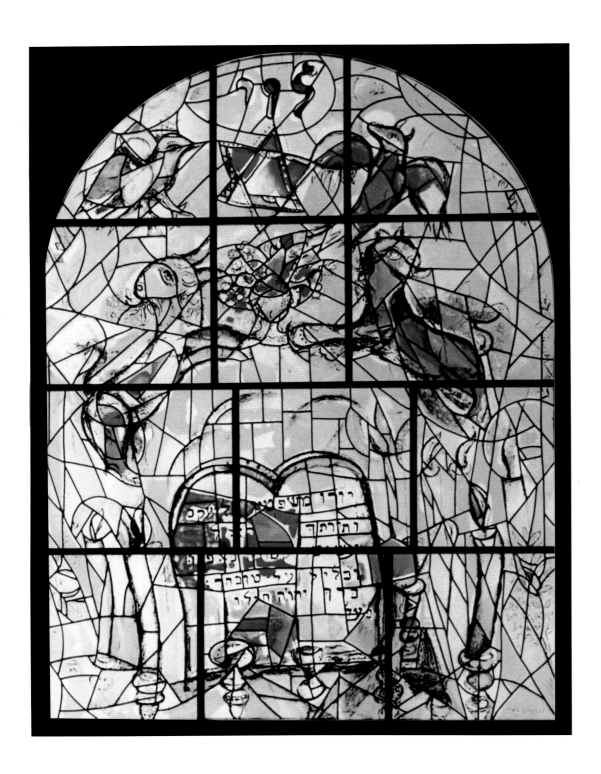

The Tribe of Levi, 1960-61

Stained glass
133×98¾ inches (338×251 cm)
Synagogue of the Hadassah University
Hospital, Jerusalem

The third of the windows on the east wall of the Hadassah Hospital Synagogue represents the tribe of Levi, Simeon's brother and companion in crime. The overpowering yellow of this window is in striking contrast to the cool blue of the two previous windows, and color here also serves a symbolic function. In Genesis, Jacob admonishes Simeon and Levi together, but in Deuteronomy, Moses offers his blessing only to the tribe of Levi. The reason for this change of emphasis is that members of the trive of Levi became holy men and preachers in order to redeem the sins of their ancestors Simeon and Levi. Moses himself was a Levite, and his blessing refers to piety and holiness of the tribe: 'They have observed thy word, and kept thy covenant. They shall teach Jacob thy judgments, and Israel thy law.' The holy nature of the Levites gives significance to the violent color of this window, for Chagall often used yellow to signify the sacred word of Moses and the Tablets of the Law. The use of yellow is particularly unusual in stained-glass windows, because any painting on the glass can potentially be obscured when the light of the sun shines through it. But the shade of yellow that Chagall chose allows the subject of the window to be visible through the penetrating light. The window is filled with holy images associated with Judaism. From the star of David at the top of the window, to the four heraldic animals of the synagogue, the objects depicted reflect the function of Levi's tribe as a conveyor of the Holy Law.

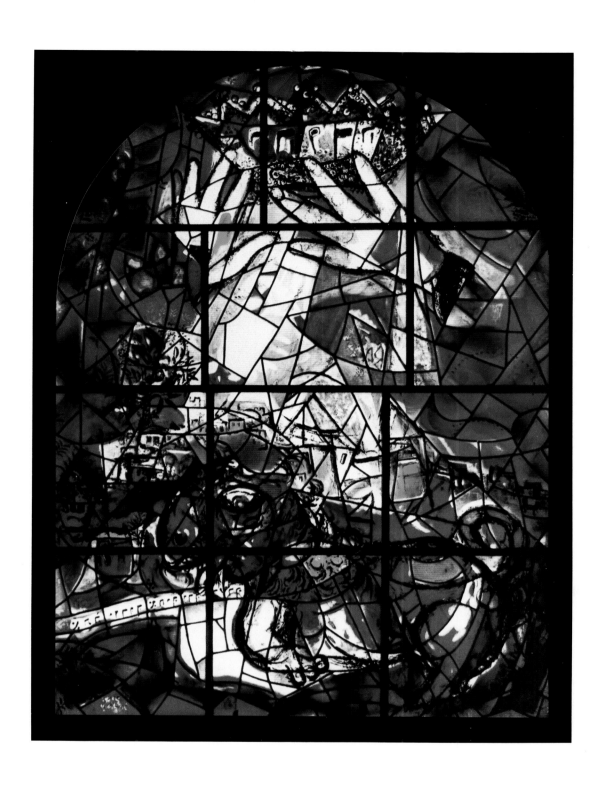

The Tribe of Judah, 1960-61

Stained glass
133×98¾ inches (338×251 cm)
Synagogue of the Hadassah University
Hospital, Jerusalem

The Judah window is the next in the progression and the first window on the south wall of the Hadassah Hospital Synagogue. The juxtaposition of the rich red of the Judah window with the blinding yellow of the Levi window, positioned at right angles to it, is especially powerful. The fourth of Leah's sons, Judah was singled out for a special blessing, as each of his elder brothers, Reuben, Simeon and Levi, had sinned. Jacob blessed Judah with the words: 'Judah is a lion's whelp. The scepter shall not depart from Judah, nor a lawgiver from between his feet.' The 'lion's whelp' appears at the bottom of the window to symbolize the tribe. Also in the window is the city of Jerusalem which had a special significance for the descendants of Judah. King David was a member of this tribe, and he carried the Ark of the Covenant for Solomon's temple, thus creating Jerusalem the capital and holy city. Judah's importance is further signified by a pair of hands that raise a royal crown: this refers to both the blessing of Judah himself, and the later tradition of the king's annual blessing of the people. The crimson color of the window refers to another comment Jacob made about Judah: 'He washeth his garments in wine, and his vesture in the blood of grapes.' Chagall was especially fond of this window, and he signed his name in Hebrew letters on it.

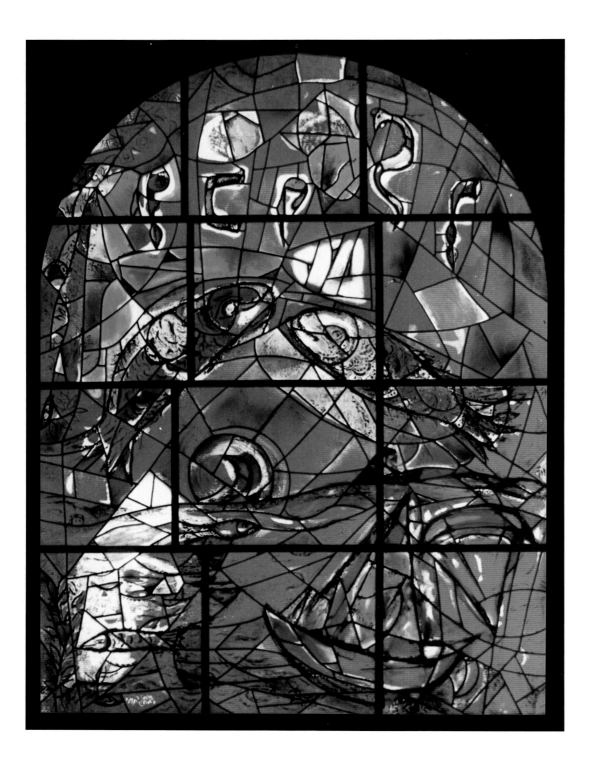

The Tribe of Zebulun, 1960-61

Stained glass
133×98¾ inches (338×251 cm)
Synagogue of the Hadassah University
Hospital, Jerusalem

Zebulun was the sixth son of Leah, and Jacob's blessing to him presaged the later occupation of his tribe: 'Zebulun shall dwell at the haven of the sea; and he shall be for an haven of ships; and his border shall be unto Zidon.' As the basis for his Zebulun window, Chagall took up this reference to the maritime strengths of Zebulun's tribe, and has filled his window with fish. As he was obliged to follow the tenets of Jewish law and exclude the human figure from the Hadassah windows, Chagall used animals and plants most imaginatively to convey the essence of each tribe. In this instance, the predominance of fish is particularly appropriate as Zebu-lun's tribe became prosperous through sea trade and commerce. Less appropriate, perhaps, is the color of the window. The murky red of this window reflects little on the nature of the tribe itself, which is more accurately characterized by the liquid blueness of the fish. However, the window provides an appropriate visual contrast with the more piercing and dominant red-ness of the Judah window beside it, and its color relates to the appropriate jewel on Aaron's breastplate. Chagall has even moved the window of Zebulun out of its sequence, perhaps in order to coordinate the overall color scheme of the windows more satisfactorily. As it represents the sixth son of Jacob, the Zebulun window should not be immediately after that of the fourth son, Judah, but Chagall has manipulated the placement of the windows to create a more striking coloristic juxtaposition.

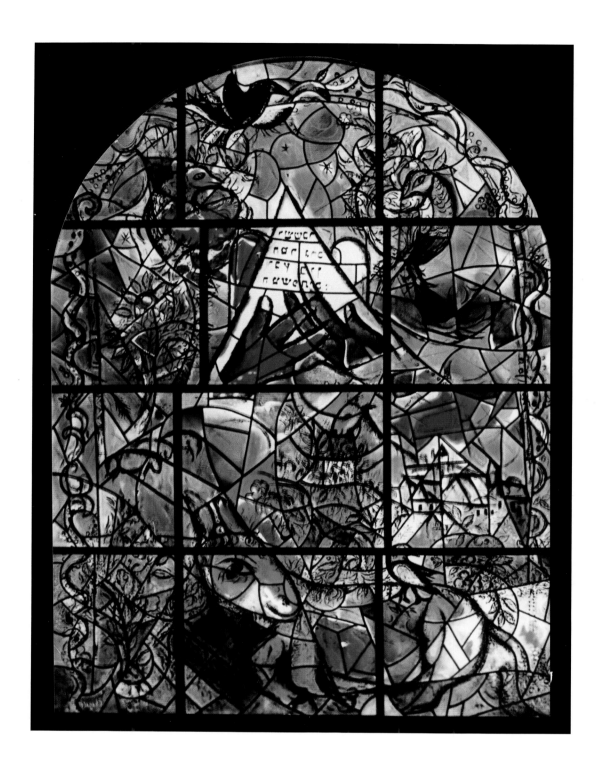

The Tribe of Issacher, 1960-61

Stained glass
133×98¾ inches (338×251 cm)
Synagogue of the Hadassah University
Hospital, Jerusalem

The sequence of windows in the Hadassah Hospital Synagogue roughly follows a chronological pattern relative to the birth of Jacob's sons. This sequence begins on the east wall, and moves counter-clockwise through the south, west and north walls. The Issachar window is the first in the sequence to be dominated by green, and like the Levi window, this color relates specifically to the occupation of the tribe. Issachar was the fifth son of Jacob and Leah, and his birth followed an extended period of infertility. When it seemed as if Leah would have no more children, her

son Reuben brought her a mandrake, which was said to cure infertility. Jacob's blessing to Issachar is somewhat cryptic but nevertheless pertinent: 'Issachar is a strong ass couching down between two burdens: And he saw that rest was good, and the land that it was pleasant.' Of all Jacob's sons, Issachar was granted the greatest quantity of fertile land. The abundance of this land created both difficulty and prosperity for the tribe, as they had to defend it from invaders – the 'burdens' mentioned in the blessing. However, the fertility of the land was ultimately the legacy of Issachar, and Chagall has stressed this aspect of the tribe through both the dominant green color of the window, and the imagery he uses in it. As Issachar was an agricultural tribe, Chagall has depicted goats and vines, to emphasize both the use of pasture for flocks and the cultivation of farmland for food and drink.

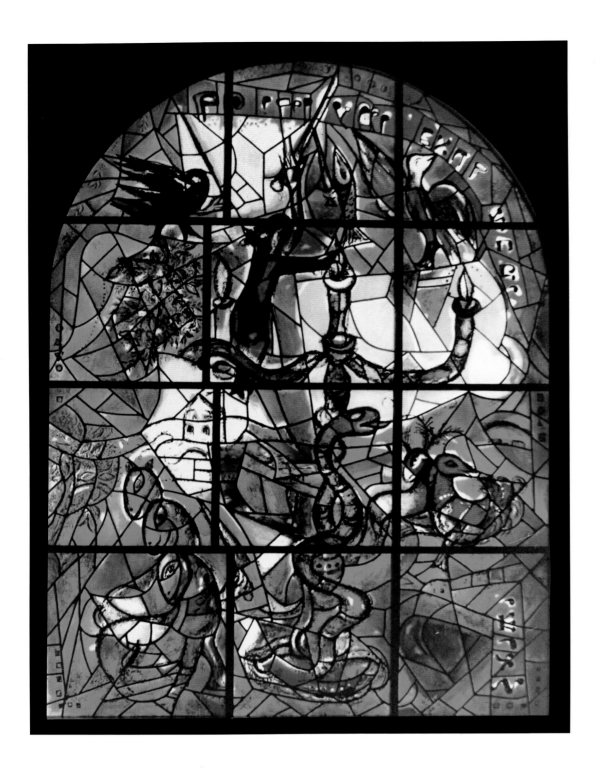

The Tribe of Dan, 1960-61

Stained glass
133×98¾ inches (338×251 cm)
Synagogue of the Hadassah University
Hospital, Jerusalem

In contrast to the pastoral green of the Issachar window, the tribe of Dan window returns to the color blue. However, the tone is different from that of the Reuben and Simeon windows, just as Dan's destiny was distinct from theirs: 'Dan shall judge his people, as one of the tribes of Israel. Dan shall be a serpent by the way, an adder in the path.' Dan was the first son of Jacob's concubine Bilhah, and in Jacob's apportioning of land, Dan's tribe was granted a small plot on the coast of Jaffa. As the tribe

grew, its people were forced to move on to find enough land to hold its people, and in the process, they destroyed the old city of Laish and built a new city there. As in many of the other Hadassah windows, Chagall here visualized the metaphors contained in Jacob's blessing. The candelabrum which dominates the window represents the balance of judgment, signifying Dan's position as judge of his people. Climbing up the candelabrum is a snake, or the 'adder in the path' of Jacob's blessing. Chagall's use of animal imagery is again appropriate to the nature of the tribe represented. Although forbidden from using human figures in his windows, Chagall has exploited a full range of animal and plant symbolism to characterize the tribes and to allude to their history.

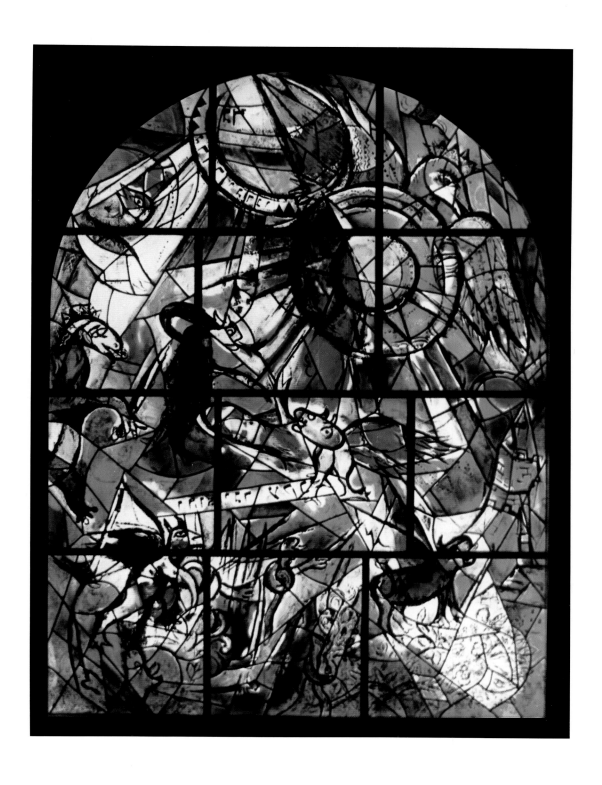

The Tribe of Gad, 1960-61

Stained glass
133×98¾ inches (338×251 cm)
Synagogue of the Hadassah University
Hospital, Jerusalem

Just as Dan was the first son of Rachel's servant, Bilhah, so Gad was the first son of Leah's servant Zilpah. Jacob's blessing to Gad was both concise and pertinent to the fate of his tribe: 'Gad, a troop shall overcome him: but he shall overcome at the last.' Gad's tribe was the most military of the tribes of Israel, as it assisted other tribes in the conquest of Canaan. Once Canaan was conquered, Gad's tribe moved to Galilee, where its members were forced to defend the rich land from invaders who were lured by the land's fruitfulness. The cloudy green of the Gad window signifies the fecundity of Galilee, but it is cut through with bloody red, which represents the warlike nature of Gad's tribe. Again, Chagall has used animal symbolism to underline the character of the tribe. The animals in the window represent the forces of confrontation: the charging horses and eagle hold up their swords to fight off a variety of hybrid beasts. Their attitudes are determined and ferocious. At the bottom of the window is a collection of spears and lances, further representing the paraphernalia of war, which was to become the stamp of Gad's tribe. In both defensive and offensive situations, Gad's tribe produced some of the most powerful warriors of the Bible, and despite the continual trials of battle, the tribe, as Jacob predicted, overcame their enemies.

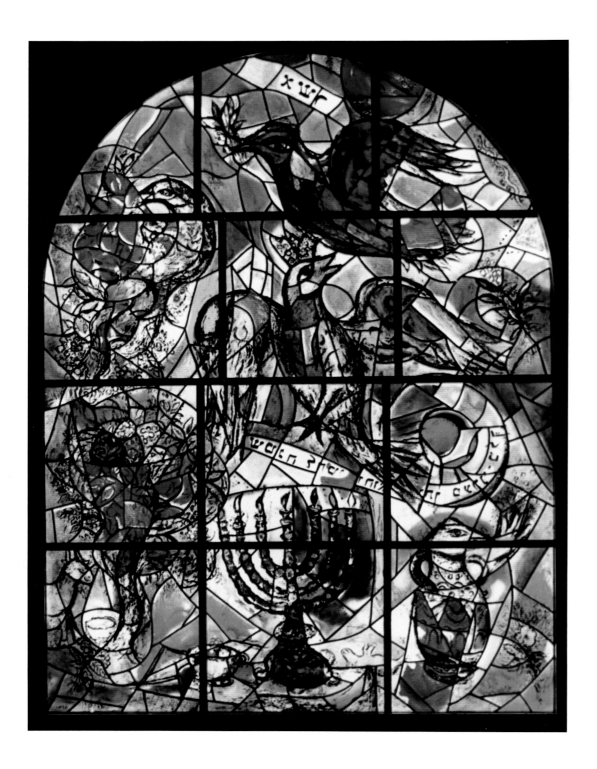

The Tribe of Asher, 1960-61

Stained glass
133×98¾ inches (338×251 cm)
Synagogue of the Hadassah University
Hospital, Jerusalem

Like the Gad window, the Asher window is predominantly green with splashes of red and blue, and here too the color is a significant indicator of the nature of the tribe. Like Gad, Asher was the son of Zilpah and Jacob, but his tribe was as peaceful as Gad's was warlike. For the imagery in this window, Chagall relied on both Jacob's blessing to Asher and Moses's prophecy for the tribe of Asher. Jacob predicted: 'Out of Asher his bread shall be fat, and he shall yield royal dainties,' and in Deuteronomy, Moses said of Asher: 'he shall bathe his foot in oil.' The references to fat and oil refer to the olive trees, which provided the liveli-

hood for Asher's tribe. Just as Gad's tribe lived in a state of continual conflict, so Asher's was blessed with peacefulness amid fruitful olive groves. The green of this window is therefore a particularly appropriate allusion to the occupation of Asher's tribe. Typically, Chagall has gone beyond the symbolism of the color, and extended his representation of the tribe into the imagery of the window. The olive trees on the right of the window are the fruits of Asher's labors, and the candles of the menorah are burning because of this useful olive oil. At the top center of the window is a dove, traditionally a symbol of peace, and appropriately holding an olive branch in its beak. By placing the dove of peace at the top of the Asher window, Chagall further emphasized the contrast between the peacefulness of this tribe and the martial nature of the tribe of Gad.

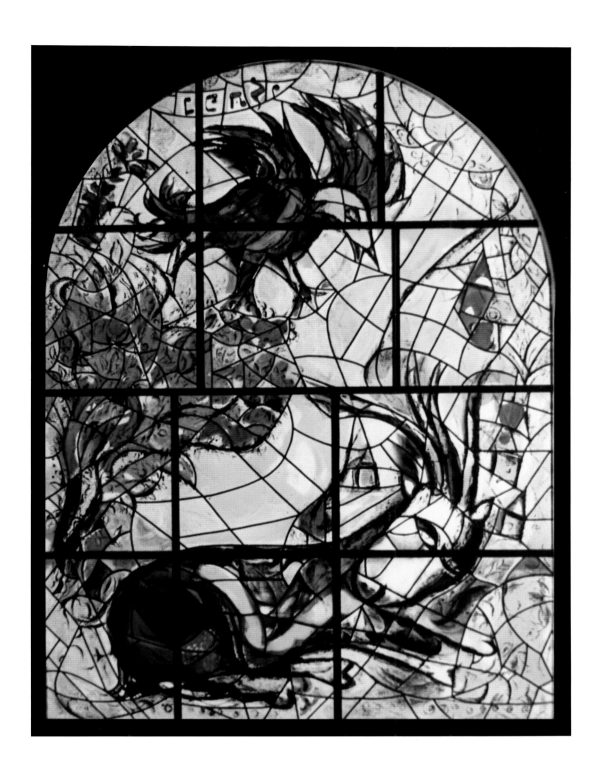

The Tribe of Naphtali, 1960-61

Stained glass
133×98¾ inches (338×251 cm)
Synagogue of the Hadassah University
Hospital, Jerusalem

The north wall of the Hadassah Hospital Synagogue contains the last three windows of Chagall's series, which represent Jacob's younger sons Naphtali, Joseph, and Benjamin. Naphtali, the first of these sons, was the second son of Rachel's servant Bilhah and thus brother to Dan. In this window, Chagall used yellow for the second time in the series to characterize Naphtali's tribe. As in the more dazzling yellow of the Levi window, Chagall had to overcome a number of technical difficulties in order to prevent his imagery from becoming invisible in the sunlight, and here again he has succeeded admirably. Jacob's blessing to Naphtali refers to an act that made his father favor him: 'Naphtali is a hind let loose: he giveth goodly words.' Through the image of the racing deer, Jacob alludes to the speed at which Naphtali conveyed the message to him that his son Joseph, although feared dead, was alive in Egypt. In the imagery of this window, Chagall again realizes Jacob's analogy literally, and the window is therefore dominated by a red hind which stands out prominently amid the surrounding yellow.

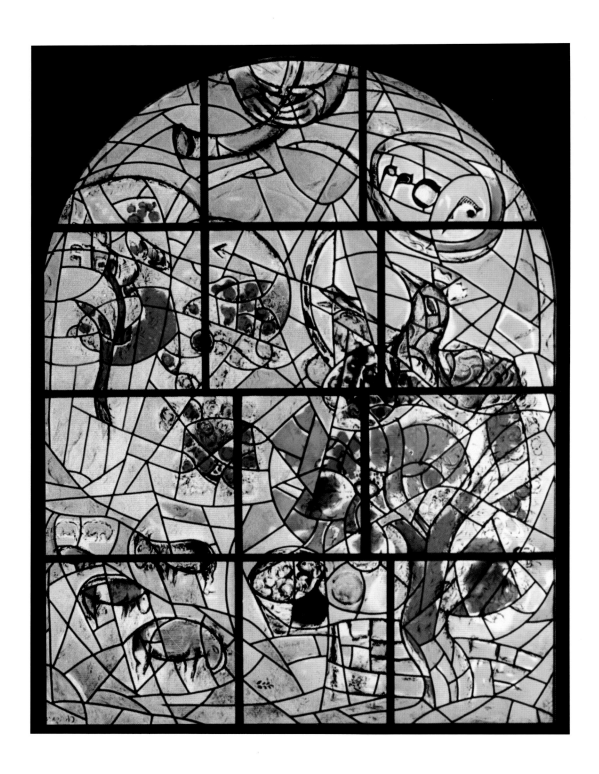

The Tribe of Joseph, 1960-61

Stained glass
133×98¾ inches (338×251 cm)
Synagogue of the Hadassah University
Hospital, Jerusalem

Joseph was the first son of Jacob and Rachel, and as Jacob had waited many years for the privilege of marrying Rachel, Joseph was his favorite son. The marriage of Jacob and Rachel was delayed by the duplicity of Rachel's father Laban. Having fallen in love with Rachel, Jacob agreed to do a seven-year service for Laban in return for Rachel's hand. But Laban tricked Jacob into marrying his elder daughter Leah, and insisted that Jacob toil for seven more years before he would be allowed to marry Rachel. After such a long delay, the birth of Rachel's first son was a joyful occasion for Jacob. However, Jacob's unashamed favor-

itism of Joseph roused the jealousy of his other sons, who sold their younger brother into slavery. The subsequent story of Joseph's sojourn in Egypt is one of the most fascinating in the Old Testament. In the Joseph window, Chagall has used yellow to signify the privilege that Joseph enjoyed, although here the color is more golden than that of the Levi or the Naphtali windows. Jacob's blessing to Joseph is also represented in the window: 'Joseph is a fruitful bough, even a fruitful bough by a well; whose branches run over the wall.' In the lower left side of the window is a red vine, which signifies the fruitfulness of Joseph's tribe, and behind the vine is the wall, which is overtaken by the vine's branches. A crowned bird represents Joseph's later status as viceroy of Egypt, and a *shofar* or trumpet in the shape of a ram's horn, indicates the Judaic significance of the tribe.

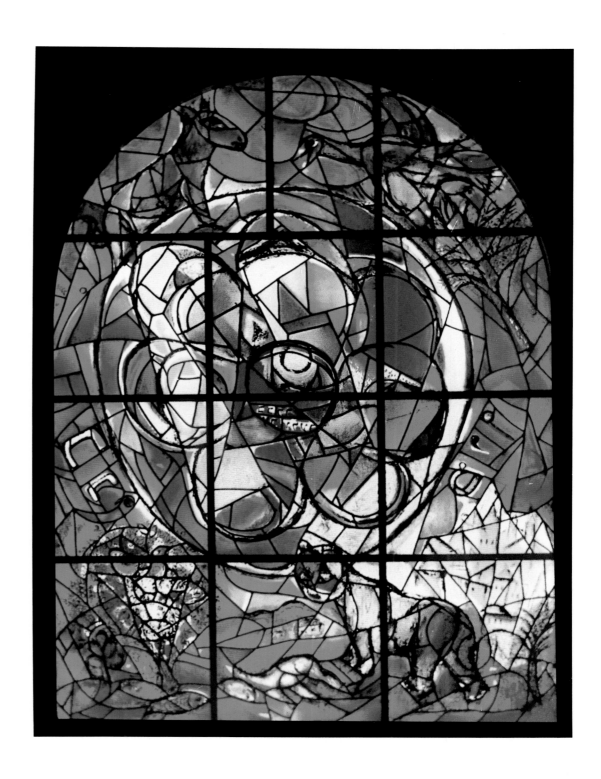

The Tribe of Benjamin 1960-61

Stained glass
133×98¾ inches (338×251 cm)
Synagogue of the Hadassah University
Hospital, Jerusalem

Benjamin was Jacob's youngest son, and his second and last child by Rachel, who died giving birth to him. Jacob's blessing to Benjamin provided Chagall with his inspiration for the imagery of this window: 'Benjamin shall ravin as a wolf; in the morning he shall devour the prey, and at night he shall divide the spoil.' At the bottom of the window, Chagall has represented the lion standing over his dead prey. Like Gad's tribe, Benjamin's tribe had warlike tendencies, and this is further signified by a large shield which dominates the center of the window. Surrounding the shield are the heraldic animals of the Synagogue, which has also appeared in the Levi window. For his last window in the Hadassah series, Chagall returned to the color blue, and again he endowed this color with both emotional and symbolic significance. Each of the windows can certainly be observed and appreciated separately, but their true power only comes through when they are seen together. The interaction of such a striking, even blinding, variety of colors, made more intense by the sharp light of the sun, gives the windows a shimmering quality not unlike the jewels on Aaron's breastplate to which they allude. The Hadassah windows show Chagall at his most insightful and imaginative, as well as his most emotional.

Paradise, 1962
Oil on canvas
Musée National Message Biblique,
Marc Chagall, Nice

Chagall painted the large pictures in the
main room of the Biblical Message
Museum over a period of years, but only
gradually did the narrative cycle form
itself. This small study for a rather later
work represents an early chronological
moment in the Bible series, and it relates to
two other paintings hung near it in the gal-
lery – *The Creation of Man* and the *Ex-
pulsion from the Garden*. Chagall translates
the creation into a love story, and this
obsession with love seems to form a princi-
pal theme of the Biblical Message paint-
ings. *The Creation of Man*, for example,
shows an angel carrying the body of Adam,
and in the lower left-hand corner, Adam
and Eve put their heads together in the
midst of a blue paradise. A swirling red sun
forms the creative impetus by flinging out
from its center various figures and objects
from the Bible: the Tablets of the Law and
the Crucified Christ compete with the Jew-
ish emblems of the Torah and the men-
orah. In *Paradise* shown here, the love
theme which is relegated to the corner of
the *Creation of Man* takes center stage.
Again the composition contains the leafy
green of the garden and heavenly blue
angels, with bursts of red vegetation and a
yellow figure straight from Gauguin to add
color contrast. The lovers in the center
right of the painting seem fused together
like the figures in *Homage to Apollinaire*
(page 44), and Eve offers the apple to
Adam in the familiar gesture. The final
painting of this group of three is the *Ex-
pulsion from the Garden*, which again is
dominated by the green of the garden and
the blue of the heavenly spirits. The angel
chases the sinful pair out of the garden
with his sword, frightening away many
animals and birds in the process. Although
these three paintings are only the first part
of a 12 painting cycle, they can be read to-
gether both thematically and coloristically.

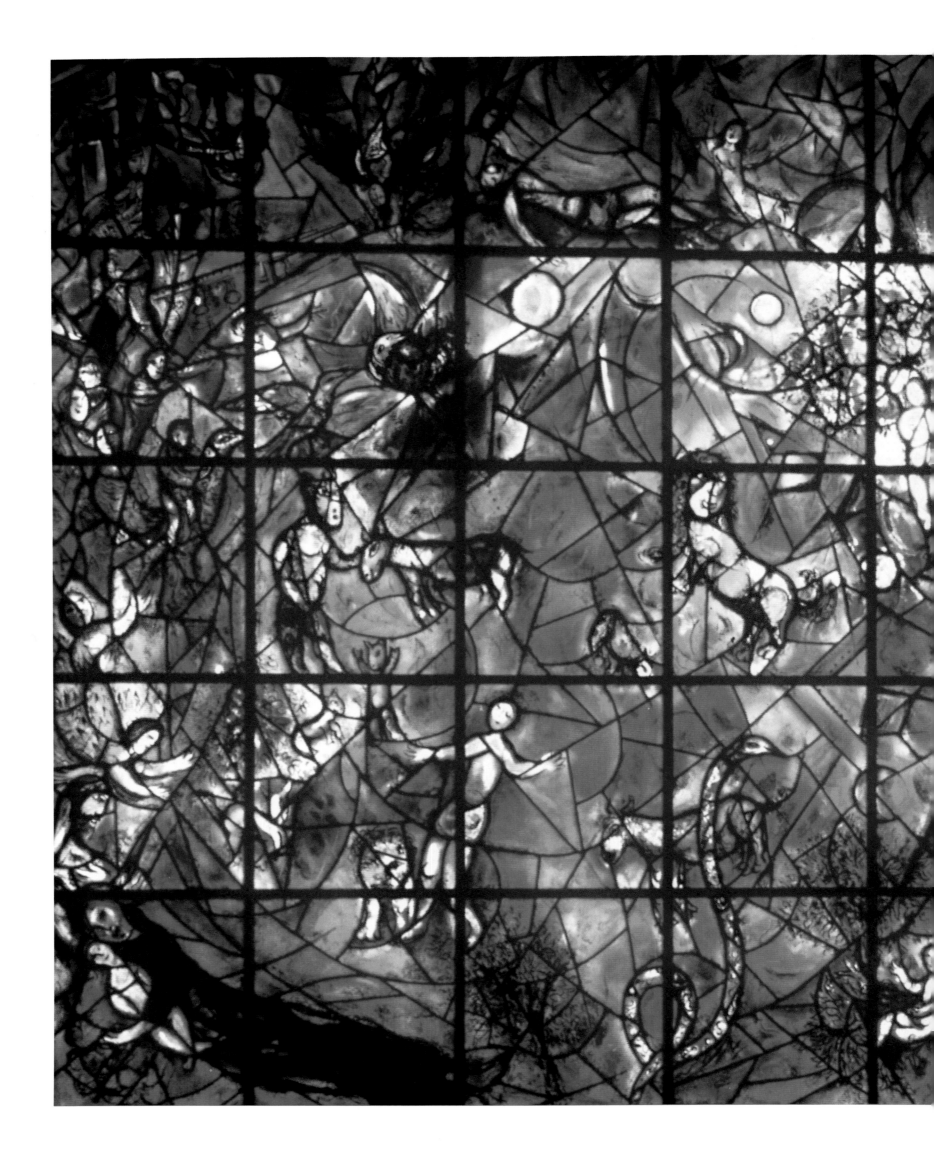

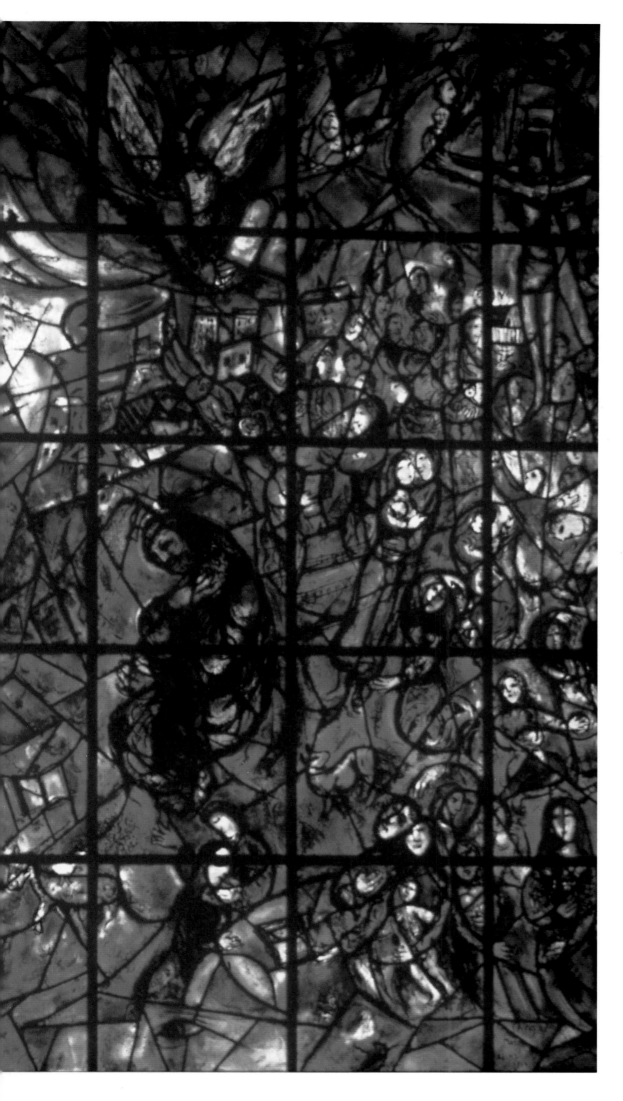

Peace Window, 1964

Stained glass
12 feet 7¼ inches×15 feet 8 inches
(3.23×4.8 metres)
United Nations Building, New York

After World War II Chagall began producing more and more large-scale works with universal themes. As the physical size of his work increased, so did the intended scope of his subject-matter. The Bible dominated his paintings, stained glass, tapestries, and sculpture of the 1960s and 1970s. When he diverged from Biblical subjects, Chagall tackled no less significant ideas: for example, his mosaic of Odysseus for the Faculty of Law at the University of Nice is concerned with the appropriate theme of wisdom. In the same year that Chagall's design for the ceiling of the opera house was unveiled in Paris, his *Peace* window was mounted in its prominent position as part of the United Nations Building in New York. The window was dedicated to the memory of the Director General of the United Nations, Dag Hammarskjöld (1905-61), whose life had been spent pursuing the aim of world peace. Peace is therefore a relevant theme for the window, but Chagall approached it through a slightly indirect route. Despite a request that he avoid specifically religious imagery, Chagall loaded his *Peace* window with references to the Biblical prophesies of Isaiah. Isaiah predicted the coming of the new Eden: a place where the wolf will lie down with the lamb and the sins of the world will be washed clean. In this respect, Chagall's use of imagery from the text of Isaiah is appropriate for the subject. However, in Christian terms, Isaiah's prophecies are said to prefigure the Crucifixion and Resurrection of Christ, through which the Original Sin of Adam and Eve was cleansed. Such prefigurative associations with the subject of Isaiah made the *Peace* window especially controversial among Jews when it was first shown to the public. Chagall's stained-glass windows also offered him an enormous technical challenge. For most of his windows, he worked closely with Charles Marq in his Reims workshop. Chagall conceived of the window as a whole and supervised Marq's production of individual pieces of glass. By painstaking methods, and an imaginative use of leading, Chagall gave his windows a striking colorism and individuality that transcend the problematic nature of his subject-matter.

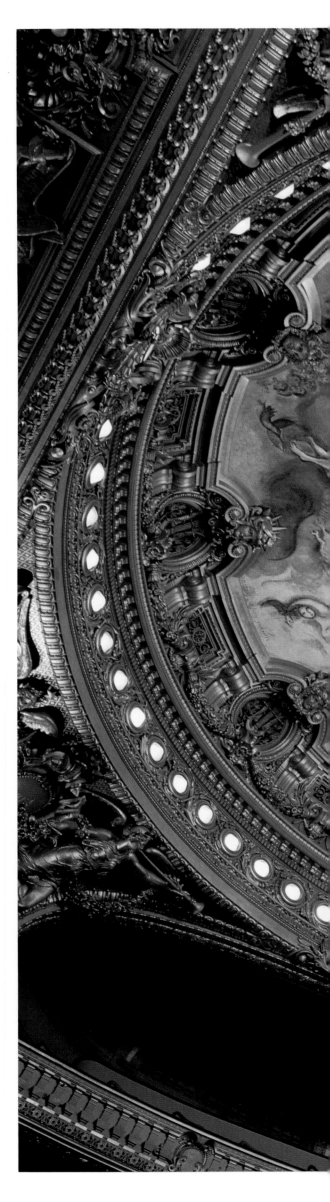

Ceiling of the Paris Opera House, 1964

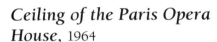

Oil on canvas
2367 square feet (220 m²)
Opera, Paris

One of the largest and most important projects of Chagall's life, the commission to paint the ceiling of the Paris Opera House came from the Minister of Culture, André Malraux, in 1963. Chagall chose to paint variations on the theme of the great composers, and for the work he used the lavish, and even garish, color schemes that he had developed since the War. The painting of the Paris ceiling was problematic for a number of reasons. First of all, the elaborate Classical/Baroque style of Charles Garnier's 19th-century Opera House was not the most appropriate setting for Chagall's often fussy and expressive designs. In addition, Chagall had to fit his work into an awkward ceiling space that was ornamented by a series of 40 golden sculpted heads. Although the final ceiling was controversial and not entirely a success, Chagall did use the ceiling space imaginatively. Rather than painting a strictly controlled composition, Chagall used a swirling, rhythmic arrangement loosely defined by color, rather than com-position. Chagall said that the purpose of the ceiling was 'to pay homage to the great composers of opera and ballet,' and each of the five color zones of the ceiling does just this both through color and imagery. The pale blue zone celebrates Mozart and Mussorgsky, and the latter's *Boris Gudonov* is alluded to in the Russian landscape which forms the backdrop to the composition. A flute-playing bird and angel make the obvious reference to Mozart's *Magic Flute*. The second band of green is devoted to Wagner and Berlioz: both Wagner's *Tristan and Isolde* and Berlioz's *Romeo and Juliet* are alluded to by the pair of lovers which dominates this part of the ceiling. The city of Paris below them pays a further homage to Berlioz's home. The third band contains white mixed with yellow, and is dedicated to Rameau and Debussy, and the fourth, a wash of warm red, is the province of Ravel and Stravinsky. Chagall chose red for these composers as a symbol of the passion which he felt their music conveyed. The final yellow band for Tchaikovsky represents the airy beauty of *Swan Lake*. Inside this large circle is another smaller circle with similar coloristic bands devoted to Gluck, Verdi, Beethoven, and Bizet. Chagall used both his characteristic imagery and his latest experiments with color to build up this complex homage to the great composers of the past.

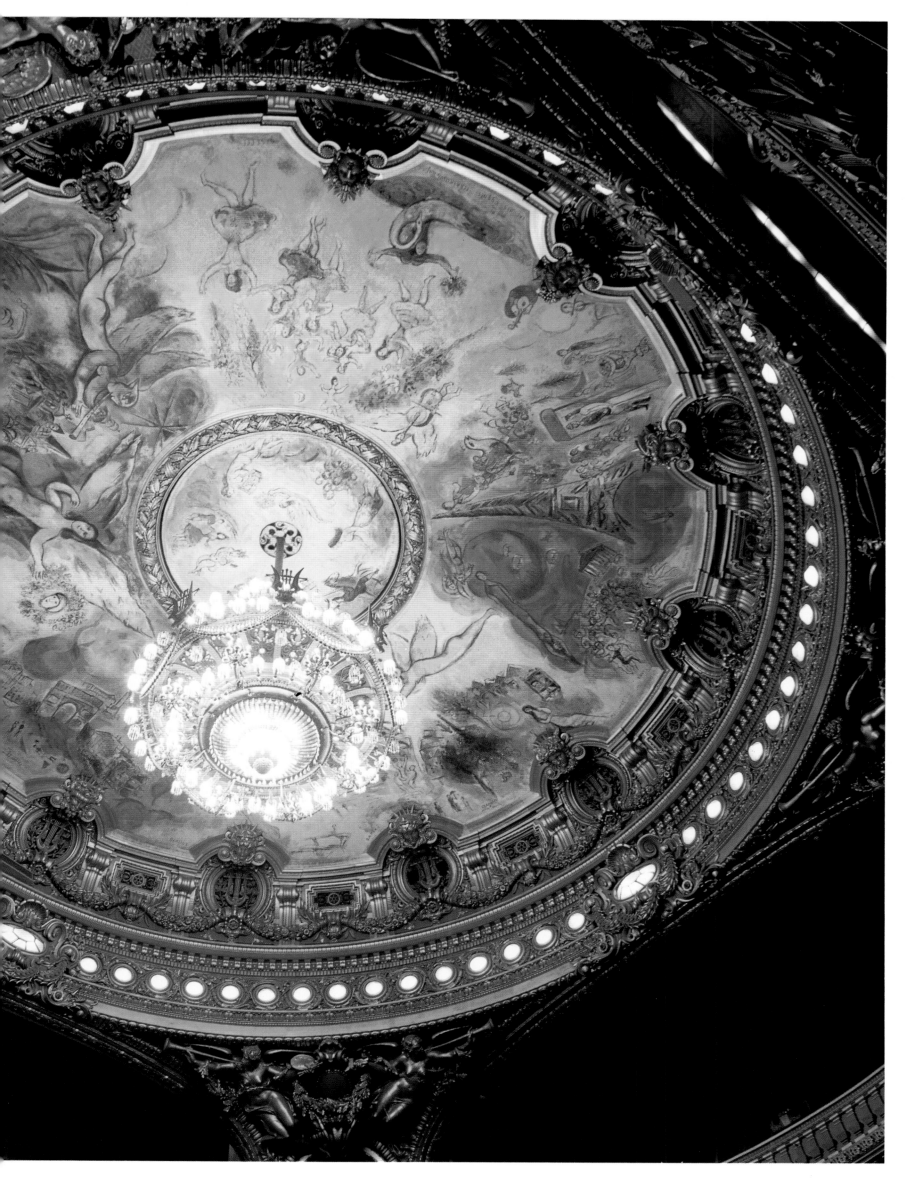

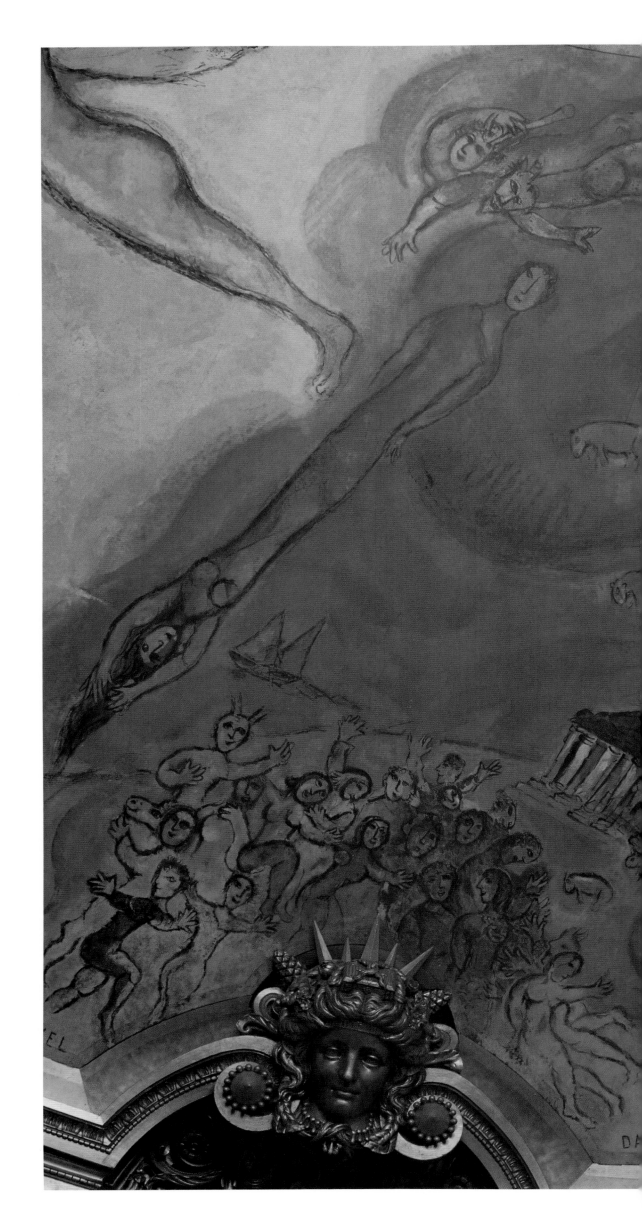

Ceiling of the Paris Opera, 1964
(detail)

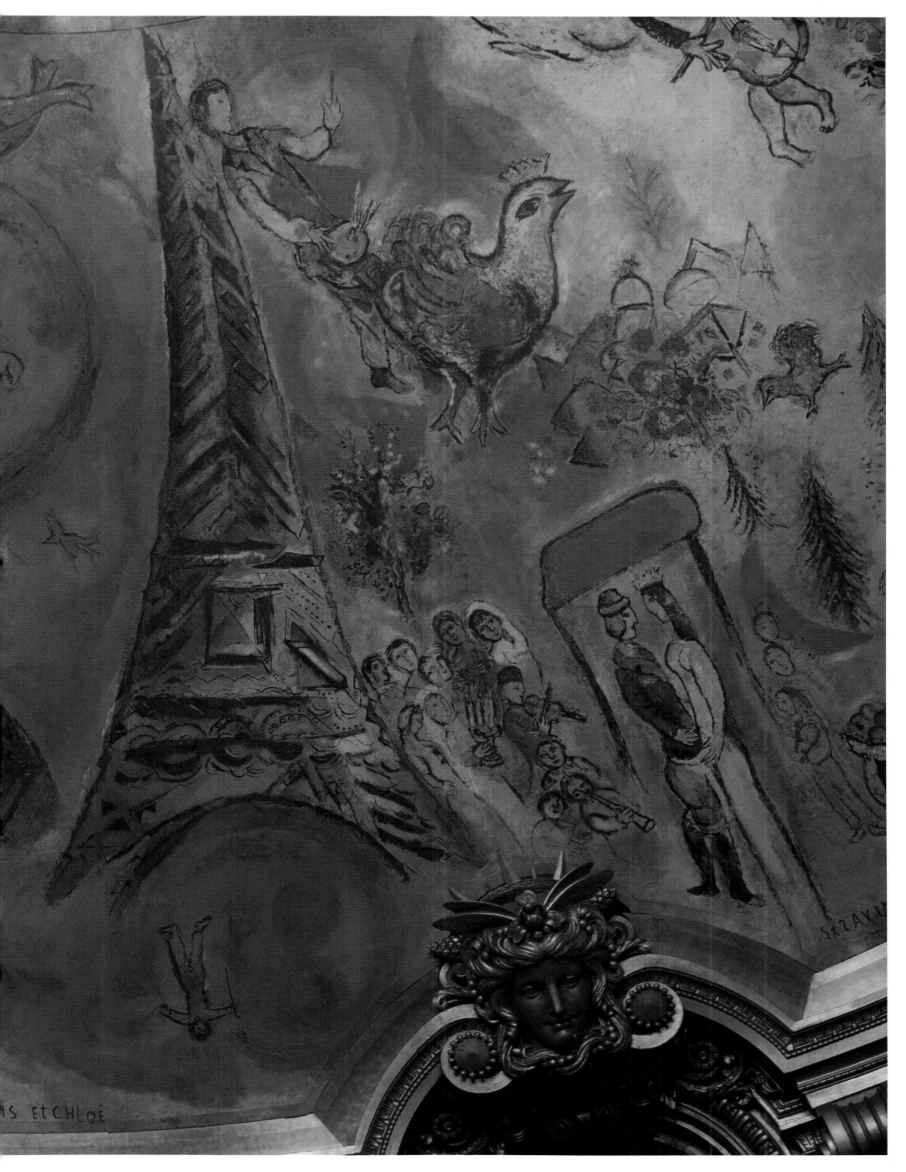

ET CHLOÉ

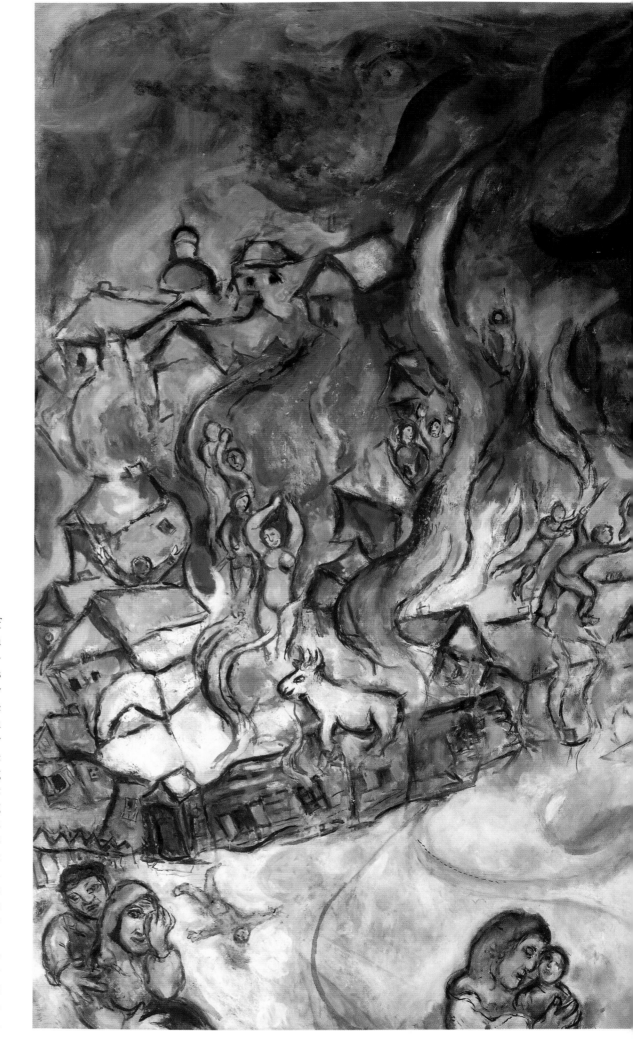

War, 1964-6

Oil on canvas
64¼×90⅞ inches (163×231cm)
Kunsthaus, Zürich
Vereinigung Zürcher Kunstfreunde

The self-referential nature of many of Chagall's late paintings is also present in *War*, and it seems that he found it increasingly difficult to invent new themes or to approach the old themes in a new way. The subject of war was not out of the news in the early 1960s, and the war in Israel would have held a particularly strong significance for Chagall. But here Chagall does not appear to be responding to the effect of a specific conflict. In the paintings he executed before and during World War II, particularly his Crucifixion scenes, Chagall was reacting to the horrors of the devastation in Europe and the ghastly nature of the discrimination against the Jews. Here, the impact of the work is lessened by the domination of the familiar 'Chagallian animal' – a goat/heifer which rises up out of the snowy landscape. The figure of the Crucified Christ in the right background has become here merely a stylized emblem of human suffering, just as the peddler with the sack symbolizes Elijah who brought hope for the Jewish people. Chagall does make an effort to show the domestic upheavals created by the war and the human reaction to them. Here again, he may have had Picasso's *Guernica* (1937) in the back of his mind, but his painting shows little direct quotation from that source.

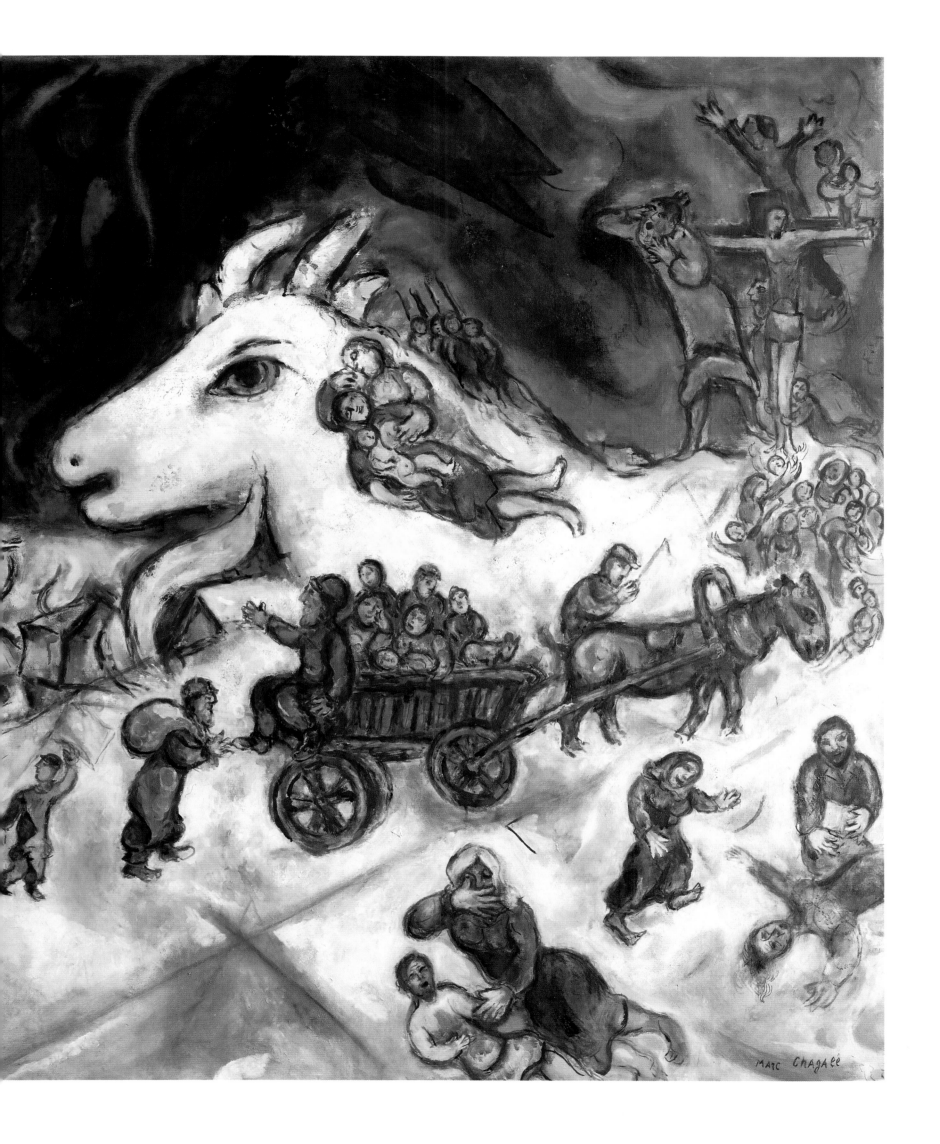

The Walk, 1973

Oil on canvas
45½×32 inches (115.6×81.3 cm)
Pierre Matisse Gallery, New York

The image of a couple fused into a single entity had first appeared in Chagall's *Homage to Apollinaire* (page 44), and it became an infrequent but consistent motif in his art. The meaning of the image also retained its continuity. In *Homage to Apollinaire* the fusion of Adam and Eve had stood for a desired unity between man and woman, echoing the Cabalistic concept that the universe had originally been a single form. The reunification of the separated universe was a goal to be sought, and love was to be the catalyst that would make such unification possible. This painting reflects this idea of unity, but other elements in the work serve to obscure or alter the obvious interpretation. *The Walk* is one of a number of Chagall's paintings that writers have subjected to a strained Jungian interpretation. According to Jung, human behavior is the result of individual and social conflicts which human beings are continually trying to resolve. Creativity is one aspect of man's struggle towards this completion. Another quality of human character is memory, which, according to Jung, is racial and archetypal, and can be tapped through mythological symbols. As a Jewish artist, and an artist prone to using metaphorical or symbolic images, Chagall can all too easily be taken as an exemplar of Jung's theory. The cluttered symbols that cover the motley dress of the man in *The Walk* could be seen to be archetypes or manifestations of Jung's universal subconscious. Equally, the horse's head, sun, and other details of the painting are common in Chagall's art, and there is an obvious danger of over-interpretation. Chagall himself was irritated by and dismissive of convoluted interpretations of what he saw simple products of his imagination.

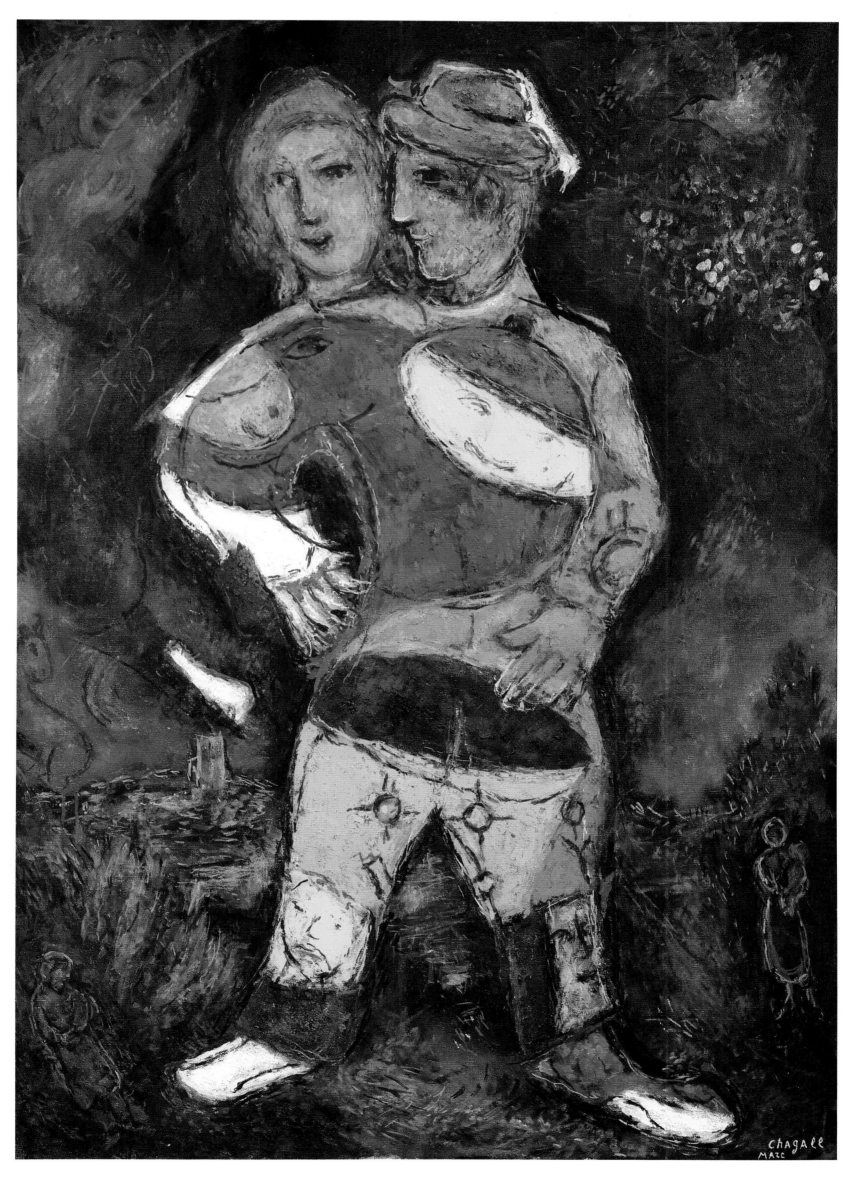

The Fall of Icarus, 1975

Oil on canvas
83⅞×78 inches (213×198 cm)
Musée National d'Art Moderne,
Centre Georges Pompidou, Paris

After Chagall's visits to Greece in 1952 and 1954, mythological subject-matter became more prominent in his work. His lithographs and theater designs for *Daphnis and Chloe* and his mosaic of Odysseus for the Faculty of Law at the University of Nice are only a few of the exceptional examples of his treatment of mythological themes. For this painting, Chagall chose to represent the story of Icarus. Icarus was the son of the inventor Daedalus, who made a pair of wings to allow them both to fly away from Crete. Icarus was so carried away with his

ability to fly that he went too near the sun, and his wings melted. The myth is an allegory of hubris, but Chagall also intends it as a symbol of the risks taken by the creative artist. The subject of the fall of Icarus had been treated most notably in earlier art by Bruegel, who represented the fall taking place in a rural area. In Bruegel's scene, the tragic fall does not disturb the peasant farmers, who must carry on with their daily work regardless of suffering and death. Chagall's *The Fall of Icarus* overturns this theme. Although Icarus plunges towards a rural village, the inhabitants of the village watch the fall and react in what appears to be a joyous way. Unlike Chagall's earlier *The Fall of the Angel* (page 138), this painting is not pessimistic, as it glorifies artistic inspiration.

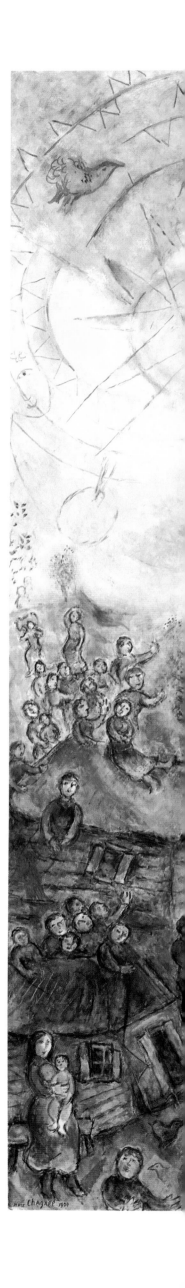

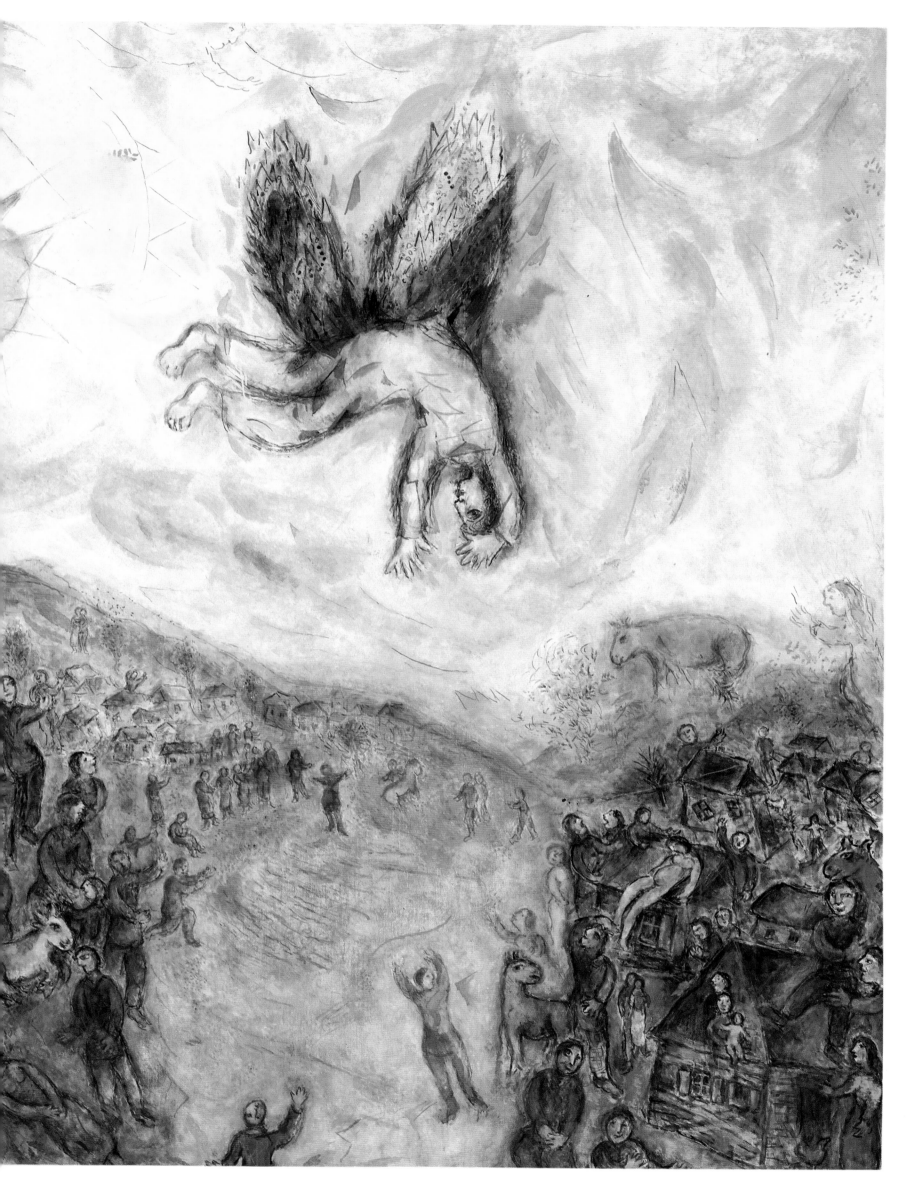

Index

Acknowledgments

The publisher would like to thank Martin Bristow who designed this book; Maria Costantino, the picture researcher; and Aileen Reid, the editor. Special thanks to Janet Tod of DACS and to the Estate of Marc Chagall. We would also like to thank the following museums, agencies, and individuals for the illustrations:

Albright-Knox Art Gallery, Buffalo, New York: page 9 (top) (General Purchase Fund, 1957), 10 (top) (Room of Contemporary Art Fund, 1939), 102 (Room of Contemporary Art Fund, 1941) (© ADAGP, Paris and DACS, London, 1990)

Archiv für Kunst und Geschichte, Berlin: page 11 (below right) (© Cosmopress, Geneva and DACS, London 1990), 13 (left), 14 (below), 18 (below) (© DACS 1990), 20 (top) (Photo: Lotte Jacobi)

The Art Institute of Chicago/Photos © 1989 The Art Institute of Chicago, All Rights Reserved (© ADAGP, Paris and DACS, London 1990): page 15 (below), 38-39 (Gift of Mr and Mrs Maurice E Culberg, 1952.3), 122-123 (Gift of Alfred S Alschuler, 1946.925), 132 (Gift of Mrs Gilbert W Chapman, 1952.1005)

Art Gallery of Ontario, Toronto/Photo: Carlo Catenazzi, Art Gallery of Ontario/(© ADAGP, Paris and DACS, London 1990): page 70-71 (Gift of Sam and Ayala Zacks, 1970)

The Art Museum of the Ateneum, Helsinki (© ADAGP, Paris and DACS, London 1990): page 73

Bildarchiv Preussischer Kulturbesitz: page 12 (top left and right), 20 (below) (Photo: Philippe Halsmann)

Courtesy of the Trustees of the British Museum (© ADAGP, Paris and DACS, London 1990): page 14 (top), 16 (below), 17, 23 (below)

Folkwang Museum, Essen (© ADAGP, Paris and DACS, London 1990): page 145

Galerie Beyeler, Basle (© ADAGP, Paris and DACS, London 1990): page 86-87

Goteborgs Konstmuseum, Goteborg (© ADAGP, Paris and DACS, London 1990): page 109

Hamburger Kunsthalle/Photo: Elke Walford (© ADAGP, Paris and DACS, London 1990): page 142-143

Israel Museum, Jerusalem/Photos: David Harris/(© ADAGP, Paris and DACS, London 1990): page 60, 106 (Gift of Baron Edmond de Rothschild, Paris)

Jewish Museum, New York/ART RESOURCE, NY (© ADAGP, Paris and DACS, London 1990): page 15 (top)

Kunsthaus Zürich/Foto Drayer, Zürich (© ADAGP, Paris and DACS, London 1990): page 31 (Gift of the City of Zürich to the Kunsthaus Zürich), 32-33, 98 (Gift of Gustav Zumsteg to the Vereiningung Zürcher Kunstfreunde, Kunsthaus Zürich), 128, 168-169 (Vereiningung Zürcher Kunstfreunde, Kunsthaus Zürich)

Kunstmuseum Bern (© ADAGP, Paris and DACS, London 1990): page 37

Kunstsammlung Nordrhein-Westfalen (© ADAGP, Paris and DACS, London 1990): page 27, 77

Location Unknown/Bridgeman Art Library: page 7 (below)

Musée d'Art Moderne de la Ville de Paris/Photothèque des Musées de la Ville de Paris (© ADAGP, Paris and DACS, London 1990): page 8 (below), 104-105

Museo d'Arte Moderna, Venice/Photo: Reale Fotografia Giacomelli (© ADAGP, Paris and DACS, London 1990): page 78

Musée des Beaux-Arts, Liège/Photo: Giraudon/ART RESOURCE NY/(© ADAGP, Paris and DACS, London 1990): page 90-91

Musée de Grenoble (© ADAGP, Paris and DACS, London 1990): page 124

Musée National d'Art Moderne, Centre Georges Pompidou, Paris (© ADAGP, Paris and DACS, London 1990): page 46, 88, 112, 133, 137, 172-173

Musée National Message Biblique Marc Chagall, Nice/Photos: Réunion des Musées Nationaux (© ADAGP, Paris and DACS, London 1990): page 24 (top), 119, 146-147, 160-161

Museum Ludwig, Cologne/Photo: ARTOTHEK (© ADAGP, Paris and DACS, London 1990) page 36

Collection of the Museum of Modern Art, New York: page 19, (© ADAGP, Paris and DACS, London 1990): page 47 (Mrs Simon Guggenheim Fund), 56-57 (Acquired through the Lillie P Bliss Bequest), 80-81 (Acquired through the Lillie P Bliss Bequest), 94-95 (Acquired through the Lillie P Bliss Bequest), 115 (Anonymous Gift), 130-131 (Acquired through the Lillie P Bliss Bequest)

National Swedish Art Museums, Stockholm (© ADAGP, Paris and DACS, London 1990): page 8 (top)

Novosti Press Agency: page 12 (below), 24 (below) (Photo: Lev Ivanov)

Öffentliche Kunstsammlung Basle, Kunstmuseum/Photos: Colorphoto Hans Hinz (© ADAGP, Paris and DACS, London 1990): page 28, 54-55, 138-139 (Loan of Mrs Ida Chagall)

Perls Galleries, New York (© ADAGP, Paris and DACS, London 1990): page 101

Philadelphia Museum of Art (© ADAGP, Paris and DACS, London 1990): page 51 (The Louise and Walter Arensberg Collection), (The Louis E Stern Collection): pages 68, 74-75, 84-85, 103, 134-135

Philip Granville (© ADAGP, Paris and DACS, London 1990): page 9 (below)

Pierre Matisse Gallery, New York (© ADAGP, Paris and DACS, London 1990): page 171

Private Collection/Bridgeman Art Library (© ADAGP, Paris and DACS, London): page 140-141

Private Collection/Photo: Colorphoto Hans Hinz (© ADAGP, Paris and DACS, London 1990): page 21 (below), 49, 53, 89, 96, 100

Private Collection, St Paul de Vence/Photo: SCALA (© ADAGP, Paris and DACS, London 1990): page 2

Roger-Viollet, Paris: page 10 (below), 11 (top and below left), 16 (top), 18 (top), 21 (top)

The Saint Louis Art Museum, St Louis, Missouri (© ADAGP, Paris and DACS, London 1990): page 52 (Gift of Morton D May, St Louis)

The Collection of the Solomon R Guggenheim Museum, New York (© ADAGP, Paris and DACS, London 1990)/Photos: David Heald: page 35, 43, 62-63, 97,/Photo: Myles Aronowitz: page 66-67

Staatliche Museen Preussischer Kulturbesitz, Kupferstichkabinett, West Berlin/Photo: Jörg P Anders/Bildarchiv Preussischer Kulturbesitz/(© ADAGP, Paris and DACS, London 1990): page 22

Staatsgalerie Stuttgart (© ADAGP, Paris and DACS, London 1990): page 92-93

Collection of the Stedelijk Museum, Amsterdam: page 13 (right), (© ADAGP, Paris and DACS, London 1990): pages 58, 61, 65, 99, 117

Collection of the Stedelijk Van Abbemuseum, Eindhoven (© ADAGP, Paris and DACS, London 1990): page 45

The Synagogue of the Hadassah University Hospital, Jerusalem/Photos: Hadassah Medical Relief Association Inc (© ADAGP, Paris and DACS, London 1990): pages 148, 149, 150, 151, 152, 153, 154, 155, 156, 157, 158, 159

Tate Gallery, London (© ADAGP, Paris and DACS, London 1990): page 6, 40-41, 82-83

Tel-Aviv Museum of Art, Tel-Aviv © ADAGP, Paris and DACS, London 1990): page 120 (Gift of the Artist, 1948), 121 (Gift of the Artist, 1953)

Théâtre National de l'Opéra, Paris/Photo: Jacques Moatti/Explorer Photography, Paris (© ADAGP, Paris and DACS, London 1990): page 164-165, 166-167

Thyssen-Bornemisza Collection, Lugano, Switzerland (© ADAGP, Paris and DACS, London 1990): page 110, 126-127

The United Nations, New York (© ADAGP, Paris and DACS, London 1990): pages 25, 162-163

Courtesy of the Board of Trustees of the Victoria and Albert Museum, London/E T Archive: page 7 (top)

Weidenfeld Archive: page 23 (top)